12/06

MORE WORD HISTORIES *and* MYSTERIES

From Aardvark to Zombie

From the Editors of the
AMERICAN HERITAGE®
DICTIONARIES

HOUGHTON MIFFLIN COMPANY
BOSTON NEW YORK

Visit our website: www.houghtonmifflinbooks.com

Library of Congress Cataloging-in-Publication Data

More word histories and mysteries : from aardvark to zombie / From the editors of the American Heritage dictionaries.
 p. cm.
 Includes index.
 ISBN-13: 978-0-618-71681-4
 ISBN-10: 0-618-71681-5
 1. English language--Etymology--Dictionaries. I. Houghton Mifflin Company. II. American Heritage dictionary.
 PE1580.M57 2006
 422.03--dc22

 2006020835

Manufactured in the United States of America

RRD 10 9 8 7 6 5 4 3 2 1

Table of Contents

Editorial and Production Staff

Vice President, Publisher of Dictionaries
Margery S. Berube

Vice President, Executive Editor
Joseph P. Pickett

Vice President, Managing Editor
Christopher Leonesio

Project Editor
Patrick Taylor

Associate Editor
Nicholas A. Durlacher

Art and Production Supervisor
Margaret Anne Miles

Editor
Catherine Pratt

Manufacturing Supervisor
James W. Mitchell

Administrative Coordinator
Darcy Conroy

Production Associate
Katherine M. Getz

Text Design
Catherine Hawkes, Cat & Mouse

Database Production Supervisor
Christopher Granniss

Introduction

The Etymology of Etymology

When we in the modern world read the classical myth of Narcissus as told by the Roman poet Ovid (and retold in this book at the entry for *narcissism*), we may feel a certain sense of satisfaction and reassurance in knowing the story behind words like *narcissus* and *narcissism.* The Greeks as well must have enjoyed the same feeling of satisfaction in hearing similar stories. Their fascination with etymology did not end with inventing fanciful stories about mythological figures who gave their names to cities, countries, trees, and flowers, however. In a work called the *Cratylus,* the ancient Greek philosopher Plato portrays his beloved teacher Socrates explaining the etymology of various Greek words to two of his fellow citizens, and the two men are obviously spellbound by the ingeniousness of many of Socrates' explanations. For instance, Socrates derives the goddess of the moon, *Selēnē,* from the Greek common noun *selas,* "brightness," and linguists today would agree with him in making a connection between the two words. However, modern linguists would reject almost all of the other etymological explanations that Plato puts in Socrates' mouth. Plato probably intended his readers to take some of the more outrageous etymologies as jokes, and perhaps as illustrations of the dangers of uncontrolled speculation in tracing the history of words. Nevertheless, the modern science of etymology in the West springs from the kind of inquisitive discussion about language that Plato depicts in the *Cratylus.*

The word *etymology* comes from Greek *etumologiā,* which is ultimately derived from Greek *etumos,* "true," added to the word element *–logia,* meaning "discourse about, study of." (The element *–logia* itself is derived from the Greek word *logos,* "speech, discussion.") The Greeks also used the word *etumon* (a form of the adjec-

tive *etumos*) as a noun meaning "the true sense of a word according to its origin," and this is the origin of the modern term used in linguistics, *etymon*, meaning "an earlier form of a word in the same or another language from which a particular word is derived."

It is, of course, untrue that the etymology of a word will always reveal its true meaning, if we interpret the phrase *true meaning* as "the meaning that a word has in current usage." Any glance at the etymologies on a single page of a dictionary is sufficient to prove this. Among the words discussed in this book, *gymnasium* (originally a "nude practice area" in Greek) or *school* (from a Greek word meaning "free time") show how far the meaning of a modern word can drift away from the meaning of its ancestor. Just because the Greek practiced in the nude in their *gumnasia* does not mean that the true meaning of English *gymnasium* is "nude practice area" and American high school students should properly shed their clothes for physical education class.

Etymology and Human History

Even if etymologies do not help us pin down the true meaning or meanings of a word in contemporary usage, they can nevertheless lead us to another sort of truth: etymology can help reveal aspects of human history that would otherwise be unknown to us.

The study of the history of human language, called *historical linguistics*, has made many important contributions to the study of human history in general. For example, linguists have shown that most of the languages of Europe as well as many of the languages of southwest Asia and northern India are all descended from a single language spoken many thousands of years ago, probably somewhere in the area to the north of the Black Sea. Linguists call this language *Proto-Indo-European*, and they call the family of languages descended from Proto-Indo-European *the Indo-European language family.*

In the late 18th and early 19th centuries, European scholars who had become familiar with languages of Asia like Sanskrit and Persian noticed that the grammar and vocabulary of these Asian languages bore a curious resemblance to the grammar and vocabulary of

European languages. For example, *dvau*, the Sanskrit word for "two," resembles the word for Greek *duō*, "two," Latin *duo*, "two," and to a lesser extent, English *two* itself. The Sanskrit word for "three," *trayah*, resembles Greek *treis*, Latin *trēs*, and English *three*. Sanskrit *pādam*, "foot," resembles Greek *poda*, Latin *pedem*, and English *foot*. Sanskrit *pitā*, "father," resembles Greek *patēr*, Latin *pater*, and English *father*. As another example drawn from the body parts, Sanskrit *jānu*, "knee," resembles Latin *genū*, Greek *gonu*, and English *knee* (from Old English *cnēo*, in which the *c* was pronounced as *k*).

The scholars were able to find many hundreds of similar sets of corresponding words—words, it should be noted, that belong to the most basic levels of vocabulary and are among the first to be learned by young children. They also found many grammatical correspondences among the languages they were comparing. The correspondences led them to propose that Sanskrit, Greek, Latin, English, and many of the other languages of Europe and Asia descended from a common ancestor, now called Proto-Indo-European.

They also noted that the differences between the words from language to language were not random: one particular sound in one language usually corresponds to another particular sound in another language. Wherever Sanskrit, Greek, and Latin have a *p*, for instance, English often has an *f*. And even though the correspondence between English *f* and Greek *p* is not as exact as the correspondence between Sanskrit *p* and Greek *p*, the English *f* is still made in the same place in the mouth as Greek and Sanskrit *p*. Both the *p* in Greek *poda* and *patēr* and the *f* in English *foot* and *father* are sounds made with the lips. Similarly, both the *d* in Greek *duo* and *poda* and the *t* in English *two* and *foot* are sounds made with the tip of the tongue behind the teeth. So it seemed likely that English *f* could have developed from an earlier Proto-Indo-European *p* that was still preserved as *p* in most of the other Indo-European languages.

Based on the many regular sound correspondences among the Indo-European languages, the scholars (followed by linguists in more recent times) hypothesized the existence of Proto-Indo-European roots and words like *ped-*, "foot," *pətēr*, "father," and *genu-*, "knee." Proto-Indo-European must have been spoken long

before the invention of writing, and we will never find a written Proto-Indo-European text in any archaeological excavation. Instead, Proto-Indo-European is only known through the comparison of words and grammatical structures in the languages that have descended from it. None of the words or roots in Proto-Indo-European are attested—that is, they are hypothetical and not found in any written text or known from the speech of living people. Linguists indicate that a word is unattested by putting an asterisk (*) in front of the unattested forms.

English words derive from Proto-Indo-European roots and words by regular sound changes, such as those that turned *p* sounds to *f* sounds and *g* sounds to *k* sounds. Many of the entries in this book, such as *groom* and *helicopter,* explain how families of words can be derived from a single word or root in Proto-Indo-European by sound changes.

The existence of the Indo-European family of languages poses interesting questions for other scholars besides linguists. Archae–ologists, for example, are attempting to locate the place in Europe or Asia where the speakers of Proto-Indo-European lived. Together, archaeologists, linguists, and other scholars are still trying to discover exactly how the languages descended from Proto-Indo-European came to be spoken over such a wide geographic area. At some point, however, Proto-Indo-European began to split up into different languages, and these languages further developed into the separate branches of the Indo-European language family including the modern Indo-European languages spoken around the globe today.

English belongs to the Germanic branch of the Indo-European family. This branch includes Dutch, German, and the Scandinavian languages. The Celtic branch of the family includes the modern languages Irish, Scottish Gaelic, Welsh, and Breton, as well as their extinct relatives like Gaulish, the language spoken in the area that is now France both before and during the period of the Roman Empire. The Balto-Slavic branch contains the Baltic languages (including Lithuanian and Latvian as well as the extinct language Old Prussian) and the Slavic languages (such as Polish, Russian, Serbo-Croatian,

and other languages). The Italic branch contains Latin (as well as its descendants, the Romance languages like French and Spanish) and the various relatives of Latin that were spoken in Italy in ancient times. The Indo-Iranian branch contains Sanskrit and many of the languages of Northern India like Hindi, Urdu, and Bengali, as well as Iranian languages like Persian. Greek, Armenian, and Albanian each constitute a separate branch of the family as well, and the Tocharian branch, discussed at the entry for *shaman,* contains two languages called *Tocharian A* and *Tocharian B.* There are also a multitude of languages known mostly from ancient inscriptions. These inscriptions are often quite short—just long enough, in many cases, for linguists to determine that the languages are Indo-European, but too short to be sure of much else.

Many of the entries in this book trace English words from their beginning in the mists of prehistory, the time when Proto-Indo-European was spoken. The language of one group of Proto-Indo-European speakers began to develop into what linguists call *Proto-Germanic,* the hypothetical ancestor of Old English and all the other Germanic languages. Proto-Germanic was spoken on the European continent, not in Great Britain (where Celtic languages had long been spoken), and Proto-Germanic itself later broke up into many different languages, the ancestors of the separate modern Germanic languages like English, German, and Norwegian. This book follows a variety of Proto-Indo-European words as they change on their way from Proto-Indo-European through Proto-Germanic into Old English. The Old English period can be said to begin about AD 450, the period given by the medieval scholar Bede for the first arrival of the Germanic tribes in Great Britain from the continent.

Borrowings in English

Many of the words that Old English inherited from Indo-European have not survived into Modern English. Instead, Modern English has received much of its vocabulary from other languages, and the majority of these new words have in fact been borrowed from other Indo-European languages.

One of the earliest and most important sources of new words in the history of English was Old Norse, the language of the Scandinavians who began to make permanent settlements in the northern half of England in the middle of the 9th century. During the long period of contact between Old English and Old Norse, around a thousand words of Norse origin entered the English language.

The Middle English period is usually said to have lasted from about 1100 to about 1500, having begun after the conquest of England by the French-speaking Normans in 1066. During the Middle English period, a very large number of loanwords entered English from Old French, and more specifically, from the dialect of French spoken by the Normans in England, called *Anglo-Norman*. Since 1500, English has continued to borrow very heavily from French and Latin, as well as from other languages, and after many centuries of borrowing, English now contains words that have originated in—or at least passed through—most of the major branches of the Indo-European language family besides Germanic. We even have a word, *shaman,* that has probably passed through the long-extinct Tocharian branch of Indo-European, once spoken in Central Asia on the Silk Road between Europe and China.

Throughout this book, special care is taken to present the cultural context that explains why words like *shaman* have passed from language to language and followed the long and tortuous road that finally led them into English. When we read an etymology at the end of a dictionary entry, it can often seem like just one language after another. In fact, when we take a closer look, an etymology can reveal a wealth of historical information about how people in the past lived their daily lives: how they governed their cities (*ostracize*), where the clothing came from (*muslin, tabby cat*), and even where the vegetables in their markets came from (*scallion*).

The Most Ancient Words

In a sense, all of the English words inherited from Proto-Indo-European, whether directly in words of Old English origin or indirectly through borrowing, are equally ancient. But this book also

explores the history of words that are ancient in another sense—the words that originate in the earliest languages ever to be written down, like Sumerian and Egyptian, and whose histories we can, in some cases, follow through written documents back to the very beginning of writing over four thousand years ago. *Adobe, cider, divan, gum, nitrogen,* and *sash* are among the "most ancient words" discussed in this book.

Regionalisms

This book also explores the relationship between language and history in the entries discussing the regional vocabulary of American English. In recent times, the traditional dialect regions of the United States have begun to blur somewhat since Americans frequently move to another part of the country to go to a university or to take a job. In general, however, the traditional distribution of regionalisms across the United States reflects the westward-moving patterns of settlement by English speakers, first by early colonists on the Atlantic Coast and then by settlers moving to the interior regions of North America. The boundaries between traditional dialect regions often show such influences as physical barriers like mountain ranges, the roads taken by settlers, or even local climate and soil types that encouraged settlement by people familiar with growing a certain kind of crop like cotton. At the boundaries between dialect areas, there nevertheless may be mixing of features from various dialects.

Some of the regional terms discussed in this book may only be known to older speakers. Many of them are rural or farming terms that younger city-dwellers in the dialect region may never have an opportunity to learn on the urban streets. Readers should not be surprised if they do not know or use some of the regional words discussed in these notes even though they live in the region where they are supposed to be used. Once readers have begun to keep an ear open for older or uncommon regional expressions, however, it can be a very enjoyable experience to hear a colorful regional word pop up unexpectedly in the speech that surrounds us everywhere in our daily lives. Newly emerging regional terms, like the various

names of the sandwich called the *submarine,* are also discussed in this book.

Unsolved Mysteries

In addition to distinctive American regional words, this book also discusses slang and the newest expressions in American speech—history in the making, so to speak. The entries for slang words are often the darkest corners of a dictionary, and not just because many slang words describe taboo topics. The history of slang words can be very difficult to investigate, and the etymologists for a dictionary must frequently throw up their hands and put *origin unknown* after many slang words. Sometimes their origins are revealed or clarified only by a chance remark preserved in a yellowed newspaper. Many scholars of the English language devote their time to reading old documents of all sorts—newspapers, popular magazines, dime novels, advertising posters—in order to discover the origins of current slang and recover the culture of the bygone times when the expressions were created.

In describing the origins of words and phrases like *brogue* and *red herring,* this book also attempts to give readers an idea of the methods used by scholars and researchers who investigate the history of words, and some of the excitement that they feel in discovering a new etymology or uncovering a relevant fact. When readers of this book become curious about the origin of a certain word, they may even find that they enjoy speculating about its etymology for a while, associating meanings and sounds as people have done since ancient times, before they finally look the word up in the dictionary and dispel their doubts. Readers may even want to try their hand at solving some of the remaining mysteries among the word histories of English.

A Note on Sources

Many different editors have worked over the years to produce the word history notes collected in this volume. Major sources of evidence that they have used in compiling this book are the great historical dictionaries of English and other languages, and readers who

seek to know more about the history of English are encouraged to consult these works for further enlightenment. Most important among these sources is the *Oxford English Dictionary* (*OED Online*, http://www.oed.com, Oxford University Press, 1989–). Also essential are the *Middle English Dictionary*, edited by Hans Kurath, Sherman E. Kuhn, et al. (University of Michigan Press, Ann Arbor, 1952–2001), the *Dictionary of American Regional English*, edited by Frederic G. Cassidy and Joan Houston Hall (four volumes, A–Sk; Belknap Press of the Harvard University Press, 1985–2002), and the *Random House Historical Dictionary of American Slang*, edited by J. E. Lighter (two volumes, A–O; Random House, 1994–). When we have given dates at which words or meanings entered the English language, we have often given the dates recorded in these large historical dictionaries.

For the further etymologies of words from other languages, we have often consulted the 24th edition of Friedrich Kluge's *Etymologisches Wörterbuch der deutschen Sprache*, edited by Elmar Seebold (De Gruyter, 2002) as well as the *Trésor de la langue française informatisé* produced by the Centre National de la Recherche Scientifique (http://atilf.atilf.fr/tlf.htm). To the authors and editors—past and present—of all these great works we are heavily indebted.

Another important resource in tracing the history of words is the work of linguists who reconstruct unrecorded languages, such as Germanic and Indo-European. The *American Heritage Dictionary of Indo-European Roots*, 2nd edition, edited by Calvert Watkins (Houghton Mifflin, 2000) has been especially helpful to us.

In the note for the word *cannibal*, Bartolomé de Las Casas's version of Christopher Columbus's log is quoted from page 367 of the edition by Francesca Lardicci et al., *Repertorium Columbianum, Volume VI: A Synoptic Edition of the Log of Columbus's First Voyage* (Brepols, 1999).

We are also greatly indebted to the many authors who have devoted their time to researching individual English words and publishing their findings in scholarly works.

Pronunciation Key and Other Symbols

Symbol	Examples	Symbol	Examples	Symbol	Examples	Symbol	Examples
ă	pat	îr	deer, pier	ōō	boot	y	yes
ā	pay	j	judge	ou	out	z	zebra, xylem
âr	care	k	kick, cat,	p	pop	zh	vision,
ä	father		pique	r	roar		pleasure,
b	bib	l	lid, needle	s	sauce		garage
ch	church	m	mum	sh	ship, dish	ə	about, item,
d	deed, milled	n	no, sudden	t	tight,		edible,
ě	pet	ng	thing		stopped		gallop,
ē	bee	ŏ	pot	th	thin		circus
f	fife, phase,	ō	toe	th	this	ər	butter
	rough	ô	caught,	ŭ	cut	N	French bon
g	gag		paw	ûr	urge, term,		(boN), blanc
h	hat	ôr	core		firm, word,		(bläN)
hw	which	oi	noise		heard	KH	German ach
ĭ	pit	t	took	v	valve		Scottish
ī	pie, by	ōōr	lure	w	with		loch

In the text of this book, words from English and other languages are given in italic type when quoted as words; meanings of words are enclosed by quotation marks; symbols representing pronunciations are enclosed in parentheses, as follows: French *doux*, "sweet, soft," pronounced (du). In pronunciations of English words, the stressed syllable is put in boldface type and marked with the symbol (ʹ): *elephant* (ĕlʹə-fənt). When an asterisk (*) is put in front of a word or a word element, it means that the word or word element is unattested—that is, not found in any written text or known from the speech of any people. Words appearing in small capitals are defined in the glossary.

This book illustrates the history of some words with exact quotations from Old and Middle English writings. To give the reader an idea of the way that English looked on the page in the medieval period, the quotations often attempt to represent as closely as possible the spelling used in medieval manuscripts. In particular, some quotations use the obsolete letters þ (called *thorn*) and ð (called *edh*). Medieval English scribes often used both þ and ð to represent the sound (th), as heard in the Modern English word *teeth* (tēth), as well as the sound (*th*), as heard in Modern English *teethe* (tē*th*). The capital forms of þ and ð are Þ and Ð, respectively. In Modern English spelling, þ and ð have simply been replaced by the letters *th*, and modern readers can usually read medieval writings using þ and ð quite easily simply by mentally substituting *th*.

xvi

aardvark The aardvark is a burrowing mammal, with a stocky, hairy body, large ears, and a long tubular snout somewhat resembling a pig's. It is found over much of Africa, and it eats the ants and termites that it excavates with its powerful digging claws. The animal is in actuality a pale yellowish-gray color, but in the wild it is usually seen covered with a thick layer of reddish dust from its digging activities.

The English name for this animal is borrowed from Afrikaans, the language descended from the Dutch dialects spoken by settlers from the Netherlands who moved to the south of Africa in the 17th century. Today Afrikaans is one of the official languages of the Republic of South Africa, and the language is also spoken by a large percentage of the population of Namibia. The Afrikaans spelling system differs somewhat from the one used in Modern Standard Dutch, and there are some differences in grammar and vocabulary between the two languages. Nevertheless, modern Afrikaans and standard Dutch still resemble each other quite closely, and a speaker of Dutch and a speaker of Afrikaans can converse with no trouble at all.

In Afrikaans, *aardvark* is a compound that literally means "earth-pig." The name is motivated by the animal's piglike snout and its habit of digging in the earth for its food. Afrikaans belongs to the Germanic branch of the Indo-European language family just like English, and both the words that go in to make up the word *aardvark* have close relatives in English. Afrikaans *aard,* "earth," comes from Middle Dutch *aerde, eerde,* which in turn comes from Proto-Germanic **erthō,* also the source of the

English *earth* and German *Erde*. In this case, the *th* heard in the English word preserves the original Proto-Germanic sound, which both Dutch and German have changed to a *d*.

The Afrikaans word *vark*, "pig," comes from Middle Dutch *varken*, which in turn comes from Proto-Germanic **farhaz*. In German, this word is preserved as part of the word *Ferkel*, "piglet." English too has kept this ancient word as *farrow*, which can be both a noun meaning "a litter of pigs" and a verb meaning "to give birth to a litter of pigs." Proto-Germanic **farhaz* itself descends from Proto-Indo-European **porko–*, a word that will undoubtedly remind English speakers of their word *pork*. In Latin, Proto-Indo-European **porko–* developed into *porcus*, "pig," and *porcus* then developed into French *porc*. *Porc* was then borrowed into Middle English as *porke*, which at first could mean both "pig" and "pig-meat." Only the latter meaning has survived in the Modern English word *pork*.

Other aspects of the etymology of *pork* are discussed at the separate entry for the word in this book.

abacus With the advent of the computer and the modern hand-held calculator, many abaci probably sit disused and gathering dust nowadays. From the point of view of etymology, this is only appropriate, since originally, this counting device was in fact dusty. The source of our word *abacus*, the Greek word *abax*, probably comes from Hebrew *'ābāq*, "dust," although the details of transmission are obscure. In postbiblical usage, *'ābāq* meant "sand used as a writing surface." The Greek word *abax* has as one of its senses "a board sprinkled with sand or dust for drawing geometric diagrams." Boards like this were also used for performing arithmetic calculations by moving pebbles around the board, and these early abaci eventually developed into the abaci with movable counters strung on rods familiar to us today. Greek *abax* was borrowed into Latin as *abacus*, and then the Latin word was borrowed into Middle English. The first known attestation of *abacus* in English occurs in a work written before 1387, in which the word refers to a sand-board abacus used by the Arabs.

aboveboard Cardsharps take note: the word *aboveboard*, now meaning "without deceit or trickery," was originally a gambler's term, recorded as early as the 17th century. If the gambler's hands were above the board or gaming table, then presumably he could not surreptitiously change his cards or indulge in other forms of cheating. *Board* once meant "a table of any kind," a sense that is preserved in the expressions *room and board* (*board* being a table at which food is served) and *board of directors* (*board* being a table where a council is held).

absquatulate In the 19th century, the vibrant energy of American English appeared in the use of Latin affixes to create jocular pseudo-Latin "learned" words. There is a precedent for this in the language of Shakespeare, whose plays contain scores of made-up Latinate words. Midwestern and Western US *absquatulate* has a prefix *ab–*, "away from," and a suffix *–ate*, "to act upon in a specified manner," affixed to a nonexistent base form *–squatul–*, probably suggested by *squat*. Hence the whimsical *absquatulate* literally means "to squat away from." A more familiar meaning would be "to depart in a hurry."

A similar coinage is Northern *busticate*, which joins *bust* with *–icate* by analogy with verbs like *medicate*, and means "to break into pieces." Southern *argufy* joins *argue* to a redundant *–fy*, a suffix meaning "to make; cause to become." Today, these creations have an old-fashioned and rustic flavor curiously at odds with their elegance. They are kept alive in regions of the United States where change is slow.

absurd *Absurdus* in Latin meant "silly and irrational," just as *absurd* does in English, but its literal sense was "out of tune." By the time English borrowed the word from French in the 16th century, the figurative sense had already eclipsed the literal, and most of the early occurrences of the word *absurd* in English texts refer to incongruous reasoning, not discordant sounds. The musical sense of Latin *absurdus* goes back to Latin *surdus*, meaning "deaf

or insensitive to sound." The Latin prefix *ab–*, which usually has the sense "away from," as in *abnormal*, here functioned to intensify the meaning of *surdus*—just as an English speaker might say "way off-key." The Indo-European root of *surdus* is **swer–*, an imitative word meaning "to buzz or whisper" that also gives us the English word *swarm*, from the sound emitted by a mass of migrating bees.

a cappella Nowadays many genres of music are sung a cappella, and even hip-hop songs can be performed entirely with the human voice since the advent of beatboxing, a contemporary style of vocal percussion. The Italian expression *a cappella*, however, originates in the musical traditions of the early Christian Church as they were upheld and continued by the Roman Catholic Church in the medieval era. In the days of the first Christian scholars and saints, there was already a tendency in the Christian Church to discourage—or prohibit altogether—the use of instruments in worship. An authoritative Christian writer of the 2nd and 3rd centuries, Clement of Alexandria, specifically contrasts the use of instruments by pagans to the unaccompanied singing of the early Christians: *We use one instrument, the word of peace alone, by which we honor God, and not the psaltery of old, the trumpet, the timbrel, and the flute.* Throughout the medieval period, however, certain instruments like the organ or the harp were sometimes permitted as support to the human voice in religious services, but their musical parts were never allowed to become overly independent of the singing. Other instruments like flutes and drums were often banned outright, since it was thought that they made the service too theatrical and distracted the congregation from spiritual contemplation. Unaccompanied singing was thus typical of the performances in chapels, and the Italian term *a cappella*, "in the manner of the chapel," came to be applied to such singing in general, even when performed in the concert hall.

The etymology of Italian *cappella*, and indeed English *chapel* itself, provides another fascinating glimpse of the great impor-

tance of religion in medieval culture. *Cappella* and *chapel* ultimately derive from a legend surrounding the miraculous cloak belonging to the great French saint, St. Martin of Tours (315 or 316–397). Martin was a Roman soldier stationed in France, and one time, when he was riding into the city of Amiens, he noticed a naked beggar. He tore his own cloak in two and gave half to the beggar. That night, Martin dreamed that Jesus himself was clothed in his torn cloak, and when he awoke, he found that the cloak had miraculously been made whole again. The cloak of St. Martin became a highly revered relic—the early kings of France supposedly carried it into battle to assure victory. The cloak, or *cappa* in Medieval Latin, was kept in the Cathedral of Tours, and a separate shrine was built in the church to accommodate the many pilgrims who came to view it. The shrine where Martin's *cappa* was kept came to be called the *cappella* in Medieval Latin, and the persons in charge of the shrine, *cappellānī* or chaplains. Eventually the word *cappella*, also spelled *capella*, came to be applied to any sanctuary housing relics in a church, and then to any small place of worship in general. From Medieval Latin, *capella* then spread to the other languages of Europe. The Old French form of the word was *chapelle*, and this is the source of the English word *chapel*, which begins to appear early in the 13th century. The related word *chaplain* occurs even earlier, in a text written before 1121.

accident *Accident* unfortunately occurs in general use all too often, but when it first came into English its senses were chiefly technical. *Accident* goes back to a Latin word that meant "a chance event" and also "a contingent attribute." The second sense was useful to medieval philosophers and theologians in discussing the nonessential characteristics of things. Such characteristics were particularly important in regard to the nature of the sacramental bread and wine. *Accident* was used to refer to their outward physical properties, such as texture, color, and taste. The philosophers and theologians thought that after transubstantiation the essence of the bread and wine was changed though the

accidents remained. Physicians also used the word *accident* in various ways, for example, as a term for a disease that was not normal or natural.

These technical senses of *accident* are used rarely if at all by the general public, but the first Latin sense, "a chance event," has associated with it two senses that are heard everywhere and that keep the word firmly entrenched in the language. One sense is "a bad chance event," perhaps illustrating the unhappy nature of many a chance event. The other sense, "chance," is often seen in the phrase *by accident.*

adder The biblical injunction to be wise as serpents and innocent as doves looks somewhat alien in Middle English guise: "Loke ye be prudent as neddris and symple as dowves." *Neddris,* which is perhaps the strangest-looking word in this Middle English passage, would be *adders* in Modern English, with a different meaning and form. *Adder,* an example of specialization in meaning, no longer refers to just any serpent or snake, as it once did, but now denotes only specific kinds of snakes. *Adder* also illustrates a process known as false splitting, or juncture loss: the word came from Old English *nǣdre* and kept its *n* into the Middle English period, but later during that stage of the language people started analyzing the phrase *a naddre* as *an addre*—the false splitting that has given us *adder.*

See also *umpire.*

adobe From the ancient Egyptians along the Nile to modern Americans in the desert southwest of the United States, many groups of people living in hot, dry areas have built their houses with thick walls of adobe bricks. Adobe bricks are made by mixing earth—usually earth composed mostly of sand and clay—with straw and water. The mixture is shaped into bricks that are then dried in the sun. Thick walls of adobe will keep the interior of a house cool in the daytime, but they will also gradually release heat soaked up during the day to warm the house during cold desert nights. Appropriately enough, our term for this building

material ideally suited to the desert comes from the ancient Egyptian word for "brick."

In the hieroglyphic writing system, this word was written as *ḏbt*. The hieroglyph (or combination of hieroglyphs) transcribed with the letter *ḏ* in this word probably originally had a sound like English (j) in *jay*, but its pronunciation seems to have changed over the long history of the Egyptian language. The ancient Egyptian writing system also had no straightforward way of writing vowels, and when Egyptologists wish to give a spoken form to the word *ḏbt*, "brick," they will insert vowels according to certain conventions and pronounce it as (*jĕ-bĕt*).

As the ancient Egyptian language developed into Coptic, the language of medieval Christian Egypt, *ḏbt* became *tōbe* or *tōōbe*. After the Islamic conquest of Egypt beginning in 639, Coptic *tōbe* passed into Arabic as *ṭūba*. (In transcriptions of the Arabic alphabet into Roman letters, the *t* with a dot represents the Arabic letter *ṭā*, which has a sound like English (t) but with a characteristic "deep" or "dark" quality.) From Arabic, the word made its way into Spanish as *adobe*.

Some readers may wonder where the initial letter *a* in Spanish *adobe* comes from. In Arabic, the word for "the" is *al*, and the *l* of *al* will undergo ASSIMILATION (that is, become similar or identical to) any following consonant that is made using the front part of the tongue, like *t* or *ṭ*. The phrase "the brick" is thus pronounced *aṭ ṭūba*. This entire Arabic phrase passed into Spanish as a single noun, *adobe*, meaning just "adobe," not "the adobe."

Adobe is just one of the many Arabic words that entered Spanish after the Islamic conquest of the Iberian peninsula beginning in 711. The Spanish language kept its rich heritage of Arabic words even after the region was gradually reconquered by Christian rulers, and *adobe* was later spread to the Western Hemisphere with the expansion of Spain's imperial power. The word begins to appear in English in the 18th century, at first in descriptions of buildings in Spanish-speaking areas of the Western Hemisphere.

adolescent The adolescent grows up to become the adult. The words *adolescent* and *adult* ultimately come from forms of the same Latin word, *adolēscere*, meaning "to grow up." The present participle of *adolēscere*, *adolēscēns*, from which *adolescent* derives, means "growing up," while the past participle *adultus*, the source of *adult*, means "grown up." Appropriately enough, *adolescent*, first recorded in English in a work written perhaps in 1440, seems to have come into the language before *adult*, first recorded in a work published in 1531.

agnostic An agnostic does not deny the existence of God and heaven but holds that one cannot know for certain whether or not they actually exist. The term *agnostic* was coined by the 19th-century British scientist and advocate of Darwinian evolution Thomas H. Huxley, who believed that only material phenomena could be objects of exact knowledge. He made up the word from the prefix *a–*, meaning "without, not," as in *amoral*, and the noun *Gnostic*. *Gnostic* is related to the

agnostic
*photographic portrait
of Thomas Henry Huxley*

Greek word *gnōsis*, "knowledge," which was used by early Christian writers to mean "higher, esoteric knowledge of spiritual things"; hence, *Gnostic* referred to those with such knowledge. In coining the term *agnostic*, Huxley was considering as "Gnostics" a group of his colleagues who had eagerly accepted various doctrines or theories that explained the whole world to their satisfaction. Huxley referred to such intellectuals as "ists," because they embraced various "isms." Because he was a "man without a rag of a label to cover himself with," Huxley coined the term *agnostic* for himself, its first published use being in 1870.

album *Album* literally means "white" in Latin. In ancient Rome, municipal officers would write down records of official business

for public display on wooden tablets whitened with plaster. These records included lists of names of people chosen to judge law cases, and thus *album* came to mean any list of names in general.

When the word *album* first appears in English in the middle of the 17th century, it denotes a blank book in which the owner would collect souvenirs of various sorts, such as the signatures of famous people. Such books were essentially like the modern autograph book filled with names of film stars written by their own hand. In its first recorded appearances in English, *album* was usually used in the Latin form *albo* from the phrase *in albō* "on the white (tablet)." (The Latin form *albō* is the ablative case of *album*. The ablative case is the form of the word used after prepositions in Latin under some circumstances.) Later, the form *album* predominated, and the word came to mean any book in which various items worth preserving, such as verses, sheets of music, or photographs, were kept.

In the 1950s, *album* also came to be applied to long-playing vinyl records and the contents recorded on them. The etymology of the word *album* adds an interesting artistic resonance to the cover of the Beatles' album that is officially titled *The Beatles*. On account of its spare, all-white cover—contrasting greatly with the crowded cover of some of the Beatles' earlier albums like *Sgt. Pepper's Lonely Hearts Club Band*, for instance—this masterpiece of the Beatles is now usually referred to as *The White Album*. The cover was designed by Richard Hamilton, a leading figure of the Pop Art movement, and he conceived the idea that the covers of the first pressing of the album should be individually numbered—as an ironic subversion of the idea of the limited edition. Every Beatles fan could thus own a copy of a limited edition of over three million.

algorithm Because of its popularity over the last century, one might figure *algorithm* for a new coinage. The source of *algorithm*, however, is not Silicon Valley but Khwarizm, a region near the Aral Sea in south-central Asia and the birthplace of the 9th-century Persian mathematician, Mohammed ibn-Musa al-

Khwarizmi (780–850?). Al-Khwarizmi, "the Khwarizmian," who later lived near Baghdad, is perhaps most important to us because Arabic numerals became generally known in Europe through a translation of his work on algebra. He also wrote a treatise on algorism, the Arabic or decimal system of numeration, in which he was the first to discuss these numerals. *Algorism,* named after him, gave rise to the variant spelling *algorithm,* probably influenced by the word *arithmetic* or its Greek source *arithmos,* "number." With the development of sophisticated mechanical computing devices in the 20th century, *algorithm* was adopted as a convenient word for a recursive mathematical procedure, the computer's stock-in-trade. In its new life as a computer term, *algorithm,* no longer a variant of *algorism,* nevertheless reminds us of the debt that modern technology owes to the scientists and scholars of ancient and medieval times.

all Colloquial English has several ways of introducing direct speech—that is, quoted speech that is reported or repeated using exactly the same words as the speaker originally used. Among the newest ways of introducing direct speech is the construction consisting of a form of *be* with *all,* as in *I'm all, "I'm not gonna do that!" And she's all, "Yes you are!"* This construction is particularly common in the animated speech of young people. Similar expressions that indicate direct speech are *be like* and *go,* as in *He's like* [or *goes*], *"I'm not gonna do that!"* These indicators tend to be used more often with pronoun subjects (*He's all, "No way!"*) than with nouns (*The man's all, "No way!"*), and with the historical present (*He's all, "No way!"*) than with the past (*He was all, "No way!"*). All of these locutions can introduce a gesture or facial expression rather than a quotation, as in *He's all.... * followed by a shrug of the shoulders. *Be all* and *be like* can also preface a statement that sums up an attitude, as in *I'm all, "No way!"*

Allegheny River The Allegheny River rises in north-central Pennsylvania and flows northwest into New York. It then turns southwest into Pennsylvania again, where it joins the

Monongahela River at Pittsburgh to form the Ohio River. The Iroquois who inhabited western Pennsylvania considered the Allegheny to be the upper part of the Ohio River. Iroquois *Ohio* means "beautiful river" (*oh–*, "river"; *–io*, "good, fine, beautiful"). When the Delaware, an Algonquian people, moved to western Pennsylvania in the 18th century and displaced the Iroquois, they translated Iroquoian *Ohio* into Delaware, yielding *welhik-heny,* "most beautiful stream" (*welhik,* "most beautiful"; *heny,* "stream"). The name *Welhik-heny* was then anglicized as *Allegheny.* Iroquois *Ohio,* however, was preserved further downstream.

amethyst The English word *amethyst,* denoting purplish varieties of quartz, comes from the Greek term for this gemstone, *amethustos.* The Greek word literally means "not drunk" or "not intoxicating," and in antiquity, amethysts were thought to ward off the effects of wine. To remain sober during a drinking bout, a person only had to wear amethysts. The belief in the power of amethysts to ward off drunkenness probably stems from the association of their purple hue with the color of red wine. Popular belief even attributed other magical powers to these gemstones, as the Roman scholar Pliny the Elder mentions in his vast work called *Natural History,* which summarizes the scientific and pseudoscientific knowledge of his time:

> *The false stories of the magicians promise that these gems prevent inebriety, and it is from this that they are called* amethysts. *Moreover, they say that if we inscribe the words for "sun" and "moon" upon these gems, and wear them suspended from the neck with some hairs from a baboon and some feathers from a swallow, they will act against the effects of sorcery.*

The Greek word *amethustos,* "not drunk" or "not intoxicating," is derived from the prefix *a–,* "not," and the verb *methuskein,* "to intoxicate." *Methuskein* is in turn derived from *methu,* a poetic

term for "wine" in Greek. (The usual Greek word for "wine" was *oinos*, a word distantly related to English *wine*.) The Greek word *methu* descends from the Proto-Indo-European word **medhu*, which covered such meanings as "honey," "sweet drink," and specifically "mead (the alcoholic beverage made from fermented honey)." The word **medhu* has many descendants among the Indo-European languages, but the meaning of the words descended from **medhu* varies somewhat. The speakers of Proto-Indo-European doubtless drank a variety of fermented beverages, but their main alcoholic drink was probably not wine made solely from grapes. Although fermented beverages were very common in many ancient cultures—just as they are in many modern societies—actual traces of ancient fermented beverages in archaeological sites are in fact quite rare, since their residues are quickly broken down by microorganisms. Because of this, we have only the vaguest idea of what ancient beer and wine were like before the invention of writing. Archaeological excavations of a royal tomb in Turkey, however, have revealed that in the early part of the first millenium BC, the Phrygians (an Indo-European people speaking a language closely related to Greek) drank a fermented beverage made from a mixture of honey, grapes, and malted barley. The Indo-Europeans may have drunk similarly complex fermented beverages. Not only would the grapes or other fruits added to the barley and honey mixture have given extra flavor to the beverage, but the natural yeasts present on their skins would have helped fermentation as well.

In the history of Greek, the Indo-European word for "sweet beverage," **medhu*, developed the specific meaning "wine." When the people who spoke the Indo-European language that was eventually to become Greek first moved into the Mediterranean area, they probably encountered cultures in which the grape was one of the main crops, and by cultural assimilation, they made wine their sweet drink of choice. **Medhu* thus became specialized as a word for wine.

In many other Indo-European languages, however, **medhu* shows up as the word for "honey": Sanskrit *madhu*, Tocharian

mit, Russian *mëd*, and Lithuanian *medùs*. In the Celtic and in the Germanic languages, **medhu* appears as the word for *mead*, the drink made from fermented honey that was at the center of the warrior culture described in Old English and Old Norse heroic literature. Despite the beer-loving reputation of the Dutch, English, Germans, and other peoples who speak the modern Germanic languages, the ancient Germanic peoples seem to have prized mead even more than ale: in the hall of Odin, the father of the Norse gods, there was a fabulous goat whose udder gave forth limitless quantities of mead to be drunk by Odin's honored guests, mortal men who had died bravely in battle.

among The word *among* comes from the Old English phrase *on gemang*. (The first *g* in this word was pronounced like the Modern English sound (y), which is the usual pronunciation of the letter *g* before the vowel *e* in Old English.) Old English *on* meant "in," and *gemang*, composed of the prefix *ge–*, "together," and the root *–mang*, "to mingle," meant "crowd". One of the earliest occurrences of the phrase is in an Old English poem in which the emperor Constantine orders a banner to be carried *on feonda gemang*, "in the throng of enemies." Over time, *on gemang*, was shortened to *onmang* or *gemang*, which eventually became the modern word *among*.

andiron An *andiron* is one of the paired metal supports used for holding up logs in a fireplace. The word descends from Middle English *aundiren*, an alteration of Old French *andier*, which is probably ultimately of Celtic origin. It has been suggested that the Old French word originates in a hypothetical Gaulish word **anderos*, meaning "bull," since the medieval andirons were often wrought in the form of animals or adorned with animal heads of various sorts. The difference between Old French *andier* and Middle English

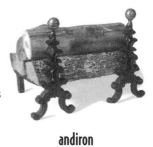

andiron

aundiren reflects the influence of another word, Middle English *iren*, "iron," since andirons are typically made of this metal.

A number of words that formerly were limited to one region of the US are now used throughout the country. *Andiron* was once Northern, contrasting with Southern *dog iron* and *firedog*. The Southern terms remain limited to that region, but *andiron* is now everywhere. Other formerly Northern words that have become national include *faucet*, contrasting with Southern *spigot*; *frying pan*, contrasting with Midland and Upper Southern *skillet*; and *freestone peach*, contrasting with *clearseed* and *open peach* in parts of the South. Southern words that are now used nationwide include *feisty* and *gutters*.

anesthesia English *anesthesia* comes from New Latin *anaesthēsia*, which in turn is from the Greek word *anaisthēsia*, "lack of sensation." The Greek word is ultimately derived from the prefix *an–*, meaning "not" or "without," and the verb *aisthanesthai*, meaning "to feel." The following passage, written on November 21, 1846, by the poet and physician Oliver Wendell Holmes (the father of the Supreme Court justice of the same name), allows us to pinpoint the entry of *anesthesia* and *anesthetic* into English:

> *Every body wants to have a hand in a great discovery. All I will do is to give you a hint or two as to names—or the name—to be applied to the state produced and the agent. The state should, I think, be called "Anaesthesia." This signifies insensibility.... The adjective will be "Anaesthetic." Thus we might say the state of Anaesthesia, or the anaesthetic state.*

This citation is taken from a letter to William Thomas Green Morton, who in October of that year had successfully demonstrated the use of ether at Massachusetts General Hospital in Boston. Although *anaesthesia* is recorded in Nathan Bailey's *Universal Etymological English Dictionary* in 1721, it is clear that Holmes really was responsible for its entry into the language. The

Oxford English Dictionary has several citations for *anesthesia* and *anesthetic* in 1847 and 1848, indicating that the words gained rapid acceptance.

Antares Antares is the brightest star in the southern sky. Its Greek name *Antarēs*, is a compound of *anti-*, "rival of," and *Arēs*, "the planet Mars," and it refers to the star's pronounced red color, which sometimes causes it to be misidentified as Mars. The word *Arēs*, also the name of the Greek god of war, is probably related to Greek *arē*, "strife." The association of Ares with the planet Mars comes from the Babylonian religion in which the planet was identified with the god Nergal, who presided over the underworld and caused strife on earth. Likewise, the Latin word *Mārs* was originally the name for the Roman god of war.

antic The word *antic* was first borrowed into English in the 16th century from the Italian word *antico*, "ancient," as a term for the bizarre and fanciful designs that had been discovered on ancient Roman artifacts. The source of Italian *antico* is Latin *antīquus*, the same word from which English *antique* is derived. During the Renaissance, archaeological discoveries in Italy began to reveal the art of classical antiquity, and the newly unearthed treasures made a tremendous impression on the artists of the time. The walls of the rooms in long-buried Roman buildings were found to be adorned with fanciful animals and exaggerated human caricatures elaborately interwoven with floral motifs.

Fascination with these strange images helped the word *antic* to flourish outside the decorative arts, where it was applied to ludicrous or extravagant acts, gestures, and people. Shakespeare, for example, uses the word in this sense in his play *Hamlet.* Prince Hamlet says he will put on an *antic disposition* when he explains to his friend Horatio that he will feign madness so that he may investigate and expose his father's murderer unhindered.

By the 19th century, the original sense of *antic* referring to the exaggerated caricatures had been superseded by *grotesque*, a

French term that comes from Italian *grotta*, "grotto," the word for the buried Roman chambers in which many of the grotesque images were found. Today the word *antics* is used mostly to mean "capers" or "escapades."

anymore In standard American English the word *anymore* is often found in negative sentences: *They don't live here anymore.* But *anymore* is widely used in regional American English in positive sentences with the meaning similar to "nowadays," as in this sentence spoken by an informant from Oklahoma and cited in the *Dictionary of American Regional English*: "*We use a gas stove anymore.*" This use, which appears to be spreading, is centered in the South Midland and Midwestern states, as well as in the Western states that received settlers from those areas. The earliest recorded examples of the construction are from Northern Ireland, where the positive use of *anymore* still occurs today.

appendicitis Even though the word *appendicitis* was in use in 1885, the year in which the *Oxford English Dictionary* published the section "Anta–Battening" that would have contained the word, the editor, James Murray, omitted this "crack-jaw medical and surgical word" on the advice of Oxford's Regius Professor of Medicine, Sir Henry Wentworth Acland. As K. M. Elisabeth Murray, the granddaughter and biographer of James Murray, points out, *The problem of what scientific words to include was a continuing one, and James Murray was always under pressure— from his advisers . . . who thought the emphasis should be on words from good literature and from those in the [Oxford University] Press who wanted to save cost and time—not to include scientific words of recent origin.* In 1902 no less a person than Edward VII had his appendix removed, and his coronation was postponed because of the operation. *Appendicitis* hence came into widespread use and has remained so, thereby pointing up the lexicographer's difficult task of selecting the new words that people will look for in their dictionaries.

apricot *Apricot* comes to English by a rather unusual route. The word ultimately derives from Latin *praecoquus*—a compound of *prae*–, "early," and *coquere*, "to cook, ripen"—which literally translates "ripe early." The meaning "apricot" probably developed because the fruit, thought to be a variety of peach, ripened earlier than most peaches.

On its roundabout way to English, Latin *praecoquus* first traveled to Greece where it appeared in the forms *praikokion* and *berikokkia*. The latter form was borrowed into Arabic, probably through trade with North Africa and the Middle East, where it became *al-barqūq*, "the apricot." From Arabia the word traveled back to Europe with the Moors who conquered the Iberian Peninsula in the 8th century. During the six centuries of the Moorish occupation, the word entered Spanish, Portuguese, and Catalan (a language of northeast Spain) and eventually spread throughout the European languages. Middle English *abrecock* most likely came from Catalan *abercoc* and then was later altered in order to make the word resemble its French cognate *abricot* more closely. The later substitution of *p* for *b* may have been based on a false etymology. A history of *apricot* given by John Minsheu (1560–1627), the English lexicographer, erroneously supposes its Latin source to be the phrase *in aprīcō coctus*, literally "ripened in the sun."

Arctic The Arctic, the great frigid region of the north, takes its name from a familiar northern constellation—the polar Bear, so to speak. *Arctic* goes back to Greek *arktos*, meaning "bear." The ancient Greeks included the stars we know as the Big Dipper as part of a larger constellation that they called the *Arktos Megalē*, literally "Great Bear." The Greek name was translated into Latin as *Ursa Major*, which is still the term that modern astronomers use for the constellation today. The constellation's proximity to the celestial north pole gave rise to the Greek word *arktikos*, "of or relating to the north." Greek *arktikos* was borrowed into Latin as *arcticus*, which became *articus* in Medieval Latin as a result of the

loss of the first *c* in the word by DISSIMILATION. The word thus entered English in the 15th century as *artic*—without the *c*. In the 16th century, under the influence of the original Latin form, the *c* was restored, resulting in the modern spelling *Arctic*. Some people pronounce this word without the first (k) sound, and this pronunciation may result from a repetition of the same process that produced the Medieval Latin form *articus*.

It has struck many that the outline of a bear is curiously ill-suited to the basic star pattern of the Big Dipper: tracing the bear requires either a complex arrangement of faint background stars or a bear with an abnormally long tail. The linguist Oswald Szemerényi has proposed that the representation of the constellation as a bear was actually the result of a misinterpretation of a Near Eastern word meaning "wagon," such as Akkadian *eriqqu*. The conception of the constellation as a wagon was in fact familiar to the Greeks, who sometimes referred to the constellation by the word *hamaxa*, "wagon." (In medieval Europe, too, the Big Dipper was also often considered to be a wagon—in Old English, for example, it was considered to be *Carles wægn*, "Charlemagne's Wagon." This is the origin of the English term *Charles's Wain*.) The Near Eastern word related to *eriqqu* could have developed into Greek *Arkos* through regular sound changes and then been mistaken for a variant of Greek *arktos*, "bear." The name *Arktos* may then have inspired the myth of the nymph Callisto. In a typical version of the myth, Callisto, who is a companion of Artemis, the virgin goddess of the hunt, has a child by Zeus named *Arcas*. Artemis turns Callisto into a bear as punishment for forsaking her chastity, and Callisto is rescued by Zeus and transformed into the constellation Ursa Major.

See also **cynosure.**

arrowroot The arrowroot is just one of many unfamiliar plants that the European settlers and explorers came to know in the New World. The Arawak, a people who formerly lived on the Caribbean islands and continue to inhabit certain regions of Guiana, named this plant *aru-aru*, meaning "meal of meals," because they

thought very highly of the starchy, nutritious meal made from the arrowroot. The plant also had medicinal value because its tubers could be used to draw poison from wounds inflicted by poison arrows. The medicinal application of the roots provided the impetus for English speakers to remake *aru-aru* into *arrowroot,* first recorded in English in 1696. FOLK ETYMOLOGY—the process by which an unfamiliar element in a word is changed to resemble a more familiar word, often one that is semantically associated with the word being refashioned—has triumphed once again, giving us *arrowroot* instead of the direct borrowing of *aru-aru.*

artery The development of the word *artery* provides a glimpse into the history of medical science. The word is derived from the ancient Greek *artēriā,* a word originally applied to any of the vessels that emanated from the chest cavity, including arteries, veins, and the bronchial tubes. The difference in the functions of these vessels was not yet known; because they were all empty in cadavers, early anatomists supposed they all carried air. As medical knowledge advanced, however, students of anatomy realized that arteries carry blood and only the windpipe and bronchial tubes carry air. To specify the windpipe, they coined the phrase *artēriā trakheia,* "rough artery," referring to its rough cartilaginous structure. The adjective *trakheia,* "rough," entered English as *trachea,* the current medical term for the windpipe.

Although the ancient Greeks understood that some vessels in the body carried blood, the modern distinction between veins and arteries could not take shape until the circulation of the blood was properly understood. The theories of medicine that prevailed in Europe before the Renaissance were based on the ideas of the Greek physician Galen (130?–200?), and according to these theories, the system of veins in the body and the system of arteries were basically separate. The veins carried blood produced in the liver and distributed throughout the body, where it was used up by the tissues—it did not return to the heart. The arteries carried another substance (usually thought of as blood mixed with air) that was formed in the heart and distributed throughout the body

to be used up. The Arab physician Ibn Al-Nafis (b. 1213) made the first correct observations about the movement of the blood through the heart and lungs. Although he did not use terms that correspond exactly to modern medical language, he explained that the right ventricle of the heart pumped blood to the lungs to be mixed with air and then this blood returned to the left ventricle to form a substance that moved through the arteries. (Ibn Al-Nafis called this substance by an Arabic term equivalent to the *spirit* that circulated in the arteries in theories based on Galen.) As more and more correct observations of the body were made by other physicians, such as Miguel Serveto (1511–1553) and William Harvey (1578–1657), the modern understanding of the circulation of blood emerged—finally completed around 1660 with the discovery by Marcello Malpighi (1628–1694) of the capillaries linking the arteries to the veins.

The English term *vein* itself is from Old French *veine,* which is from Latin *vēna,* perhaps familiar from such medical terms as *vena cava,* (or "hollow vein," in Latin) designating either of two large veins that drain blood from the upper body and from the lower body and empty into the right atrium of the heart. The ancient Greek term roughly corresponding to English *vein* is *phleps,* which can be seen in such English words as *phlebitis* and *phlebotomy.*

assassin The history of the word *assassin* shows how mere legends can influence the development of words just as powerfully as historical facts. Active in Persia and Syria from the 8th to 14th centuries, the original Assassins belonged to a militant branch of the Nizaris, a group of Shi'ite Muslims that opposed the rule of Abbasid caliphs, who were Sunni. The Abbasids, whose dynasty lasted from 750 to 1258, greatly expanded the borders of the Muslim empire, and from their capital in Baghdad, they helped foster an age of cultural splendor in the history of Islamic civilization. However, some Shi'ite groups suffered discrimination under the Abbasids, and they mounted a resistance to Abbasid rule. In their struggle with the caliphate, one of the Nizaris' most

formidable weapons was the threat of sudden assassination by their network of secret agents.

Other groups of the area regarded the Nizaris as unorthodox, and from this attitude came one of the names for the group, *ḥaššāšīn*. This word originally meant "hashish users" but had become a general term of abuse. Reliable sources offer no evidence of hashish use by Nizari agents, but sensationalistic stories of murderous, drug-crazed *ḥaššāšīn* or Assassins were widely repeated in Europe. Marco Polo tells a tale of how young Assassins were given a potion and made to yearn for paradise— their reward for dying in action—by being allowed to live a life of pleasure before being sent into action. As the legends spread, the word *ḥaššāšīn* passed through French or Italian and appeared in English as *assassin* in the 16th century, already with meanings like "treacherous killer."

author From an etymological perspective, the word *author* ought to be pronounced almost like *otter*. *Author* ultimately comes from Latin *auctor*, "creator," a noun derived from the verb *augēre*, "to create." The subsequent history of the Latin word illustrates how etymology influences spelling, and how spelling in turn influences pronunciation. In Old French, the Latin word originally became *autor*, but French scribes often added a *c* to *autor* and wrote the word in such forms as *auctor* or *aucteur*, under the influence of the spelling of the original Latin word. Such spellings are called *learned* or *etymological spellings*. The orthographic *c* in *aucteur* was doubtless never pronounced in speech, since the Modern French word *auteur* is spelled and pronounced without *c*. The Old French word spelled variously as *autor* and *auctor* was then borrowed into Middle English, where it first appears in texts of the late 14th century. In Middle English, too, the spelling of the word fluctuates between forms with and without a *c*, such as *autour* and *auctour*.

The history of the word *author* was then complicated by yet another learned respelling given to the French word. During the later medieval period, the French language did not have the sound

(th), and in French words of Greek origin, the original Greek (th) was pronounced as (t). French scribes of the 15th and 16th century were aware of the Greek origin of many French words, however, and they attempted to reflect the original Greek origin by learned spellings. When a French (t) came from a Greek (th), they represented (t) not just with the simple letter *t*, but also with the combination *th*. Thus in Old French words of Greek origin like *theatre*, "theater," or *authentique*, "original," the letters *th* were pronounced simply as *t*, just as they are in Modern French today. Sometimes, however, the scribes mistook original Latin words—which never had the sound (th)—to be Greek words, and introduced *th* where it was etymologically unjustified. Such mistakes are often called *hypercorrections*, and the hypercorrect French spelling *auctheur* for *auteur* seems to have originated in the 15th century. (Specifically, *auctheur* may perhaps have arisen by association with the word *authentique*, which derives from Greek *authentēs*, "one who does a thing himself." *Authentique* itself was sometimes given a hypercorrect spelling—*aucthentique*—by association with Latin *auctor*, "creator.") According to the *Oxford English Dictionary*, spellings like *aucthor* begin to appear in English around 1550. The Modern English pronunciation *author* with (th) thus has no real etymological justification, but is entirely based on the 16th-century hypercorrect spelling with *th*.

Nevertheless, we cannot tell exactly when the spelling pronunciation of *author* with (th) won out in speech over the original pronunciation with (t), since it is spelling tendencies themselves that provide most of the evidence of the way words were pronounced in the past. In general, the spelling system lags behind changes in the spoken word, but in the case of *author*, the new spelling with *th* brought about the change in pronunciation. The *c* so common in Middle English spellings of *author*, however, has left no trace in modern orthography or speech.

ax *Ax*, a common nonstandard variant of *ask*, is often identified as an especially salient feature of AFRICAN AMERICAN VERNACULAR ENGLISH. While it is true that the form is frequent in the speech

of African Americans, it used to be common in the speech of white Americans as well, especially in the South and in the middle sections of the US. It was once common among New Englanders but has largely died out as a local feature in New England. The widespread use of the pronunciation *ax* is not surprising, since both *ask* and *ax* go back to Old English and have been used in England for over a thousand years. In Old English we find both *āscian* and *ācsian*, and in Middle English both *asken* and *axen*. Moreover, the forms with *cs* or *x* had no stigma associated with them. Manuscripts of Geoffrey Chaucer's *Canterbury Tales*, for example, show both *asken* and *axen*, interchangeably, as in the lines *I wol aske, if it hir will be / To be my wyf* and *Men axed hym, what sholde bifalle.* Chaucer himself was sensitive to regional variation in speech, and he even used it in one of the Canterbury Tales as a literary device to delineate character. Nevertheless, his works do not seem to offer evidence of any special prejudice directed towards either *asken* or *axen* in his time.

The forms in *x* arose from the forms in *sk* by a linguistic process called METATHESIS, in which two sounds are reversed. The *x* thus represents (ks), the flipped version of (sk). Metathesis is a common linguistic process around the world and does not arise from a defect in speaking. Nevertheless, *ax* has become stigmatized as substandard—a fate that has befallen other words, like *ain't*, that were once perfectly acceptable in literate circles.

bad Most people might think that the slang usage of *bad* to mean its opposite, "excellent," is a recent innovation of AFRICAN AMERICAN VERNACULAR ENGLISH. While the usage does undoubtedly originate in African American Vernacular English, it has in fact been recorded for over a century. According to the *Random House Historical Dictionary of American Slang*, edited by J. E. Lighter, the first known example dates from 1897: *She sutny fix up a pohk chop 'at's bad to eat.* Even earlier, beginning in the 1850s, the word appears in the sense "formidable, very tough," as applied to persons. Whether or not the two usages are related, they both illustrate a favorite creative device of informal and slang language— using a word to mean the opposite of what it "really" means. This is by no means uncommon; people use words sarcastically to mean the opposite of their actual meanings on a daily basis. What is more unusual is for such a usage to be so widely accepted within a larger community. Perhaps when the concepts are as basic as "good" and "bad," this general acceptance is made easier. A similar instance is the word *uptight*, which in the 1960s enjoyed usage in the sense "excellent" alongside its now-current, negative meaning of "stiff." The words *wicked* and *sick* are sometimes used as praising adjectives today, especially in the speech of teenagers.

bank Does your wordbank have three different *banks*? The *banks* in *a bank of a river, a savings and loan bank,* and *a bank of elevators* are each a different word. The first *bank* was borrowed in the early Middle English period, probably from a Scandinavian source akin to Old Danish *banke,* "sandbank." Originally associated with ridges,

especially those near the water, the word developed a variety of uses including *a cloud* (or *fog*) *bank, a sharply banked turn,* and *an expertly banked pool shot.* Another *bank,* this one meaning "a financial institution," appeared in English in the late 15th century as a borrowing of the Italian word *banca,* "moneychanger's table" possibly influenced by Middle French *banque.* Italian *banca,* in turn, is derived from an ancestor of German *Bank,* "bench." The third *bank,* which is now restricted to sets of things arranged in rows, such as elevators or the keys of a keyboard, first appeared in Middle English with the general meaning "bench" and later the specific senses "a judge's bench" and "a row of oars in a galley." This *bank* was borrowed from the Old French word *banc* (also the source of English *banquet*), from Late Latin *bancus,* both meaning "bench."

The three *banks* have a common origin in the Proto-Germanic forms **bankiz* and **bankōn–,* "bench, table," which through a string of hypothetical senses—such as "a rustic bench or table," "a bank of earth," "riverbank," "escarpment," "feature where the contour of the ground is broken,"—ultimately go back to the Indo-European root **bheg–,* "to break."

baroque The etymology of *baroque* is itself a little baroque. The word is mostly—so to speak—from the Portuguese word *barroco,* "irregular pearl." The word apparently entered Italian as *barroco* and French as *baroque* and came to refer to a style of elaborate architectural ornament that arose in Italy around 1600. Baroque painting and sculpture often make dramatic use of asymmetry in their compositions, and the name of the period may thus derive from the asymmetry of irregular pearls. The florid curves typical of baroque architecture may have suggested the rounded bosses and involutions of irregular pearls as well.

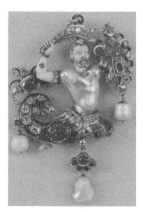

baroque
enamel, gemstone, and baroque pearl pendant known as the Canning Jewel

However, some scholars have suggested that the development of the word baroque was influenced by the Medieval Latin word *baroco,* one of a variety of technical terms coined by medieval philosophers as names for the various types of syllogisms. A *baroco* is a syllogism of the following type: *All B are A. Some C are not A. Therefore, some C are not B.* Writers of the Renaissance used the names of syllogisms in their mockery of those who clung to medieval ideas. Michel Eyquem de Montaigne (1533–1592), one of the greatest French writers of the Renaissance, mentions the names of the syllogisms *baroco* and *baralipton* when describing the personality of persons with real appreciation of wisdom, as opposed to those who refuse to abandon medieval ways of thinking:

> *The most obvious sign of wisdom is continual enjoyment; the state of wisdom is like that of the things above the moon—always serene. It is* baroco *and* baralipton *that make their henchmen* [followers of old-fashioned ideas] *so dirty and degraded. It is not wisdom.*

The term *baroco* may thus have influenced the development of the word *baroque* when applied to tortuous reasoning or overly complicated diction.

be In place of the inflected forms of *be* (such as *is* and *are)* used in Standard English, AFRICAN AMERICAN VERNACULAR ENGLISH (AAVE) and some varieties of Southern American English may omit the verb altogether (what linguists call *zero copula*) or use an invariant *be,* as in *He be working,* instead of the Standard English *He is usually working.* As an identifying feature of the vernacular of many African Americans, invariant *be* in recent years has been frequently seized on by writers and commentators trying to imitate or parody Black speech. However, most imitators use it simply as a substitute for *is,* as in *John be sitting in that chair now,* without realizing that within AAVE, invariant *be* is used primarily for habitual or extended actions set in the present. Among African Americans the form is most commonly used by working-

class speakers and young persons. Since the 1980s, younger speakers have tended to restrict the use of the form to progressive verb forms (as in *He be walking*), whereas their parents use it with progressives, adjectives (as in *He be nice*), and expressions referring to a location (as in *He be at home*). Younger speakers also use invariant *be* more exclusively to indicate habitual action, whereas older speakers more commonly omit *be* forms (as in *He walking*) or use present tense verb forms (such as *He walks*), sometimes with adverbs like *often* or *usually*, to indicate habituality.

The source of invariant habitual *be* in AAVE is still disputed. Some linguists suggest that it represents influence from finite *be* in the 17th- to 19th-century English of British settlers, especially those from the southwest of England. Other linguists feel that contemporaneous Irish or Scotch-Irish immigrants may have played a larger role, since their dialects mark habitual verb forms with *be* and *do be*, as in *They be shooting and fishing out at the Forestry Lakes* (archival recordings of the Royal Irish Academy) and *Up half the night he does be* (James Joyce). Other linguists believe that it may have evolved from the *does be* construction indicating habitual action used by Gullah speakers from coastal South Carolina and Georgia and by Caribbean Creole immigrants. Still other linguists suggest that invariant *be* is a mid- to late-20th-century innovation within AAVE, essentially a response to the wide range of meanings that can be expressed by the English progressive tense.

beignet New Orleans, Louisiana, has been a rich contributor of French loanwords and local expressions to American English. Many words frequently used in the daily life of the city, such as *beignet, café au lait, faubourg,* and *lagniappe* reflect the New World French cuisine and culture characterizing this region. *Beignet* is a southern Louisiana term for a square doughnut with no hole and comes from the general French term meaning "fritter." Beignets can be eaten with *café au lait*, which is coffee with scalded milk, usually made from coffee mixed with ground roasted chicory root that imparts a richer flavor.

Still other words reflect distinctive physical characteristics of the city. A raised sidewalk, for instance, is called a *banquette*, another term which comes from French. The French word in turn is from Provençal *banqueta*, a diminutive of *banca*, "bench." There are also colorful names for the distinctive architectural styles found among New Orleans houses. A *camelback* is a narrow house with one story in front and two in the rear, giving it a camel-like profile, while a *shotgun* is a house characterized by several rooms joined in a straight line from the front to the back—a floor plan that would allow a shot from a gun fired into the front door to pass out the back door and hit something in the back yard without meeting any obstacles in between.

More words originating in New Orleans and southern Louisiana are discussed at their own entries elsewhere in this book, including *faubourg, krewe, lagniappe,* and *picayune.*

bitter Mustard and horseradish will add bite to a sauce, and in fact, from an etymological perspective, *bitter* foods are foods that *bite*. Both *bitter* and *bite* descend from the Indo-European root **bheid–*, "to split." This root in particular provides a good illustration of the typical changes that occurred in the history of English as it developed from its prehistoric ancestor, Proto-Indo-European, spoken thousands of years ago in central Eurasia. The derivatives of the root **bheid–* also illustrate the way the Proto-Indo-European language added or changed the vowels in a root when making words from a root, as English still does in a few groups of words like *sing, sang, sung,* and *song*. English has words coming from three different related forms of the root meaning "to split": **bhid–, *bheid–,* and **bhoid–*. In the terminology used by linguists who study the Indo-European languages, the first form *bhid–* is called the *zero-grade* (since there is no *e* or *o* in the root), the second form **bheid–* is called the *e-grade* of the root, and **bhoid–* is called the *o-grade*. The different vowels of related words in Modern English, like *bitter* and *bite*, often reflect vowel differences like these that already existed in Proto-Indo-European times.

On the way from Proto-Indo-European to English and its

cousins, the other Germanic languages, the *bh* and *d* in **bheid–* became *b* and *t*, respectively, by the sound change known as GRIMM's LAW. English *bitter* thus comes from the Proto-Indo-European adjective **bhid-ro–*, "cutting, sharp, biting," where the root in the zero-grade has had added to it the suffix *–ro–*, which was commonly used in Proto-Indo-European to make adjectives.

The English verb *bite*, on the other hand, comes from the *e-grade* of the root **bheid–*. On the way from Proto-Indo-European to Old English, the sequence of sounds **ei* became long *ī*. In this way, **bheid,–* "to split," gave rise to the Old English *bītan*, "to bite," since the act of biting splits one piece off from another. Later in the history of English, the long *ī* of Old English, pronounced (ē), eventually acquired the pronunciation it has in Modern English as (ī), and Old English *bītan* thus developed into Modern English *bite*.

The Modern English word *boat* descends from the Old English word *bāt*. The Old English word is thought to come ultimately from **bhoid–*, the o-grade of **bheid–*. The long *ā* in the Old English word comes from the Proto-Indo-European diphthong **oi*. The original meaning of the prehistoric word that became modern *boat* was thus something like "split log" or "split timber," the raw materials for making a boat.

blackmail Though one may imagine a blackmailer's demands arriving by mail, the *mail* in *blackmail* is actually the Scots word meaning "rent, payment, or tribute." The Scandinavian roots of *mail* are obscure, but it can be traced back at least as far as Old English *māl*, "legal suit," which carried the additional sense "agreement or deal." The term *blackmail* originated in Scotland, where Highland chieftains at one time extorted tribute from Lowlanders and Englishmen on the Scottish border in return for "protection" from pillage. The *black* in *blackmail* is probably a pun on the term *white money*, "silver money," contrasting blackmail with legitimate rent that was often paid in silver coin. Today, such threats might be called *protection rackets* or simply *extortion*, with the word *blackmail* now limited to threats of exposing discredit-

ing information. However, in the 1980s, the word's freebooting past was recalled when the term *greenmail*—*green* being the traditional color of United States currency—was coined to refer to an unsavory practice of corporate raiders.

blue chip Blue chips in poker are usually the chips with the highest value. It is from this usage that the term *blue chip* is applied to stock that sells at a high price because of public confidence in its long record of steady earnings. The term came to be applied to stocks in the 1920s. According to the *Oxford English Dictionary*, the first known appearance of *blue chip* in relation to stocks occurs in the October 30, 1929, edition of the *Baltimore Sun*, one day after the infamous stock crash on Black Tuesday: *Agriculture still has too much to reclaim ... to become a "blue chip" in the near future.*

bodice *Bodice* began as an alternative spelling of *bodies*, which at the time *bodice* was first recorded, reflected the pronunciation of the plural with a voiceless (s). From its appearance in the 17th century, the spelling *bodice* was attached almost exclusively to two sartorial senses of *body*: "the upper part of a woman's dress," and "a corset-like garment." The garment in the latter sense was referred to with the collocation *a pair of bodies* or simply *bodies* because it was fashioned out of two pieces of quilted and stiffened fabric that that were laced together. *Bodies* and *bodice* were used interchangeably until the 19th century, when *bodice* first appears with a singular verb. By then, the plural of *body* was pronounced with a voiced (z), and *bodice* was mistaken for a separate word.

For other examples of words with histories similar to *bodice*, see *dice.*

bohemian A bohemian was originally a native or inhabitant of Bohemia, a historical region located in what is today the western Czech Republic. The region takes its name from a Celtic tribe known as the Boii, whose name goes back to the Indo-European root **bheiə–*, "to strike." In the 17th century, English *Bohemian* developed a specialized use as a term for the Roma, a people who

were not from Bohemia but from northern India. (In the past, the Roma were usually called *Gypsies* in English, but this term has acquired pejorative connotations. The term *Gypsies* comes from *Egyptian* and reflects a popular misconception about the origin of the Roma.) The French equivalent of *Bohemian* was first applied to the Roma people in the 14th century, around the same time that the Roma people arrived in Europe and the word *Gypsy* first appeared in English. By the time English *bohemian* acquired this sense, the meaning of the French word had been extended further, and it was used to describe persons whose disregard for conventional standards of behavior resembled the independent ways of the "Gypsies," as they were perceived in the popular mind at the time. This French use of the word, applying in particular to artists and writers, was introduced to English by William Thackeray in his novel *Vanity Fair,* published in 1848. That same year it was featured in the title of a popular French novel by Henri Murger, *Scènes de la vie de Bohème,* the work that inspired Puccini's opera *La Bohème.*

Bolshevik The word *Bolshevik,* an emotionally charged term in English, is derived from an ordinary word in Russian, *bol'she,* "bigger, more," the comparative form of *bol'shoĭ,* "big." The plural form *Bol'sheviki* was the name given to the majority faction at the Second Congress of the Russian Social Democratic Workers' Party in 1903 (the term is first recorded in English in 1907). The smaller faction was known as *Men'sheviki,* from *men'she,* "less, smaller," the comparative of *malyĭ,* "little, few." The *Bol'sheviki,* who sided with Lenin in the split that followed the Congress, subsequently became the Russian Communist Party. In 1952 the word *Bol'shevik* was dropped as an official term in the Soviet Union, but it had long since passed into many other languages, including English.

The Russian word *bol'shoĭ,* is a derivative of the Indo-European root *bel–,* "strong." Traces of this root can also be found elsewhere in English, in words like *debility* and *debilitate,* that derive from the Latin adjective *dēbilis,* "weak." *Dēbilis* developed from an earlier

compound *dē-bel-i– "without strength," made up of the Latin prefix dē–, "without," added to a form of the root *bel–.

boss Most of us would bristle at the thought of calling a person in a managerial position our master. So many may be surprised to learn that the more acceptable term *boss* was borrowed from a Dutch word, *baas*, which meant just that. *Boss* was used in the early days of the American republic as a replacement for *master*, probably because *boss*, coming from a foreign word, had fewer negative connotations. Dutch *baas*, in turn, may be related to the German word *Base*, "female cousin," and Old High German *basa*, "aunt," suggesting that in Dutch, too, *baas* was once a euphemistic or affectionate replacement of a more formal word. While *boss* has remained less pejorative than *master*, which most people now associate with slaveholders, it is not free of negative connotations. This is especially evident in such phrases as *stop bossing us around*, *corrupt party bosses*, and *a bossy toddler*. Nevertheless, *boss* has recently developed the slang sense "first-rate or top-notch" and is still widely used as a term of respect.

bowdlerize

> CLOWN: *Why, masters, have your instruments been in*
> *Naples, that they speak i' th' nose thus?*
> FIRST MUSICIAN: *How, sir? how?*
> CLOWN: *Are these, I pray you, wind instruments?*
> FIRST MUSICIAN: *Ay, marry, are they, sir.*
> CLOWN: *O, thereby hangs a tail.*
> FIRST MUSICIAN: *Whereby hangs a tale, sir?*
> CLOWN: *Marry, sir, by many a wind instrument that I know.*
>
> —William Shakespeare, *Othello*, Act 3, Scene 1

Parents, prudes, and even some scholars have long fretted over the obscenity and crude jokes, like the one about flatulence above, found in Shakespeare's plays. Modern performances of Shakespeare tend to emphasize such elements, but prior to the 19th century, passages deemed indecent were typically omitted

or rewritten—often with the excuse that Shakespeare had been obliged for financial reasons to conform to the vulgar tastes of his Elizabethan audience. In addition to excising material that was offensive to Christian morality, many attempted to "improve" Shakespeare's plays in other ways. For example, a popular 18th-century version of *Romeo and Juliet* prepared by the English actor David Garrick edited out Romeo's love for the character Rosaline and added a scene between Romeo and Juliet just before their deaths.

But the morality of taking such liberties with Shakespeare's words was called into question in 1818, when a debate arose over an expurgated edition of Shakespeare's complete works edited by Dr. Thomas Bowdler (1754–1825) and his sister Henrietta. The preface to the Bowdlers' *The Family Shakespeare* states, *I can hardly imagine a more pleasing occupation for a winter's evening in the country, than for a father to read one of Shakspeare's plays to his family circle. My object is to enable him to do so without incurring the danger of falling unawares among words and expressions which are of such a nature as to raise a blush on the cheek of modesty, or render it necessary for the reader to pause, and examine the sequel, before he proceeds further in the entertainment of the evening.* Knowledge of Shakespeare's plays had gained a certain prestige in England, and *The Family Shakespeare* became especially popular among the rising middle class who were keen to start their children off in the appreciation of great literature and the arts as early as possible.

Yet, despite the Bowdlers' narrow purpose and the relative care with which they emended the text, *The Family Shakespeare* came to represent all that was wrong with the practice of altering Shakespeare's works both in performance and in print—a tradition in which Samuel Johnson and Alexander Pope were also implicated. The Bowdlers called this tradition to their defense, claiming it as evidence that "erasure of the indecent passages" does not necessarily harm "the spirit and fire of the poet," but they were unable to convince their critics or to prevent their name from becoming synonymous with the prudish expurgation

of works of literature. More recently, the verb *bowdlerize* has come to refer more generally to any sort of deliberate change that skews the perspective or falsifies the essential nature of the thing being modified, often for reasons of mere political convenience or personal opinion.

brand new Nowadays, the word *brand* is probably most often heard with the meaning "a trademark or distinctive name identifying a product or a manufacturer," but it can be traced all the way back to an Old English word *brand,* meaning "a piece of wood burning in a fire." Although *brand* still keeps this meaning today, the word has a variety of other meanings that have developed over the centuries. The verb *brand,* "to burn with a hot iron," first appeared around 1400. In the middle of the 1500s, the noun *brand* began to designate the mark made with a hot iron to identify criminals. Somewhat later, *brand* was applied to similar marks made on cattle. Wooden containers like casks of wine could also be burned with an iron to leave a sign indicating their producer or distributor, and thus *brand* came to mean a mark that identifies a commercial product. In the middle of the 19th century, *brand* began to refer not simply to the mark identifying a company's product, but also to the product itself, as in *a superior brand of beer.*

When we visit the supermarket or department store nowadays, we are pelted with advertisements touting new brands of products. Nevertheless, the *brand* in the expression *brand-new* has nothing to do with modern commerce—instead, it returns us to the original meaning, "burning wood." According to the *Oxford English Dictionary,* the phrase *brand-new* was brand-new in 1570, when it first occurred in the text of a sermon given by John Foxe, an early English Protestant Reformer: *New bodies, new minds... and all thinges new, brande-newe.* (Foxe's sermon discussed II Corinthians, a book of the Bible containing the following passage: *Therefore if any man be in Christ, he is a new creature: old things are passed away; behold, all things are become new.*) The people who heard Foxe's sermon would have immediately recog-

nized the vivid metaphor behind the expression *brand-new*, meaning literally "new like a piece of iron just taken from the furnace and forged"—or, to use the terms of modern advertising, "red hot." A little later than Foxe, Shakespeare even makes use of a similar term, *fire-new*, in several of his plays. In *Twelfth Night* (Act 3, Scene 2), after the foolish Sir Andrew has observed that Lady Olivia is indifferent to him and prefers a younger man, the roguish servant Fabian offers Sir Andrew the following misleading advice about the way to win Olivia's affections:

> She did show favor to the youth in your sight only to exasperate you, to awake your dormouse valor, to put fire in your heart, and brimstone in your liver. You should then have accosted her, and with some excellent jests, fire-new from the mint, you should have bang'd the youth into dumbness.

Brazil The name *Brazil* is derived from the Portuguese and Spanish word *brasil*, the name of an East Indian tree with reddish-brown wood from which a red dye was extracted. The Portuguese found a New World tree related to the Old World brasil tree when they explored what is now called Brazil, and as a result they named the New World country after the Old World tree. The word *brasil* is a cognate with French *brésil*, Old French *berzi* and *bresil*, Old Italian *verzino*, and Medieval Latin *brezellum*, *brasilium*, *bresillum*, and *braxile*. The many Latin forms suggest that the word ultimately has a non-Latin, non-Romance origin that remains obscure.

brickbat The earliest sense of the word *brickbat*, first recorded in the second half of the 16th century, was "a piece of brick." Such pieces of brick have not infrequently been thrown at others in the hope of injuring them; hence, the figurative *brickbats* that critics hurl at performances they dislike. According to the *Oxford English Dictionary*, the first known occurrence of the metaphorical use of the word is found in a work by John Milton dating from 1642, *a modest confutation of the animadversions upon the remonstrant against Smectymnuus*. The appearance of *bat* as the second part of

the compound *brickbat* is explained by the fact that the word *bat*, "war club, cudgel," developed in Middle English the sense "chunk, clod, wad," and in the 16th century came to be used specifically for a piece of brick that was unbroken on one end.

brogue The word *brogue* has two meanings in English—it can describe a shoe or an accent. As a term for shoes, *brogues* originally referred to a kind of heavy leather shoe formerly worn in Ireland and Scotland, but nowadays the shoes sold as *brogues* are usually sturdy oxford shoes with ornamental

brogue
a classic Dr. Martens brogue shoe

perforations and wing tips. The English term is clearly derived from the word *bróg*, which can denote a shoe of any sort in Irish, the native Celtic language of Ireland. In Scottish Gaelic, a language very closely related to Irish, the equivalent of this Irish word is *bròg*, "shoe," and the Scottish Gaelic term probably served as an additional source of the English word as well.

A *brogue*, however, can also be a thick dialectal accent, especially a strong Irish or Scottish accent. Judging from the earliest attestations of the word in the 18th century, the term was at first applied only to Irish accents. Since both the meaning "shoe" and the meaning "accent" have connections to Ireland, we may well wonder whether the two words *brogue* are ultimately the same. An attempt to answer this question will provide an interesting illustration of one way in which scholars go about tracing the history of words.

In his classic dictionary of the Irish language, *Foclóir Gaedhilge agus Béarla: An Irish-English Dictionary* (first published in 1904 and later revised), the Reverend Patrick S. Dinneen provides a wealth of cultural information about Ireland. Even in the 21st century, Dinneen's work is invaluable not only to scholars studying Irish but even those studying English as it is spoken in Ireland. The entry for the word *barróg* in Dinneen's dictionary

reads as follows: *an embrace, a hold (in wrestling), a tight grip; leverage; a stitch in sickness; defective accentuation; hence the Anglo-Irish word* brogue.

Apparently Dinneen had heard, or thought himself, that the English word *brogue* originated in an Irish expression in which a strong Irish accent in English was likened to a speech defect. In many Irish dialects of the south of Ireland, like Dinneen's own dialect, *barróg* would be stressed on the second syllable, and the first vowel would also be elided. The word would thus sound something like (brōg), and Dinneen's etymology therefore seems quite plausible.

It remained uncertain, however, whether a hypothetical Irish expression like *tá barróg ar a theangaidh,* "there is a grip on his tongue," was ever actually used in any Irish dialect to mean "he has a strong Irish accent in English." In the 1940s, scholars of the Irish language decided to investigate the matter. Gerard Murphy, the editor of the Irish scholarly journal *Éigse,* sent out inquiries to speakers of many different Irish dialects, asking them about the possible use of *barróg* to mean "accent." It turned out that in one dialect there did happen to be an expression *tá gréim ar a theangaidh,* "there is a grip on his tongue" (using another word for "grip," *gréim*), which was used to mean "he speaks indistinctly." However, the phrase did not refer specifically to an Irish accent in English, and in any case, the word *barróg* was never used in this expression. In fact, most speakers of Irish knew *brogue,* "an Irish accent," only as an English word, and they did not associate it with the Irish word *barróg,* "grip," at all. The few sources of dialectal information that did connect English *brogue* to *barróg* may have simply been influenced by Dinneen's dictionary.

The results of this survey were published in the 1941–1942 volume of *Éigse,* in which Murphy decides in favor of another explanation of the English term *brogue,* "accent." The word probably originated in a notion likening a heavy Irish accent to a sturdy country shoe weighing down the tongue—"talking English with your brogues on," so to speak. Thus *brogue* meaning "shoe" and *brogue* meaning "accent" both ultimately derive from Irish

bróg, "shoe," but in all likelihood, the metaphorical use of the term arose in English rather than Irish.

buckaroo In the minds of many Americans, cowboys and the Wild West are quintessentially American institutions, but from the very beginning, the culture and language of the United States have featured a complex mixture to which many different groups have contributed. A number of "typically American" words associated with cowboys were borrowed from American Spanish (that is, the Spanish dialects spoken in the Western Hemisphere), for instance. These borrowings include *buckaroo, corral, lasso, mustang, ranch, rodeo,* and *stampede.* They come from Spanish *vaquero, corral, lazo, mesteño* (also found in the form *mestengo,*) *rancho, rodeo,* and *estampida,* respectively. *Buckaroo,* interestingly, is an example of a word borrowed twice: it is an Americanized form of Spanish *vaquero,* which also made it into English as *vaquero,* "cowboy." The Spanish word is derived from *vaca,* "cow."

C

Canada Linguistically, mountains can be made out of molehills, so to speak: words denoting a small thing can, over time, come to denote something much larger. This is the case with *Canada*, now the name of the second-largest country in the world but having a much humbler origin. Apparently its history starts with the word *kanata*, which in Huron (an Iroquoian language of eastern Canada) meant "village." Jacques Cartier, the early French explorer, picked up the word and used it to refer to the land around his settlement, now part of Quebec City. By the 18th century it referred to all of New France, which extended from the St. Lawrence River to the Great Lakes and down into what is now the American Midwest. In 1759, the British conquered New France and used the name *Quebec* for the colony north of the St. Lawrence River, and *Canada* for the rest of the territory. Eventually, as the territory increased in size and the present arrangement of the provinces developed, *Canada* applied to all the land north of the United States and east of Alaska.

The first known occurrence of the name *Québec* in French dates from 1601. *Québec* itself is of Algonquian, rather than Iroquoian, origin—it comes from an Algonquian word meaning "place where the river narrows" or "strait." The name was originally applied to the area around modern Quebec City, where the St. Lawrence River narrows and meets the St. Charles River beneath the cliffs of Cap Diamant.

canard The word *canard*, meaning "an unfounded or false and deliberately misleading story," may puzzle English speakers who

know French, since *canard* means "duck" in that language. The English word is derived from the French word, and in French too *canard* can mean both "duck" and "a trumped-up or false story." The second meaning derives from the expression *bailler un canard à moitié*—literally meaning "to half-deliver a duck" or "to half-give a duck," but employed figuratively in the sense "to dupe, take in." The expression makes its appearance in the second half of the 16th century. Later another expression, *vendre un canard à moitié*, "to half-sell a duck," joins it.

Under the influence of these expressions, the French noun *canard* acquired the meaning "false and grossly exaggerated story" around 1750. In this sense, the noun begins to appear in English somewhat later, in the middle of the 19th century. Just as today, some English speakers were puzzled about the origin of *canard*, and various stories attempting to explain the origin of the word were put into circulation. Some, for example, thought that the meaning of the word reflected the propensity of ducks to swallow anything remotely edible-looking. Such stories are almost canards in themselves, and although a great many of the etymologies reported in the popular press or making the rounds by word of mouth might well be called *canards*, the etymology of *canard* itself seems reasonably certain.

canary The canary is native to the Canary Islands, which are located in the eastern Atlantic Ocean off the coast of Morocco and together form two provinces of Spain. The Canaries were noted for their bird life even in ancient times, but canary birds get their name from the islands, and not the other way around. *Canary*, first attested in the form *canara byrd*, begins to appear in English in the 16th century and comes from French *canari*, which in turn is from Spanish *canario*, "of the Canary Islands." In medieval times, the Canary Islands were known in Latin as the *Canāriae Īnsulae*, literally, "the islands of dogs."

Earlier, in classical times, the islands lay at the very edge of the world known to the Greeks and Romans. The Roman author Pliny the Elder (AD 23–79) gives the name *Fortunātae*, or "Blessed

Isles," to the archipelago in his great work summarizing the scientific knowledge of his time, called *Natural History*. In this book, Pliny relates what he learned about the islands from King Juba II of Numidia. There was, for instance, one island crawling with big lizards, and another island wrapped in clouds and characterized by perpetual snow (a detail that allows us to identify this island as Tenerife, with its lofty volcano). Pliny then goes on to describe yet another island:

> *Near that island is one called* Canaria, *from the large number of huge dogs* [in Latin *canum*] *living there—two of these dogs were brought back to Juba. He says that there are remains of buildings on the island. While all the islands have an abundance of fruit and birds of every kind, he says this one also abounds in groves yielding dates and in pine trees bearing nuts.*

Pliny's isle roamed by wild dogs and blessed with fruit and nuts is most probably the island known as Gran Canaria today, and his account of the archipelago eventually led to the application of the name *Canāriae*, "having dogs," from Latin *canis*, "dog," to the whole group. Of the variety of birds mentioned by Pliny in this passage, the male canary was eventually noticed by sailors for its bright plumage and cheerful twittering, and canaries were taken back to continental Europe, where they became popular as pet birds in the 17th century.

Until quite recently, canaries also accompanied miners into pits and mineshafts, since the birds are very sensitive to carbon monoxide, a colorless and odorless but nevertheless highly poisonous gas that can accumulate in mines. The canaries would chirp along as the miners worked, and the cessation of their singing would serve to warn miners of the buildup of carbon monoxide. If carbon monoxide concentrations were very high, the canaries would sometimes even die. The accumulation of carbon monoxide in mines is often accompanied by the build-up of other gases such as methane, which is explosive, and so the

end of the canaries' song and their deaths in their cages would also warn the miners of an impending explosion. The common expression *a canary in a coal mine*, meaning "something that gives a sign of imminent disaster," arose from this practice, which continued in British mines until quite recently. It was only in 1986 that modern gas-detecting technology fully replaced canaries in British coal pits and deprived the miners of their welcome companionship.

cancer Although in the age of modern medicine the words *canker sore*, *chancre*, and *cancer* denote distinct conditions of very different degrees of seriousness, in fact these three words all descend from the same source in the medical terminology of classical and medieval times. Modern English *cancer* is ultimately from the Latin word *cancer*, which could mean both "crab" and "a spreading sore, gangrene, cancer." Latin *cancer* was the word used by classical physicians to translate the Greek technical term *karkinos*, literally "crab," but applied to a kind of tumor or inflammation in writings attributed to the great Greek physician Hippocrates (460?–377? BC). The inflamed veins around the affected area suggested the claws of a crab to early Greek physicians, and thus the medical condition and the zodiacal constellation of the Crab eventually came to have the same name. The Greeks also used another word, *karkinōma*, derived from *karkinos*, to describe this condition, and *karkinōma* would later enter English as *carcinoma*, the technical medical term for a specific type of tumor.

As the general medieval medical term for any spreading malignancy, Latin *cancer* has actually entered English in several forms, now used to distinguish different conditions. Latin *cancer* first entered Old English as *cancer*, and the Old English word may survive as *canker* (as in *canker sore*), although *canker* is partly from Old French as well. As the spoken Latin of Gaul developed into French in medieval times, Latin *cancer* became *cancre* in Northern French dialects but *chancre* in the dialects of central France, like the dialect of Paris. The Northern French form *cancre*

entered Middle English and fell together with the Old English word as *canker*, which was used to denote a variety of conditions, some of which we would call cancer today. Later, around 1600, the central French form *chancre* also was borrowed into English in specific reference to the sores caused by venereal disease. Around the same time, *cancer* was borrowed into English again, this time directly from medical Latin, and replaced *canker* as the word indicating the conditions called *cancer* in modern terminology. In this way, the diseases came to have the same name as the zodiacal constellation of the Crab, *Cancer*.

Both Latin *cancer* and Greek *karkinos* belong to a family of words containing a root **kar–* and referring to things with hard shells. This is probably ultimately identical to the Indo-European root **ker–* found in the English adjective *hard* itself, where the Indo-European **k* has regularly become *h* by GRIMM'S LAW.

candy The simple noun *candy* did not occur on its own until the 18th century. The word first appeared in the 15th century in a compound, *sugar candy*, that referred to a particular kind of crystallized sugar often served as a confection. *Sugar candy* derives through French and Italian from the Arabic phrase *sukkar qandī*, "candied sugar." *Sukkar* came from Sanskrit *śarkara*, "grit, ground sugar." *Qandī*, a form of Arabic *qand*, "cane sugar," probably originated in the Dravidian language spoken by the pre-Indo-European people of southern India as the word *kaṇṭu*, meaning "lump." In British English today *candy* is still largely restricted to sweets of sugar candy. However, in the United States, the meaning of *candy* has expanded to include confections made of ingredients besides sugar, such as chocolate, fruit, and nuts.

cannibal Though no one would expect the word *cannibal* to be connected to *Caribbean*, they in fact share a common origin in an Arawakan language of the West Indies. Christopher Columbus initially recorded the two words on his first voyage to America. Columbus noted specifically that Caribs in Haiti referred to themselves as *Caribes*, while those in Cuba used the term

Caníbales. Columbus seems to have heard the difference accurately, for the transposition of *r* and *n* between dialects is common in the area. But Columbus's interpretation of the two was completely wrong, however. Erroneously assuming he had reached the East Indies, Columbus mistook the *Can-* in *Caníbales* for a word of Mongolian origin, *khan,* used to designate the rulers of Central Asian origin that had spread their empires over Asia in medieval

cannibal
portrait of Christopher Columbus

times. Furthermore, he explained *Caníbales* and *Caribes* as designating the people of a place called *Caniba* or *Carib.* Evidence suggests that the original Arawakan word may have perhaps had such meanings as "person" and "brave." The Spanish monk and historian Bartolomé de Las Casas, who accompanied Columbus on his third voyage, produced a version of Columbus's journals on which we depend for information about the explorer's voyages. Las Casas describes how Columbus came to believe that the islands where he had recently arrived were actually somewhere in Asia. In the following passage (presented in the original 16th-century Spanish spelling), Las Casas directly quotes from Columbus's journal entry of December 11, 1492:

> *... Todas estas islas biven con gran miedo de los de Caniba; y así torno a dezir como otras vezes dixe... que Caniba no es otra cosa sino la gente del Gran Can, que deve ser aquí muy vezino, y terná navíos y vernán a captibarlos, y como no buelven, creen que se los [han] comido.*

"All of these islands live in great fear of the people of Caniba, and so I repeat what I have said on other occasions... that Caniba is nothing other than the people of the Great Khan, who should be here, very near, and he

will have ships, and they will come to capture them, and since they [who have been captured] don't return, they [the people of the islands] believe they have been eaten."

Spanish *Caribe* and *Canibales* were borrowed into English in the 16th century, and for a time, served interchangeably as terms for the Caribs. *Canibal*, as well as the distorted views that Europeans held of the indigenous Caribbean peoples, probably provided the inspiration for the name of Shakespeare's character Caliban, Prospero's brutish slave in *The Tempest*. In the 17th century, frightening reports of cannibalism in the West Indies seized the popular imagination and eclipsed almost all other associations with the people of the area. The spurious derivation of *Canibal* from the Latin word *canis* meaning "dog" (as found in such English words as *canine*), strengthened the link between cannibalism and this particular term for the Caribs. As the English received more objective reports of the Caribs, the association between *Carib* and *cannibal* was forgotten.

canvas The cannabis plant goes by two other names in English. Parts of the plant can be used as a drug that when smoked or otherwise ingested produces euphoria and stimulates appetite. When grown for this purpose, cannabis is usually known as *marijuana*, a word that comes from Mexican Spanish but whose ultimate origins remain obscure. However, some varieties of cannabis are also grown to produce a tough fiber called *hemp*, the fiber from which the fabric called *canvas* was originally made. The word *canvas* comes from Old French *canevas* and Medieval Latin *canavāsium*, both ultimately derived from the Latin word *cannabis*, "hemp."

In the 16th century, the word *canvas* began to be used as a verb meaning "to toss someone into the air in a canvas sheet." This sense became attached to the spelling variant *canvass*, with an extra *s*, and *canvass* soon came to be considered a separate word. By the 17th century, the original meaning of *canvass* had multiplied to include "to toss about or handle roughly," "to examine

carefully or discuss thoroughly, scrutinize," and "to solicit voters, orders, or opinions."

The development of the last two senses, the only uses that survive today, remains somewhat mysterious. Some have suggested that the meanings have their roots in the concept of winnowing, the process of separating chaff (dried husks) from kernels of grain by tossing the grain in a sheet and allowing the wind to blow away the chaff. However, there is no evidence that *canvass* was ever used to refer to tossing anything other than people. A more likely explanation may be that soliciting and scrutinizing were both considered forms of rough handling. This is probably the metaphor behind the modern phrasal verb *shake down,* which today means "to extort or solicit" and "to search or examine thoroughly."

The English term *cannabis* is a borrowing of the name of the plant in New Latin, or modern scientific Latin. The botanist Carolus Linnaeus (1707–1778) used the Latin term as the name of the genus of the hemp plant in his system of taxonomic classification. We can trace the Latin word *cannabis* itself back to ancient roots—it developed from an ancient word pronounced something like **kannabis.* This word, however, was originally not a native term in the Indo-European languages. The consonant *b* in **kannabis* was extremely rare in Proto-Indo-European, and the two short *a*-sounds in a row would also be unusual in a native Proto-Indo-European word. Linguists therefore think that the early Indo-European peoples had just begun to grow hemp as they moved out of their homelands in Central Asia or Eastern Europe many thousands of years ago. The early speakers of Indo-European languages borrowed the foreign word **kannabis* for this new and useful crop from an unknown non-Indo-European source just after the moment when the various branches of the Indo-European language family had begun to go their separate ways. This would account for the fact that the word, with its *b* and two *a*-vowels, looks very un-Indo-European but is nevertheless found in several branches of the family. In one of these branches, Germanic, the *k* in **kannabis* became an *h* and the *b* became a *p*

by the working of GRIMM'S LAW. As a borrowing into the early Indo-European languages, *kannabis* is thus the source of the native English word *hemp* as well as Latin *cannabis*.

careen The word *careen*, "to lurch or swerve while in motion," illustrates a phenomenon that is frequently encountered when tracing the history of language: the development of a word can be influenced by other words of similar sound and related meaning, and similar words can exert mutual influence on each other.

Careen was originally a nautical term meaning "to lean a ship on its side for cleaning, caulking, or repairing." The word comes from the French phrase *en carène*, meaning "on the keel." *Carène* is descended from the Latin word *carīna*, "keel, nutshell." From the original sense relating to ships at rest, *careen* also came to be used of ships leaning to one side when sailing in the wind. In more recent times, the word *careen* has developed another sense, "to rush headlong," as in the sentence *The truck went careening into the intersection,* and in other expressions in which the emphasis is on forward, rather than sideways, motion. In this sense the word *careen* has probably been influenced by the word *career,* "to move or run at high speed." Not only do the two verbs sound similar, but automobiles generally *careen* (that is, lurch or tip over) only when driven at high speed—in other words, when they are *careering.* Since the two verbs can be used in similar circumstances, the meaning of *careen* was probably extended to include that of *career.* This newer use of *careen* begins to appear only in the 1920s. Many authorities on English usage, in fact, still recommend keeping *careen,* "to lurch to the side," distinct from *career,* "to rush headlong forward."

The etymology of *career* is discussed in the following entry.

career In today's competitive business world, no one would be surprised to learn that *career* has its roots in horse racing. However, there may have been a time when one's career had more in common with a track than a race. *Career* comes from the French word *carrière,* "race course," which entered Old French from Old

Provençal *carriera,* "street," and goes back to *carrus,* the Latin word for a type of wagon. *Carrus* comes from Gaulish, the language of the Celtic tribes that inhabited the area that is now France both before and during the period of the Roman Empire. The Gaulish word is ultimately from the Indo-European root **kers–,* "to run," which is also the source of the Latin verb *currere,* "to run," from which English ultimately gets such words as *courier.*

In early use, *career* had such senses as "race course," "a short gallop at full speed," "a rapid course," and "the moment of peak activity." It appears that the sense "a profession" originated in French *carrière,* which never acquired the English connotations of haste. Subsequent to the borrowing of English *career* in the 16th century, *carrière* came to mean "the course of the stars and planets through the sky," "the course of one's life," and "the course of one's profession." This ultimate sense became associated with the English word in the 19th century, and today stands appropriately alongside the native sense "to rush."

See also *careen* discussed above.

cartoon The words *carton* and *cartoon* both come from French *carton,* which means both "cardboard" or "pasteboard" and "carton, cardboard container." Their different spellings reflect the different time periods in which they were borrowed. From the 16th to the 18th century, the French ending *–on,* when stressed, was sometimes rendered in English as *–oon.* This change occurred most commonly in French words of Italian and Spanish origin in which the ending was derived from Italian *–one* or Spanish *–on,* both of which are AUGMENTATIVE suffixes (i.e., they amplify some aspect of the root's meaning). French *carton* was borrowed from Italian *cartone,* "pasteboard," an augmentative of *carta,* "card, paper." Thus, French *carton* entered English in the 17th century as *cartoon,* "an artist's sketch made on pasteboard," and in the 19th century as *carton,* "a container made from pasteboard."

The first cartoons to be called *cartoons* appeared in the July 1843 issue of *Punch,* a British magazine famous for its satirical drawings. At the time, the word *cartoon* meant only "a preliminary

sketch or study on a piece of cardboard as for a painting or tapestry." The British government had just held an exhibition of "cartoons," or sketches, for a set of paintings and murals that were to adorn the walls of the newly renovated Palace of Westminster, the site of the British Houses of Parliament. *Punch* responded by publishing its own "cartoons" in the form of satirical drawings that ridiculed the British government for its excesses and inefficiency.

casino The history of the word *casino* reveals a transformation from a cottage to a gambling palace. The source of our word, Italian *casino*, is a diminutive of *casa*, "house." (A diminutive is a word that has been suffixed to indicate smallness or qualities such as youth, familiarity, affection, or contempt. The word *booklet* in English, for example, is a diminutive of *book*.) Central to the transformation is the development of the senses of *casino* in Italian. The word was first applied to a country house and then came to be used for a social gathering place, a room or building where one could dance, listen to music, and gamble. This last pastime seems to have gained precedence over the others, at least as far as the development of the word is concerned, and *casino* took on the meaning "gambling establishment." When the Italian word was borrowed into English, it appeared in the same broad range of meanings as the Italian word. The sense "social gathering place" is recorded first in the 18th century, while the modern sense "gambling establishment" is first attested in 1851.

The Italian word *casa* descends from the Latin word *casa*, "hut, cottage." The same Latin word is also the source of the words for "house" in Spanish and Portuguese—these words are spelled *casa* as well. From restaurant names like *Chez Henri*, English speakers may be familiar with yet another descendant of Latin *casa*, the French preposition *chez* meaning "at the house of."

cauldron *Cauldron* and *chowder* are two words from the same pot. Both go back to the same Late Latin word *caldāria*, "kettle," which is derived from Latin *calidus*, "warm." *Cauldron*, which appeared in Middle English with the spelling *cauderon* (the *l* was introduced

by medieval scribes), was borrowed from Norman French, a dialect of French in which the Latin consonant *c* was preserved as *c* before the vowel *a*. In the dialects of central France, including the dialect of Paris, the Latin consonant *c* became *ch* before the vowel *a*. (This *ch* was pronounced like English (ch) in *chip*, in early medieval times, but later became the (sh) heard in Modern French words with *ch*.) In these central French dialects, *caldāria*, developed into *chaudière*, "pot," the source of the English word *chowder*. The meaning "fish stew," probably developed in the region of Brittany in the far north-west of France and spread, together with the dish, to Newfoundland and the Maritime Provinces of Canada, and then to New England. *Chowder* is not the only word for a cooking vessel that has come to denote the contents instead: *lasagne*, derived from Latin *lasanum*, "cooking pot," and *casserole*, from French *casserole*, "saucepan," are two others.

cheap We may be happy to find a *cheap fare* or to sit in a *cheap seat*, but we usually prefer *inexpensive clothing* to *cheap clothes*, choose *discount* or *low-cost airlines* over *cheap airlines*, and would never want to be considered *cheap*. *Cheap* is thus an example of a word that has suffered PEJORATION, the semantic process by which meaning degenerates over time.

Cheap probably originated as a Latin word borrowed very early into the Germanic branch of the Indo-European family. The word comes from Latin *caupō*, meaning "shopkeeper." Likewise, Old English *cēap* and its Middle English descendant *chep* were nouns with neutral senses such as "bargaining," "purchase," and "price." Middle English *chep* was commonly used in the phrases *god chep*, "a good bargain," *lyght chepe*, "at a favorable price," and *gret chepe*, "low-priced." From the shortening of phrases like these came our adjective *cheap*, first recorded on its own in the 16th century and meaning simply "costing little." What costs little may not always be of good quality, and over time *cheap* also came to mean "of poor quality." This new, pejorative sense has not robbed *cheap* of all value: something that is cheap at half the regular price is a bargain and is well worth having.

Chicago People from Chicago ought to like onions. The name *Chicago* is first recorded in 1688 in a French document, where it appears as *Chigagou,* an ALGONQUIAN word meaning "onion field." In explanation of this name, the document states that wild onion or garlic grew profusely in the area. The name of the field or meadow was first transferred to the river and then was given to the city in 1830.

cider

Tənu-šēkār lə'ôbēd wəyayin ləmārê nāpeš

Give strong drink unto him that is ready to perish; and wine unto those that be of heavy hearts.

—Proverbs 31:6

When Americans and Canadians say the word *cider* nowadays, they usually mean *sweet cider*—tangy unfiltered apple juice made from young apples—but originally all cider was hard cider. In the days before refrigeration, fresh fruit juice was either consumed immediately or made into an alcoholic beverage, since the yeasts naturally present on the skins of fresh fruit would begin to ferment the juice soon after pressing. If the process was not controlled, the juice would turn to vinegar or otherwise go bad quite quickly. In the ancient and medieval world, however, allowing foodstuffs to ferment under controlled conditions was sometimes the best way to preserve them for human use, and hard cider was a popular drink in medieval Europe. We can follow the history of the word *cider* even further back in time, however, to the ancient Near East of the 3rd millennium BC and beyond.

The English word *cider* first appears around 1300 and is a borrowing of Old French *sidre,* which referred to fermented apple juice. The French word developed from the Late Latin word *sīcera,* "strong alcoholic drink." The appearance of the consonant *d* in the French word, versus the *c* in Late Latin, is somewhat unexpected. The development of this consonant remains obscure. The *c* in the Late Latin word *sīcera* probably came to be pronounced

as (s). The middle vowel was then lost, and the (s) became voiced—that is, it became a (z) before the voiced sound (r). The word would then have been pronounced something like *(sizrə). The cluster (zr) may have presented some difficulties to the speakers of Old French, and the (z) underwent changes leading to the attested forms with (d). Early English spellings include forms like *sithere*, with a *th* probably indicating a voiced (*th*) sound.

Late Latin *sīcera* was often used in the context of Church writings, and it was perhaps taken up by early Christian monks in France who used it to distinguish fermented apple juice from the other alcoholic beverages they prepared, like beer and wine. The Late Latin word in turn is a borrowing of Greek *sīkera*. When the Bible was translated into Greek and Latin in antiquity, Latin *sīcera* and Greek *sīkera* were used to render Hebrew *šēkār*, a word which denoted some type of strong alcoholic drink. *Šēkār* is also the Hebrew word usually translated with the English expression *strong drink* in the King James Version of the Bible.

The Greek word *sīkera* used to translate *šēkār* is itself borrowed from a Semitic source closely related to the Hebrew word. The other Semitic languages besides Hebrew have terms similar to *šēkār* with the meaning "intoxicating drink." For example, in Akkadian, one of the main languages of the Near East from around 2500 BC until Roman times, the word *šikaru* was used to designate a kind of unhopped beer, often flavored with roots or spices, that was a common drink in ancient Mesopotamia. Akkadian *šikaru* and Hebrew *šēkār* ultimately descend from the Proto-Semitic noun *šikar–*, "intoxicating drink."

CİRCUS The modern circus owes its name, but fortunately not its regular program of events, to the amusements of ancient times. The Latin word *circus*, which comes from the Greek word *kirkos*, "circle, ring," referred to a circular or oval area enclosed by rows of seats for spectators. In the center ring, so to speak, was held a variety of events, including chariot races and gladiatorial combats, spectacles in which bloodshed and brutality were not uncommon. The first use of *circus* recorded in English, in a work

by Chaucer written around 1380, probably refers to the Circus Maximus in Rome. Our modern circus, which dates to the end of the 18th century, was originally an equestrian spectacle as well, but the trick riders were soon joined in the ring by such performers as rope dancers, acrobats, and jugglers. Even though the circular shape of the arena and the equestrian nature of some of the performances are carried over from its Roman namesake, the modern circus has little connection with its brutal namesake of long ago.

clan The word *clan* is, from the etymological point of view, the same word as *plant*. Such a statement may at first appear unlikely to English speakers, since the two words begin with very different consonants. But to the speakers of the Celtic language of Ireland in the 400s, known as Old Irish, *c* and *p* sounded quite similar, and the peculiarities of the sounds used in Old Irish can help us explain how *clan* can be related to *plant*.

When St. Patrick converted Ireland to Christianity in the 5th century, the Irish people began to borrow many words from Latin (the international language of culture in western Europe at the time), in much the same way that English enriched its vocabulary with words from Latin and Old French later in the medieval period. Curiously, in St. Patrick's time, the Old Irish language had no consonant *p*. Irish is an Indo-European language just like English, but all the *p*'s that Old Irish should have inherited from Proto-Indo-European (a language with plenty of *p*'s) had simply disappeared by regular sound change. The Old Irish word for "father," for example, is *athair*, which is related to Latin *pater*, Greek *patēr*, Sanskrit *pitā*, and English *father* (with an *f* from an earlier *p*), and *athair* resembles these words quite closely except in its lack of a *p*. When the speakers of early Old Irish tried to pronounce *p* in the new Latin words they were borrowing, the best they could manage was a (kw) or (k) sound, spelled *c* in Old Irish. For instance, the Latin words *purpura*, "purple," and *Pascha*, "Easter," eventually came out as *corcur* and *Casc*. Even St. Patrick's name itself posed problems. St. Patrick was a Welshman by birth, and he had

taken the Latin name *Patricius,* meaning "patrician" or "noble," when he was ordained a priest in France. The earliest form of Patrick's name in the Irish language was *Cothraige.* Later, as their language continued to develop and change, the Irish learned to cope with *p,* and Modern Irish has many words containing this consonant. St. Patrick is now called *Pádraig* in Modern Irish.

When the early Irish borrowed the Latin word *planta,* meaning "sprout" or "sprig"—which is also the source of the English word *plant*—it came out as *cland.* In Old Irish, it came to refer to a group of people tracing descent from a common ancestor. (Similar metaphorical extensions of terms referring to plant parts can be found in English expressions like *branch of a family.*) The word *cland* was carried to the area that is now Scotland when speakers of Old Irish gained power in the region in the late 400s. The form of Old Irish spoken in Scotland eventually developed into the language now known as *Scottish Gaelic.* In Scottish Gaelic, *cland* developed the form *clann,* and it was from Scottish Gaelic that the word *clan* entered English in the 15th century, at first with reference to the clans of the Scottish highlands.

codex *Cōdex* is a variant of the Latin word *caudex,* "tree trunk." This word was used of the wooden stump to which petty criminals were tied in ancient Rome, rather like the stocks used to punish wrongdoers in medieval Europe or colonial America. It was also the word for a book made of thin wooden strips coated with wax upon which one wrote. The usual modern sense of English *codex,* "book formed of bound leaves of paper or parchment," is due to Christianity. By the first century BC there existed at Rome notebooks made of leaves of parchment, used for rough copy, first drafts, and notes. By the first century AD such manuals were used for commercial copies of classical literature. The Christians adopted this parchment manual format for the Scriptures used in their liturgy because a codex is easier to handle than a scroll and because one can write on both sides of a parchment but on only one side of a papyrus scroll. By the early second century all Scripture was reproduced in codex form. In traditional Christian

iconography, therefore, the Hebrew prophets are represented holding scrolls and the Evangelists holding codices.

colossal The noun *colossus*, source of the word *colossal*, first appears in English in reference to an ancient statue known as the Colossus of Rhodes. Between 294 and 282 BC, the inhabitants of the Greek island of Rhodes erected a huge bronze statue of Helios, the Greek sun god who was the patron deity of their island. No descriptions survive of this statue before it was toppled in an earthquake 56 years later, but according to the Roman scholar Pliny the Elder (AD 23–79), who visited the ruins, the colossus originally stood 110 feet tall—almost three quarters the size of the Statue of Liberty. It is said that the colossus was so large that 900 camels were required when the remains of the statue were finally carried away to Syria nearly a millennium after it fell. Though little is known for certain about the statue's original appearance or location, it was probably a naked figure of a man standing on a large pedestal somewhere near Mandraki harbor. (Few historians believe that it actually bestrode the mouth of the harbor, as it is traditionally depicted.)

The Greek etymon of *colossus* was most likely borrowed into the Doric dialect of Greek from an eastern Mediterranean language in which it meant simply "statue or statuette," and it is probably in this sense that the Dorian inhabitants of Rhodes first applied it to the Colossus of Rhodes. In the Ionian dialect of Greek, the word first appears in the writings of Herodotus (5th century BC), who uses it strictly in reference to large stone statues of ancient Egypt. By the time the Greek word, *kolossos*, was borrowed into Latin as *colossus*, it had acquired the meaning "huge statue." In both Greek and Latin, the noun inspired an adjective form, like English *colossal*, that meant "gigantic." The Latin adjective is the source of English *coliseum* (also spelled *colosseum*) and the name of the colossal Roman amphitheater from which *coliseum* derives.

comrade A comrade can be socially or politically close, a closeness that is found at the etymological heart of the word *comrade*. The

term ultimately originates in the Latin word *camera*, "vault," also found in the spelling *camara*. In Late Latin, the word developed the meaning "chamber, room," which is still the sense of its descendant in Spanish, *cámara*. In Spanish, the word *camarada*, with the sense "roommates, especially barrack mates," was formed from *cámara*. *Camarada* then came to have the general sense "companion." English borrowed the word from Spanish and French, English *comrade* being first recorded in the 16th century. In the 19th century, *comrade* began to be used as a title by socialists and communists in order to avoid such forms of address as *mister*. The first known use of the term in this sense dates from 1884.

The Latin word *camera* is also the source of the English term *camera* designating a device that takes photographs. The modern word developed from the earlier term *camera obscura*, literally "dark room" in Latin. A *camera obscura* is a darkened chamber or box in which the real image of an object is received through a small opening or lens and focused in natural color onto a facing surface. The modern camera developed from camera obscuras in which a light-sensitive film or plate was placed on the facing surface.

cookie　On the surface, *cookie* looks like it might be related to the word *cook*, which ultimately derives from Latin *coquere*, "to cook." After all, the word corresponding to *cookie* in British English is *biscuit*, which comes from an Old French *bescuit* literally meaning "twice cooked" and originally referring to a kind of hard, flat, crisp bread. The Old French word is derived from Latin *bis*, "twice," and *coctus*, "cooked," past participle of the verb *coquere*, "to cook." The name of the Italian cookies called *biscotti* is of course also derived from the same Latin words.

Cookie, however, probably has nothing to do with the verb *cook* and other words ultimately derived from the Latin verb *coquere*. *Cookie* was borrowed into American English from the Dutch settlers of New York. The word comes from Dutch *koekje*, "little cake," a diminutive of Dutch *koek*, "cake." (In Dutch, the sound (o͞o) is written as *oe*, so the Dutch word *koekje* actually sounds quite like the English word *cookie*.) Dutch *koekje* is ulti-

mately akin to the English word *cake* itself, which itself is a borrowing of Old Norse *kaka*. The ultimate origin of Dutch *koek* and its relatives like Old Norse *kaka*, "cake," and German *Kuchen* is obscure, but linguists do not think that these Germanic words can have developed from an early borrowing of a word derived from Latin *coquere*, "to cook." Instead, it has been suggested that the word is an early borrowing of a word in a Romance language, **coca*, related to Sardinian *cocca*, "cake," and ultimately descended from Latin *cochlea*, "snail"—the word may originally have referred to some sort of rounded, whorled baked good resembling a snail shell and made of a spiral of overlapping sheets of dough. The unusual modern spelling of *cookie* with an *–ie* rather than a *–y* may have arisen because the word, denoting something small and toothsome, was more commonly seen in the plural, which ends with *–ies*.

cool The usage of *cool* as a general positive epithet or interjection has been part and parcel of English slang since World War II, and has even been borrowed into other languages, such as French and German. Originally this sense is a development from a Black English usage meaning "excellent, superlative," first recorded in written English in the early 1930s. Jazz musicians who used the term are responsible for its popularization during the 1940s. As a slang word expressing generally positive sentiment, it has stayed current (and cool) far longer than most such words. One of the main characteristics of slang is the continual renewal of its vocabulary and storehouse of expressions: in order for slang to stay slangy, it has to have a feeling of novelty. Slang expressions meaning the same thing as *cool*, like *bully, capital, hot, groovy, hep, crazy, nervous, far-out, rad,* and *tubular* have for the most part not had the staying power or continued universal appeal of *cool*. In general there is no intrinsic reason why one word stays alive and others get consigned to the scrapheap of linguistic history; slang terms are like fashion designs, constantly changing and never "in" for long. The jury is still out on how long newer expressions of approval such as *def* and *phat* will survive.

corned beef As more and more of us shop in supermarkets where food is offered in cans and packages almost ready to serve—rather than at the local butcher's shop or the farm stand—we have fewer opportunities to learn how plants and animals are grown and prepared for our consumption. Children sometimes wonder where the *corn* in *corned beef* is, since there are no yellow kernels of maize to be found in a corned beef sandwich. Some may even reason that the beef must have come from a cow fed with *corn* (that is, *maize*). In fact, corned beef is in origin beef preserved by *corning*, or dry-curing with salt. The word *corn* was used in the past to describe the large, coarse grains of salt sprinkled and rubbed onto beef or into which the beef was set to cure, the method traditionally used to make corned beef, and still used to make cured meats like prosciutto. (Nowadays, however, most corned beef is soaked in brine.)

Originally, the English word *corn* meant any rounded grain or seed whatsoever. In particular, it was used to refer to the kind of grain most often grown in a certain region. Thus in England, a *cornfield* is usually a field of wheat. The pretty blue *cornflower* (also called a *bachelor's button*) is a Eurasian weed that originally plagued fields of wheat, not maize. In Scotland, on the other hand, *corn* can mean "oats," the grain that thrives best in Scotland's cool and damp climate. To modern North Americans, however, *corn* means *maize*—that is, the plant *Zea mays* and its seeds. When they first encountered *Zea mays* in the 16th century, English-speaking Europeans borrowed the Spanish term for the grain, *maíz*, which is in turn a borrowing of Arawakan *mahiz* or *mahís*. Later, in the 17th century, another term for maize first appears, *Indian corn* (*Indian* here meaning "native to the Americas"). The American use of *corn* in the specific meaning "maize" eventually arose from a simple shortening of this expression.

coupon A Roman might have had difficulty predicting what would become of the Latin word *colaphus*, which meant "a blow with the

fist." As the variety of Latin spoken in the Roman province of Gaul (the area now known as France) developed into Old French, the Late Latin word *colpus,* derived from *colaphus,* became *colp.* Old French *colp* subsequently developed into Modern French *coup,* with the same sense. *Coup* has had a rich development in French, gaining numerous senses, participating in numerous phrases, such as *coup d'état,* and giving rise to many derivatives, including *couper,* "to divide with a blow or stroke, cut." *Couper* yielded the word *coupon,* "a portion that is cut off," which came to refer to a certificate that was detachable from a principal certificate. The detachable certificate could be exchanged for interest or dividend payments by the holder of the principal certificate. *Coupon* is first recorded in English in 1822 with this sense and then came to apply to forms or tickets, detachable or otherwise, that could be exchanged for various benefits or used to request information.

critter *Critter* is the same word as *creature,* from the etymological point of view. It originates as a dialectal variant of *creature,* but owing to the PRONUNCIATION SPELLING *critter,* the term has taken on something of a life of its own as a separate word. The American regional word also has its own variants, including *creeter* and *cretter.* In some ways, the pronunciation of *critter* would have been very familiar to Shakespeare: 16th- and 17th-century English had not yet begun to pronounce the *–ture* suffix with its modern (ch) sound. This archaic pronunciation survives not only in American *critter,* but also in Irish English *creature,* pronounced (**krā′**tŭr) and used in the same senses as the American word.

The most common meaning of *critter* is "a living creature," whether wild or domestic; it also can mean "a child" when used as a term of sympathetic endearment, or it can mean "an unfortunate person." In old-fashioned speech, *critter* and *beast* denoted a large domestic animal. The more restricted senses "a cow," "a horse," or "a mule" are still characteristic of the speech in specific regions of the United States. The use of *critter* among younger speakers

almost always carries with it a jocular or informal connotation.

In many American regional dialects, the word *bull*, meaning "adult male bovine," was once highly taboo. When speaking in mixed company, people would substitute a variety of words and call the bull a *booman, brute, gentleman cow,* or *surly.* In the Northeast in particular, *critter* was a common word used to avoid saying *bull*, both by itself and in combinations like *beef critter* and *cross critter.*

crucial A crucial election is like a signpost because it shows which way the electorate is moving. The metaphor of a signpost, in fact, gives us the sense of the word *crucial*, "of supreme importance, critical." In a work dating from 1620, the English philosopher and essayist Francis Bacon used the phrase *instantia crucis*, "crucial instance," to refer to something in an experiment that proves one of two hypotheses and disproves the other. Bacon's phrase was based on a sense of the Latin word *crux*, "cross," which had come to mean "a guidepost that gives directions at a place where one road becomes two," and hence was suitable for Bacon's metaphor. Both Robert Boyle, often called the father of modern chemistry, and Isaac Newton used the similar Latin phrase *experimentum crucis*, "crucial experiment." When these phrases were translated into English, they became *crucial instance* and *crucial experiment.*

cynosure Today, the word *cynosure* means "a center of attention and admiration" and also "something that serves to guide." However, it first appeared in English as a name for the constellation Ursa Minor (the Little Dipper), a star formation that was once noted for its use in locating the celestial north pole—the axis around which all the constellations of the Northern

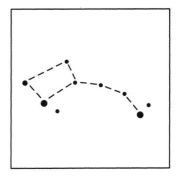

cynosure
the constellation Ursa Minor

Hemisphere rotate. The last star in the handle of the "dipper," or ladle, is Polaris, which, because of its proximity to the pole, also goes by the names *polestar, polar star,* and *North Star.* Polaris's relatively constant position in the north sky has made it an important beacon for celestial navigators and a wellspring of metaphors for poets. According to ancient sources, the practice of using Ursa Minor to locate the star originated in Phoenicia, an ancient maritime country of southwest Asia. Prior to adopting the Phoenician custom, the Greeks relied on Ursa Major (the constellation including the Big Dipper), a larger but less accurate guide. The word *cynosure* itself can be traced back to one of the early representations of Ursa Minor. The word's Greek ancestor, *kunosoura,* was another name for the constellation Ursa Minor and literally translates as "dog's tail." While the literal meaning of Greek *kunosoura* may not be widely known, some may want to bear it in mind next time they call someone their *cynosure.*

See also **Arctic.**

D

dachshund The dachshund, a small breed of dog known for its elongated body, short legs, and often ferocious temper, was originally developed in Germany to hunt burrowing animals. Like the names of many other dog breeds such as the otter hound, boarhound, foxhound, wolfhound, elkhound, and cocker spaniel (originally used for hunting woodcocks), the dachshund's name indicates its usual quarry—in German, *Dachshund* literally means "badger-dog." *Dachs* is the German word for "badger," and *Hund*, which is closely related to the English word *hound*, means "dog."

The word *Dachs* derives from Proto-Germanic **thahsuz*, "badger." The origins of **thahsuz* are uncertain, but the word could have come from the Proto-Indo-European root **teks–*, "to fabricate, weave," a root that could refer to such processes of construction as hewing timber into shape or making fences by weaving willow rods. Thus, **thahsuz* may originally have meant "the animal that builds burrows." Another possibility is that **thahsuz* is not of Indo-European origin. Rather, it was borrowed from one of the languages of Europe that were replaced by Indo-European languages as the Indo-European peoples migrated from their central Eurasian homelands. It has been suggested that the word-building element found in ancient Celtic names, **tazgo–*, was borrowed from the same source. The totem animal of the people bearing these names would thus have been the

dachshund

badger, a fierce animal known for its sharp claws and powerful bite. This ancient Celtic name survives in modern Ireland to this day as *Tadhg* (pronounced like the first syllable in *tiger*).

debonair The word *debonair* is nowadays used in a variety of meanings, including "genteel," "suave," "genial," and "jaunty." The development of English *debonair* reflects the attitudes prevailing among the upper classes in medieval European society, in which the virtues of gentleness and courtesy were thought to flourish only in the houses of the nobility. When *debonair* first appears in English in the 13th century, it has the meaning "of gentle or kindly disposition" and "courteous." The adjective in fact derives from a phrase in Old French, *de bonne aire*, which literally means "from a good aerie." An aerie is a large nest built by a bird of prey on a cliff or other high place. The phrase *de bonne aire* was used to mean "of good pedigree" or "from good stock"—in other words, "noble."

The English word *aerie*, also spelled *eyrie*, is in fact ultimately from Old French *aire* as well. *Aire*, a word of disputed origin, was adopted into Medieval Latin as *aeria*. After its adoption into Medieval Latin, the word *aeria* was borrowed into English as *aerie*. Medieval Latin, used as the international language of religion, law, and scholarship throughout the medieval period, contains many words borrowed from the everyday speech of medieval Europe. Classical Latin sometimes could not offer a good translation for new concepts of the time. In other cases, the Classical Latin terms might have looked strange to speakers of French and the other Romance languages, even though usually the Latin and the Romance words looked quite the same. Scholars and scribes also freely adapted words from their everyday French or English by tacking on a Latin suffix, even when Classical Latin offered a good way of saying what was to be expressed.

debt Unlike many of the silent letters found in Modern English, the *b* in *debt* has probably never been pronounced at any time since the word entered the English language. When *debt* first appeared

in Middle English, it had the same spelling as its Old French source *dette*. However, medieval scribes knew that Middle English and Old French *dette* was ultimately derived from Latin *dēbitum*, "debt," and they reintroduced the *b* in the 15th century. *Debt* has a doublet in the word *debit*, which was borrowed directly from the Latin *dēbitum*, and was roughly synonymous with *debt* until the 18th century, when *debit* was restricted to the province of book-keeping and financial transactions.

Latin *dēbitum* is actually the past participle of *dēbēre*, "to owe." As the spoken Latin of Roman Gaul developed into Old French, the verb *dēbēre* developed into Old French *devoir*. The past participle of Old French *devoir* was *deu*, literally meaning "owed." This word was borrowed into Middle English and became the Modern English adjective *due*.

diabetes Diabetes is named for one of its distressing symptoms. The disease was known to the Greeks as *diabētēs*, a word derived from the verb *diabainein*, made up of the prefix *dia–*, "across, apart," and the word *bainein*, "to walk, stand." The verb *diabainein* meant "to stride, walk, or stand with legs asunder"; hence, its derivative *diabētēs* meant "one that straddles," or specifically "a compass, siphon." The sense "siphon" gave rise to the use of *diabētēs* as the name for a disease involving the discharge of excessive amounts of urine. *Diabetes* is first recorded in English, in the form *diabete*, in a medical text written around 1425.

dice The plural *dice* is a fascinating linguistic fossil. Nowadays, the regular plural ending of nouns appears in three different forms depending upon the nature of the sound preceding it. After a vowel or most VOICED consonants, it is pronounced as (z): *trees, birds, waves, rivers, streams*. After most VOICELESS consonants, it is pronounced (s): *rocks, plants, ships*. After the sounds (s), (z), (sh), (zh), (ch), and (j)—all sounds made in the mouth by blowing a hissing stream of air through a narrow space formed by the tip of the tongue in the region behind the upper incisors—the plural ending takes the form (əz): *brushes, bridges*. In Early Middle

English, however, the plural ending –(e)s had a much different pattern of pronunciation. It was realized as (əs) after consonants and (s), not (z), after vowels. Thus *trees* would have sounded something like *trace*, (trās), to the modern ear.

Sometime in the Middle English period, the -s that indicated the plural of nouns was voiced—that is, it became pronounced as (z)—after a vowel. (Other final s sounds, no matter how spelled, simply stayed (s), as in *us, pass,* or *ice.*) However, a few plural words escaped this voicing, including *dice,* which is actually the old regular plural of *die* preserved in amber, so to speak. These words were more often used in the plural to denote sets or collections of objects often found together. Dice, in such games as craps or backgammon, are usually rolled in pairs, and from the 14th to the 17th centuries, *dice* was in fact sometimes used as a singular word: *the cast of a dice.* Because they were plurals that could be thought of as denoting a single set of things, words like *dice* escaped the general voicing of final plural (s) to (z) in Middle English. The word *pence,* an old plural of *penny,* is a similar plural that has not undergone the voicing of (s). The spelling of the sound (s) with the letters –ce in such words can also be seen in *mice* and *lice,* plurals of *mouse* and *louse.*

Truce is another frozen plural form with (s) like *dice* and *pence,* but in this case, the word has become a singular in modern usage. In Middle English, a *trewe* was a cessation of hostilities, and the word was often used in the plural with the same meaning. Today only the plural survives, reanalyzed as a singular. The Middle English noun *trewe* comes from Old English *trēow,* which meant "an assurance," that is, a promise to remain true to an agreement. Old English *trēow* is in fact closely related to the Modern English adjective *true,* the descendant of Old English *trēowe.*

See also **bodice.**

die The euphemistic expression *breathe one's last* illustrates a widespread linguistic and cultural phenomenon known as *taboo avoidance.* There are certain concepts that few people like to talk or think about, and death is certainly one of them. Such concepts

are often expressed linguistically by the invention of circumlocutions or other substitutions for the word that expresses the concept directly—in this case, the verb *to die*—probably as a way of minimizing the power of the basic word for the concept.

It is interesting to compare how two different styles of language, formal and slang, avoid saying "die." More formal or elevated speech is full of euphemistic expressions such as *breathe one's last, pass away, depart, expire, go to one's eternal reward, go the way of all flesh*, and *go to a better place*. Many of these expressions try to cast death in a positive light, often with religious overtones.

Speakers of slang are just as interested in avoiding the word *die*, partly for the same taboo-avoidance reasons and partly because of the general striving on the part of slang speakers to come up with novel expressions for old concepts. The result is a raft of irreverent expressions that are much more direct than the elevated ones—but not so direct as to actually say "die." These expressions often concentrate on a particular physical aspect of dying, lending them an unusually vivid quality: *croak, go belly up, kick the bucket, cash in one's chips, bite the dust, eat it, crap out*.

The English words *die* and *death* come from an Indo-European root having the variant forms **dheu–* or **dheuə–*, "to die." This root is suspiciously similar to another Indo-European root, **dheuə–*, meaning "to come full circle." The root **dheuə–* is the source of Old English *dūn*, "hill." Ancient ring-forts were constructed by completing a circular fence around a piece of high ground, and the word for the circular ring-fort eventually came to be applied to the fortified hill itself. *Dūn* is the source of the element *–don* in place names like *Wimbledon*. The ancient Celts also made similar forts, which they called *dūnon*. This word can be seen in many Irish place names such as *Donegal*, from Irish *Dún na nGall* "fort of the foreigners," or *Dundalk*, from *Dún Dealgan*, "fort of Dealga." The Celtic word was also borrowed into Germanic and eventually shows up as the English word *town*. The resemblance between **dheu–*, "to die," and **dheuə–*, meaning "to come full circle," suggests an ancient euphemism expressing a cyclical conception of the nature of life and death.

diet We commonly hear the word *diet* in reference to a regimen of food and drink, as in *crash diet* or *diet soda*. But there is another word *diet* used to refer to the legislative assemblies of certain countries, especially the Diet of Japan. What could these two *diets* possibly have to do with each other? Both words ultimately derive from Greek *diaita*, "way of living," a derivative of the verb *diaitāsthai*, "to live one's life." The Greek word was borrowed into Latin as *diaeta*, which referred to any mode of life prescribed by a physician, including but not limited to a regimen of food intake, the notion most often indicated by the English word *diet* in modern times.

In Medieval Latin, the diphthong *ae* was often written simply as *e*, and Latin *diaeta* thus often appeared as Medieval Latin *diēta*. From meanings like "prescribed regimen," Medieval Latin *diēta* developed extended meanings such as "daily course of events" and "daily routine" in the context of the Christian Church, and *diēta* was therefore associated with the unrelated Latin *diēs*, meaning simply "day." In the other languages of Europe at the time, words meaning "day" or "the space of a day" were often used in an extended sense to mean things like "daily business" and "daily assembly," and the Latin word *diēta* began to be used to translate these words into Latin. For example, the German word *Tag*, literally "day," has also been used to mean "assembly," and *Tag* can still be found in this sense in the compound word *Reichstag*, which originally referred to the assembly of princes and dukes in the Holy Roman Empire but is now used as the name of the building that houses the German legislative assembly, the *Bundestag*. Used in the sense "assembly," *diēta* passed into English around 1450 and was later applied to the national legislative assemblies of various countries.

Medieval Latin *diēta*, in the sense "way of living" and "prescribed regimen," was also borrowed into Old French as *diete*, and the Old French word was borrowed into Middle English. Although in modern times the English word *diet* has come to refer mostly to diets of food and drink, perhaps owing to the modern

obsession with healthy eating and weight loss, this specific sense of the word had already developed in Middle English times.

disheveled The meaning of *disheveled*, "disarrayed, unkempt," suggests that the first part of the word is a prefix, *dis–*, meaning roughly "undo, do the opposite of," as in *disarrayed* itself. But what then is the rest of the word? Was there once a verb *hevel*, meaning "to do up the hair"? In fact, the verb *dishevel* is probably a BACK-FORMATION from the adjective *disheveled* (like the verb *baby-sit* from the noun *babysitter*, for example).

The verb *dishevel* begins to appear in English only in the 1500s, while the adjective *disheveled* first appears in the 1400s, in Middle English, where it has the form *discheveled*. Middle English *discheveled* meant specifically "without a headdress, with the hair hanging loose, with disordered hair," and developed from an earlier Middle English word *dischevele* that first appears in the late 1300s. *Dischevele* itself comes from Old French *deschevelé*, the past participle of the verb *descheveler*, "to put the hair in disorder, muss up the hair." The Old French verb in turn was created by adding the prefix *des–*, "apart, away, with the opposite effect," to the noun *chevel*, "hair," and so literally means "to do apart the hair, undo one's hairdo." And so the *shevel* in *dishevel* is simply the Old French word for "hair."

The Old French word *chevel*, "hair" (now Modern French *cheveu*), developed from the Latin word *capillus*. Latin *capillus*, "hair," is also the source of a few other English words, such as *capillary*, denoting fine (that is, hair-thin) blood vessels distributing blood to the various tissues of the body. The name of the hair-thin pasta called *capellini* means "fine hairs" in Italian, and it too descends from *capillus*.

divan Nowadays, the English word *divan* most often denotes a long, backless sofa usually set with pillows against a wall. In a sense, we could consider the word *divan* to be one of the oldest words in the English language—if we follow its long and complicated history back through the written record of humanity, we

eventually reach the very beginning of writing itself. In fact, the history of the word *divan* begins with a word for the earliest writing materials used by humanity, the clay tablets of Sumeria.

Around 3100 BC or earlier, the Sumerians, who lived in what is now the southern part of Iraq, created the first fully developed writing system. They recorded official business information like quantities of grain or numbers of sheep on tablets of wet clay. The Sumerians made marks on these tablets with cut reeds that produced wedge-shape impressions, and the modern term for their writing system, *cuneiform*, makes reference to these wedges and comes from the Latin word *cuneus*, "wedge." The Sumerians eventually used cuneiform writing to record the earliest known literary works of humanity, written on tablets which date from the middle of the 3rd millennium BC. The Sumerian word for "tablet" was *dub*, and the archive or scribal school where their tablets were copied and kept was called *e dub-ba*, "house of the tablet."

Sumerian, which is not known to be related to any other language, was gradually replaced by the Semitic language Akkadian in ancient Mesopotamia. The speakers of Akkadian, however, continued to write in cuneiform on clay and borrowed many words from Sumerian, including the word for "tablet," which they pronounced *ṭuppum*. Eventually, Mesopotamia was conquered by speakers of Old Persian, which became one of the official languages of the great Achaemenid Empire that held sway over large areas of the Near East from around 559 to 330 BC. Old Persian came to be written in a kind of cuneiform alphabet modeled on the Akkadian writing system, and the speakers of Old Persian also borrowed the Akkadian word *ṭuppum*, "tablet," as *dipī–*, "writing, document." In Old Persian and the other dialects spoken in ancient Iran, there was probably a word like **dipivahanam*, literally meaning "document house," that denoted the place where official documents were written or archived, perhaps an institution similar to the *e dub-ba* of the Sumerians. This Iranian word was a compound of Old Persian *dipī*, "document," with Old Persian *vahanam*, "house," or their equivalents in other Iranian dialects.

The hypothetical Iranian word **dipivahanam* later developed

into Persian *dīvān*, meaning "roster" or "place of assembly." The Persian word was eventually borrowed into Turkish, where it denoted an audience hall or room for official business. In particular, the word was used of the room in which the sultan of the Ottoman Empire met with his council of advisers and conducted state affairs. From Turkish, the word *divan* eventually reached English in the 1500s, and the English word could be used in various ways to denote a government bureau or audience room in a Muslim country, or the seat used by an administrator when holding audience in such a room, or even a coffeehouse or smoking room. A Turkish *divan* was presumably graced with fine furnishings, such as a backless couch set against a wall and provided with cushions, and it was from such furnished rooms that *divan* also developed the meaning "a backless sofa," a sense that first appears in English in the early 1700s. In this way, a trace of the word for first writing materials of mankind, the *dub* or clay tablet of the ancient Sumerians, has come to be preserved—in a very altered form—in the modern living room.

dogie In the language of the American West, a stray or motherless calf is known as a *dogie*. In *Western Words*, the noted scholar Ramon F. Adams gives one possible etymology for *dogie*, a word whose origin still remains uncertain. During the 1880s, when a series of harsh winters left large numbers of orphaned calves, the little calves, weaned too early, were unable to digest coarse range grass, and their swollen bellies "very much resembled a batch of sourdough carried in a sack." Such a calf was referred to as *dough-guts*. The term, altered to *dogie* according to Adams, "has been used ever since throughout cattleland to refer to a pot-gutted orphan calf." Another possibility is that *dogie* is an alteration of Spanish *dogal*, "lariat." Still another is that it is simply a variant pronunciation of *doggie*.

don

> *Don we now our gay apparel*
> *Fa-la-la, la-la-la, la-la-la.*

Troll the ancient Yule-tide carol
Fa-la-la-la-la, la-la-la-la.

Many readers have probably sung these lines from "Deck the Hall" hundreds of times without considering the etymology of the old-fashioned word *don*, "to put on." In fact *don* is simply an old contraction of *do on*, with *do* used in the sense of *put*: *Do on we now are gay apparel.* Similarly, the verb *doff*, "to take off," is a contraction of *do off*. These contractions happened in Middle English when the weakly stressed verb *do* coalesced with the preposition following it, and the resulting contractions began to take verbal endings such as *–ed (donned* instead of *did on*) and *–ing (doffing* instead of *doing off*) just like any other regular verb. These contractions date from at least the 14th century. Although the Modern English verb *don* is used mostly of people dressing themselves in clothing or putting on an ironic air or attitude, the Middle English verb *don* was also used in the sense "to put an article of clothing on another person." In a Middle English text describing Jesus's trial by Pontius Pilate and dating from around 1425, we find *doff* and *don* used side by side: *His clothes þai dof, on him þai don… a purple mantyll.* ("They doff his clothes and on him put a purple robe.")

A few other verbs formed by the contraction of *do* with a following preposition were once common in the past, but they have now fallen out of use. *Dout*, a contraction of *do out*, is found in the 16th and 17th centuries in meanings like "to put out (a light)." Shakespeare uses the verb *dup*, "to open," thought to be a contraction of *do* and *up*, in *Hamlet* (Act 4, Scene 5). Ophelia, having fallen into a fit of madness, sings the following lines of a bawdy song: *Then up he rose and donn'd his clo'es, / And dupp'd the chamber-door.* In the *Classical Dictionary of the Vulgar Tongue*, a dictionary of slang by Captain Francis Grose dating from 1785, the phrase *Dub the Jigger* is explained as "Open the door." This verb *dub* is thought to be a later form of *dup*. Captain Grose indicates that the expression is thieves' cant, and he perhaps intends the reader to understand that the door will be opened by picking the lock.

Don River The Don River in Mother Russia is well known, as are the unruly Cossacks who dwelt there, defying khan and czar. But there are also six Don Rivers in the United Kingdom! Were there Cossacks in Shropshire? Hardly. All these Don Rivers flow from one Indo-European source.

The Indo-European root *dā–* means "to flow, flowing," and its suffixed derivative *dānu–* means "river." In Avestan, the earliest Iranian language we know, *dānu–* means "river, stream." In modern Ossetic (the language of the Ossets, descendants of the Scythians, an Iranian tribe of the Russian steppes), *don* means "river, stream." The name of the Don River of Russia (as well as of the rivers in the United Kingdom) therefore simply translates as "the River River." The Russian rivers Dnieper and Dniester (earlier *Danapris* and *Danastius*, respectively) come from Scythian *Dānu apara* and *Dānu nazdya* ("the river in the rear" and "the river in front," respectively).

The six Don Rivers in Britain come from the Celtic version of the "river" word, also *dānu–*. This survives more or less intact in the name of the *Danube*, which was called *Dānuvius* by the Romans. The presence of Celtic river names both in Britain and in central Europe attests to the Celts' earlier glory as one of the most important peoples of ancient Europe.

dope *Dope* is a borrowing of the Dutch word *doop*, "sauce," which is itself ultimately related to such English words as *dip*. Throughout the 19th century, *dope* meant "gravy," and in the North Midland United States, particularly Ohio, *dope* is still heard as the term for a topping for ice cream, such as chocolate syrup or fruit sauce. Also in the 19th century, the meaning of *dope* was extended to include various medicinal mixtures or syrups, including the syrups from which soda-fountain drinks like Coca-Cola were prepared. A continuation of this usage survives in the South, particularly in South Carolina, where *dope* means "a cola-flavored soft drink." *Dope* was especially used of those medicinal preparations that produced a stupefying effect, and it even became a slang term for the dark, molasses-like form of opium that was smoked in

opium dens. Some of the common modern meanings of the word *dope*, including "a narcotic substance" and "narcotics considered as a group," developed from this use of the word.

dragonfly Regional terms for the dragonfly are numerous—the *Dictionary of American Regional English* lists nearly eighty of them. The greatest variety of terms is to be found in the South, where the most widespread term is *snake doctor* (a name based on a folk belief that dragonflies take care of snakes). The Midland equivalent is *snake feeder*. Speakers from the Lower South and the Mississippi Valley, on the other hand, are more likely to refer to the same insect as a *mosquito fly, mosquito hawk*, or, in the South Atlantic states, a *skeeter hawk*. The imagery outside the South often alludes to the insect's shape rather than its behavior or diet: speakers in the West, Upper North, and New England call it a *darner, darning needle*, or, less commonly, a *devil's darning needle*, and those in the Upper North also refer to it just as a *needle;* those in coastal New Jersey, a *spindle;* and those in the San Francisco Bay area, an *ear sewer*, that is, a creature that sews up your ears.

dreary *Drizzly* weather is *dreary*, but it hardly *drips* with blood. Modern English *dreary*, however, descends from Old English *drēorig*, meaning both "gory, covered with blood" and "sorrowful." The second meaning is without doubt a development of the first, since a day when much blood flows in battle is also a sad day for the forces of the defeated and the kinfolk of the slain. *Drēorig*, in turn, is derived by means of the suffix *–ig* (ancestor of the ubiquitous Modern English suffix *–y*) from the Old English noun *drēor*, which referred to gore or flowing blood—in particular, blood shed in battle. The word played an important role in the Old English heroic literature recounting the ways and deeds of warriors. In the following passage from *Beowulf*, King Hrothgar of the Danes describes the aftermath of a nocturnal attack on his feasting hall by the monster Grendel, and he twice uses the word *drēore*. (Old English scribes did not mark length on vowels systematically, so *drēore* is spelled *dreore* below.)

Ðonne wæs þeos medoheal on morgentid
drihtsele dreor-fah. Ðonne dæg lixte,
eal benc-þelu blode bestymed,
heall heoru-dreore. Ahte ic holdra þy læs.

Then was this mead-hall, in the morning-time,
a lordly dwelling gore-stained. When the day gleamed,
all the bench-planks with blood were bedewed,
the hall with sword-gore. I had loyal men thereby the less.

Drēorig further developed into Middle English *dreri*, which was used more often with the sense "sorrowful" than with the original meaning "gory." The word begins to appear with its principal modern sense, "dismal," in the 16th century.

Old English *drēor* has cognates meaning "gore, flowing blood" in the other Germanic languages, such as Old High German *trôr* and Old Norse *dreyri*, and these are all derived, by way of Proto-Germanic **drauzaz*, from the Proto-Indo-European root **dhreu–*, "to flow." (The *dh–* of this root becomes English *d-* by the effect of GRIMM's LAW.) Interestingly, the Modern German word for "sad," *traurig*, is derived from Old High German *trôr* in the same way that *dreary* is from *drēor*.

The Indo-European root **dhreu–* is also the source of several other words in English relating to liquids, including *drizzle*, *drop*, and *drip*. Things that are sodden with liquid tend to *droop*, and this word too is a derivative of **dhreu–*.

dumb In ordinary spoken English, a sentence such as *He is dumb* will be interpreted to mean "He is stupid" rather than "He lacks the power of speech." "Lacking the power of speech" is, however, the original sense of the word, which descends from Old English *dumb*, "mute, without speech"—but this sense has been eclipsed by the meaning "stupid." For this change in meaning, it appears that the Germans are responsible. German has a similar and related word *dumm* that means "stupid," and over time, as a result of the waves of German immigrants to the United States, it

has come to influence the meaning of English *dumb*. This is one of dozens of marks left by German on American English. Some words, like *kindergarten, dachshund,* and *schnapps* still have a German feel or are associated to some extent with Germany, but others, like *bum, cookbook, fresh* (in the meaning "impertinent"), and *noodle* have become so thoroughly Americanized that their German origins may surprise some.

dump The alliterative phrase *down in the dumps* is known to have been popular by 1796, the date of the third edition of a remarkable collection of 18th-century slang, entitled *A Classical Dictionary of the Vulgar Tongue,* by Captain Francis Grose. Of course, the expression was probably in use a good deal earlier before it found its way into the dictionaries of the time. In his usual cheeky style, Captain Grose offers the following explanation of the origin of the word: *jocularly said to be derived from Dumpos, a king of Egypt, who died of melancholy*—a spurious etymology if there ever was one! Many speakers of Modern English, if they paused to consider the phrase, would probably suggest that the *dump* in *down in the dumps* is somehow the same *dump* as in *garbage dump* and summon up the mental picture of a sad person seated amidst heaps of rusty cans and banana peels. In fact, these two words *dump* have separate origins.

The *dump* in *garbage dump* comes from the verb *dump*, which is probably of Old Norse origin and related to words in the Modern Scandinavian languages like Danish *dumpe*, "to tumble, flop down." The use of this *dump* as a noun meaning "a pile of refuse" and "a place for dumping" seems to have begun in the United States—in British English the term *rubbish tip* is used instead of *garbage dump*.

The *dump* in *down in the dumps* has a far different origin. The word first appears in the 16th century with the meanings "a dazed or absent-minded state of mind" as well as "a fit of melancholy." This *dump* is usually said to be a borrowing of the Middle Dutch word *domp*, "haze, mist," and the modern phrase *mental fog* shows how easily the development of the meaning "depression"

from "haze" might have occurred. Middle Dutch *domp* itself belongs to the same family of words that also includes English *damp* and German *Dampf*, "steam." For the most part, this word *dump* has survived into recent times only in the phrase *down in the dumps* and related usages. Interestingly, the *dump* meaning "a fit of melancholy" also developed another sense, "a plaintive melody," in the 16th century. Although this is no longer found in modern times, readers may occasionally encounter it in Shakespeare. In *Romeo and Juliet* (Act 4, Scene 5), Juliet has deliberately taken a potion causing her to fall into a deep deathlike sleep as part of an elaborate plan to escape from Verona with Romeo. Her family believes her dead, and the minstrels entertaining the Capulet household fall silent. After this moving scene, Shakespeare provides a little comic relief through the character of Peter, one of Juliet's servants. He engages in clownish wordplay with the musicians and makes a peculiar and paradoxical request, a happy dump to brighten the somber scene that has just occurred.

> PETER: *O, musicians, because my heart itself plays "My heart is full." O, play me some merry dump to comfort me.*
> FIRST MUSICIAN: *Not a dump we, 'tis no time to play now.*

dynamite The Nobel Prizes, which honor not only the greatest authors and scientists but also the most outstanding advocates of world peace, were established by the Swedish chemist and industrialist Alfred Nobel (1833–1896) with funds from his immense personal fortune, amassed in part through the manufacture of explosives and military armaments. Nobel was the inventor of dynamite—he had discovered that the highly explosive chemical compound nitroglycerine could be made easier to transport and handle if it was mixed with an inert substance. In naming his mixture, Nobel also invented the word *dynamite* itself. Coined in Swedish in the form *dynamit*, the word was compounded from Greek *dunamis*, "power," and the Swedish suffix –*it*, which corre-

sponds to the English suffix *–ite*. Greek *dunamis* also gave us words such as *dynamic* and *dynamo*. *Dunamis* is related to the verb *dunasthai*, "to be able," from which comes English *dynasty*, denoting a family or group that wields power over several generations. The second part of the compound, the suffix *–ite*, ultimately comes from the Greek suffix *–ītēs* used to make nouns and adjectives in that language. In English, the suffix *–ite* is still widely used to form names for commercial products. It is also used to form words in various scientific fields, as in the names of minerals like *calcite* or *anthracite* or in biological terms like *metabolite*.

E

earwig According to a widespread folk tradition, earwigs enter the ears of sleeping people and burrow into their brains, eating a network of tunnels through the head and even leaving their eggs to hatch within the skull. In fact, this belief is completely false. Although very, very occasionally an earwig, being a creature that prefers moist dark places, may find its way into the human ear, it will not eat through the eardrum. In general, earwigs eat a variety of plants, insects, and decaying organic matter, but the folk belief in the deadly earwig is very old and has remained persistent. An Old English text of around AD 1000 even includes a remedy *wiþ éarwicgan*, "against earwigs," involving the use of a particular kind of straw held against the ear. The Modern English word *earwig* itself descends from Old English *éarwicga*, a compound of *éar*, "ear," and *wicga*, a word denoting some kind of insect, and this compound obviously reflects the folk tradition about the earwig's horrific habits. The second member of the compound, *wicga*, is no doubt a member of the same family of words that includes the Modern English verbs *wiggle* (thought to be a borrowing of Middle Low German *wiggelen*) and *wag* (from Middle English *waggen*). This group of terms denotes quick movements of various sorts, and the prehistoric ancestor of the Old English word *wicga* probably meant something like "creature that moves quickly."

In many countries around Europe, the word for "earwig" reflects the same mistaken belief found in English-speaking countries. In French, the insect is called *perce-oreille* ("ear-piercer"); in German, *Ohrwurm* ("ear-worm"); and in Russian, *ukhovërtka* ("ear-turner"). The earwig's evil reputation has perhaps been bol-

stered by the sinister look of the two pincers (called *cerci*) at the end of its abdomen. These are used to deliver a defensive pinch and also to hold prey, among other purposes. In other languages around the world, the earwig gets its name from the resemblance of these cerci to a pair of scissors. In Spanish, the insect is sometimes called *cortapicos*, a word derived from *cortar*, "to cut," and *pico*, "nib, pick, beak," and is also known as a *tijereta*, which recalls the word *tijeras*, "scissors." In Italian, the earwig is called *forbicina*, "little scissors," while in Japanese it is called *hasami-mushi*—literally, "scissors-bug." *Forficula auricularia*, the scientific name of the common European earwig now widespread in North America, combines these two notions of the earwig—in Latin, it means "little scissors of the ear."

earwig

ecru French has given English a good number of words for making fine distinctions between different colors, a phenomenon that reaffirms French as the international language of fashion. *Ecru*, applied to light grayish-yellow hues like the color of unbleached linen or silk, is just one of these color words of French origin. *Ecru* first begins to appear in English in the 19th century and is a borrowing of French *écru*. The French word means "raw, untreated" in general and "unbleached" when used of fabric in particular.

The French word itself descends from Old French *escru*, a compound of *es–*, a prefix meaning "very," and *cru*, meaning "raw." *Cru* in turn comes from Latin *crūdus*, which is also the direct source of English *crude*, "unrefined." Latin *crūdus* is a derivative of the Indo-European root **kreuə–*, "raw flesh," and the same root also gives us the English word *raw* itself. In Proto-Indo-European, the root **kreuə–* was used to make an adjective **krowəo–*, meaning something like "raw." On the way to the modern Germanic languages from Proto-Indo-European, the initial *k* in this word became *h* by the effect of GRIMM'S LAW, and **krowəo–* thus became Germanic **hrawaz* and eventually Old English *hrēaw*, "raw." Already by the year 1000, speakers of Old English were "dropping their *h*'s" in

words beginning with *hr*– like *hrēaw*, and the word *raw* begins to take on its modern shape in the Middle English period.

erudite In our culture, the processes of learning, education, and the acquisition of social skills are often described using expressions like *honing one's abilities* and *taking the rough edges off*. Personal manners as well can be described as *polished*, and they can be cultivated at a *finishing school*. In these expressions, the uneducated person is likened to an unfinished artisanal work or a raw material to be improved or refined through the process of education. Similar metaphors also influenced the history of two English words of Latin origin, *erudite* and *rude*. *Erudite* comes from the Latin adjective *ērudītus*, "well-instructed, learned," from the past participle of the verb *ērudīre*, "to educate, train." The verb is in turn formed from the prefix *ex*–, "out, out of," and the adjective *rudis*. *Rudis* meant basically "unformed," "unused," "rough," and "raw," and thus by extension the word was used to mean "untaught" and "untrained," as well. *Rudis* is also the source of our word *rude*, which is first attested in the English language around the middle of the 14th century.

The English word *erudite* is first recorded in a work possibly written before 1425 with the senses "instructed, learned." The *Oxford English Dictionary* notes that *erudite* meaning "learned" seems to have become rare except in sarcastic use during the latter part of the 19th century, but the word now seems to have been somewhat restored to favor.

eunuch

> *Critics are like eunuchs in a harem: They know how it's done, they've seen it done every day, but they're unable to do it themselves.*
>
> —Brendan Behan

Since modern readers usually encounter the word *eunuch* in accounts of ancient history, they may wonder whether it is derived from a word meaning "castrated male" in some language

of the ancient world. In origin, however, the word makes no direct reference to the process of castration. *Eunuch* goes back to the Greek word *eunoukhos*, "a castrated male employed to take charge of the women in the women's quarters and to act as chamberlain," and the Greek word is derived from *eunē*, "bed," and *ekhein*, "to hold, to keep." In order to avoid suspicion about the parentage of their children, upper-class men in various ancient societies would post eunuchs to guard and serve in the bedchambers of the women of the household. Since eunuchs serving in the palace or in the houses of powerful men were privy to the personal lives of ruling families, some of them rose to positions of great power and amassed enormous private fortunes.

Although the term *eunuch* is sometimes used in modern times as a term of opprobrium for an ineffectual or powerless man, history records the exploits of many capable and strong-willed eunuchs serving in ancient courts. The eunuch Bagoas made and unmade kings in the last days of the Achaemenid Empire, which ruled the ancient Near East from Egypt to Iran before it fell to Alexander the Great. The Egyptian eunuch courtier Ganymedes showed himself an able military commander when organizing the resistance to Julius Caesar during the Roman conquerer's campaigns in Egypt.

exorcise An oath is to be found at the etymological heart of *exorcise*, a term going back to the Greek word *exorkizein*, meaning "to swear in, take an oath by, conjure" and "exorcise." *Exorkizein* in turn is formed from the prefix *ex–*, "thoroughly," and the verb *horkizein*, "to make one swear, administer an oath to," derived from *horkos*, "oath." The notion of binding by an oath probably provides the link between the legal and the supernatural senses of the Greek word—by means of a magical verbal formula, the ancient exorcist could bind spiritual or demonic forces to his will. The English word *exorcise* is first recorded in a work composed possibly before the beginning of the 15th century, and in this use *exorcise* means "to call up or conjure spirits" rather than "to drive out spirits," a sense first recorded in 1546.

The word *conjure* provides a fascinating parallel to the development of the word *exorcise,* although the starting point in this instance is Latin rather than Greek. *Conjure,* from Middle English *conjuren,* is a borrowing of Old French *conjurer,* "to use a spell." The Old French verb developed from Late Latin *coniūrāre,* "to entreat by invoking the name of God or something holy." The earlier meaning of *coniūrāre* in Classical Latin was "to swear together," and the verb is a compound of *com–,* "together," and *iūrāre,* "to swear." *Iūrāre* is in turn derived from the Latin noun *iūs,* an important word in Roman culture, meaning basically "that which is binding or obligatory" and including such notions as "justice," "law," "duty," and "legal right."

F

faubourg The close political ties between Scotland and France during the 15th through 17th centuries were reflected in linguistic borrowing from French to Scots, as in the case of *faubourg*, a synonym for *suburb*. In England *faubourg* seems to have lost the competition with the more popular *suburb*. However, in contemporary American English the word still exists, although it is virtually confined to the city of New Orleans, where *faubourg* remains in use because of the city's French background. Even there it is used not as a common noun like *suburb* but in combination with the names of various quarters of the city, for example, *Faubourg Sainte Marie*. These city districts, like their counterparts in Paris, such as *Faubourg Saint-Germain* and *Faubourg Saint-Antoine* originally lay outside the city limits, hence the designation *faubourg*. *Faubourg* descends from Old French *faubourg*, an alteration of *forsborc*, which is a compound of the words *fors*, "outside," and *borc*, "town." *Borc* in turn comes from Late Latin *burgus*, "fort," a word of Germanic origin; *borc* is thus akin to English words like *borough*. The alternation of *forsborc* to *faubourg* reflects the influence of the Old French adjective *faux*, "false," since faubourgs, in a sense, are not quite the city. As the population grew outward, these former suburbs became part of the city proper.

More words characteristic of daily life in New Orleans or otherwise of southern Louisianan origin are discussed elsewhere in this book at the entries for *beignet, krewe, lagniappe,* and *picayune.*

fiction To most people "the latest fiction" means the latest novels or stories rather than the most recently invented pretense or the latest lie. However, both senses of the word *fiction* point back to its source, Latin *fictiō*, "the action of shaping, a feigning, that which is feigned." *Fictiō* in turn was derived from *fingere*, "to make by shaping, feign, make up or invent a story or excuse." Our first instance of *fiction*, recorded in a work composed around 1412, was used in the sense "invention of the mind, that which is imaginatively invented." It is not a far step from this meaning to the sense "imaginative literature," first recorded in 1599.

The Latin verb *fingere* is derived from the Indo-European root **dheigh–*, "to form, to build." On the way from Proto-Indo-European to Modern English, **dheigh–* also served as the source of the Old English word *dāg*, which developed into the Modern English word *dough*. Dough, of course, is something that is kneaded and shaped into a loaf.

Although the etymological relationship between *fiction* and *dough* may seem unlikely at first, other correspondences between Latin words beginning with *f* and English words beginning with *d* can easily be found. Latin *facere* "to do, to make," the source of English words like *fact*, is related to the native English words *do* and *deed*. These words come from the Indo-European root **dhē*, "to set, put, establish." The English word *door* is related to the Latin word *forās*, "out of doors, outside," ultimately the source of the English word *foreign*. A Roman *forum* as well was originally an outdoor market held in an enclosed courtyard. *Forum* and *door* come from the Proto-Indo-European word **dhwer–*, "doorway." The Latin word for "smoke," *fūmus*, source of English *fume*, and the native English word *dust* are both derived from the Indo-European root **dheu–*, "to rise in a cloud." As can be seen from these examples, a Proto-Indo-European *dh* regularly became an *f* at the beginning of a word in Latin, while it became a simple *d* in English.

fixin' to *Fixin' to* ranks with *y'all* as one of the best known markers of Southern dialects, although it occasionally appears in the informal speech and writing of non-Southerners as well. *Fixin' to*

means "on the verge of or in preparation for (doing a given thing)." It often follows a form of the verb *to be,* and it consists of the present participle of the verb *fix* followed by the infinitive marker *to: They were fixin' to leave without me.* Although locutions like *is fixin' to* can be used somewhat like the auxiliary verb *will* in sentences that describe future events, *fixin' to* can refer only to events that immediately follow the speaker's point of reference. One cannot say, *We're fixin' to have a baby in a couple of years.* The use of *fixin' to* as an immediate or proximate future is very common in African American Vernacular English, and is one of many features that this variety of English shares with Southern dialects. Although this expression sometimes appears in writing as *fixing to,* in speech it is usually pronounced *fixin' to.*

The American regionalism *fixin' to* developed from the earlier use of the expressions *fix to* and *fix for* with the meaning "to get ready, prepare." *Fix to* and *fix for* could once be used in a full range of tenses, not just in the progressive tenses like *is fixing to* and *was fixing to.* The *Oxford English Dictionary* cites an early example of this usage in a text dating from 1716: *He fixes for another Expedition.* The use of *fix to* and *fix for* in this way is now confined to regional English and sounds somewhat archaic when used in Standard English. The *Dictionary of American Regional English* records several examples of the use of *fix to* and *fix to,* "to get ready, prepare," from the middle of the 20th century in Tennessee and Kentucky: *Go long home to your pap now and fix for going to the school house.* Speakers of Appalachian English continue to use the expression *fix to* in this meaning today, in the 21st century.

flak The word *flak* caught on in English during World War II. The German word for "anti-aircraft gun" is *Flugabwehrkanone*—literally "flight (*Flug*) defense (*Abwehr*) gun (*Kanone*)"—and this compound was abbreviated to *Flak* in German as Germany developed more sophisticated anti-aircraft guns between World War I and II. Slightly before the outbreak of World War II, the abbreviation appears in English as part of the descriptions of German war-

ships equipped with anti-aircraft artillery. Although *flak* original-ly referred to the guns themselves, rather than to the shrapnel-filled explosive shells that they fired, Allied airmen in World War II soon began to use the abbreviation to describe the hostile anti-aircraft fire they encountered from German artillery. (*Flak* may have caught on quickly because it rhymes with *ack-ack*, British military slang for "anti-aircraft fire" during World Wars I and II. *Ack-ack* comes from the abbreviation *AA* of *anti-aircraft*, with the letter *a* rendered as *ack* in the British system used to pronounce individual letters when sending military messages.) In the 1944 volume of the journal *American Speech*, Robert Trout, a well-known American journalist for CBS during World War II, wrote that some airmen were careful to make a distinction between the two slang terms—*flak* for German fire, and *ack-ack* for Allied fire. The military use of the word as a term for anti-aircraft fire and explosive shrapnel-filled shells continued even after 1945, and the informal metaphorical use of *flak* to mean "a barrage of adverse criticism" begins to appear in the 1960s.

food The sharing of food is an ancient and universally recognized gesture of hospitality and companionship, and so it is fitting that *food* and *companion* spring from the same prehistoric root. *Food* comes from Old English *fōd*, which is in turn made from the Indo-European root *pā–*, "feed, nourish, protect." (By the working of GRIMM'S LAW the *p* in this root became *f* in the history of English.) When we consider that the Proto-Indo-Europeans lived in a traditional society where most of the population was directly engaged in agriculture and cattle-raising, it is easy to see how the notions of feeding and protecting would be intimately linked. Herds of cattle must be fed and kept safe from predators, and car-ing for family members and guests entails providing them with food and protection from danger.

The root expressing this fundamental notion, **pā–*, is also the source of many other native English words, such as *fodder, foster,* and *feed.* Old English *fēdan* comes from a Germanic verb **fōd-jan*, "to give food too," made from the noun **fōd–* by the addition

of a suffix. The *j* in the suffix caused the vowel *ō* in **fōdjan* to become *ē* on the way to Old English, and thus the resemblance in sound between *food* and *feed* is ancient.

In Latin, a cousin of English in the Indo-European family of languages, the same root **pā–* "protect, feed" shows up in *pāstor,* "herdsman, shepherd," source of the English word *pastor,* and in *pānis,* the Latin word for the fundamental food for European societies since ancient times—bread. Latin *pānis* is the ultimate source of almost a dozen English words that have entered English by way of one language or another. English *pantry,* for example, comes from Old French *paneterie,* "pantry, closet where bread is stored," ultimately derived from *pānis.* English *companion* is a borrowing of Old French *compaignon,* from Vulgar Latin **compāniō,* which is a compound of Latin *com–,* "with," and *pānis.* A companion is etymologically "one who breaks bread with another" or a "mess-mate." English *company,* with its senses like "fellowship," "houseguest," "business organization," and "theatrical troupe," is ultimately a derivative of Vulgar Latin **compāniō* too.

foot In various regions of the United States, including New England and the South, words that denote measurements are sometimes not put into the plural when they follow a numeral directly. Constructions such as *three foot* and *five mile* are used in place of the Standard English constructions *three feet* and *five miles* in certain contexts. These singular constructions are found not only with measures of distance, but also with measures of time, as in *He was gone three year,* and with measures of weight and other quantities. Interestingly, such constructions are used only if a specific numeral (other than *one*) precedes the noun. Thus, *She gave me four gallon of cider* can be heard in vernacular speech; however, no one would say *She gave me gallon of cider* for *She gave me gallons of cider.*

Although this use of singular nouns for the plural is generally frowned upon in written Standard English, it nevertheless has an ancient pedigree. Nouns denoting measurements were used in this way by many Middle English authors, including Chaucer—

we find the construction in the following lines from the Knight's Tale in *The Canterbury Tales*:

Up spryngen speres twenty foot on highte;
Out goon the swerdes as the silver brighte.

Up spring lances twenty feet in height;
Out go the swords bright as silver.

The apparently singular form used for the plural in such constructions is the modern descendant of an Old English grammatical form called the GENITIVE plural. The Modern English word *foot* descends from the Old English word *fōt,* "foot." When the plural of the word *fōt* functioned as the subject or the direct object of the verb in a sentence, it had the form *fēt,* which is the ancestor of Modern English *feet.* But when the plural of the word *fōt* was used in constructions specifying a measurement, it took the genitive plural form *fōta,* as in *nigon fōta,* "nine feet." (The genitive plural was also used to express possession, as in this Old English translation of a phrase from the biblical book of Psalms: *fōtsceamol his fōta,* "the footstool of his feet.") The Old English genitive plural *fōta* would naturally develop into Modern English *foot,* and thus, from the historical point of view at least, the *foot* in phrases like *nine foot down* is a plural rather than a singular. The other nouns of measurement that have a singular form after a number in Modern English have either followed a development similar to *foot* or were influenced by *foot* and nouns like it.

fraction Our word *fraction* did not originally have a mathematical sense. It goes back ultimately to the Latin verb *frangere,* "to break." From the stem of the past participle *frāctus* is derived Late Latin *frāctiō* (stem *frāctiōn–*), "a breaking" or "a breaking in pieces," as in the breaking of the Eucharistic Host. It was in Medieval Latin that the word *frāctiō* developed its mathematical sense. The earliest recorded sense of our word is "a part of a unit, a subdivision," found in a work by Chaucer written about 1400. One of the next recorded instances of the word recalls its origins,

referring to the "brekying or fraccioun" of a bone. In this sense, the word has been replaced by *fracture,* from Latin *fractūra,* "a breach, a cleft," another derivative of *frangere.*

The Latin verb *frangere* and the English verb *break* are distant cousins—they both come from the Proto-Indo-European **bhreg–,* which meant, quite naturally, "to break." In the development of the Latin language from Proto-Indo-European, *bh* regularly became *f* at the beginning of a word, while *bh* regularly became *b* in the development of English from Proto-Indo-European. The same correspondence is illustrated by the Latin word *frāter,* "brother" (source of English words like *fraternal* and *fraternity*), and the English word *brother* itself, both from Proto-Indo-European **bhrāter–,* "brother."

frog　From an etymological point of view, a *frog* is a "hopper." This etymology is suggested by a variety of words found in the other Indo-European languages, such as Sanskrit *právate,* "he hops," and Russian *pryt',* "speed." Through comparison of these cognate words, linguists have postulated the existence of a prehistoric Indo-European root **preu–,* "to hop." In the Germanic languages, the initial *p* of the root becomes *f* by Grimm's Law just as the *p* in the Proto-Indo-European word **pətēr,* "father," also seen in Latin *pater,* becomes the *f* in English *father.* The word for "frog" in most of the Germanic languages, such as German *Frosche* and Norwegian *frosk,* is thus derived from this root **preu–.* The Old English *froxa,* "frog," can be compared with the German word directly, and the descendant of *froxa* survived as *frosk* in some English dialects up to the 19th century.

The usual Modern English word, *frog,* descends from another Old English word, *frogga,* also ultimately derived from the root **preu–,* "hop." The origin of the *g* sound at the end of *frog* is obscure, but the same *g* can be found in the English names of many other animals, such as *dog, hog, pig,* and *stag. Docga,* the Old English ancestor of *dog,* is attested only once in Old English texts, although it later replaces the general Old English word for "dog," *hund,* which survives as modern *hound,* the name for a

particular group of breeds. Middle English *hogge, pigge,* and *stagge* also appear relatively late in the history of English, when we consider the fact that these words belong to the basic, everyday vocabulary of a traditional agricultural society like that of medieval Europe. Perhaps an original core group of Old English animal names ending in *–gga* exerted influence on other terms for animals, and these were then altered or reformed on the model of the original group. For the most part, the further origin of all these words remains uncertain.

The root **preu–,* "hop," has given us two other words in English, *frolic* and *schadenfreude,* although both are borrowings from other Germanic languages. The notion associating leaping with feelings of gaiety or satisfaction is nearly a cultural universal—consider the expression *jumping for joy*—and it seems that the early Germanic peoples too got *hopping happy,* rather than *hopping mad.* The word *frolic,* now both a verb and a noun, was originally an adjective when it first appeared in English in the 16th century. Readers can still encounter this adjectival use in some of the great literary works of the past, as in this line from John Milton's poem *L'Allegro: The frolic wind that breathes the spring. Frolic* is in fact from Dutch *vrolijk,* "merry," which is in turn a derivative of Dutch *vro,* "happy." The sound spelled *v* in *vro* comes from an earlier Proto-Germanic **f* and therefore ultimately from a Proto-Indo-European *p.* Dutch *vro* is thus the descendant of a Proto-Indo-European form **prowo–* derived from **preu–,* "to hop," and originally meaning something like "leaping," and by extension, "leaping for joy."

Proto-Germanic also had a noun derived from **preu–* as well, **frewida,* and in German, this noun developed into *Freude,* "joy." *Freude* can be found in English as the second element in the word *schadenfreude,* "pleasure derived from the misfortunes of others." The original German source of this term, *Schadenfreude,* is a compound of *Freude* with another noun *Schaden,* meaning "harm" or "damage." *Schaden* itself is related to English *scathe,* as in *scathing comment* or *unscathed.*

frosting Although both *frosting* and *icing* are widespread, people in New England, the Upper Midwest, and the Western US tend to put *frosting* on cake. In Pennsylvania, New Jersey, the Lower Midwest, and all of the South, the preferred term is *icing*. There is some overlap, especially in upstate New York, Michigan, and California, but the regions in which the two words predominate are surprisingly distinct. A few people in the South call it by a third name, *filling*, even when it goes on top.

frying pan The terms *frying pan* and *skillet* are now virtually interchangeable, but there was a time when they were so regional as to be distinct dialect markers. *Frying pan* and the shortened version *fry pan* were once New England terms; *frying pan* is now in general use, as is the less common *fry pan*, now heard in the Atlantic states, the South, and the West, as well as New England. *Skillet* seems to have been confined to the Midland section of the country, including the Upper South. Its use is still concentrated there, but it is no longer used in that area alone, probably because of the national marketing of skillet dinner mixes.

Another term for "frying pan," *spider*, spread from New England westward to the Upper Northern states and down the coast to the South Atlantic states. It is still well known in both these regions, although it is now considered old-fashioned. The term originally denoted a type of frying pan that had long legs to hold it up over the coals, and its shape thus resembled that of a spider standing on its spindly limbs.

gerrymander A gerrymander is a voting district whose boundaries are settled merely to give unfair advantage to one party in elections. Such districts often show flagrant disregard for considerations that might be considered more important in dividing a region into voting districts—simple geographic continuity, for instance, or the balanced representation of the diversity of the constituency. The strange political beast now called the gerrymander was named by combining the word *salamander* with the last name of Elbridge Gerry (1744–1814), vice president of the United States (1813–1814) and governor of Massachusetts (1801 and 1810–1812). Gerry's name, incidentally, was pronounced with a hard (g) sound, even though *gerrymander*, the word which has immortalized him, is now commonly pronounced with a soft (j) sound as in *Jerry*.

gerrymander
*from the March 26, 1812 edition
of the* Boston Gazette

In 1812, as governor of Massachusetts, Gerry signed a bill authorizing the revision of voting districts in his state. Members of Gerry's party redrew them in order to secure their representation in the state senate, and out of Gerry's home county, Essex County, they carved an unlikely-looking district with the shape of a salamander. According to one version of the coining of *gerry-*

mander, the shape of the district attracted the eye of the painter Gilbert Stuart, who noticed it on a map in a newspaper editor's office. Stuart decorated the outline of the district with a head, wings, and claws and then said to the editor, "That will do for a salamander!" "Gerrymander!" came the reply. The image created by Stuart first appeared in the March 26, 1812, edition of the *Boston Gazette,* where it was accompanied by the following title: *The Gerrymander. A New Species of Monster, which appeared in the Essex South District in Jan. 1812.* The new word *gerrymander* caught on instantly—within the same year *gerrymander* is also recorded as a verb. Gerry ran for reelection in 1812, and popular outrage directed at the flagrant use of the technique we now call the *gerrymandering* doubtless played a role in his defeat.

ginkgo The ginkgo tree is famous for having seen the dinosaurs rise and fall—species of trees closely related to the modern ginkgo are recognizable in fossils dating from 270 million years ago. The ginkgo was common in prehistoric forests until comparatively recently, but for unknown reasons its numbers began to decline a few million years ago. It is now almost extinct in the wild, apart from a few isolated stands in China.

ginkgo
Ginkgo biloba

Nevertheless, the tree still flourishes in cultivation—especially in East Asia, where it is widely planted for its vivid yellow fall foliage and for the nuts that it produces. Since the ginkgo survived the great wave of extinctions in which the dinosaurs perished 65 million years ago, it is not surprising that it can also thrive even under the harsh conditions of the modern city street, and male ginkgos now adorn the avenues of many large American metropolises. Female ginkgo trees are not planted as often as their male counterparts, since they drop an abundance of seeds with a mushy, foul-smelling outer covering. Underneath this outer cov-

ering is a smooth, pale-colored shell like a large pistachio shell, and within this shell is an edible seed. Gingko nuts, as these seeds are called, are relished in China, Japan, and Korea, where they are prepared in a variety of ways.

The odd spelling of the word *ginkgo*, which hardly indicates the usual pronunciation (**ging′**ko) very well, is thought to result from a botanist's error. In Japanese, the name of the ginkgo tree is written with Chinese characters that can be read as *ginkyō*. These characters mean "silver (*gin*) apricot (*kyō*)" and probably make reference to the pale green fruit containing a hard inner seed covering like an apricot pit. In Modern Japanese, it should be noted, *ginkyō* is not the usual name for the ginkgo. The nuts are usually called *ginnan*, while the tree itself is called *ichō*. These words are nevertheless written with the same Chinese characters meaning "silver apricot."

The first Western scientist to learn of the existence of the ginkgo tree was Engelbert Kaempfer (1651–1716), a German physician and naturalist who visited Japan in 1691 and brought some seeds of the ginkgo back to Europe upon his return. Kaempfer wrote a five-volume work about Asian botany, and many species of plants are now named in his honor, such as the ornamental azalea commonly seen in American gardens, *Rhododendron kaempferi*. It is said, however, that Kaempfer had bad handwriting, and at some point, his transcription of the Japanese characters, *ginkyō*, was misread as *ginkgo*. The great Swedish botanist Carl von Linné perpetuated the error when assigning the tree the scientific name *Ginkgo biloba*, and the spelling has been fixed ever since.

gnome *Gnome* would seem at first to be a very old word. Nowadays it usually refers to a being like an elf or a brownie, one of the spirits of the natural world that were honored and respected in Europe before the introduction of Christianity and that retired to their fairy-mounds after the triumph of the new religion. But *gnome* is in fact a recent coinage—it dates from the very dawn of the modern tradition of scientific enquiry in the 16th century, when the supernatural and the natural were still intimately

entwined in the minds of early scientists. Astrology was not yet fully distinguished from astronomy, and alchemy and chemistry amounted to the same science.

Perhaps the most celebrated of the early alchemist-chemists was Theophrastus Bombastus von Hohenheim (1493–1541), a German-Swiss polymath usually known as Paracelsus. Well-known in his day as a physician, Paracelsus held that illness was the result of external agents attacking the body rather than imbalances within the body and advocated the use of chemicals against disease-causing agents. He advocated allowing wounds to drain and heal naturally rather than cauterizing them with boiling oil. These opinions were quite unorthodox in their time, however obvious they may seem to us now. Nevertheless, Paracelsus had other ideas that might be considered more than a little eccentric, and perhaps even downright crazy, in modern times. He wrote a widely read treatise elaborating his ideas about the various supernatural beings that inhabit the elements air, water, earth, and fire called *sylphs, nymphs, gnomes,* and *salamanders,* respectively, to use the English forms of the names that Paracelsus gave to them. Paracelsus's treatise was widely read and served to popularize these words in English. The word *sylph,* for example, is still used today in meaning "a slim, graceful woman or girl," and Paracelsus perhaps invented the term himself by blending elements ultimately derived from Latin *silva* "woodland" and *nympha* "water or woodland spirit."

In Paracelsus's system, the *gnomes* are beings who could move as easily through the earth as human beings move through the air above ground. It is sometimes stated that when Paracelsus coined this word, he was thinking of Greek words beginning with *gnō–* that express the concept of knowledge, such as *gnōmōn,* "interpreter." The *Oxford English Dictionary,* however, suggests that the word is actually an alteration of a hypothetical Greek word of Paracelsus's own invention, **gēnomos,* meaning "dwelling in the earth," derived from the Greek words *gē,* "earth," and *nomos,* "habitation." Paracelsus also used the Latin word *pygmæus,* "dwarf," to refer to his gnomes, and in certain respects they

resemble the diminutive beings of German folklore called *Kobolden*, who know the location of the treasures of the earth and play tricks on miners.

From its beginnings in the occult philosophy of Paracelsus, *gnome* has spread to popular folklore and taken its place beside other words like *elf* and *goblin*. Although the exact elements out of which Paracelsus compounded the word *gnome* remain uncertain, the term has proved to be an enduring testimony to the curious mind of its creator—an alchemist with words as well as metals.

goober Most Southerners recognize the terms *goober* and *goober pea* as other names for the peanut. *Goober* originates among the BANTU languages and is akin to the word meaning "peanut" in the Kongo and Kimbundu languages, *n-guba*. This regionalism is one of a small stock of words that entered American English from the languages spoken by the Africans who were enslaved and brought to the Americas during the 17th and 18th centuries. Many of these words have to do with foods. *Gumbo*, for example, is also of Bantu origin—it is related to such words as Tshiluba *ki-ngumbo*, "okra." (In some regional dialects of the South, *gumbo* can still mean simply "okra" in addition to "thick okra stew.") *Yam* originates among the languages of West Africa, and it may be akin to Wolof *ñam*, meaning "food" and "to eat" or to Bambara *ñambu*, "manioc." The English word *cooter* is related to the Mandingo word *kuta* and the Tshiluba word *nkudu*, both meaning "turtle." *Cooter* is still used in South Carolina, Georgia, and the Gulf states to denote edible freshwater turtles of the genus *Chrysemys* and, by extension, other turtles and tortoises.

grass widow The term *grass widow* cries out for explanation of what *grass* means and how *grass widow* came to have its varied though related senses. *Grass* probably refers to a bed of grass or hay as opposed to a real bed. This association helps explain the earliest recorded sense of *grass widow* (1528), "an unmarried woman who has lived with one or more men," as well as the related senses "an abandoned mistress" and "a woman who has had a

child out of wedlock." Later on, after the sense of *grass* in *grass widow* had been obscured, people may have interpreted *grass* as equivalent to the figurative use of *pasture*, as in *out to pasture*. Hence *grass widow* developed the senses "a woman who is divorced or separated from her husband," and "a wife whose husband is temporarily absent."

greasy One of the most notable regional distinctions in the United States is the "greasy-greazy" line. It is famous among scholars of American dialects for marking a clear division between major American dialect regions. In the North and West, *greasy* is pronounced with an (s) sound; in the Midland dialect region and the South, it is pronounced with a (z). According to the *Dictionary of American Regional English*, the "greazy" region extends from the Deep South to southern parts of New Jersey, Pennsylvania, Ohio, Indiana, and Illinois and all of Missouri, Texas, and New Mexico. The verb *grease* also follows this pattern, although not the noun *grease*, which is pronounced with an (s) sound everywhere. A few Southerners also use (z) in *blouse*. The (z) pronunciation is so stable and so characteristic of Southern dialects that dialect scholars use it to trace the migration of Southern speakers into other dialect areas, such as Colorado, Oregon, and California.

Greenland How did a glacier-covered island get the name *Greenland*? In Icelandic sagas written in the 12th century and later, it is told that Eric the Red (or in Icelandic, Eiríkr rauði) explored the southeast and southwest coasts of Greenland in AD 983–986. He thought his fellow Icelanders would be more likely to go there if it had an attractive name, and he therefore called it *Grænland*, Icelandic for "Greenland." This was not exactly a case of false advertising. Greenland was warmer in the 10th century than it is now. There were many islands teeming with birds off its western coast, the sea was excellent for fishing, and the coast of Greenland itself had many fjords where anchorage was good. Moreover, at the head of the fjords there were enormous meadows full of grass, willows, junipers, birch, and wild berries. Thus

Greenland actually deserved its name, and the Icelanders set up colonies in Greenland that thrived for much of the next three hundred years. In the middle of the 14th century, however, the North Atlantic area began to cool significantly. The colonies began to die out, and they finally disappeared at the very beginning of the 15th century. Only the Inuit continued to live on the island as the climate grew progressively colder and the formerly green valleys of Greenland were covered by ice.

groom A bride would stand beside her *gome* at their wedding, were it not for a small misinterpretation. The Old English ancestor of *bridegroom* was *brýdguma*, a compound of *brýd*, "bride," and *guma*, a common Old English word for "man." Old English *guma* developed into Middle English *gome*, which remained a perfectly usual and frequent word during the Middle English period, but by the early 1500s *gome* had died out completely as a separate word in Early Modern English. It is usually thought, however, that before *gome* entirely disappeared from English, it was replaced by the similar-sounding term *groom* in the compound *bridegome*.

Modern English *groom*, referring to a person who takes care of horses, descends from Middle English *grome*, a word whose ultimate origins are unknown. *Grome* first appears in the early 1200s, when it has the meaning "boy." By around 1300, its meaning had been extended to "young man." *Grome* was also frequently used with the meanings "male servant" and "man of low birth," but it was only in the 1600s that its descendant in Early Modern English, *groom*, began to refer specifically to a servant taking care of horses. The verb *groom*, "to make neat and trim," or "to clean and brush," is derived from the noun *groom* and developed even later, in the 1800s. At the time when *groom* was probably substituted for *gome*, "man," in the compound *bridegome*, however, the sense of *groom* was still primarily "man" or "male servant," and not "one who cares for horses."

The Old English word *guma*, "man," itself has an unexpected origin. Speaking from an etymological point of view, *guma* originally meant "earthling." We normally think of *earthling* as a word

useful for distinguishing humans from invading Martians or other extraterrestrials in modern science fiction, but words meaning "earthling" have been around for millennia. In the early Indo-European languages, words for "earthling" were used to distinguish humans from gods—celestial beings of a different sort. The Proto-Indo-European noun meaning "earth," *dhghem–, furnished the base for a number of words with the meaning "human being" in the Indo-European languages. From this noun dhghem–, a derivative *dhgh(e)mōn, meaning "one that is on the earth, earthling (as opposed to a god), human being," could be formed in Proto-Indo-European. In Latin, the complex initial cluster *dhgh of this word *dhgh(e)mōn was simplified to h, and *dhgh(e)mōn eventually became Latin homō, "man, human being." This word is familiar to English speakers from the scientific name of the human species, Homo sapiens, literally meaning "wise man." Latin homō and its stem homin– can also be found in several other English words, such as homicide and hominid. Another Proto-Indo-European form meaning "earthling" (and closely related to *dhgh(e)mōn) was *dhghm̥-ōn. On the way from Proto-Indo-European to Old English, the complex cluster *dhgh in this word was simplified into g, and *dhghm̥-ōn thus developed into the Old English word guma, "man," surviving today in altered form as the second element of bridegroom.

gum If we pause to consider that the word gum meaning "tissue around the teeth" and the word gum meaning "sticky or elastic substance" are both connected to the notion of chewing, we might at first suspect the two words to be related in some way. Is gum literally something that we gum? From the etymological point of view, however, the two words are completely separate.

Gum meaning "connective tissue around the teeth and jawbone" comes from Middle English gome, which in turns comes from Old English gōma, meaning "palate" or "jaw." The word is in fact a direct inheritance from the prehistoric ancestor of English spoken over five thousand years ago, Proto-Indo-European, for Old English gōma is derived from the Indo-European root *ghēu–

meaning "to yawn" or "to gape." The same root is also the source of English *chaos*, a borrowing of the Greek word *khaos*. *Khaos* in Greek originally meant "an expanse of emptiness," and especially "the yawning gap that existed before the birth of the first gods." On the way to Greek, the Proto-Indo-European sound **gh* became *kh*, and the notion of yawning emptiness suggests that Greek *khaos* is thus derived from **ghēu–*. After *khaos* was borrowed into English, the original meaning "unformed primordial state of the universe" was eventually extended to "complete disorder," the sense in which the word is most often used today.

Gum meaning "chewy substance" has an entirely different origin and can in fact be traced back to Egyptian, one of the earliest languages ever to be written down. Our sticky *gum* comes from Old French *gomme*, and the Old French developed from Late Latin *gumma*, a variant of the Classical Latin word *gummi*, which was also found with the spelling *cummi*. The Latin word is in turn a borrowing of Greek *kommi*, which most often designated gum arabic, a viscous edible substance exuded by two species of acacia tree native to the Nile Valley and sub-Saharan Africa. Much of the gum arabic available in the ancient world was exported through Egypt, and the Greek term for the substance comes from Egyptian *ḳmy-t*, "gum" or "resin," a word that entered Greek as part of the lively trade in goods and ideas that the ancient Greeks conducted with Egypt. (The exact pronunciation of the consonant *ḳ* in Egyptian remains unknown. It was perhaps a sound that linguists call an EJECTIVE VELAR stop, or it may have been a *k*-like sound made very deep in the throat, like the Arabic sound usually transcribed as *q* in such words as *Qur'an*.) Gum arabic had a wide variety of uses in the ancient world, and it is still used today as a thickener for soft-drink syrups and as the base of watercolor paints.

gung ho The word *gung ho* has been in English only since 1942—it is one of the many words that entered the language as a result of World War II. It comes from Mandarin Chinese *gōnghé*, "to work together,"—*gōng* means "work," and *hé* means "together." *Gōnghé* was used as a motto by the Chinese Industrial Cooperative

Society (or the *Gōngyèhézuòshè* in Mandarin). Lieutenant Colonel Evans F. Carlson (1896–1947) borrowed the motto as a moniker for meetings in which problems were discussed and worked out; the motto caught on among his Marines (the famous "Carlson's Raiders"), who began calling themselves the "Gung Ho Battalion." From there eager individuals began to be referred to as *gung ho*. Other words and expressions that entered Eng-

gung ho
Colonel Carlson (left) and Major Coyte of the U.S. Second Marine Raider Battalion at the U.S. Navy base on Espiritu Santo

lish during World War II include *gizmo*, *task force*, and *hit the sack*. Another of these words, *flak*, is discussed as a separate entry elsewhere in this book.

gunnysack A large sack made from loosely woven, coarse material goes by a variety of names in regional American English. The most general term is *burlap bag*, known everywhere but used especially in the Northeast. The origin of the word *burlap* is uncertain. The word first appears in the late 17th century, and some have speculated that it derives from a Dutch word like *boerenlap* made up of Dutch *boeren*, "coarse," and *lap*, "piece of cloth." However, such a word is not actually attested in the Dutch language.

In the Midwest and West the usual term is *gunnysack*. The *gunny* in *gunnysack* means "a coarse, heavy fabric made of jute or hemp." This word comes from Hindi, and Hindi descends from the Sanskrit word *goṇī*, "sack."

In the Upper South, the same sack would be called a *tow sack*, and in Eastern North Carolina, a *tow bag*. The word *tow* is another synonym for fabric made from jute or hemp and probably derives from an Old English word for "spinning" found in the Old English term *towcræft*, "skill in spinning."

In South Carolina and adjacent parts of Georgia, it is called a

crocus sack, and in the Gulf states, a *croker sack,* both terms ultimately deriving from the word *crocus,* in this case used to denote saffron, the spice consisting of dried parts of a certain species of crocus flower. According to Craig M. Carver, who draws on the research of Walter S. Avis, "*crocus* is a coarse, loosely woven material once worn by slaves and laborers and common in colonial New England. It probably took its name from the sacks in which crocus or saffron was shipped." Though the term *crocus sack* virtually disappeared from New England by the end of the 19th century, it survives in the South.

gutter Certain household words have proved important as markers for major US dialect boundaries. The channels along the edge of a roof for carrying away rainwater (normally referred to in the plural) are known by various names in American regional dialects. They are called *eaves troughs* or, less commonly, *eaves spouts* in parts of New England and in the Great Lakes states, and *eaves troughs* is also known in the West. They are known as *spouting* or *rainspouts* in eastern Pennsylvania and the Delmarva Peninsula (the peninsula separating Chesapeake Bay from Delaware Bay and the Atlantic Ocean and including all of Delaware and parts of Maryland and Virginia). From Virginia southward, they are called *gutters.* Along the Atlantic coast, the transition points between these words have marked unusually clear boundaries for the three major dialect areas—Northern, Midland, and Southern—traditionally acknowledged by scholars of American dialects. Nowadays, however, Southern *gutters* seems to have become the standard US term. According to the *Dictionary of American Regional English, gutters* has become well established in northern states along the Atlantic coast from Maine to New Jersey; in Illinois, Indiana, and Missouri; and as far west as California.

The word *gutter* itself comes from Middle English *goter,* which could refer to both the gutters on the house or gutters draining water and waste from a street. The Middle English word comes from Old French *gotier. Gotier* is derived from the Old French noun *gote,* "drop (of liquid)," which in turn is from Latin *gutta.*

gymnasium From an etymological perspective at least, a *gymnasium* is a place for being naked. The relationship between the words *gymnasium* and *naked* may come as a surprise, since nowadays student wrestlers change into uniforms in the locker room before training in the gymnasium of an American high school. Ancient Greek athletes, however, trained in the nude. The English word *gymnasium* is a borrowing of Latin *gymnasium*, which is in turn from Greek *gumnasion*. The Greek *gumnasion* was originally an area where boys and youths trained in the nude at sports such as wrestling, boxing, running, and throwing the discus and javelin. The *gumnasion* came to be a meeting place for philosophers as well, and at last a general educational institution. Greek *gumnasion* is derived from *gumnazein*, "to exercise naked," which is in turn from the adjective *gumnos*, "naked."

The source of Greek *gumnos* is the Indo-European root *nogʷ–*, "naked," from which speakers of the early Indo-European languages made several adjectives by the addition of different suffixes. The suffixed form *nogʷmo–* can be seen in the Greek word *gumnos,*where the consonants *gʷ*, *m*, and *n* have switched places by the process called TABOO DEFORMATION (the same process that transforms *God damn it!* to *Goldurnit!* and *Dagnabit!*). Since the Greek word meaning "naked" shows the effects of taboo, apparently some Greeks—or at least their early ancestors—were once ashamed to be seen nude, and certainly mature Athenian women of the upper classes in historical times would never have appeared nude in public.

The English word *nude* is also from the same root *nogʷ–*. *Nude* is a borrowing of Latin *nūdus*, which in turn developed from a pre-Latin suffixed form *nogʷedo–*. And yet another suffixed form of *nogʷ–*, Proto-Indo-European *nogʷeto–* or *nogʷoto–*, is the ancestor of the native English adjective *naked*.

As a curious aside, the leavened flatbread called *naan*, characteristic of Indian cuisine, is also derived from *nogʷ–*. The Hindi word for such bread, *nān*, is from Persian, and the Persian word is ultimately from an unattested Old Persian *nagna–*, meaning "naked, bare." This is in turn from a Proto-Indo-European form

nogʷno–, "naked." Naan is baked uncovered in the oven—that is, naked—or on a griddle, rather than under a layer of hot ashes like many other traditional breads.

hall The *halls of academe* and *city hall* remind us that what we commonly mean by the word *hall*, "a passageway, an entrance room," represents a shrunken version of what *hall* once commonly designated. Going back to the Indo-European root **kel–*, "to cover," the Old English word *heall*, ancestor of our *hall*, referred to a variety of large spaces covered by a roof, whether a royal residence, an official building, a large private residence, or a large room in a residence where the public life of the household was carried on. These senses of the word, as well as other senses related to these, are still in use, as attested by compounds such as *music hall* and *study hall*. Our common use of the term *hall* for a vestibule or a corridor harks back to medieval times when the hall was the main public room of a residence and people lived much less privately than now. As private rooms in houses took on the importance they have today, the hall lost its function. *Hall* also had come to mean any large room, and the vestibule was at one time one of the main sitting rooms in a house, but this sort of room has largely disappeared also, and *hall* has become the designation for the small vestibule of today as well as for an entrance passage or any passageway.

haywire Why should the word for something as functional and mundane as *haywire*—that is, wire for baling hay or straw—have come to be applied to something that is not functioning properly or to a person who is crazy? It would seem to be a story of semantics gone haywire. In fact, it is the practice of makeshift repairs that lies behind this puzzling development. As noted by the *Oxford English*

Dictionary, a bulletin of the United States Bureau of Forestry published in 1905 explains the expression *hay wire outfit* as a contemptuous term for poorly equipped loggers. *Haywire* later begins to be used attributively in other contexts with the general sense "makeshift, inefficient." The extended sense "not functioning properly" is recorded in the late 1920s, and soon after, in the 1930s, *haywire* begins to be applied to people, with the meaning "crazy."

hectic In a survey of writers, scholars, and other distinguished users of English conducted for the 1969 edition of the *American Heritage Dictionary,* 92 percent of those surveyed approved of the use of *hectic* in its most familiar sense, "characterized by feverish activity, confusion, or haste." The question was posed because this sense, which first appeared at the very beginning of the 20th century, had sometimes been deprecated as a loose extension of the term's meaning in medicine, "relating to an undulating fever, such as those accompanying tuberculosis." Nowadays, however, the more recently developed meaning of the word has gained extremely widespread acceptance.

Hectic descends from Middle English *etik,* whose form one would be hard pressed to recognize without some acquaintance with Middle English. *Etik* is first found in a text written before 1398 and the word was used to mean "suffering from hectic fever" and probably "consumptive, infected with tuberculosis" as well. The Middle English term comes from Old French *etique,* and the Old French from the Late Latin word *hecticus.* (Influence from the original Latin word, incidentally, helped restore *h* and *c* in the pronunciation of the English word in the 16th century.) Late Latin *hecticus* comes from Greek *hektikos,* which meant both "formed by habit or forming habit" and "consumptive." *Hektikos,* in turn, is derived from the Greek word *hexis,* "habit." *Hektikos* developed the sense "consumptive" because of the chronic or habitual nature of tuberculous fevers.

helicopter The two Greek words that are the origin of *helicopter* may be particularly hard for English speakers to spot. *Helicopter*

was borrowed from the French word *hélicoptère,* a word constructed from Greek *heliko–* and *pteron,* "wing." *Heliko–,* the combining form of *helix,* "spiral," has given us *helico–,* which can be joined with other words and word forms to create new words. The consonant cluster *pt* in *pteron* begins many Greek words but relatively few English words. English speakers unfamiliar with Greek are thus not likely to recognize the word's elements as *helico–pter;* many analyze the word into the elements *heli–copter,* as is shown by the clipped form *copter.*

Etymology, however, may help English speakers recognize the Greek word *pteron,* "wing," in *helicopter. Pteron* is derived from the Indo-European root **pet–,* "to fly," and this root is also the source of English *feather.* The same correspondence between the *p* and *t* in Greek *pteron* and the *f* and *th* in English *feather* can be seen in many other pairs of Greek and English words, such as Greek *pente,* "five," and English *five,* both from Proto-Indo-European **penkʷe,* or Greek *treis,* "three," and English *three,* both from Proto-Indo-European **trei–.*

helpmate The existence of the synonyms *helpmeet* and *helpmate* is the result of an error compounded. God's promise to Adam in Genesis 2:18, as translated in the King James Version of the Bible (1611), was to give him "an help [helper] meet [fit or suitable] for him." In 1673, the poet John Dryden used the phrase "help-meet for man," with a hyphen between *help* and *meet,* and this was one step on the way toward the establishment of the phrase "help meet" as an independent word. Another was the use of "help meet" without "for man" to mean a suitable helper, usually a spouse, as Eve had been to Adam. Despite such usages, *helpmeet* was not usually thought of as a word in its own right until the 19th century. Nonetheless, the phrase "help meet" probably played a role in the creation of *helpmate,* from *help* and *mate,* first recorded in 1715.

hey Traditionally, *hey* was just an exclamation. Sometimes it expressed delight, sometimes a warning. Nowadays we find it

used for emphasis as well, especially in the expression *but hey,* which usually indicates mocking or ironic acceptance of something, and so implies criticism. The word *hey* is also a greeting. It is the short, colloquial equivalent of the more formal *How are you?* and thus close kin to the informal salutation *hi,* which it seems to be replacing in many situations. Until recently, the greeting *hey* had a distinctly Southern flavor. The national survey conducted in the 1960s by the *Dictionary of American Regional English* found *hey* as a greeting restricted chiefly to Arkansas, Louisiana, Mississippi, Florida, Georgia, and the Carolinas. The friendly *hey* has since spread throughout the United States. Words sounding like *hey* are also used as greetings in other languages, such as Swedish *hej.*

Like *hey,* the informal greeting *hi* is descended from an earlier exclamation used to call someone's attention. The use of *hi* as a greeting seems, for the most part, to have originated in the United States, where it first became common in the 19th century.

highfalutin H. L. Mencken, in his famous book *The American Language,* mentions *highfalutin* as an example of the many words coined in the United States during the first half of the 19th century, a period of vigorous linguistic inventiveness in the growing young republic. Although *highfalutin* is characteristic of American folk speech, it is not a true regionalism because it has always occurred in all parts of the country. The origin of *highfalutin,* like that of many folk expressions, remains obscure. It has been suggested that the second element, *–falutin,* comes from the verb *flute*—hence *high-fluting*—and perhaps the expression originally invoked a notion by which pompous talk is likened to bombastic music. (Similar notions can be found in phrases like *tooting one's own horn,* a comical indictment of people who think too highly of themselves.) It has also been suggested that *highfalutin* is a modification of *high-flown* or *high-flying.*

hisself Speakers of some vernacular American dialects, particularly in the South, may use the possessive reflexive form *hisself*

instead of *himself* (as in *He cut hisself shaving*) and *theirselves* or *theirself* for *themselves* (as in *They found theirselves alone*). These forms reflect the tendency, found among speakers of all languages, to regularize patterns that are perceived as irregular, and we can observe such processes of regularization very frequently when we trace the development of languages over time. In Standard English, the forms of the reflexive pronoun show slightly irregular patterning: all forms but two are composed of the possessive form of the pronoun and *–self* or *–selves*, as in *myself* and *ourselves*. The exceptions are *himself* and *themselves*, which are formed by attaching the suffix *–self/–selves* to the object forms of *he* and *they* rather than their possessive forms. Thus speakers who use *hisself* and *theirselves* are actually smoothing out the pattern's inconsistencies by applying the same rule to all forms in the set.

A further regularization is the use of *–self* regardless of number, yielding the forms *ourself* and *theirself*. Using a singular form of *–self* in the plural reflexive pronouns may seem imprecise to speakers of standard American English, but the plural meaning of *ourself* and *theirself* is made clear by the presence of the plural forms *our–* and *their–*. Forms like *hisself* and *theirselves* have origins in British English and are still found today in vernacular speech in England.

hokey *Hokey* has what may seem hopelessly contrived, or even *hokey*, etymology. However, the history of this word vividly illustrates the variety of ways in which new words are born and evolve, and it also shows how their creation may depend on a single person or event. *Hokey* first appears in the 1920s and is derived from the noun *hokum*, meaning "something apparently impressive or legitimate but actually untrue or insincere, nonsense." *Hokum* in turn is thought to derive from a blend of *hocus pocus* and *bunkum*, both words with fascinating and unexpected histories.

Hocus-pocus is first attested in the 1600s with the meanings "juggler" and "a conjuror's trick," and the word seems to have

originated in the court of King James of England. According to the *Oxford English Dictionary*, which quotes a work called *A candle in the dark; or, a treatise concerning the nature of witches and witchcraft* (1656) by Thomas Ady, there was a conjuror who styled himself *The Kings Majesties most excellent Hocus Pocus* at James's court. During the performance of a trick, he would say the words *Hocus pocus, tontus talontus, vade celeriter jubeo,* a bit of half-Latin gibberish to distract his audience from his sleight of hand. *Vade celeriter jubeo* in fact means "Go quickly, I command!", while the phrase *hocus pocus* is perhaps intended to suggest the words spoken by the priest at the moment when, according to popular belief, the transubstantiation of the Eucharistic bread into the body of Christ occurs: *hoc est enim corpus meum,* "This is indeed my body." (The alliterative phrase *tontus talontus* is entirely obscure.) *Hocus pocus* also developed the broader meaning "empty pretense used to disguise deception," and it is most likely that the word *hoax,* which begins to appear in the late 1700s, originated as a contraction of *hocus.*

Bunkum, the other word blended into *hokum,* is more often encountered in the shortened form *bunk* nowadays. Appropriately enough, *bunkum* originated in the House of Representatives of the United States. The 16th Congress (1819–1821) was engaged in heated discussion of the extent to which the institution of slavery should be permitted in the western territories of the United States and the new state of Missouri. After one period of lengthy debate, Felix Walker, representative from the district in North Carolina including Buncombe County, rose and proceeded to deliver a particularly pointless speech intended merely to convince his constituency that he was making a difference in Washington. His harried colleagues asked him to desist, but he nattered on despite their protests—he was speaking not to Congress, he explained, but "to Buncombe." *Buncombe,* respelled as *bunkum,* thus entered the language as a word for "high-falutin' political oratory" or "clap-trap," from which the more general meaning "nonsense" later developed.

holler *Holler* can be a verb meaning "to yell or bellow." But *holler* is also a regional American pronunciation of *hollow*. One feature of Upper Southern English and specifically of Appalachian English is its pronunciation of the final unstressed syllable in words such as *hollow, window,* and *potato* as (ər). *Holler, winder,* and *tater* are merely variant pronunciations reflected in spelling. As a noun, *holler* has the specific meaning in the Appalachians of "a small valley between mountains": *They live up in the holler underneath Big Bald Mountain.* The form *tater* has even made some inroads into other varieties of English around the country as part of *Tater Tots,* a trademark of the H. J. Heinz Company for a commercial product consisting of small hash browns.

Hoosier We know where Hoosiers come from: Indiana. But where does the name *Hoosier* come from? That is harder to answer. The origins of *Hoosier* are rather obscure, but the most likely possibility is that the term is an alteration of *hoozer,* an English dialect word recorded in Cumberland, a former county of northwest England, in the late 19th century and used to refer to anything unusually large. The transition from *hoozer* to *Hoosier* is not clear. The first recorded instance of *Hoosier* meaning "Indiana resident" is dated 1826; however, it seems possible that senses of the word recorded later in the *Dictionary of Americanisms,* including "a big, burly, uncouth specimen or individual; a frontiersman, country-man, rustic," reflect the kind of use this word had before it settled down in Indiana.

As a nickname, *Hoosier* was but one of a variety of disparaging terms arising in the early 19th century for the inhabitants of particular states. For example, Texans were called *Beetheads,* Alabamans were *Lizards;* Nebraskans were *Bug-eaters;* South Carolinians were *Weasels,* and Pennsylvanians were *Leatherheads.* People in Missouri might have had it worst of all—they were called *Pukes.* Originally, these names were probably taken up by people living in neighboring states, but belittled residents adopted them in a spirit of defiant pride, much as American colonists

turned the derisive term *Yankee* into a moniker for their spirit of rebellion. Today, most of these frontier nicknames have disappeared from the landscape. A few, like *Okie,* still exist with much of their original animus. Others survive as nicknames for the sports teams of state universities—the North Carolina *Tarheels,* the Ohio *Buckeyes,* and so on—fighting words only on the playing field or court.

hornswoggle

We do not know the origin of *hornswoggle,* but we do know that it belongs to a group of "fancified" words that were particularly popular in the American West in the 19th century. *Hornswoggle* is one of the earliest, first appearing around 1829. It is possible that these words were invented to poke fun at the more "sophisticated" East. Some other words of this ilk are *skedaddle,* first attested in 1861 in Missouri, and *discombobulate,* first recorded in 1916.

The several other colorful American terms like *hornswoggle* are discussed at the entry for the word *absquatulate* elsewhere in this book.

horseradish

It is hard to imagine horses relishing the pungent roots of the horseradish plant, so we may wonder how horseradish got its name. In English, the word *horse* is often joined to other words to express such notions as "strong," "rough," "whopping big," or even "low-grade"—that is, "good enough only for the horses." The term *horseplay,* for instance, is used of rowdy play involving a good deal of physical contact and exertion. Among the names of plants, the use of *horse* to mean "rough" or "coarse" is found in words such as *horsemint,* a word that can designate either of two species of aromatic plants, rather tall members of the mint family that commonly grow in disturbed ground in North America. It has therefore been suggested that when the word *horseradish* was first created, *horse* was added to *radish* to give an idea of the large size of the plant or the strength of this very pungent seasoning. A horseradish root looks quite like the roots of some varieties of radish, and the flavor of horseradish

resembles that of radish somewhat, although it is far stronger. In origin, *horseradish* would thus simply mean "large radish" or "strong radish"—strong enough to kill a horse, so to speak.

However, it has also been suggested that the name is an adaptation of the German word for "horseradish," *Meerrettich*, interpreted by English speakers as "mare's radish." Horseradish is in fact a comparatively recent addition to English-speaking kitchens. The use of horseradish as a condiment may have originated in Eastern Europe in medieval times and gradually spread westward, reaching England only in the 1500s. In 1597, the great English botanist John Gerard (1545–1612) evidently did not count horseradish among the usual condimen'zs present on the English table: *Horse Radish stamped with a little vinegar put thereto, is commonly used among the Germanes for sauce to eate fish with, and such like meates, as we do mustard; but this kind of sauce doth heate the stomacke better, and causeth better digestion than mustard.* An old name for horseradish in English is in fact *German mustard.* English speakers may have first encountered horseradish as a seasoning in Germany, and hearing the German word for this new condiment, they may have misinterpreted *Meerrettich* as a compound of the German words *Mähre*, "mare, jade" and *Rettich*, "radish." (German *Mähre* is, as may be expected, closely related to the English word *mare*. German *Rettich* and English *radish* are also both ultimately descended from Latin *radix* "root.") According to this theory of the origin of *horseradish*, English speakers created a new word for the new seasoning by translating each part of the German compound separately and replacing *Mähre* with *horse*, perhaps because the word *horse* was already used in English to express notions of coarseness and strength. However, there are no English forms like *mare radish* attested, which makes this ingenious explanation somewhat doubtful. Most scholars prefer the simpler explanation that *horse* just means "big" in *horseradish*.

The etymology of the German word *Meerrettich* is itself a subject of dispute. The final element *–rettich* is of course identical to the word *Rettich*, "radish," but the original meaning of the ele-

ment *Meer–* is not certain. In fact, the word may not have originated as a compound of *Rettich* at all. Rather, it may be an alteration, by FOLK ETYMOLOGY, of the Latin word for horseradish, *armoricea*, which literally means "Armorican"—that is, "from Brittany." This etymology is supported by the fact that the horseradish plant flourishes abundantly in northwestern France.

hosey In New England, especially in the Boston area, sentences like *I hosey the front seat* are used in circumstances where other Americans might use expressions like *I've got dibs on* (or *I call*) *the front seat*. The verb *hosey* thus means something like "to stake one's claim or lay claim to." The force of one's claim can be strengthened using the form *high hosey* (also sometimes seen spelled *hi hosey*): *I high hosey the last cookie* or *I call high hosey on the last cookie*. The origin of *hosey*, however, remains unknown. The *Dictionary of American Regional English* suggests that it derives from an early *holdsie* and makes reference to putting "holds" on something. It has also been proposed that the expression has a French-Canadian origin and derives from the French verb *choisir*, "to choose."

humor Physicians in ancient and medieval times thought that the human body contained a mixture of four fluids and that a person's health and character depended upon the relative proportions of these fluids within the body. In Middle English, these fluids were called *humours*, ultimately from the Latin word *hūmor*, "fluid." (Latin *hūmor*, also found in the variant form *ūmor*, contains the same root found in the Latin adjective *hūmidus*, "moist," from which English gets the word *humid*.) The humors differed from each other in being either warm or cold and moist or dry, and each humor was also associated with one of the four elements. Blood was the warm, moist humor associated with the element fire, and phlegm was the cold, moist humor associated with water. Black bile was the cold, dry humor associated with the earth, and yellow bile was the warm, dry humor associated with the air.

The theory of the four humors can be traced to the Greek physician Hippocrates (5th century BC), although the medieval Europeans physicians knew it primarily through Latin translations of the writings of the Greek physician Galen (2nd century AD). In Latin, blood was called *sanguis;* phlegm, *phlegma;* black bile, *melancholia;* and yellow bile, *choler.* These Latin words have given rise to a set of English terms which are still used today to describe the mental disposition associated with each humor in medieval medical theory. For example, if blood was the predominant humor in one's body, one had a ruddy face and a *sanguine* disposition, marked by courage, hope, and a readiness to fall in love. An excess of phlegm made a person *phlegmatic,* or calm, sluggish, and unemotional. Too much black bile induced depression, or *melancholy,* while a superfluity of yellow bile caused a person to become *choleric,* or easily angered.

In the 16th century, the word *humour* came to be used to refer to a person's temperament when dominated by one of the four humors. A number of authors produced works in which the principal characters each suffered from an excess of one of the humors, and a character in one of these, Ben Jonson's *Every Man in His Humour* (1598), describes a *humour* as follows: *When some one peculiar quality doth so possess a man, that it doth draw all his effects, his spirits and his powers, in their confluctions, all to run one way,—This may be truly said to be a humour.* As an extension of this sense, *humour* came to indicate changing moods or states of mind, particularly whimsical and capricious fancies that, when revealed in action, provide amusement to others. In the 17th century, *humour* at last came to mean the quality that makes something amusing or laughable, as well as the ability to amuse others and to appreciate those things that are amusing—that is, a sense of humor. The modern American spelling of the word as *humor,* by the way, results from the spelling reforms instituted by Noah Webster during the late 18th century in the United States.

I'm Speakers of some scattered varieties of American English sometimes use *I'm* instead of *I've* or *I have* in present perfect constructions, as in *I'm forgot to do it* for *I've forgotten to do it.* This usage, sometimes called *perfective I'm,* has been noted in the Chesapeake Bay area, particularly among older speakers, and it has been found to be prevalent in the speech of the Lumbee Tribe, a Native American community of southeastern North Carolina. Interestingly, although the Lumbee community has existed historically side by side with communities of people of African and European descent, neither of these other groups uses this construction. In this regard, *I'm* parallels other language features that set the Lumbee apart from surrounding communities. For example, African Americans in the area commonly use *be* in sentences such as *He be talking all the time;* however, the Lumbee sometimes use *bees,* as in *He bees talking.* Similarly, the Lumbee often use *weren't* for *wasn't,* as in *She weren't home,* while their non-Lumbee neighbors rarely use this feature.

The American dialectologist Walt Wolfram has offered an explanation for the grammatical construction used by the Lumbee. In earlier stages of English, *be,* rather than *have,* was often used to form the perfect tenses of verbs of motion like *go* or other INTRANSTIVE verbs like *become.* It is well documented in Early Modern English in the works of Shakespeare (*"The gentleman is happily arriv'd"* in *The Taming of the Shrew*) and in the King James Bible (*"their memoriall is perished with them"* in Psalms 9:6). In present-day Scots English and Irish English, present tense forms of the verb *be,* such as *am* and *is,* are used in con-

texts where other dialects would use the present perfect forms *have been* or *has been*: *I'm fifty-five years here* (that is, *I have been here fifty-five years now*). Such constructions as these probably contributed to the Lumbee use of *I'm* in circumstances where most American dialects use *I've*.

It should be noted that the Lumbee use *I'm* in this way only in its contracted form—that is, speakers do not say *I am forgot*, but only *I'm forgot*. Moreover, the use of perfective *I'm* is for the most part not paralleled in other persons of the verb or in the plural. Forms such as *we're* for *we've* or *they're* for *they've* are rare, although they do occasionally occur in the vernacular of the Lumbee. The existence of subtle grammatical rules such as these in Lumbee English would probably not be at all evident to speakers of Standard American English when they first hear the Lumbee dialect, but all human language reveals such linguistic intricacy when studied from a scientific viewpoint.

industry A clear indication of the way in which human effort has been harnessed as a force for the commercial production of goods and services is the change in meaning of the word *industry*. Coming from the Latin word *industria*, meaning "diligent activity directed to some purpose," and its descendant, Old French *industrie*, with the senses "activity," "ability," and "a trade or occupation," our word (first recorded around 1477) originally meant "skill," "a device," and "diligence" as well as "a trade." Over the course of the Industrial Revolution, as more and more human effort became involved in producing goods and services for sale, this last sense of *industry* as well as the slightly newer sense "systematic work or habitual employment" grew in importance, to a large extent taking over the word.

The Latin word *industria* is derived from the adjective *industrius*, "diligent." The form of this adjective was in the very oldest Latin *indostruus*, and this word is derived from early Latin *endo*, "within," and the root **streu–*, a descendant of the Indo-European root **sterə–*, "to spread." The same root **streu–* is also the source of the Latin verb *struere*, "to pile up, arrange, or build."

This verb is the ultimate source of many English words like *construct, destruction, instruct, instrument,* and *obstruct.* Thus in the phrase *construction industry,* both words are descendants of the root **streu–.*

infantry *Grunt* is an informal term for an infantryman in the United States Army—a curious coincidence, since the word *infantry* is ultimately from the Latin word *īnfāns,* "unable to speak." In Latin, *īnfāns* was also used in the meaning "newborn child," and the word even came to be applied loosely to older children as well. As the spoken Latin of Italy underwent its natural evolution into the Italian language as we know it today, the Latin word *īnfāns,* whose stem was *īnfant–,* became *infante,* which could mean both "youth" and by extension "foot soldier." From *infante,* the word *infanteria,* "foot-soldiery," was formed, and this was borrowed into French as *infanterie.* The French word was then borrowed into English, where it first appears in the 16th century.

On the other hand, the English word *infant,* "very young child," which first appears in English in the 14th century, is a direct borrowing of the original Latin word *īnfāns.* Thus the words *infantryman* and *infant* share a common origin, however great the gap between their meanings. Before the introduction of the word *infantrymen*—that is, the soldiers who fought on foot with pikes, lances, and such, as distinguished from knights on horseback or archers armed with bows and arrows—were designated by the good old Middle English term *fotemen* (the equivalent of Modern English *footmen*).

The development of a word meaning "warrior" or "trained fighting man" from a word meaning basically "boy" finds a parallel in the English word *knight.* The Old English ancestor of this word, *cniht,* originally meant simply "a lad." Later it developed the meaning "a servant," and from there, "one fulfilling military service to a king or lord." In the heyday of feudalism, during the Middle English period, knights were usually men of noble birth who had performed a kind of apprenticeship by first serving as

pages and then squires to other, older knights, before finally being dubbed knights themselves. *Knecht*, the Modern German equivalent of Old English *cniht* and Modern English *knight*, still means simply "male servant," "farmhand," and "drudge."

inflammable Historically, *flammable* and *inflammable* mean the same thing. However, the presence of the prefix *in–* has misled many people into assuming that *inflammable* means "not flammable" or "noncombustible." The prefix *in–* in *inflammable* is not, however, the Latin negative prefix *in–*, which is related to the English *un–* and appears in such words as *indecent* and *inglorious*. Rather, this *in–* is an intensive prefix derived from the Latin preposition *in*. This prefix also appears in the word *inflame*, both of which go back to the Latin word *īnflammāre*, from Latin *flammāre*, "to set on fire." In order to eliminate possibly dangerous confusion about the combustibility of various materials, safety officials in the 20th century have eschewed *inflammable* in favor of the less ambiguous terms *flammable* and *nonflammable*.

it

"I told Anse it likely won't be no need."

This quotation from William Faulkner's *As I Lay Dying* demonstrates a use of *it* that occurs in some vernacular varieties of American speech. The expression *it is* is used instead of Standard English *there is* and *there are* in what linguists call *existential constructions*. Existential constructions are grammatical constructions that indicate the simple existence of something, rather than its physical location in a certain place. For example, the sentence *There is a boy at the door* contains the existential construction *there is*, but the sentence *The boy is there, at the door* does not. Notice the difference in meaning between the *there* in the first sentence and the *there* in the second. The *there* in the existential *there is* does not to refer to any specific place; it is merely part of the existential construction. In some vernacular dialects, on the other hand, the existential construction is formed

not with *there*, but with *it* and the third person singular of the verb *to be*. For example, *It was nothing I could do* is used instead of (or in addition to) *There was nothing I could do*.

Existential *it* is hardly a recent innovation—it appears in Middle English; in Elizabethan English, as in Marlowe's *Edward II*: "*Cousin, it is no dealing with him now*"; and in modern American literature as well. Although most British and American varieties of English no longer have this historical feature, it still occurs in some Southern-based dialects and in African American Vernacular English. Use of existential *it* may actually be increasing in some places, such as Smith Island, Maryland, a historically isolated community. While older Smith Islanders sometimes use existential *it* rather than *there*, younger islanders almost always do.

In some American vernacular dialects, particularly in the South (including the Appalachian and Ozark mountains), speakers may pronounce *it* as *hit* in stressed positions, especially at the beginning of a sentence, as in *Hit's cold out here!* This pronunciation is called a *relic dialect feature* because it represents the retention of an older English form. In fact, *hit* is the original form of the third person singular neuter pronoun and thus can be traced to the beginnings of the Old English period (c. 449–1100). Early in the history of English, speakers began to drop the *h* from *hit*, particularly in unaccented positions, as in *I saw it yesterday*. Gradually, *h* also came to be lost in accented positions, although *hit* persisted in socially prestigious speech well into the Elizabethan period. Some relatively isolated dialects in Great Britain and the United States have retained *h*, since linguistic innovations such as the dropping of *h* are often slow to reach isolated areas. But even in such places, *h* tends to be retained only in accented words. Thus, we might hear *Hit's the one I want* side by side with *I took it back to the store*. Nowadays, *hit* is fading even in the most isolated dialect communities and occurs primarily among older speakers.

This loss of *h* reflects a longstanding tendency among speakers of English to omit *h*'s in unaccented words, particularly pronouns, such as *'er* and *'im* for *her* and *him*, as in *I told 'er to meet*

me outside. This kind of *h*-loss is widespread in casual speech today, even though it is not reflected in spelling.

izzard The curious and charming word *izzard*, meaning "the letter *z*," is practically limited to certain fixed expressions in American vernacular English, such as *from A to izzard*, "from beginning to end," and *not to know A from izzard*, "not to know even the most basic things." The English lexicographer Samuel Johnson mentions the word *izzard* as part of his attempt to explain the sound of the letter *z* in the grammar of English he placed at the beginning of his *Dictionary of the English Language*, published in 1755: *Z begins no word originally English; it has the sound, as its name izzard... expresses, of an s uttered with a closer compression of the palate.* In Johnson's time, a variant form *uzzard* was also in use.

Izzard is related to the usual name of the letter *z* in British English, *zed*. In Scottish English, *z* was also once known as *ezed*, and this form gives us a clue to the origin of *izzard*. The name probably developed from the Middle French phrase pronounced at the end of a recitation of the alphabet, *et zede*, "and zed (zee)." The Old French word *zede* itself goes back to Late Latin *zēta*, which in turn goes back to the name used by the Greeks for their letter ζ, *zēta*.

The development of the word *izzard* has an interesting parallel in the word *ampersand*. The symbol &, read *and* in English, was once placed at the end of the alphabet, and when reciting the alphabet, English speakers ended by saying *x, y, z, and, per se, &* (that is, *and, per se, "and"*). (*Per se* is a Latin phrase meaning "by itself." The phrase thus meant, "the symbol &, by itself, is read as *and*.") The final phrase eventually developed into the word *ampersand*.

J

johnnycake When the Native Americans showed the Pilgrims how to cook with maize, they must have taught them to make *johnnycake*, a dense cornmeal bread whose thick batter is shaped into a flat cake and baked or fried on a griddle. *Johnnycake*, also spelled *jonnycake* and also called *journey cake* and *Shawnee cake*, is a New England specialty, especially in Rhode Island, where it is celebrated by the Society for the Propagation of Johnny Cakes. The Usquepaugh, Rhode Island, Johnnycake Festival features johnnycakes made of white Indian corn called *flint corn*. Outside New England the name *johnnycake* is best known in the Upper Midwest, but the food itself is most popular in the South and South Midland states, where it is known as *ashcake, batter bread, battercake, corn cake, cornpone,* or *hoecake*. The color of the cornmeal, the consistency of the batter, the size of the cake, and the cooking method can vary from region to region. For example, one local tradition of preparing an ashcake was described by Dudley Clendinen in a 1986 *New York Times* article on Southern culinary traditions. Based on the reminiscences of Clifford Brooks, a Georgian, an ashcake was "made by wrapping cornbread batter in cabbage leaves and burying it gently at the back of the fireplace, under hot oak ashes."

The etymology of *johnnycake* remains unknown. It perhaps derives from *jonakin*, an early American term meaning "johnnycake," and some have suggested that *jonakin* itself is of Native American origin. Definite evidence of Native American origin is lacking, however, and no one seems to have proposed a word in any known Native American language that could be akin to *jon-*

akin. Others have suggested that *johnnycake* is an alteration of the original form *journey cake*, since johnnycakes are often taken along as provisions for an excursion. However, it could just as well have worked the other way around—by FOLK ETYMOLOGY, the word *johnnycake* could have been altered to *journey cake*, reflecting the very same tradition of taking johnnycakes along as food for the road.

julep For many Americans, the word *julep* instantly evokes the memory of a delicious sensation of coolness relieving hot, humid summer afternoons. Although they may associate the drink with Kentucky and the more southerly parts of the United States, the word *julep* itself comes ultimately from Persian. Nowadays *julep* refers mostly to a drink made of bourbon whiskey, sugar, shaved ice, and crushed mint leaves, but in the past it could refer to any sweet syrupy drink and in particular to drinks containing medicine. *Julep* came to English by way of Old French *julep* from Arabic *julab*, meaning "rose water" or "julep." Rose water and other scented waters were frequently used as flavorings in various refreshing drinks prepared in the Near East in order to restore flagging spirits or provide relief from the heat of the day. The Arabic word itself is a borrowing of Persian *gulāb*, "rose water," a compound of the Persian words *gul*, "rose," and *āb*, "water." During the medieval period in the Near East, the refined gentility of Persian culture had a great influence on other Islamic civilizations, and many Persian words entered the Arabic language as a result—including the word that would eventually appear in English as *julep*.

The Persian word *āb* in *gulāb* comes from Proto-Indo-European and is derived from the root **ap–*, "water, river." Although found in many other members of the Indo-European family, this root is not continued in any English words of Old English origin. It is, however, found in another English word of Persian origin discussed in this book, *Punjab*.

keister The etymology of *keister,* like that of so many other slang words, is not entirely clear, although the word first appears in American rather than British English. According to the *Random House Historical Dictionary of American Slang,* the first known attestation of the word *keister* dates from 1881, where it appears in a slightly different spelling as part of the name of a confidence trickster, Kiester Bob, mentioned in a text describing the New York City underworld. Apparently Kiester Bob's trade involved satchels or suitcases in some way, for this is the meaning of *keister* in most of its earliest attestations. In many of its early uses, the word has associations with the criminal underworld, as is apparent from the following quotation from the *Atlantic Monthly* of December 1925 (cited in the *Random House Historical Dictionary of American Slang* by Jonathan Lighter): *The master cracksman and his two assistants appear outside the door with the "keister" or satchel holding the money and stamps. Keister* was also underworld slang for "safe" or "strongbox."

In the 1920s and 30s, the more common modern meaning of the word, "rump," begins to appear, mostly in lists of contemporary slang. The double meaning of the word *keister,* "case" and "rump," suggests that the word originated in German. In Modern High German, *Kiste* is an everyday word for "box" or "case," but it has also developed the vulgar slang meaning "posterior, rump." (The final *-e* in *Kiste* represents the vowel schwa (ə), and speakers of American English who drop their final *-r*'s, as many residents of New York City do, could have interpreted this schwa as *–er* and thus adopted the German word as *keister.*) Nevertheless, the exact

means of transmission of the word from German to English in the 19th century—as well as the reason for the late appearance of the meaning "rump"— remains unclear.

The transference of a word for "case" to a part of the body may seem a far-fetched explanation at first, but the history of the word *chest*—the native English equivalent of the German word *Kiste*—offers an interesting parallel development. Both *Kiste* and *chest* ultimately descend from Greek *kistē*, "basket, hamper." The Greek word was borrowed into Latin as *cista*, and from there the word entered the prehistoric ancestor of the West Germanic languages (the subdivision of the Germanic language group that includes German, Dutch, English, and Frisian). The West Germanic form of the word, **kista*, regularly developed into *Kiste* in Modern High German and eventually acquired the slang meaning "rump" in addition to "box." In English, however, **kista* developed into Old English *cest*, which meant simply "box." (The *c* in the Old English word was pronounced (ch) just as in Modern English *chest*, and the correspondence between a German (k) and English (ch) can be seen in other pairs like German *Kinn*, "chin," and English *chin*, or German *Käse*, "cheese," and English *cheese*.) Old English *cest* further developed into Middle English *chest*, and it was in Middle English times that *chest* underwent the strange and poetic development whereby it acquired its other modern meaning, "breast, thorax." The upper torso, as the place where the heart is found, was considered the repository of the soul and the emotions, enclosing them like a box or chest.

This metaphor was still explicit in the time of the Middle English poet John Lydgate (1370?–1451?), whose poems include such phrases as *My brest … cheste of wrecchedness* and *The brest is chest of dule* [grief] *and drerynesse*. The metaphorical basis for this use of this *chest* was eventually forgotten, and the purely physical application of the term as an ordinary word for the front of the upper torso begins to appear in the 16th century. The development was perhaps assisted by the similarity in sound between *breast* and *chest* as well.

kindling There are several regional terms for *kindling. Lightwood,* derived from the verb *light* (as in *to light a fire*), probably originated in Virginia and is now used throughout the South and especially in the South Atlantic states. *Fatwood* is used chiefly in Florida and Georgia. *Fat pine* can also refer to kindling derived from various pine species. One particular species native to the Gulf and Southern Atlantic states, the longleaf pine (*Pinus palustris*) goes by the name *fat pine* as well, since its resin makes even a small sliver of the wood easily kindled. In *Walden; or, Life in the Woods* (1854), Henry David Thoreau describes how he obtained kindling from the old roots of pitch pines (*Pinus rigida*) in Massachusetts, and his account provides a vivid illustration of how the term *fat* came to be applied to pinewood that is good for kindling a fire:

> *A few pieces of fat pine were a great treasure. It is interesting to remember how much of this food for fire is still concealed in the bowels of the earth. In previous years I had often gone "prospecting" over some bare hill-side, where a pitch-pine wood had formerly stood, and got out the fat pine roots.... With axe and shovel you explore this mine, and follow the marrowy store, yellow as beef tallow, or as if you had struck on a vein of gold, deep into the earth.*

knockout An attractive or exciting person or thing can colloquially be called a *knockout.* First used in the early 20th century, this expression comes from a metaphorical use of the boxing term *knock out.* The sport of boxing has produced many terms, such as *lightweight, heavyweight,* and *slaphappy,* that have entered our everyday language. Two political candidates will *square off* at the beginning of a debate, an expression with origins in the 18th- and 19th-century rules by which fighters began each round facing each other across a one-yard square in the center of the ring. One of our political candidates might anticipate a comment by the other and so *beat her to the punch.* If a candidate is clearly losing

a debate, he may be said to be *on the ropes*, and he could even suffer a *knockout blow*, after which he might *throw in the sponge* or *towel* and quit his candidacy. Or, before any of that happens, perhaps time will run out on the other candidate, and he will be *saved by the bell*.

krewe In order to organize and stage the enormous Mardi Gras carnival every year, many New Orleans families have belonged for generations to krewes, groups that create elaborate costumes and floats for the many parades in the two weeks leading up to Mardi Gras, literally "Fat Tuesday" in French. Not only do the krewes participate in the parades, but, as leaders of

krewe
Rex, King of Carnival

New Orleans society, they also hold balls and other elaborate events during the carnival season, which lasts from Christmas up to Mardi Gras itself. The krewes are responsible for electing Rex, the annual king of the carnival, whose parade is the climax of Mardi Gras. While masked paraders had long been a part of Mardi Gras, the first carnival group organized as such was the Mystick Krewe of Comus in 1857. *Krewe* is only an imitation of an old-fashioned spelling of *crew* in its standard meaning, but the word, thanks to its association with Mardi Gras and New Orleans high society, has taken on some of the mystique of the carnival.

L

lagniappe

We picked up one excellent word—a word worth traveling to New Orleans to get; a nice limber, expressive, handy word—"lagniappe".… It is the equivalent of the thirteenth roll in a "baker's dozen." It is something thrown in, gratis, for good measure. The custom originated in the Spanish quarter of the city. When a child or a servant buys something in a shop—or even the mayor or the governor, for aught I know—he finishes the operation by saying—
"Give me something for lagniappe."

—Mark Twain, *Life on the Mississippi*, 1870

Lagniappe ultimately comes from the Quechua word *yapay*, "to give more." (Quechua was the language of the Inca Empire, and it is still widely spoken in Peru, Bolivia, and other countries in South America.) The Quechua word was borrowed into the Spanish of the New World as a noun, *ñapa*, meaning "gift," and the Spanish word then spread around the Spanish-speaking areas of the Western Hemisphere. Eventually, the Spanish phrase *la ñapa*, meaning "the gift," entered the rich Creole dialect mixture of New Orleans, where it came to be thought of as a single word and acquired the French spelling *lagniappe*. The word was then borrowed into the English of the region. *Lagniappe* continues to be used in the Gulf states, especially southern Louisiana, to denote a little bonus that a friendly shopkeeper might add to a purchase. By extension, it may mean "an extra or unexpected gift or benefit."

Other words of Louisiana origin are discussed at the entries for *beignet, faubourg, krewe,* and *picayune* in this book.

left The entire world still feels the influence of the changes enacted and the institutions founded during the French Revolution. Even many fundamental terms of political discussion in the United States, like *left-wing* and *right-wing,* reflect the layout of the various legislative bodies formed and dissolved in France during the revolutionary period. At the meetings of the *Assemblée national constituante* (called the *National Constituent Assembly* in English) in 1789, the nobles took the position of honor at the right hand of the president of the assembly, and the representatives of the commoners took their place on the left. These seating patterns continued among three factions of the *Assemblée législative* (or "Legislative Assembly" in English), France's legislative body during the increasing political turmoil of 1791–1792. The Feuillants, one group of moderates who basically supported the king and institutions of the past, sat on the right side of the chamber of the assembly, while the most radical supporters of republican values and reform, such as the Jacobins and Girondins, sat on the left. The center was occupied by more moderate supporters of reform, who usually voted with the left. Thus the French terms for "left" and "right," *gauche* and *droite,* came to be used as shorthand for political tendencies, and this use eventually spread to English. The resulting English use of *right* to mean both "correct" and "the conservative side" may seem like an unfair advantage to those on the left who believe that the right wing is not always in the right.

legend The word *legend* is derived from the Latin adjective *legenda,* a form of the verb *legere,* "to read." In Medieval Latin *legenda* was used to mean "something to be read," particularly the narrative of a saint's life. Some of the earliest appearances of the word in English referred to Jacobus de Voragine's (1230–1298?) popular collection of fanciful hagiographies commonly known as the *Legenda Aurea,* "Golden Legend." Biographies of saints were con-

sidered important as historical records and moral examples but were also widely read for their entertaining stories. In the 14th century, the meaning of Middle English *legende* began to encompass all manner of historical subjects as is evident in *The Canterbury Tales* when the Wife of Bath says in her description of her husband, the clerk:

> *And every nyght and day was his custume,*
> *Whan he hadde leyser and vacacioun*
> *From oother worldly occupacioun,*
> *To reden on this book of wikked wyves.*
> *He knew of hem mo legendes and lyves*
> *Than been of goode wyves in the bible.*

In the 16th century, the word's meaning was extended from written accounts to traditional stories transmitted orally from generation to generation. The sort of embellishment common in oral storytelling may have led to the development in the 17th century of the sense "an unverified or apocryphal tale," which persists in the modern collocation *urban legend*. Today, *legend* is also applied to a person whose renown is perpetuated by such stories, as in the hyperbolic clichés *a living legend* and *a legend in her own time*.

lettuce The many different kinds of lettuce that are offered by an American greengrocer are all varieties of a single species of plant, *Lactuca sativa*, that probably originated as the cultivated form of a common European weed, *Lactuca serriola*. The word for *lettuce* comes from Middle English *lettuse*, which is a borrowing of French *laitues*, the plural of *laitue*, "lettuce," reinterpreted as a singular by the speakers of Middle English. French *laitue* in turn comes from Latin *lactūca*, the same word still used as the scientific name of the lettuce family. *Lactūca* itself is derived from the Latin word *lac*, "milk." The *t* in *lactūca* is part of the stem of *lac*, which was *lact–*, as seen in such forms as *lactis*, "of milk," and familiar to English speakers from other English words of Latin

origin like *lactose*, "milk sugar," and *lactate*, "to produce milk."

Although nothing about the leaves of a young cultivated lettuce eaten in a salad may seem very milky, when the lettuce plant is allowed to bolt—that is, to mature and grow a flowering stalk—it is easy to see why the Romans gave it the name *lactūca*. Readers can perform the experiment for themselves by allowing a lettuce plant to bolt in their own garden or, as is possible in many parts of the United States, simply by walking on the roadside and finding a specimen of the wild lettuce *Lactuca canadiensis*, a very common weed with narrow, coarsely toothed leaves with a prominent midrib as well as small flowers like dandelions borne in a cluster at the top of a long, thin stalk. Upon being broken, the stalk and leaves will produce a very bitter, milky juice. Most wild members of the lettuce family are in fact quite bitter, and one could hardly imagine eating them. The mild-tasting lettuce leaves we enjoy in a modern salad are the result of patient selection and improvement of the plant by the Greeks, Romans, Egyptians, and other ancient peoples who lived in the regions around the Mediterranean Sea.

licorice The flavor of black licorice is derived from the root of the licorice plant (*Glycyrrhiza glabra*). Licorice root contains a chemical compound fifty times sweeter than sugar, and it is also an effective cough remedy. In the Middle Ages, licorice was widely used both as a flavoring and as a medicine. (It should be remembered that sugar was an expensive commodity in the Middle Ages, and rather than being used as a basic ingredient, it was added sparingly like a seasoning. Medieval cooks thus appreciated all the more the note of sweetness that licorice could supply.) The extract of the licorice root was evaporated into a thick black substance, the precursor of the leathery licorice sticks sold today. Medieval English literature makes frequent reference to the sweet taste of licorice, and when the Miller in Geoffrey Chaucer's *Canterbury Tales* wishes to describe the pleasant character of a young scholar, he compares the young man to licorice and zedoary (the aromatic root of an Asian plant that was much used in medieval cookery):

A chambre hadde he in that hostelrye
Allone, withouten any compaignye,
Ful fetisly ydight with herbes swoote,
And he hymself as sweete as is the roote
Of lycorys or any cetewale.

He had a room in that hostel
to himself, without any companionship.
It was neatly decorated with sweet-smelling herbs
and he himself was as sweet as the root
of licorice or zedoary.

The word *licorice* itself comes from Middle English *licoris*, which in turn is from Old French *licorece*. The Old French word is from Medieval Latin *liquiritia*, which in turn is from Greek *glykyrrhiza*, a compound of *glykys*, "sweet," and *rhiza*, "root." The form of the Medieval Latin word *liquiritia* probably reflects the influence of Latin words like *liquēre*, "to be liquid," and *liquidus*, "liquid," since licorice was prepared by boiling the extract of the root into a thick syrup.

Licorice seems to have originally been pronounced with a final (s) sound in Middle English, not with (sh) as is very common in the United States today. The first indications of the new pronunciation, through spellings like *likerish*, begin to occur in the 18th century. The great American lexicographer Noah Webster, for instance, criticized the spelling of the word *licorice* as *lickerish* in his influential and popular spelling guide published in 1783. Webster himself advocated the spelling *liquorice* in this work, rather than *licorice*. (In this regard, it is interesting to note the existence of a now almost obsolete adjective *lickerish* meaning "delicious" when applied to food and "fond of good food" when applied to persons. Although this fact suggests the tantalizing possibility that the adjective *lickerish* influenced the pronunciation of *licorice*, the ultimate origins of the pronunciation with (sh) have yet to be determined.) Throughout the 19th and 20th centuries, commentators on linguistic usage disparaged the pronun-

ciation with (sh) as lower-class or uneducated, but it nevertheless remains widespread in the United States today—despite the usual spelling of the word with the letters –ce, which most often indicates the sound (s) at the end of English words.

lieutenant What is the connection between a lieutenant governor and a lieutenant in the army? In the etymology of the word *lieutenant*, at least, the connection lies in their holding a place; that is, the word *lieutenant* is from an Old French compound made up of *lieu*, "place," and *tenant*, "holding." The Old French word was borrowed into Middle English as *lieutenant*, first recorded near the end of the 14th century. Both the Old French word and its Middle English equivalent referred to a person who acted for another as a deputy. This usage has survived, for example, in our term *lieutenant governor*, the deputy of the governor and the one who replaces the governor if need be. In military usage, *lieutenant* appears by itself as well as in compounds such as *lieutenant colonel, lieutenant general, first lieutenant,* and *second lieutenant,* but the historical notion of the word was that the officer designated by the term ranked below the next one up and could replace him if circumstances required this. A first lieutenant in the United States Army was thus an officer who could step into the shoes of a captain.

The origin of the usual British pronunciation of *lieutenant*, (lĕf-tĕn′ənt), is not known with any certainty, but similar pronunciations are attested in Middle English times by such spellings as *leuftenant, luffetenand,* and *levetenaunt.* The Old French word *lieu* had a rare variant form *luef,* and a form of Old French *lieutenant* using this rare form rather than *lieu* may have been picked up by Middle English speakers. In addition, the Old French pronunciation of the word *lieu* was something like (lyĕw), although this has developed into (lyœ) in Modern French. It is possible that Middle English speakers may have heard the final (w) of this word, a sound made with the lips, as a (v) or (f), other sounds made with the lips. The *Oxford English Dictionary* suggests that use of the Middle English forms with *f* may also have

been encouraged by an association of the first element with other English words, such as the noun *leave*—a lieutenant being an officer who substitutes for another who is on *leave* or perhaps one who has the superior officer's *leave* to take command when he is absent or otherwise unable to fulfill his functions.

like *Like* seems to be one of the most well-liked words in the English language, judging by the number of interesting uses to which it is put in American vernacular speech.

In certain Southern varieties of American English there are two grammatically distinct usages of the word *like* to mean "was on the verge of." In both, either *like* or *liked* is possible. In the first, the word is followed by a past infinitive: *We liked* [or *like*] *to have drowned.* The ancestor of this construction was probably the adjective *like* in the sense "likely, on the verge of," as in *She's like to get married again.* The adjective was then reinterpreted by some speakers as a verb. Since *like to* and *liked to* are indistinguishable in normal speech, the past tense came to be marked on the following verb for clarity. From this developed a second way of expressing the same concept: the use of *like to* with a following FINITE past-tense verb form, as in *I like to died when I saw that.* This construction may at first appear odd to speakers of other varieties of English, since it ostensibly contains an ungrammatical infinitive *to died*; but that is not the case at all. What has happened is that *like to* here has been reinterpreted as an adverb meaning *almost.* In fact, it is quite common to see the phrase spelled as a single word, in the PRONUNCIATION SPELLING *liketa.*

Along with *be all* and *go,* the construction combining *be* and *like* has become a common way of introducing quotations in informal conversation throughout the United States, especially among younger people: *So I'm like, "Let's get out of here!"* As with *go,* this use of *like* can also announce a brief imitation of another person's behavior, often elaborated with facial expressions and gestures. It can also summarize a past attitude or reaction (instead of presenting direct speech). If a woman says *I'm like, "Get lost buddy!"* she may or may not have used those actual

words to tell the offending man off. In fact, she may not have said anything to him but instead may be summarizing her attitude at the time by stating what she might have said, had she chosen to speak.

loblolly

In some regional dialects of the American South, the term *loblolly* is used to refer to a mire or a mudhole. The word is a combination of *lob*, probably an ono-matopoeic word suggesting the thick heavy bubbling of cooking porridge, and *lolly*, an old British dialect word meaning "broth, soup, or any other food boiled in a pot." Thus, *loblolly* originally denoted thick por-ridge or gruel, especially that eaten by sailors onboard ship. The meaning of the word in American dialects of the South makes allusion to the consistency of such porridge. The name *loblolly* has become associated with several varieties of trees as well, all of which favor wet bottomlands or

loblolly
Pinus taeda

swamps in the Gulf and South Atlantic states. Among these is the loblolly pine (*Pinus taeda*), whose strong wood is used as lumber and for paper pulp.

love

If thou didst ever any thing believe,
Believe how I love thee…

—John Keats, *Isabella; or, the Pot of Basil*

By reconstructing ancient words, linguistics not only teaches us about the material culture of the people in the past—whether they rode horses or spun wool, for example—it can also recover words for the emotions and thoughts of ancient peoples as well. The English word *love* goes back to Old English *lufu*, and this word has relatives in many other Indo-European languages,

including Russian *l'ubov,* "love," and Sanskrit *lobha–,* "desire." Through comparison of these words, linguists have reconstructed the Indo-European root meaning "to love," *leubh–.* The same root is also the source of another common Modern English word, *believe.* In Proto-Germanic, the prehistoric intermediate ancestor between Indo-European and the modern Germanic languages like English, there was a verb *galaubjan,* meaning "to esteem, hold dear" and by extension, "to trust," since the emotions of mutual affection and trust are intimately linked. In this verb, the Proto-Germanic suffix *–jan,* which makes verbs, has been added to the root *leubh,* and the prefix *ga–* on the verb gives the verb an intensive meaning, something like "very much, thoroughly." In Modern German, *galaubjan* survives as *glauben,* "to believe." On the way to Old English, however, *galaubjan* developed into *gelēfan* and also *belēfan,* in which another prefix, *be–,* has replaced *ge–.* The latter form *belēfan* is the source of our modern verb *believe.* In this way, the pleasing similarity in sound between *love* and *believe,* so often evoked in pop song lyrics, has ancient beginnings.

Latin too had words derived from Proto-Indo-European *leubh–,* "to love." In Latin, the Indo-European vowel sound *u* sometimes becomes *i,* and *lubh–,* a form of *leubh,* shows up by regular sound change as *lib–.* We can glimpse this form in English words borrowed from Latin that relate to the concept of "love," like *libido* and *libidinous.*

lox Before migrating from their Central Asian and Eastern European homelands, the early Indo-European peoples probably welcomed the annual run of a salmon-like fish, the brown trout (*Salmo trutta*), in their rivers and streams. The early Indo-European peoples may have called the fish *laksos,* "the speckled one," from the root *lak–,* "speckle, mark." *Laksos* is the source of the word for "salmon" in many northern European languages, such as Lithuanian *lašišà* and Polish *łosoš.* In Old English, Proto-Indo-European *laksos* developed into *leax,* "salmon," and this word still survived in Middle English times as *lax. Lax,* however,

was eventually driven extinct by the introduction of Old French *salmoun* (now Modern French *saumon*).

Curiously, two words closely related to *lax* have reintroduced the ancient northern European word for "salmon" into Modern English, where it thrives again. The Modern High German word for "salmon" is still *Lachs,* and in Yiddish (which developed from Middle High German dialects), the equivalent word is *laks.* The Yiddish word is the source of American *lox,* regularly served on bagels. *Gravlax,* denoting a variety of cured salmon seasoned with dill and served raw, is a borrowing from Swedish. The word literally means "trench (*grav*) salmon (*lax*)," a remembrance of the traditional method of curing salmon by fermentation in the ground, a practice still maintained for shark meat in Iceland today.

The etymology of the word *salmon* itself is discussed elsewhere as a separate entry in this book.

M

macabre The word *macabre* comes from the Middle French phrase *Danse Macabré*, "the Dance of Death," which was a popular subject of art and literature in the late Middle Ages. In representations of this dance, Death leads people of all classes and walks of life to the same final end. The original meaning of the French word *macabré* is not known with any certainty, but it may be an alteration of Old French *Macabe*, "a Maccabee." The Maccabees were Jewish martyrs who were honored by a feast throughout the Western Church. The *Danse*

macabre
1520s woodcut from Hans Holbein the Younger's Dance of Death *series*

Macabré may have originated in part as an allegorical procession called the *chorea maccabaeorum* in Latin that is mentioned in late medieval texts. The procession perhaps included a dramatic reenactment of a series of gruesome killings told of in the Second Book of Maccabees, a book of the biblical Apocrypha describing the persecutions endured by the Jewish people in the second century BC. Seven brothers and their mother were brought before the king who ruled over the Jews at this time and ordered to eat pork. The first son refused to pollute himself in this way, and the king had him cut up and cooked in a hot cauldron before his mother's eyes. One by one the rest of his family were killed in the same way. John Lydgate is the first English author known to mention the *Danse*

Macabré in English. He wrote a poem called *Macabrees daunce* around 1430 and it purports to be a translation of a French poem that described some famous painted murals of the *Danse Macabré* located in a cemetery in Paris.

Machiavellian
The adjective *Machiavellian* is often used to describe actions or strategies characterized by deceit or cunning, as in the phrase *a Machiavellian management style*. The word makes reference to the doctrines of Nicolò Machiavelli (1469–1527), an Italian political theorist whose two major works, *The Prince* and *Discourses on Livy,* describe the ways in which a determined ruler can achieve and maintain power through indifference to moral considerations. Machiavelli's political doctrine denies the relevance of morality in political affairs and holds that craft and deceit are justified in pursuing and maintaining political power. His works are characterized by an unflinchingly realistic evaluation of human relations, as in the following passage from *The Prince* (chapter 8):

> *Therefore it is to be noted that, when taking control of a state, the occupier ought to enquire carefully into all those injuries that are necessary for him to do; and to do them all at once so that he does not have to repeat them every day, and to be able, by not repeating these injuries, to reassure the men of the state and to win them over by doing good to them.… For injuries ought to be done all at one time, so that, since they are tasted less, they offend less; benefits ought to be given bit by bit, so that men may better savor them.*

Machiavelli's theories are based on his experience as an administrator and diplomat in Florence during a tumultuous epoch in that city's history. Machiavelli had ample opportunity to observe how a crafty ruler could obtain his desires—and also how a naïve or inattentive ruler could lose everything through carelessness. Machiavelli's soberly realistic assessments of human affairs have led to the use of the word Machiavellian to describe

any behavior or policy characterized by expediency, deceit, and cunning. Despite Machiavelli's harsh depiction of human relations, however, his works are an unexpected delight to read—he expresses his brutally unromantic view of human nature with a lapidary brilliance of style.

We can find some expression of hope in Machiavelli's works— behind his pessimistic statements about human nature lies the patriotic belief that Italy could free herself from foreign domination. In Machiavelli's time, the Italian peninsula was fragmented into many city-states and small principalities, and France, the Holy Roman Empire, and other countries invaded Italian territories continually and otherwise interfered constantly in Italian political affairs. This situation was humiliating for the Italians, who had once held sway over the entire Mediterranean world during the period of the Roman Empire. Machiavelli recognizes that the rulers whom he addresses in his books must make difficult choices in order to gain and keep power, and he urges them to make these choices rationally. *The Prince* ends with a plea to Giuliano de' Medici, a member of the ruling family of Florence who was to become Pope Clement VII, to cast the barbarians out of Italy.

mannequin A department store mannequin is often not a man and often not little, but *mannequin* goes back to the Middle Dutch word *mannekijn*, the diminutive form of *man*, "man, person." As for the size of a mannequin, the Middle Dutch word could mean "dwarf," but in Modern Dutch it developed the specialized sense of "an artist's jointed model." This was the sense in which we adopted the word (first recorded in 1570), making it another term like *easel* and *landscape* taken over from the terminology of Dutch painters of the time. The modern spelling of the Dutch word that was borrowed into English is *manikin*. The Dutch word was also borrowed into French as *mannequin*, and English later borrowed the French version of the word as well. Now *mannequin* is the form most commonly encountered and the one commonly used for a department store dummy as well as a live model.

mantra Many of the world's hundreds of millions of Hindus begin each day by reciting a very holy mantra called the *Gāyatrī:*

om̐ bhūr bhuvaḥ svaḥ
tat savitur vareṇyam
bhargo devasya dhīmahi
dhiyo yo naḥ pracodayāt

Om. Earth. Air. Heaven.
May we fix our minds on
he radiance of the god Savitar,
who will set our minds in motion.

Hindus and Buddhists who practice the recitation of mantras believe that the power of the mantra transcends the mere meaning of the phrase—the very sound of words themselves sets up a propitious vibration in those who recite the mantra and in the universe surrounding them. In modern English usage, however, the word *mantra* has come to refer to any word or phrase that is commonly repeated, especially a phrase that expresses a guiding principle and is reiterated mindlessly.

The *Gāyatrī* mantra, on the other hand, is recited to awaken and refresh the mind in the morning, and the Sanskrit word *mantraḥ*, the source of English *mantra*, is related to the English word *mind* itself. *Mantraḥ* has a wide variety of meanings in Sanskrit, including "counsel," "prayer," "hymn," and "sacred spoken formula," and the word is related to the Sanskrit verb *many-ate*, "he thinks." The two Sanskrit words are derived from the Proto-Indo-European root **men–*, "to think," which is also the source of many other English words besides *mantraḥ*. The English word *mind* descends from Old English *gemynd*, a derivative of **men–*. Other English words like *mental* and *mention* (that is, "to bring to mind") come from Latin *mentis*, "mind," another derivative of **men–*.

English speakers who wish to harness the spiritual powers attributed to spoken Sanskrit should pronounce the word *mantra*

as (**mŭn′**trə). This is much closer to the original pronunciation of the Sanskrit word *mantraḥ* than the more commonly heard pronunciation (**män′**trə), based on the spelling of the word *mantra* in English. In modern times, Sanskrit is most often written in a native Indian alphabet called *Devanāgarī*, rather than in the Roman alphabet. When Sanskrit is transliterated into the Roman alphabet, the letter *ā* with a long mark is used to represent the long vowel (ä), while the simple letter *a* is used to represent the short vowel (ŭ). Since *mantraḥ* has a short *a* in the first syllable, rather than a long *ā*, the pronunciation (**mŭn′**trə) is preferred among those familiar with Sanskrit.

For the ancient Indians, the correct pronunciation of the holy language of Sanskrit could be a matter of life or death—quite literally. The first sacred texts of Hinduism, such as the collection of poems called the Rig-Veda, were composed in an early variety of Sanskrit during a period beginning around 1500 BC. (The last three verses of the *Gāyatrī* mantra above are in fact taken from the Rig-Veda.) Over the centuries, changes occurred in the pronunciation and grammar of Sanskrit as it was actually spoken by the people. Such changes are natural phenomena that occur in all human languages. Doubtless in response to these changes, early Indian priests and scholars sought to establish the correct use and understanding of the holy language—the gods, of course, speak Sanskrit fluently, and they might refuse to listen to an incompetently composed and recited prayer from worshippers asking for victory in battle, recovery from personal illness, or health and fertility among their herds of cattle. By 500 BC, these scholars' efforts had developed an extremely advanced theory of language. The ancient Indian linguists analyzed the sounds of speech with great scientific accuracy, and modern linguists often stand in awe of the depth and complexity of their achievements. The writers and grammarians of ancient India created a refined and grammatically fixed form of Sanskrit that is still cultivated for religious, literary, and scientific purposes in the modern world. The mantras faithfully preserved by this scholarly tradition are still recited by millions of people today, more than three thousand years after many of these prayers were composed.

marshmallow Marshmallows were originally medicine, despite their modern reputation as the fluffiest of foods and the emptiest of calories. They were originally made from the root of the marsh mallow (*Althaea officinalis*), a perennial plant with showy pink flowers that is native to marshy areas in Europe and North Africa. The marsh mallow has a mucilaginous root that was formerly much used in herbal remedies to soothe inflamed tissues. The *Middle English Dictionary* quotes a medical text from around 1425 describing one of the many uses to which the plant was put in medieval medicine: *Leie a plaster on þe þrote wiþ oute furþe with þe rotes of merche malue soþen & grounden.* ("Lay a plaster on the throat on the outside with the roots of marsh mallow, boiled and ground up.") The mucilage derived from the root was also used to produce soft and fluffy sweet confections, and these eventually evolved into the white, spongy modern marshmallow. However, sweets made with real marsh mallow root will lose their shape and fluffiness rather quickly when compared with modern marshmallows made from sugar, egg whites, gelatin, gum arabic, and other ingredients. Gelatin, which replaced marsh mallow extracts in candy during the 19th century, now fulfills the same role formerly played by real marsh mallow in achieving the gooey yet fluffy texture of marshmallows. The name *marshmallow* has stuck nonetheless, even though—unlike the throat-soothing decoctions of the past—the marshmallows that melt on top of hot cocoa no longer contain any marsh mallow products.

The word *mallow* can refer to any of a variety of plants of the genus *Malva*, which often have pink or purplish flowers. *Mallow* comes from Old English *mealwe*, possibly influenced in its development by Old French *malve*. Both the Old English and Old French words ultimately descend from Latin *malva*, "mallow." Later in the history of French, Old French *malve* evolved into Modern French *mauve*, which also became the designation for the purplish-pink hue characteristic of mallow flowers. *Mauve* was then borrowed into English in the middle of the 19th century, at first as the specific name for one of the rich new colors pro-

duced by the synthetic dyes that were just becoming available at the time. The *Oxford English Dictionary*, for example, quotes from an issue of *St. James's Magazine* that mentions one of the new colors of the season in 1861: *the fashionable and really beautiful* mauve *and its varieties.*

me Speakers of vernacular varieties of English, especially in the South, will commonly utter sentences like *I bought me some new clothes* or *She got her a good job*, in which the objective form of the pronoun (*me, her*) rather than the reflexive pronoun (*myself, herself*) is used to refer back to the subject of the sentence (*I, She*). However, the reflexive pronoun of Standard English cannot always be replaced by the vernacular objective pronoun. For example, *Jane baked her and John some cookies* doesn't mean "Jane baked herself and John some cookies." In this sentence, *her* must refer to someone other than Jane, just as it does in Standard English. In addition, forms like *me* and *her* cannot be used in place of *myself* or *herself* unless the noun in the phrase following the pronoun is preceded by a modifier such as *some, a,* or *a bunch of.* Thus, sentences such as *I cooked me some dinner* and *We bought us a bunch of candy* are commonplace; sentences such as *I cooked me dinner* and *We bought us candy* do not occur at all. Sometimes objective pronouns can occur where reflexive pronouns cannot. For example, some Southerners might say *I'm gonna write me a letter to the President;* nobody, no matter what variety he or she speaks, would say *I'm gonna write myself a letter to the President.*

Originally in Old and Middle English, the word *self* was not obligatory in direct or indirect object pronouns with reflexive meaning, as it is in Modern Standard English. The plain direct and indirect object pronouns could be used with no further additions. In the Knight's Tale in *The Canterbury Tales*, for example, Chaucer writes *I putte me in thy proteccioun.* ("I put myself in your protection.") However, the word *self* could be added in such sentences to reinforce the reflexive meaning. Beginning in the 14th century, the use of the word *self* in reflexive constructions begins

to gain more and more ground. In Middle English, forms like *me self* and *us self* are found beside forms like *mi self* and *oure self*, the ancestors of Modern English *myself* and *ourselves*. The modern vernacular use of the bare form *me*—without *self*—as an indirect reflexive object thus has a distinguished pedigree.

mealy-mouthed

It is fitting that a search for the origins of the expression *mealy-mouthed* leads us to Martin Luther, a man noted for the forthright expression of his ideas. *Mealy-mouthed*, a contemptuous term applied to those unwilling to state facts or opinions directly, may come from a proverbial saying comparable to German *Mehl im Maule behalten*, literally meaning "to carry meal in the mouth" but used in the figurative sense "not to be direct in speech." The first known occurrence of this German phrase is found in Luther's writings. In English, we find the terms *mealmouth* (attested in 1546) and *meal-mouthed* (1576) recorded around the same time that we find *mealymouthed* (around 1572). *Mealy-mouthed*, however, is the only form that has survived in modern usage.

mediocre

Belying the very meaning of the word, the adjective *mediocre* has a remarkable and unexpected etymology. *Mediocre* ultimately comes from Latin *mediocris*, which meant "middling, ordinary, unremarkable." The Latin word in turn makes reference to a rather concrete metaphor—the same pattern of derivation that we frequently observe elsewhere when we trace the history of words back till we hit bedrock. In this case, the bedrock is a Latin word for "mountain." *Mediocris* is a compound of the adjective *medius*, "half" or "in the middle," and the noun *ocris*, "rugged mountain." Something that is *mediocre* therefore is only midway up the mountain—that is, it rises just halfway to the highest point of excellence.

The resemblance between the Latin word *medius* and English words like *middle* and *midway* is no accident. They are all ultimately descended from the Proto-Indo-European word **medhyo-*, meaning "middle."

Melba toast The familiar foods named for Helen Porter Mitchell (1861–1931) are not recognizable as such unless one knows that her stage name was Dame Nellie Melba. This world-renowned soprano, who took the last part of her stage name from her native city of Melbourne, Australia, inspired others to honor her by naming things such as "soaps and sauces, ribbons and ruffles" after her. Perhaps the best known of such honors are Melba toast and peach Melba. Auguste Escoffier, the famous chef, is thought to have had a hand in both. *Melba toast* is said to be derived from the crisp toast that was part of Dame Melba's diet during the year 1897, a year in which she was very ill. The hotel proprietor César Ritz supposedly named it in a conversation with Escoffier. *Pêche Melba* (peaches poached in syrup and served with vanilla ice cream and raspberry sauce) was said to have been created by Escoffier for an 1892 party honoring the singer at the Savoy Hotel in London, although neither Escoffier nor Melba agreed with this version of events. *Peach Melba* is first recorded in English in 1905 (in the form *Pêches à la Melba*) and *Melba toast* in 1924.

Melba toast
photographic portrait of Dame Nellie Melba

One of Dame Nellie's most formidable rivals was the Italian soprano Luisa Tetrazzini (1871–1940). Dishes that are prepared *tetrazzini*—that is, made with chicken or other non-red meat, noodles, mushrooms, and almonds in a cream sauce topped with cheese—are named in her honor.

might In many varieties of English in the South of the United States, *might* can be paired with other auxiliary verbs such as *could*, as in *We might could park over there*. Words like *might* and *could* are known as *modals*, for they express grammatical modes or "moods" (for example, *I might go* indicates the speaker's

uncertainty). Combinations such as *might could, might would,* and *might can* are known as *double modals.* Other less common combinations include *may can, may will,* and *might should.* Since double modals typically begin with *may* or *might,* they lessen the degree of conviction or certainty (much like the word *possibly*) more than a single modal does. Double modals are used, for example, to minimize the force of what one is saying, as when asking someone for a favor or when indicating displeasure.

Although double modals may sound odd outside of the South, they carry little if any social stigma within the South and are used by speakers of all social classes and educational levels—even in formal instances like political addresses. Like many features of Southern varieties of English, the use of double modals is probably due to the fact that many of the first English speakers in the South were Scotch-Irish, whose speech made use of double modals. This feature has been noted as far back as the Middle English period, but today's most common forms were not used to any great extent until the mid-18th century. They are surprisingly rare in fiction that attempts to reproduce regional dialects in dialogue, but they do occasionally occur, as in *Old Yeller* by Fred Gipson: *Jumper's liable to throw a fit with that hide rattling along behind him, and you might not can hold him by yourself.*

milk shake To most Americans, a milk shake, that thick, sweet accompaniment to a hamburger and fries, naturally includes ice cream. But speakers in parts of New England make finer distinctions in their ice cream terminology. To a person living in Rhode Island or the adjoining part of Massachusetts, a milk shake consists of milk shaken up with flavored syrup and nothing more; if ice cream is included, the drink is called a *cabinet,* possibly, says food writer John F. Mariani in *The Dictionary of American Food and Drink,* named after the square wooden cabinet in which the mixer was encased. Farther north in New England, a milk shake made with ice cream can be called a *velvet* or a *frappe.* The word *frappe* dates back to the 19th century, when a *frappé* was an iced drink or refreshment of some kind. The term comes from the

French word *frappé* meaning "iced, chilled," derived from the verb *frapper*, "to ice, chill." *Frappe*, pronounced (frăp), appears to have originated as a spelling pronunciation of *frappé* spelled in English with a simple *e* rather than with an *é*.

mill To *mill*, in the English of the American West, means "to run cattle in a circle, sometimes deliberately in order to halt a stampede." In the *Oxford English Dictionary* we find this 19th-century example of the verb as used in *Munsey's Magazine: At last the cattle ran with less energy, and it was presently easy to "mill" them into a circle and to turn them where it seemed most desirable.* This usage of *mill* comes from the resemblance of the cattle's circular motion to the action of millstones. A related intransitive sense of the verb is better known in Standard English, as shown in the *Oxford English Dictionary* citation of an 1888 quotation from Theodore Roosevelt: *The cattle may begin to run, and then get "milling"— that is, all crowd together into a mass like a ball, wherein they move round and round.* The meaning of *mill* later evolved from "to move with a circular motion" to the meaning that is perhaps most frequently encountered today, "to move around with no pattern in particular," as in *He milled about the room talking to anyone who would listen to him.*

mine In Standard English, most possessive pronouns have different forms when used as nouns, or nominals, as in *That book is yours*, than when used as adjectives, as in *That is your book*. The two exceptions are *his* and *its*, which retain the same form in both usages. The nominal forms all end in *-s* except for *mine*. In some vernacular dialects of New England and the American South, all nominal possessive pronouns end in *-n*, just like *mine*, as in *That book is hern* (but not "That's hern book") and *Those cookies are ourn*. Although forms such as *hisn* and *hern* are highly socially stigmatized, from a strictly linguistic standpoint these forms reflect a natural phenomenon in the development of all languages and dialects: irregular patterns tend to be regularized, thereby eliminating exceptions to language "rules."

The forms *hisn, hern, ourn, yourn,* and *theirn* have, in fact, a long history in English. They arose in the Middle English period (c. 1100–1500) by analogy with *mine* and *thine,* forms that are older than *my* and *thy* and that can be traced all the way back to Old English (c. 449–1100). Originally, *my* and *thy* were used before nouns beginning with consonant sounds, as in *my book,* while *mine* and *thine* were used before nouns beginning with vowel sounds, as in *mine eyes*—as *a* and *an* still are. This distinction persisted into the 18th century. But as nominal pronouns, *mine* and *thine* remained unchanged. This invariant use of *-n* led to its use for all nominal possessive pronouns (except *its,* which usually is not used nominally, as in *That book is its*). In fact, these *-n* forms may be older than the current standard *-s* forms, which arose late in the Middle English period, by analogy to *his.*

Most likely, *hern, ourn, yourn,* and *theirn* originated somewhere in the central area of southern England, since they can still be found throughout many parts of that region. In the United States, the forms appear to be increasingly confined to older speakers in relatively isolated areas, indicating that these features are at last fading from use. In some Southern-based vernacular dialects, particularly African American Vernacular English, the irregular standard English pattern for nominal possessive forms has been regularized and made to conform to the pattern exhibited by *her* and *hers* or *our* and *ours* by adding *-s* to *mine,* as in *That book is mines.*

Minnesota Minnesotans may tell you that *Minnesota* means "ten thousand lakes" in a Native American language, and they may attempt to prove it by pointing to the motto on their license plates. The word does in fact come from a Native American language—specifically, one of the group of closely related languages including Dakota, Lakota, and Nakota that are spoken in the Upper Midwest of the United States. (These languages are often known collectively as *Sioux.* Members of the tribes speaking these languages, however, often reject the use of the word *Sioux* to designate their tribes or their languages, since the word prob-

ably originated as a derogatory term in the unrelated Ottawa language.) *Minnesota* actually means "cloudy water," an accurate description of the Minnesota River.

Another popular etymology of a similar-sounding Native American name has *Minnehaha* meaning "laughing waters," when in fact it means "waterfalls." The misinterpretation began around 1849 when European settlers, not unreasonably, assumed that the *–haha* in the local term *Minnehaha* was an imitation of laughter just as in English, and hence that *minnehaha* meant "laughing waters." The folk etymology caught on and wound up appearing in 1855 as the name of the heroine in Henry Wadsworth Longfellow's poem *The Song of Hiawatha*.

The name of the city of Minneapolis is also ultimately derived from *Minnehaha*. When the commissioners of Hennepin County began drawing up plans in 1852 for a county seat that would eventually become the city of Minneapolis, one of the original proposals for the name of the new seat was *Minnehapolis*. The first part of the name was taken from *minnehaha* and made reference to the various waterfalls, including St. Anthony Falls and Minnehaha Falls, found in and about the city of Minneapolis. The second part consists of the Greek word for city, *polis*. Eventually a form without the *h* was adopted.

mummy

> 'Tis true; there's magic in the web of it.
> A sibyl, that had numb'red in the world
> The sun to course two hundred compasses,
> In her prophetic fury sew'd the work;
> The worms were hallowed that did breed the silk,
> And it was dy'd in mummy which the skillful
> Conserv'd of maidens' hearts.

—William Shakespeare, *Othello*, Act 3, Scene 4

Many readers will perhaps be puzzled by the use of the word *mummy* in the passage above, Othello's description of the fine

handkerchief that he has presented to his wife Desdemona—a few square inches of silk that will become the sinister instrument of the villain Iago in driving Othello to murder and suicide. It was woven by a two-hundred-year-old prophetess in a mystic trance from silk produced by sacred silkworms. But what can Othello mean by *dyed in mummy* taken from virgins' hearts? That it was rubbed on the rotting flesh of corpses? This would hardly make an exquisite gift for his wife. A clue to this puzzle appears in another of Shakespeare's plays, where *mummy* appears among the ingredients of the brew prepared by the witches in *Macbeth* (Act 4, Scene 1):

> THREE WITCHES: *Double, double, toil and trouble;*
> *Fire burn, and cauldron bubble.*
> THIRD WITCH: *Scale of dragon, tooth of wolf,*
> *Witch's mummy, maw and gulf*
> *Of the ravin'd salt-sea shark,*
> *Root of hemlock digg'd i' the dark*

In fact, when the word *mummy* first appeared in the English language around 1400, it denoted a bituminous material extracted from embalmed Egyptian corpses that—incredibly—was valued as a medicine. As an example of the medical use of mummy, the *Middle English Dictionary* quotes a manuscript from around 1425 that offers the following treatment for a wound: *þen encarne it wiþ pouder of fraunke encense and drie it with pouder of mummie.* ("Then cover it with powdered frankincense and dry it with powdered mummy.") The mummy powder of the Middle Ages usually consisted of the resins and costly fragrant unguents that the ancient Egyptians used in the embalming process. These resins could be collected from around the corpses when the ancient sepulchers were opened, and the dry flesh of the corpses themselves was also broken and pulverized for use as medicinal mummy. Only later, in the 1700s, did the English word *mummy* come to refer to the entire embalmed corpse that provided the substance, in the sense in which the word is most often used today.

The word *mummy*, however, does not itself originate with the ancient Egyptians. English *mummy* comes from Old French *momie*, which in turn is from the Medieval Latin word *mumia*. This medical term derives from Arabic *mūmiyā*', originally referring to various resinous or bituminous substances used in medicine. Among the medieval Arabs, the sepulchers of the ancient Egyptians offered a source of such resins. The Arabic word *Mūmiyā*' itself is derived from Arabic *mūm*, "bitumen" or "wax," which in turn is a borrowing of Persian *mūm*.

Muse The Muse has inspired English poetry since Chaucer invoked her in 1374, just as so many other poets have done since the days when the Greeks recited the poems of Homer, who begins both *The Iliad* and *The Odyssey* with an invocation of the goddess. *Muse* comes from Latin *Mūsa*, which in turn is from Greek *Mousa*. In Greek dialects, this word is found in the variant forms *mōsa* and *moisa*, and together these forms indicate that the Greek word comes from an original **montya*. As to the further origins of this form, a clue is provided by the name of Mnemosyne, the goddess of memory and mother of the Muses. Her name is simply the Greek noun *mnēmosunē*, "memory." For the ancient Greek poets whose job it was to compose new poems in traditional styles in order to mark notable occasions, to recite the verses of Homer, and to make up material whenever they had a memory lapse, the faculty of memory was indeed the mother of invention. *Mnēmosunē* is derived from the root **mnā–*, an extended form of the Greek and Indo-European root **men–*, "to think." This is the root from which English gets the words *amnesia* (from Greek), *mental* (from Latin), and *mind* (from Germanic). The reconstructed form **montya* that is the ancestor of Greek *Mousa* could then mean something like "having mental power"—the Muse was the poet's divinized conception of the mental faculties that allowed him to create and recite poetry.

muslin Muslin, a sturdy cotton fabric of plain weave, is used to make both clothing and household items like curtains. The word

muslin designating this fabric first appears in English in the early 17th century, and it is a borrowing of French *mousseline*, which in turn is from Italian *mussolina*. The Italian word for the fabric is derived from *Mussolo*—an older Italian name for the city of Mosul in Iraq where muslin cloth was produced. In medieval times, Mosul was known in Europe for the very fine cloth of silk and gold woven in the city, but later the various European terms for "cloth from Mosul" came to refer to fine cotton cloths.

The name of Mosul in Arabic is *al-Mawṣil*, which literally means "the place of joining," and is derived from the Arabic verb *waṣala* meaning "to join" and "to form." Situated on the banks of the Tigris River at the southern edge of the northern portion of Iraq, in which the majority of the population is Kurdish, Mosul is the second largest city in Iraq and a strategically important center of oil production. Modern Mosul is very near the site of Nineveh, the capital of the Assyrian Empire that ruled much of the Near East from around 1000 BC until 612 BC, and the history of permanent human settlement in the Mosul area stretches back to at least 6000 BC.

MUUMUU People who are not from Hawaii usually think of the muumuu as the quintessential Hawaiian garment. It is in fact a relatively recent introduction that has driven more traditional attire to the edge of extinction. Prior to the 1800s, the traditional garment of Hawaiian women was the *pāʻū*, a sarong worn wrapped around the waist. (The symbol (ʻ) in Hawaiian words like *pāʻū* represents a sound called the glottal stop—a sound like a catch in the throat heard in the middle of the English exclamation *Uh-oh*.) The traditional *pāʻū*

muumuu

consisted of tapa cloth, a kind of cloth made by pounding the inner bark of the paper mulberry tree. The influence of Christian

missionaries and the appeal of exotic western fashions, however, led to the adoption in the 19th century of a long-sleeve dress called a *holokū*. The holoku was modeled after the Mother Hubbard dress worn by missionary wives but was fitted with a higher waist to accommodate the regal figures of the Hawaiian ruling class, or *ali'i*. By contrast, the chemise that accompanied the holoku was called a *mu'umu'u*, literally "cut off," because of its wide neck and short sleeves. This simple, white undergarment, although sometimes worn on its own for swimming or house-work, was not considered acceptable for public view until the 1940s. But with the introduction of colorful rayon fabrics, the loose-fitting muumuu quickly replaced the tailored holoku as the customary attire for all but the most formal occasions. The muumuu's popularity with tourists visiting Hawaii eventually made the word known throughout the English speaking world.

N

nachos This Tex-Mex staple gets its name from Sr. Ignacio "Nacho" Anaya, who invented them in 1943. Sr. Anaya was the maître d'hôtel at the Victory Club restaurant in Piedras Negras, a city in the Mexican state of Coahuila located on the Rio Grande across from Eagle Pass, Texas. One evening, after a large group of guests had arrived at the restaurant, Sr. Anaya could not find the chef, so he went into the kitchen to prepare something himself. He took tostadas (corn tortillas deep-fat fried until crisp), grated some cheese over them, and put them under the broiler. When the cheese had melted, he added some jalapeño pepper slices on top and emerged with the first plate of nachos ever made. His creation was a hit and came to be known as *Nacho's especiales* (that is, "Nacho's specials"), eventually shortened to just *nachos*. (In Spanish, *Nacho* is a common nickname for men called *Ignacio*.) Nachos became quite popular in southern Texas, and somewhat later, in the 1970s, the well-known sports journalist Howard Cosell tasted them. He began to promote them at every opportunity, and the fame of nachos spread to all corners of the United States. To honor the creation of nachos, a nacho festival is now held annually in Piedras Negras.

narcissism *Narcissism*, "excessive love or admiration of oneself," is a fairly new word in English for what is undoubtedly a very old sort of personality trait. An early use of the word *narcissism* is known from letter written by the famous poet Samuel Taylor Coleridge in 1822, but the word reappears in English only in 1905, when it is used a translation of the German technical term in psy-

chology, *Narcissismus*. The German word had been had been coined or reinvented in 1899 by the researcher Paul Näcke as a technical term meaning "pleasure derived from contemplation or admiration of one's own body or self," in reference to Narcissus, a figure of Greek legend who was transformed into the flower that bears his name. The derived word *narcissist* first appears in English in 1917.

The Roman poet Ovid tells the story of Narcissus in his work *Metamorphoses*. Narcissus, the son of a nymph and a river-god, had many admirers, but he spurned them all, including the nymph Echo. (Echo, by the way, could not form her own words, but had been condemned by the queen of the gods, Hera, always to repeat the speech of others. When Hera had gone out in search of her errant husband Zeus, Echo had often waylaid her with idle chatter so that the other nymphs, who had been disporting themselves with Zeus, could made their escape. Hera had therefore cursed her so that she could only utter words just spoken by others.) One of Narcissus' many rejected lovers cursed the beautiful young man for his hard-heartedness: "Let him love too, and be unable to obtain the one he loves!"

And so it happened. While hunting, Narcissus came to a pool of water shaded by a little wood. He leant down to drink and saw the image of a lovely youth reflected in the water. Instantly he fell in love with the handsome face, and he remained rooted to the banks of the pool, contemplating his own image. Narcissus tried to kiss the object of his desire, but it always eluded his embrace. He addressed loving words to the face he saw, and Echo, who took pity on him, repeated them so that Narcissus thought his lover was answering him. Eventually he pined away and died of his unfulfilled love, and when the nymphs came to give him a proper funeral, they found the narcissus flower nodding over the pool in place of his body.

need When *need* is used as the main verb in a sentence in Standard English, it can be followed by a present participle, as in *The car needs washing*, or by *to be* plus a past participle, as in *The car needs*

to be washed. However, in some areas of the United States, especially western Pennsylvania and eastern Ohio, many speakers omit *to be* and use just the past participle form, as in *The car needs washed,* or *This fence needs painted* or even *Workers' salaries need raised.* This use of *need* with past participles can also be found in Scottish English as well as in varieties of English spoken in the northern part of Ireland, where many English-speaking immigrants of Scottish origin had settled. Many of the immigrants who subsequently settled in Pennsylvania arrived from these two areas of the British Isles, and these immigrants exerted a strong influence on the English of that state. When settlers spread out from Pennsylvania to the Old Frontier of the United States, including the Ohio Valley, they brought with them traits originating in Scottish English and Scots-Irish, including the use of the past participle directly after *need.* The regional dialects that originated mostly in Pennsylvania are known collectively as the Midland dialects of the United States.

neutral ground The strip of grass dividing the opposing lanes of an avenue or a highway is known by a variety of terms in the United States. The most common term, used almost everywhere except westward from the Rocky Mountains, is *median strip* or *median.* In upstate New York, it is also called a *mall,* and in Pennsylvania, a *medial strip.* In the Midwest, the strip is also known as a *meridian* or a *boulevard.* In Tennessee, however, some people call it a *neutral strip,* while in Louisiana and southern Mississippi, the term used is *neutral ground*—"as if the highway were a battle zone," observes American dialectologist Craig M. Carver in *American Regional Dialects.*

nirvana In the language of advertising and pop culture, the word *nirvana* has recently come to be almost synonymous with heaven or paradise in expressions like *chocolate-caramel nirvana.* For Buddhists, Hindus, and Jains, however, the Sanskrit term *nirvāṇa* denotes a fundamental concept—the ultimate goal of all religious practice in their respective religions—which is originally rather

different from the idea of paradise in Christianity or Islam. In Buddhism, for instance, *nirvāṇa* denotes the ineffable condition of those who attain the highest wisdom and freedom from attachment, while in Hinduism the term describes the release from ignorance and from attachment usually achieved by mystical union with the supreme deity. In these Eastern schools of thought, worldly desires, as well as the inevitable suffering resulting from these desires, are likened to the burning of fire. The goal of religious practice is to extinguish this fire by extinguishing the self—which will be blown out like a candle flame.

Sanskrit *nirvāṇa* literally means "the act of blowing out, extinction (as of a flame)," and is a compound derived from *nir*, "out," and the verb *vāti*, "he blows." Sankrit *vāti* comes from the Indo-European root **wē–*, "to blow." This root is perhaps onomatopoeic in origin and imitates the sound of the wind whistling or howling. English has several other words derived in various ways from the same root **wē–*. The noun **wē-nt-o–*, made from **wē–* with the suffix *–nt–*, is at the base of the Latin word for *ventus*, "wind," the source of English words like *vent* and *ventilate*. On the way from Indo-European to English, the same **wē-nt-o–* became Germanic *windaz*, which further developed into English *wind*. *Weather* too derives from a shortened form, **we–*, of the same root by way of Proto-Germanic **we-dhro–*.

nitrogen

> *For though thou wash thee with nitre, and take thee much soap, yet thine iniquity is marked before Me, saith the Lord God.*
>
> —Jeremiah 2:22

Like *adobe* and *sash*, *nitrogen* is a word that can be traced back to Egypt and the ancient Near East, though the discovery of nitrogen as a chemical element is a consequence of modern science. The English word *nitrogen* is a borrowing of French *nitrogène*, a term coined in 1790 by the chemist Jean-Antoine Chaptal, comte

de Chanteloup (1756–1832). The French word is composed of the suffix *–gène*, "giving rise to," added to *nitro–*, which is ultimately derived from the Latin *nitrum*, "niter." In modern English usage, the word *niter* is another name for saltpeter, which is a white, gray, or colorless mineral composed of potassium nitrate (KNO_3) that is used in making gunpowder. In the 1790s, Chaptal was employed by the French government to discover a way to produce saltpeter—or *nitre* as it is called in French—cheaply. At the time, France depended on deposits in Asia and elsewhere for its supply of saltpeter—if this supply were to have been cut off somehow, France would no longer have been able to produce gunpowder and thus defend its borders. Chaptal eventually discovered a process that provided France with a plentiful supply, and the modern English term *nitrogen* springs from his research.

In the 1700s, many other scientists, such as Joseph Priestley, had been studying the make-up of air, and in 1772 the English scientist Daniel Rutherford published the first account of nitrogen, which he called *noxious air*, as a separate element. The French name for the part of air that was eventually recognized as the element nitrogen was *azote*, ultimately derived from Greek *a-*, "not," and *zōē*, "life," since nitrogen does not support respiration and animals placed in pure nitrogen will die. Although *azote* remains the name for the element nitrogen in French today, Chaptal suggested calling it *nitrogène*, since it was one of the elements present in the vital raw material niter or saltpeter, and his suggestion eventually caught on in English.

The Latin word *nitrum* did not, however, originally denote niter, but rather natron, a naturally occurring hydrous sodium carbonate ($NaCO_3 \cdot 10H_2O$) mixed with traces of other minerals. The ancient Egyptians mined natural deposits of natron found in the dry lakebeds in the desert and used the substance in embalming mummies and making soap. The Egyptians called the mineral *nṯrj*, and they exported it to the rest of the ancient world, where it was used for a variety of purposes.

The Egyptian writing system did not have a straightforward method of writing vowels, only consonants—which is why

Egyptian words written in hieroglyphs are usually transliterated by Egyptologists as long strings of consonants that look absolutely unpronounceable to someone who has not studied the language. The exact way in which the ancient Egyptians pronounced the word they wrote as *nṯrj* must remain a subject of conjecture. The Egyptian hieroglyph transliterated as *ṯ* in *nṯrj*, however, probably represented a sound like (ch) at some period in the history of the Egyptian language. Most Egyptologists usually read the word as (nĕ-chĕ-rē), using a widespread convention of inserting the vowel *e* or *a* between consonants for the purpose of pronouncing words written in hieroglyphics.

We can gather some indication of the actual pronunciation of *nṯrj* from the way that the other peoples of the ancient world who imported natron from Egypt pronounced the Egyptian word after borrowing it into their own languages. The ancient Israelites called the substance *neter* in Hebrew, while the Greeks called it *nitron* or *litron* in their own language. The Greek word entered Latin as *nitrum*, and the Latin word later appears in French as *nitre*, source of the English word *niter*. Both the French and English words originally denoted natron, but they later came to be applied to saltpeter since both natron and saltpeter (niter) are minerals found as dry incrustations left by the evaporation of water.

The medieval Arabs, too, borrowed the Greek word *nitron* and pronounced it as *natrūn*. The Arabic word then entered Spanish as *natrón* and French as *natron*, and from these languages the word *natron* reached English. In this way, English *natron* as well as *nitrogen* ultimately derives from Egyptian *nṯrj*.

nostril

> Her kittle black een they wad thirl you thro',
> Her rose-bud lips cry, kiss me now
>
> —Robert Burns "Muirland Meg"

It is easy enough to notice the word *nose* in *nostril*—but what is the *tril*? *Nostril* is in fact an old compound meaning "nose hole." Appearing as *nosthyrl* in Old English and *nosthirl* in early

Middle English, the meaning of the word would have been obvious to speakers of the time: Old English *nosu* (Middle English *nose*) meant "nose," and Old English *thȳrel* (Middle English *thirl*) meant "hole." In Old English, *th* regularly became *t* after an *s*, and so Old English already had forms like *nosterl* with a *t* as in the modern word *nostril* (although the *th* was continually being reintroduced by influence of the *th* of *thȳrel*). It was in Middle English, however, that METATHESIS of *r* and the vowel, from *nosterl* to *nostril*, occurred. The same metathesis of the *r* and *i* occurred in other words, such as *third*, from Old English *thridda*, and *bird*, from Old English *bridda*.

Old English *thȳrel*, "hole," remained a separate, living word in Middle English as *thirl*, and it survives in modern times in some English dialects in such meanings as "a hole in a wall though which sheep can pass." Old English also had a verb *thyrlian*, "to drill a hole in, pierce," derived from *thȳrel*, and the verb too survived into recent centuries as *thirl* in various English dialects. However, the metathesized version of this verb, *thrill*, has had an exciting life of its own in Modern English. In Shakespeare's time, *thrill* was still a vivid metaphor—to be *thrilled* was to be *pierced* by a strong feeling. In *Romeo and Juliet* (Act 4, Scene 3), Juliet describes her great apprehension before taking the potion that will cause her to fall into a deathlike sleep, as part of Friar Lawrence's plan to help her escape from Verona with Romeo:

> *I have a faint cold fear thrills through my veins,*
> *That almost freezes up the heat of life.*
> *I'll call them back again to comfort me.*
> *Nurse!—What should she do here?*
> *My dismal scene I needs must act alone.*
> *Come, vial.*
> *What if this mixture do not work at all?*

Only later did *thrill* acquire its modern tendency to be associated with more positive emotions like excitement and exhilaration, as in expressions like *I am thrilled to hear it* or *I was less than thrilled.*

O

of Some speakers of vernacular English varieties, particularly in isolated or mountainous regions of the southern United States, use phrases such as *of a night* or *of an evening* in place of Standard English *at night* or *in the evening*, as in *We'd go hunting of an evening*. This *of* construction is used only when referring to a repeated action—where Standard English uses *nights, evenings*, and the like, as in *We'd go hunting nights*. It is not used for single actions, as in *She returned at night*.

Interestingly, these *of* and *-s* constructions are related. The *-s* in *nights* is not, in origin, the *-s* that indicates the plural of nouns, even though at first glance we might suspect that the word *nights*, when used adverbially in *We'd go hunting nights*, is somehow an abbreviation of a prepositional phrase like *during the nights*. The *-s* in adverbial *nights* actually has a far different origin. The construction dates back to the Old English period and developed from a specialized use of the GENITIVE singular suffix *-s*, which often indicates possession. The Old English word for "day" was *dæg* and its genitive singular form was *dæges*. (Its NOMINATIVE plural form was *dagas*, and this is the form from which the modern plural form *days* can be considered to descend in a sense.) The Old English genitive singular form *dæges*, besides indicating possession like its modern descendant *day's*, was also used as an adverb meaning "by day." From adverbial genitives like *dæges*, the genitive singular ending *-s* came to be used to form adverbs even from nouns that did not originally make their genitive form in *s*. Thus the genitive of *niht*, "night," in Old English was originally *nihte* with no *-s*, but by analogy with *dæges*, "by day," *niht*

162

acquired a genitive *nihtes*, used mostly as an adverb with the meaning "by night."

Since the Middle English period, it has been possible to replace some of these adverbs ending in -*s* with prepositional phrases using *of*. Just as the modern English phrase *the king's throne* (which uses the possessive, the modern descendant of the genitive) can be reformulated as *the throne of the king*, so to can the adverb *nights* be reformulated as *of a night* in some vernacular English dialects. Sometimes the original -*s* ending remains in the *of* construction, as in *We'd walk to the store of evenings*, but usually it is omitted. Using *of* with adverbial time phrases has not always been confined to vernacular speech, as is evidenced by its occurrence in sources from the Wycliffite Bible (1382) to Theodore Dreiser's novel *Jennie Gerhardt* (1911): *There was a place out in one corner of the veranda where he liked to sit of a spring or summer evening.*

Using such *of* constructions reflects a long-standing tendency for English speakers to eliminate the case endings that were once attached to nouns to indicate their role as subject, object, or possessor. Nowadays, word order and the use of prepositional phrases usually determine a noun or noun phrase's role. Despite the trend to replace genitive -*s* with *of* phrases, marking adverbial phrases of time with *of* is fading out of American vernacular usage, probably because one can form these phrases without -*s*, as in *at night*.

Old Scratch *Old Scratch* and *Old Nick* are two widely used nicknames for the Devil. In the last century *Old Scratch* was quite common in the eastern United States, especially in New England, as is evident from the Devil's name for himself in the Stephen Vincent Benét short

Old Scratch

story "The Devil and Daniel Webster." Now the term is more often found in the South. According to the *Oxford English Dictionary,* Old Scratch is attested from the 18th century onward in Great Britain as a colloquialism: *He'd have pitched me to Old Scratch* (Anthony Trollope, 1858). The source of the name is probably the Old Norse word *skratte,* meaning "a wizard, goblin, monster, or devil." The form of the word in English was perhaps influenced by the verb *scratch.*

Old Nick is attested even earlier, in the middle of the 17th century in England. It is usually thought that the *Nick* in *Old Nick* is short for *Nicholas,* but why this nickname should be applied to the Devil remains a mystery. The *Oxford English Dictionary* also notes that *Old Nick* may have developed from *Iniquity,* the personification of vice that appeared as a character in old plays on religious themes.

omelet A brief look at English vocabulary relating to food reveals that a striking number of such words are borrowed from French, not only the names for more delicate dishes like *soufflé, meringue,* and *mousse,* but also many basic terms like *beef, pork,* and *sauce.* The typical *dinner* in a *restaurant* begins with *hors d'œuvres,* followed by a *soup,* an *entrée,* perhaps a *salad,* and as the final and most important *course,* the *dessert*—and we use words of French origin to name all of these.

The word *omelette,* too, is from French, although it is a fairly late contribution to English. Its history begins with the Latin word *lāmella,* "knife blade." The Latin word *lāmella* developed into Old French *lamelle,* and at this stage, the Old French phrase *la lamelle,* "the blade," was reanalyzed as *l'alamelle*—that is, speakers of Old French began to think that the *a* originally belonging to the definite article *la* was actually the beginning of the following noun. They thus created the new forms *alemelle* and *alumelle,* which denoted a sweet dish like an omelet of some sort. The change in meaning from "blade" to "omelet" is usually said to reflect the likeness of the thin layer of cooked egg in an omelet to the thin blade of a knife.

Sometime after the creation of forms like *alumelle*, the diminutive suffix *–ette* was substituted for *–elle* in the word. The *l* and the *m* in *alumette* also changed places, and in 1480, the Middle French form of the word, *amlette*, first makes its appearance. As the word underwent these tortuous developments, the relationship between the original meaning "thin blade" and the meaning "thin layer of cooked egg" was obscured. In the confusion, the word was altered by various attempts to relate the *amlette* to its main ingredient—egg, or *œuf* in French. We thus find various folk-etymological spellings of the word in French, including *œufmollette*, which seems to combine the French words *œuf*, "egg," and *molle*, "soft." The standard Modern French spelling *omelette* with *o* probably reflects a variant of the word *amlette* from southern France. (In Occitan, the language of southern France that has strongly influenced the French spoken in that region, the word for "egg" is *uou*, a word with an *o* sound somewhat similar to the French word but without a final *f*.) Although there was still some indecision between the forms *omelette* and *amelette* in 16th- and 17th-century French, eventually the forms beginning with *o* came to predominate in Modern French. When the word was first borrowed into English in the 17th century, however, spellings like *aumelet* and *amulet* competed with spellings like *omelet*. Perhaps under the influence of its source in French, the culinary language *par excellence*, the spelling with *o* was eventually preferred in English, too.

ostracize The verb *ostracize* ultimately derives from the Greek word *ostrakon*, "potsherd" or "shell of a mollusk." In ancient Greece, people used to jot down their short notes and receipts on pieces of broken pottery just as we write on scraps of paper in the modern world. Potsherds were easy to come by in those days, while paper from papyrus was very expensive. (The Greeks also wrote on wooden tablets coated with beeswax, but these were somewhat better suited to personal letters and lists than to short notes.) For this reason, when the Athenians held a vote to expel a citizen—a procedure called *ostrakismos*, "ostracism"—they would

pick up a potsherd, write the citizen's name on a potsherd, and put it in an urn to be counted.

Each year, the assembly of Athenian citizens would decide whether to hold an ostracism and exile a citizen. If the vote passed, then two months later the Athenian citizens who wished to banish one of their fellows would write his name on an *ostrakon* and put it in one of the urns specially set up for this purpose. The person whose name was written on the most *ostraka* was then exiled from Athens. This procedure was described with the Greek verb *ostrakizein*, "to ostracize," source of the English word *ostracize*.

The ostracized citizen could not return to Athens for ten years, on pain of death. The citizen's property, however, was not confiscated, and he could enjoy the income derived from it while staying with friends or associates in another city. When the citizen returned, he was restored to his full rights. In general, the Athenians seem to have used ostracism to prevent popular citizens from gaining too much power or to defuse political feuds, rather than to punish wrongdoers. One famous Athenian who suffered ostracism was Aristides (530–468 BC), usually called Aristides the Just. He had gained renown through his military leadership during the first war the Greeks fought against the invading Persians, and his strict honesty in distributing the spoils after the Greek victory had secured his reputation for unassailable virtue. The general esteem in which he was held grew so great that some factions apparently wished to see his downfall, and he was eventually ostracized. Nevertheless, he was recalled to Athens after just a few years to help Athens meet the threat of a second Persian invasion. The Greek historian Plutarch (AD 46?–120?) paints an interesting picture of the practice of ostracism when he reports an anecdote illustrating Aristides' upright character. On the day when the ostracism was being held, an illiterate farmer approached Aristides and asked him to write *Aristides* on his potsherd—not knowing that it was Aristides himself that he addressed. Aristides asked what harm had ever come to the farmer, that he should wish to expel Aristides from Athens.

The farmer replied, "None at all ... I don't even know the man. But I am sick of hearing him being called 'the Just' everywhere." Aristides wrote his own name on the potsherd and returned it to the farmer.

Ostrakon is related to the Greek word *ostreion,* "oyster"—ultimately named for its rough, jagged shell. (Both *ostrakon* and *ostreion* are derived from the Proto-Indo-European word **ost–,* "bone," and an interesting parallel to this derivation of a word meaning "shell" from one meaning "bone" is offered by the modern scientific term *exoskeleton,* referring to the hard outer body covering or "outer skeleton" of insects and their relatives.) The Greek word *ostreion* is also the ultimate source of the English word *oyster. Ostreion* was borrowed into Latin in the forms *ostreum* and *ostrea,* and Latin *ostrea* subsequently developed into Old French *oistre.* The Old French was then borrowed into Middle English and appears in Modern English as *oyster.*

otorhinolaryngology

Otorhinolaryngology is the type of medical word that drives the layperson to despair, both of pronouncing the word properly and of having any notion of what it means. The pronunciation of the word is (ō′tō-rī′nō-lăr′ĭng-**gŏl′**ə-jē). The meaning of the word, on the other hand, becomes clear once one knows that *oto–, rhino–,* and *laryngo–,* are the forms of the Greek words *ous,* "ear," *rhīs,* "nose," and *larunx,* "larynx or upper part of the windpipe." The cavities of the middle ear, the nose, and the throat inside the head are all connected, and infections and other medical conditions of one of these cavities often involve the other cavities as well, so they are often considered as a group in medical science—hence the creation of the long word *otorhinolaryngology* and its derivatives like *otorhinolaryngologist.*

The Greek word *larunx* has of course been borrowed into English as *larynx,* while Greek *rhīs* is familiar to English speakers from other words like *rhinoceros,* literally meaning "having a horn on the nose." The Greek word *ous* and its stem *oto–* may be less familiar, but they are in fact related to the English word *ear.* Both *ous* and *ear* are derived from the Indo-European root **ous–,* "ear."

Through the operation of a regular change that linguists call VERNER'S LAW, a Proto-Indo-European *s* often became an English *r* as Proto-Indo-European developed into English, and thus *ous–* became the modern word English word *ear*. In the history of Latin too, a Proto-Indo-European *s* often became an *r*, and the root *ous–* also gave rise to the Latin word *auris*, "ear," the source of English words like *aural*.

Ouse River The Great Ouse River rises in south-central England and meanders east and northeast to the Wash, an inlet of the North Sea. Another river in England called the Ouse, an important commercial waterway, rises in northeast England and flows southeast to join the Trent River and form the Humber River. *Ouse*, pronounced (o͞oz), is a perfectly appropriate name for a river, but one whose etymological meaning is likely to raise a smile. The name of these two rivers is derived from the Celtic languages that were spoken in England before the arrival of the Anglo-Saxons in the British Isles. Their Celtic name, *Ūsa*, is derived from *udso–*, "water," which is in turn derived from the Indo-European root *wed–*, "wet, water." The same root *wed–* gives us the English words *water* and *wet* as well. Thus the Ouse River etymologically is the "Water River" or the "Wet River." Of course, the speakers of early forms of the English language who borrowed the name from the Celts did not know the meaning of the word—as is rather frequently the case when foreign topographical terms are borrowed.

P

palm *Palm* meaning "palm of the hand" and *palm* meaning "palm tree" are traditionally considered separate words even though both are descendants of the same Latin word. Their common source, *palma*, originally meant only "palm of the hand," but later came to denote the palm tree either because the leaves of some palms resemble an outspread hand (*palma* was also used for the underside of a webbed foot) or because palm fronds, which symbolized victory in ancient Roman society, were often held in the palms of victors. Old English borrowed *palma* from Latin to mean "palm tree," as palm fronds had become an important symbol in the Christian Church, but kept the Germanic word *folm* for the palm of the hand. Beginning in the 14th century, English pilgrims were commonly known as *palmers,* because they often carried palm fronds as a symbol of their pilgrimage.

The word *palm* meaning "palm of the hand" entered the language by way of Old French *palme* (from Latin *palma*) and supplanted *folm* in Middle English. Both *folm* and *palma* go back to the Indo-European root **pelə–*, "flat," also the source of English *plain*. The *f* in *folm* is the result of GRIMM'S LAW, a series of sound changes that affected certain consonants in the Germanic branch of the Indo-European family.

paparazzi

> *Judging by the credits, half the island found employment on the set, restoring houses, splicing cables and dressing the actors' hair. Donkeys (increasingly rare in Greece) were rented at a premium; fishermen ferried paparazzi to spot*

the stars who came to sun themselves on Cephalonia's newly famous beaches.

—Maria Margaronis, "Whitewash in the Ionian," *The Nation*, August 20, 2001

Paparazzi resemble insects as they swarm around a celebrity like bees around a queen or pop their flashbulbs like so many fireflies. Paparazzi are reporters or photographers, especially freelancers, who doggedly search for sensational stories about celebrities or take candid pictures of them for magazines and newspapers. We have borrowed the singular form *paparazzo* and its plural *paparazzi* from Italian. The Italian word *paparazzo* comes from the name of a character, Signor Paparazzo, a photographer in Federico Fellini's 1960 film *La Dolce Vita*.

Fellini himself has explained that his inspiration for the shutterbug's name literally came from an insect, according to photographer Ron Galella, something of a paparazzo himself and noted for his photographic pursuit of, among others, Jacqueline Kennedy Onassis. In a letter quoted in Galella's 1974 book *Jacqueline*, Fellini said: *When I was a schoolboy in Rimini ... I shared a desk with a very restless boy who was always squirming, who was always talking so fast that his words came out stuck together in an endless buzzing. A teacher baptized him "Paparazzo," which in my part of the country is an insect, a sort of mosquito that's always emitting a buzz. While I was writing the script for* La Dolce Vita *that nickname came to mind, and so I named one of the photoreporters Paparazzo.*

Others, however, have observed that during the production of the film Fellini was reading an Italian translation of George Gissing's travel diary *By the Ionian Sea* in which Gissing mentions a solicitous innkeeper named "Coriolano Paparazzo."

petard

For 'tis the sport to have the enginer
Hoist with his own petar, an't shall go hard
But I will delve one yard below their mines,

And blow them at the moon. O, 'tis most sweet
When in one line two crafts directly meet.

—William Shakespeare, *Hamlet,* (Act 3, Scene 4)

The French word *pétard* has a variety of meanings, including "firecracker," "detonator for explosives," and also "a sensational or scandalous piece of news." In the past, the word referred to a kind of small bomb used for blasting through the gates of a city, and English borrowed the word in this sense in the middle of the 16th century, when it appears in various spellings, such as *petar, pittard,* and *petard*. The word later makes a notable appearance in Shakespeare's tragedy *Hamlet*. Hamlet uses the term when describing the trick he played on his treacherous former friends, Rosencranz

petard

engraving from Francis Grose's
Military Antiquities Respecting a
History of the English Army from
Conquest to the Present Time

and Guildenstern. They were sent with Hamlet to England along with letters ordering Hamlet's death, but Hamlet secretly altered the letters so that Rosencranz and Guildenstern would be killed instead. *To be hoist by one's own petard* ("to blow oneself up with one's own bomb, be undone by one's own devices") is a now proverbial phrase apparently originating with Shakespeare's play, which dates from around 1604.

The French noun *pétard* is in fact derived from *pet*, "fart." *Pet* developed regularly from the Latin noun *pēditum*, from the Indo-European root **pezd–*, "to fart." Proto-Indo-European had another root meaning "fart," **perd–*, the source of English *fart*, and the two roots sound strangely like each other.

Philistine The Philistines were a people of the ancient world who lived in Philistia, the area in and around the coastal region now

called the Gaza Strip. The English name of this people, the *Philistines*, ultimately comes from Hebrew *Pəlištîm*, which is in turned derived from *Pəlešet*, the Hebrew name for Philistia. In fact, the word *Palestine*, the more recent historical designation for the entire region between Lebanon and Egypt, also ultimately derives from the name of the Philistines.

Strategically located on a trade route from Egypt to Syria, the cities of Philistia formed a loose confederacy important in biblical times, and the Bible depicts the Philistines engaged in a struggle with the tribes of Israel for ascendancy in the region. The mighty Israelite warrior Samson, for example, fought with the Philistines on several occasions, even though he married a Philistine woman. Samson also fell in love with another Philistine woman, Delilah. While Samson slept in Delilah's lap, she had the magic locks that gave Samson his strength shaved off so that his Philistine enemies could capture and enslave him.

During the 17th century, as a result of the depiction of the Philistines in the Bible, the word *philistine* came to be applied figuratively to anyone considered an enemy. Nowadays, the word is most commonly used to describe a smug, ignorant person who is indifferent or antagonistic to art and culture. This usage probably stems from a memorial service given in 1693 for a student killed during a town-gown quarrel in Jena, a university town in Germany. The minister preached a sermon from the text *Philister über dir Simson!* ("The Philistines be upon thee, Samson!"), the words of Delilah to Samson after she attempted to render him powerless before the Philistines. German students came to use *Philister*, the German equivalent of the English word *Philistine*, to refer to nonstudents and hence uncultured or materialistic people, and this German usage was picked up in English in the early 19th century.

philodendron The word *philodendron* is derived from Greek *philos*, "loving," and *dendron*, "tree," and literally means "fond of trees." The name was given to this genus of climbing plants because in their tropical American habitat they twine around trees. Most

philodendrons are epiphytes—they grow upon another plant. Epiphytes, however, depend on other plants only for mechanical support, not for nutrients. The word *epiphyte* itself comes from the Greek words *epi*, "upon," and *phuton*, "plant."

philodendron

The Greek word *dendron*, which can also be found in words like *rhododendron* and *dendrochronology*, is descended from the Indo-European root **deru–*, "solid." The English word *tree* also comes from **deru–*, since trees have sturdy trunks and are the source of solid wood. In the Germanic branch of the Indo-European family, the branch to which English belongs, the initial *d* became a *t* in accordance with GRIMM'S LAW. The root **deru–* "solid, firm," has also given rise to the English words *truth*, *truce*, and *trust*.

picayune The charming word *picayune* is usually found today in the meanings "petty, trivial, paltry" and "petty, mean" as in the following excerpt from an article in *The Nation* (February 14, 2002) by journalist John Nichols:

> [*US Representative John*] *Lewis was not alone in pushing the debate beyond the picayune toward broader dialogue about the very character of American democracy.* "At issue is the shape of American democracy; at issue also is the shape of our political parties.... Do we want our parties dependent on the big and powerful or the individual citizen?"

Originally, *picayune* referred to a coin of low value, such as a five-cent piece. Its meaning was soon extended to "a thing of little value," and from there it became an adjective meaning "paltry, petty." (The same semantic development can be traced in other English expressions like *two-penny* or *two-bit*, originally referring

to something worth *two bits*—that is, twenty-five cents.) In origin, *picayune* is probably a borrowing from Louisiana French, the rich mixture of French dialects spoken in Louisiana from the beginning of French settlement there in the 17th century and still spoken there today. In the Louisiana French of the past, the word *picaillon* referred to another small coin, the Spanish half-real, that circulated in the area during colonial times. The word *picaillon* is in turn a borrowing of Provençal *picaioun*, a copper coin of Piedmont and Savoy, historical regions of the southeast of France. (Provençal, spoken in the south of France, is a Romance language closely related to French.) Provençal *picaioun* is ultimately derived from Old Provençal *piquar*, "to jingle, clink."

In the 2000 census, almost two hundred thousand persons in Louisiana identified French as one of the primary languages spoken in their home. Several different immigrant groups, including the Cajuns (originally from the region of Acadia in Canada) as well as speakers of French creoles from the Caribbean and settlers from France itself, have contributed to the formation of the French dialects spoken in Louisiana. From these various dialects, several interesting words have found their way into American English. *Bayou* is from Louisiana French *bayou*, a word also found in the form *bayouque* and perhaps ultimately from Choctaw, a Native American language.

Louisiana French has served as a conduit of words from Africa into English. *Gumbo* is from Louisiana French *gombo*, which in turn is from a Bantu word for "okra," akin to the Tshiluba word *kingumbo*. Tshiluba is a language of southeastern Congo, and the Bantu languages are a large group of languages of Africa, spoken over a vast area stretching from Cameroon and Kenya in the North to the Cape of Good Hope in South Africa.

The entries for the words *beignet, faubourg,* and *lagniappe* in this book tell the history of other words that have entered into English by way of Louisiana French.

pilot Although they do not touch ground, the pilot of an aircraft speeding through the air and the pilot of a watercraft plowing

through the water can both "make tracks," that is, move along. It is this idea that relates the English word *foot* to the word *pilot.* Both can be traced back to the Indo-European root **ped–,* meaning "foot." Through the effects of GRIMM's LAW, which changes a Proto-Indo-European *p* to an *f* and a Proto-Indo-European *d* to a *t* in the history of the Germanic languages, the root **ped–* gave rise to the English word *foot.* From a suffixed form of the same root with a lengthened vowel, **pēdo–,* came the Greek word *pēdon,* "blade of an oar." To the speakers of Proto-Indo-European or the early Greeks, it perhaps seemed that the oars of a boat sped it along just like feet. The plural of this word, *pēda,* could mean "steering paddle, rudder." In Medieval Greek there is assumed to have existed the derivative **pēdōtēs,* "steersman," which passed into Old Italian and acquired several forms, including *pedota* and *pilota.* This last form was borrowed into Middle French as *pilot* and *pilote.* English then borrowed the word from French as *pilot,* which begins to appear in the middle of the 1500s. Later, in 1848, *pilot* is first recorded with reference to an airborne pilot—a balloonist in an air balloon.

pocosin In coastal Virginia, Maryland, Delaware, and the Carolinas, a swamp or marsh can be called a *pocosin* or a *dismal,* the second term illustrated in the name of the Dismal Swamp on the border of North Carolina and Virginia. The word *pocosin,* pronounced (pə-kō′sĭn) but also occasionally (pō′kə-sən) is probably a borrowing from Virginia Algonquian, the extinct ALGONQUIAN language of eastern Virginia. The early settlers used *pocosin* as a designation for low swampy ground, especially a wooded swamp.

poke *A pig in a poke* is a colorful vernacular expression used to describe something offered in a manner that conceals its true nature or value. Naturally, a buyer cannot inspect the pig if it is covered by a poke—that is, a bag or sack. In many parts of Scotland, *poke* is still used of a little paper bag for carrying purchases or a cone-shaped piece of paper for an ice-cream cone. *Poke* first appears in English in the 14th century and probably

comes from Old North French. The Old North French word in turn is probably of Germanic origin and is related to words like Icelandic *poki*, "bag."

Poke has several relatives within English. The word *pocket* comes from Middle English *poket*, meaning "pouch, small bag," which in turn comes from Anglo-Norman *pokete*, diminutive of Old North French *poke*. *Pouche*, a variant form of Old North French *poke*, is the source of the English word *pouch* itself.

Pomerania *Pomerania* was a district, part of the kingdom of Prussia, that extended along the Baltic Sea from Straslund in eastern Germany to the Vistula River in Poland. The adjective *Pomeranian* first occurs in English around 1760, referring to the toy dog, originally a sled dog in Lapland and later a shepherd dog in Germany. *Pomerania* is the medieval Latin form of German *Pommern*, itself a loanword in German from Slavic. The Polish word for *Pomerania* is *Pomorze*, composed of the preposition *po*, "along, by," and *morze*, "sea." The earlier Slavic word for sea, *more*, which becomes *morze* in Polish, comes from the Proto-Indo-European noun **mori–*, "sea." The same Proto-Indo-European noun is also the source of Latin *mare*, "sea," familiar to English speakers from such derivatives as *mariner* and *submarine*. Proto-Indo-European **mori–* can also be seen in the *mer–* of English *mermaid*.

pone A staple of the early American colonies from New England southward to Virginia was *pone*, a bread made by Native Americans from flat cakes of cornmeal dough baked in ashes. *Pone* comes from the word for "cornbread," *poan* or *appoan*, in Virginia Algonquian, the extinct ALGONQUIAN language once spoken in eastern Virginia. The word *pone*, usually found in the compound *cornpone*, is now used mainly in the South, where it describes cakes of cornbread baked on a griddle or in hot ashes— as the Native Americans originally cooked it.

Virginia Algonquian has contributed many other words to American English, especially for things like foodstuffs and animals that were new to the European settlers in North America.

Hominy, for example, is a shortening of Virginia Algonquian *uskatahomen*, while *hickory* is short for Virginia Algonquian *pocohiquara*, a drink made of pressed hickory nuts. *Puccoon*, referring to several species of plants that provide a red dyestuff, *tuckahoe*, referring to several edible plants such as the arrow arum, and *persimmon* are among the names for other useful plants that come from Virginia Algonquian. Among the English names of North American animals, *raccoon, opossum,* and *terrapin* are of Virginia Algonquian origin as well. *Tomahawk* comes from Virginia Algonquian *tamahaac. Pocosin*, another English word that is probably from Virginia Algonquian, is discussed at a separate entry in this book.

pony up The expression *pony up*, a jocular way of saying *pay up*, seems to have originated in American English during the first few decades of the 19th century. According to the *Oxford English Dictionary*, the earliest occurrence of the phrase in print is found in an American publication dating from 1825: *Every man ... vociferously swore that he had ponied up his "quarter."* This Americanism probably has its roots in British slang of the 18th century, however. The word *pony* (spelled *poney*) is found with the meaning "a small sum of money" in the 1811 version of Captain Francis Grose's *Classical Dictionary of the Vulgar Tongue*, a British lexicon of slang that is an invaluable source of information about the colloquial English of the past. The slang use of *pony* probably arose from a notion likening a small sum of money to a small horse. *Pony* can still be used today to denote various small things, such as a small glass of beer. Captain Grose's dictionary also records the expression *post the pony*, meaning "to pay up," and the modern phrase *pony up* probably continues this usage. *Pony* has also been a British slang term for the round sum of twenty-five pounds since the late 18th century—when twenty-five pounds was in fact a considerable sum of money.

The word *pony*, "small horse," is thought to be a borrowing of the Scottish word *powney. Pony* originally referred to small Scottish breeds—in Nathan Bailey's *Dictionarium Britannicum:*

or a More Compleat Universal Etymological English Dictionary published in the 1730s, the word *pony* is defined as "a little Scotch horse." *Powney* itself is probably a borrowing of French *poulainet,* "little colt, little foal," which is a diminutive of *poulain,* "colt, foal." French *poulain* in turn ultimately derives from Latin *pullus,* a word that basically meant "small or young animal" but was used in particular of foals and also of chickens. The English words *poultry* and *pullet* ultimately derive from Latin *pullus* as well.

pork As has often been remarked, the great social disparities of medieval European society are revealed by the Modern English words for different sorts of meat. In medieval England, meats like pork, beef, veal, and mutton were presumably more often eaten by the educated and wealthy classes—most of whom could speak French or at least admired French culture—and the Modern English terms for these meats are uniformly of French origin. (The French sources of the English words are now spelled *porc, bœuf, veau,* and *mouton,* and the French words can refer both to the animal and to the meat it provides.) The English-speaking peasants who actually raised the animals—and who presumably subsisted on mostly vegetarian fare—continued to use the original Germanic words *pig, ox, calf,* and *sheep* when talking in the barnyard, and so the animals themselves have kept their native names to this day.

The further etymology of the word *pork* is discussed at the entry for *aardvark.*

powwow In the spiritual traditions of many Native American peoples, a traditional healer or holy person communicates with spiritual forces beyond the ken of the ordinary person through trances and visions. The power and knowledge gained through these visions helps the healer to cure the sick and otherwise benefit the community, as by bringing about good weather or a successful hunt. In Narragansett, the indigenous Algonquian language of Rhode Island, the traditional healer was accorded the title *powwaw,* literally meaning "one who has visions." A form of

the word *powwaw* occurs in an early piece of propaganda designed to bring more settlers to New England, a document that offers a fairly clear representation of the Puritan attitudes to the religion of the native inhabitants of the New World: *The office and dutie of the Powah is to be exercised principally in calling upon the Devil; and curing diseases of the sicke or wounded.* The spelling of the word was eventually settled in English as *powwow*, and it also came to be used as the name for ceremonies and councils, probably because of the important role played by the healer or holy person in these events. Eventually the newcomers to North America decided that they too could have powwows, the first reference to one of these being recorded in the Salem, Massachusetts, *Gazette* of 1812: *The Warriors of the Democratic Tribe will hold a powwow at Agawam on Tuesday next.* The verb *powwow*, "to confer," was recorded even earlier, in 1780.

praline Pralines are made from the kernels of nuts—traditionally of almonds but also of other nuts like pecans—that are stirred in boiling sugar syrup until crunchy and brown. The name of this confection is a borrowing of French *praline*, and the French word in turn is derived from the title of César, Comte du Plessis-Praslin (1598–1675), Marshal of France, upon whom Louis XIV later bestowed the title Duc de Choiseul. (The *s* before the *l* in *Plessis-Praslin* is silent, which explains why it later disappeared in the spelling of the word *praline* in French.) The praline was invented by a cook in the Marshal's service, and apparently the Marshal was very fond of the new creation. As a Marshal of France, César lead the royal forces at a time when many rebellions were breaking out against the growing power of the young King Louis XIV, and various pretty stories are told about how the praline served as the Marshal's secret weapon in his attempts to quell unrest. The area around the city of Bordeaux posed a serious threat of rebellion, and the Marshal invited officials from the city to a sumptuous dinner in order to secure their support. After gradually winning them to his side with each course more sumptuous than the last, at last he had a plate of sugar-coated almonds passed

around—a treat newly invented by his cook just for this purpose—and the resistance of the magistrates was crushed. Alas, it may not have happened like this. If only all wars could be won with candy! History hardly remembers the name of the cook who actually invented the confection for the Marshal's enjoyment: Clément Jaluzot or perhaps Clément Lassagne. Today we call the cook's creation a praline rather than a *jaluzot* or a *clément.*

premise Why do we call a single building *the premises*? To answer this question, we must go back to the Middle Ages. The English word *premises* comes from the Latin *praemissa,* which is both a feminine singular and a neuter plural form of *praemissus,* the past participle of *praemittere,* "to send in advance, utter by way of preface, place in front, prefix." In Medieval Latin the feminine form *praemissa* was used as a term in logic, for which we still use the term *premise* descended from the Medieval Latin word. English *premise* is first recorded in a work composed before 1380. Medieval Latin *praemissa* in the plural meant "things mentioned before" and was used in legal documents, almost always in the plural, a use that was followed in Old French and Middle English, both of which borrowed the word from Latin. A more specific legal sense in Middle English, "that property, collectively, which is specified in the beginning of a legal document and which is conveyed, as by grant," was also always in the plural in Middle English and later Modern English. And so it remained when this sense was extended to mean "a house or building with its grounds or appurtenances," a usage first recorded in 1730.

prison The word *prison* can be traced back to the Latin word *prēnsiō,* "the action or power of making an arrest." This in turn is derived from the verb *prehendere* or *prēndere,* which meant "to take hold of, take into custody, arrest." The same Latin verb is also the source of other English words like *apprehend.*

Latin *prēnsiō* resurfaces in Old French around the year 1100 with the form *prisun,* first appearing with the sense "capture" and slightly later with the sense "place of imprisonment" and "captiv-

ity." From Old French, as well as from the Medieval Latin word *prisō*, "prison," derived from Old French, the word was borrowed into very early Middle English. Middle English *prisoun* is first recorded in a work written before 1121, where it has the sense "imprisonment." The sense "place of imprisonment" is recorded in English shortly afterward in a text copied down before 1225 but perhaps actually written in the Old English.

puce There is something funny about the word, if not the color, *puce*. The sequence of sounds (py͞oo) begins several words in English with unpleasant associations, like *putrid* and the exclamation *Phew!* The similarity in sound between *puce* and the vulgar expression *puke green* may have lead to some hesitancy about the meaning of *puce*. However, the true origin of

puce
rendering of a flea from Robert Hooke's 1665 Micrographia

the word *puce* is even less savory than an imagined connection with the word *puke*. *Puce* in fact denotes a color ranging from a deep red to a dark grayish purple—the color, in fact, of a flea. *Puce* is the French word for "flea," and in the middle of the 18th century, the expression *couleur puce*, "flea color," began to be used in French to denote various brownish-purplish shades. Similarly in English, expressions like *flea colored* and *flea brown* were used of the same sorts of colors. A bit later, towards the end of the 18th century, the half-French expression *puce color* begins to appear in English, perhaps as a delicate way of avoiding the word *flea*. However, many color names, like *beige, ecru, mauve,* and *taupe,* are also relatively recent borrowings from French. Few modern English speakers would probably consider a flea to be a natural point of reference when trying to specify a color exactly, in the same way that we describe a certain shade of green or pink by likening it to the color of a lime or a rose. Nevertheless, the mere fact that the flea could be used to name a particular shade of red indicates the extent to which household flea infestations were commonplace in the past.

The flea has been a human pest since prehistoric times, and linguists can even reconstruct the word for "flea" in Proto-Indo-European. As it turns out, the French word *puce*, "flea," and the English word *flea* are distant cousins, for they both ultimately descend from the same Indo-European root. *Puce* comes from Old French *pulce*, which descends from Latin *pūlex*. *Pūlex* in turn is a descendant of the Indo-European root **plou–*, meaning "flea." In the branch of the Indo-European family that developed into the Germanic languages like English, the Proto-Indo-European consonant *p* became *f* by the effect of GRIMM'S LAW and this also happened in the root **plou–*. **Plou–* is thus the source of Old English *flēa*, ancestor of Modern English *flea*. (The same correspondence of a *p* in Latin to an *f* in English can be illustrated by other pairs of words like *pater*, "father," and English *father* or *pēs*, "foot," and English *foot*.) Thus we can be sure the speakers of Proto-Indo-European suffered from fleas just as much as the speakers of French and English did in more recent times.

The origin of several other words referring to colors, like *ecru* and *taupe*, are discussed elsewhere in this book, while the origin of the word *mauve* is discussed at the word *marshmallow*.

Pueblo The term *Pueblo* is used to describe a group of around twenty-five Native American peoples, including the Hopi, Zuñi, and Taos, living in established villages in northern and western New Mexico and northeast Arizona. The Pueblo are especially noted for their skilled craft in pottery, basketry, weaving, and metalworking. The word *pueblo* is also used to refer to the permanent villages or communities of the Pueblo peoples, typically consisting of multilevel adobe or stone apartment dwellings of terraced design clustered around a central plaza.

The word *pueblo* ultimately comes from the Latin word meaning "people," *populus*. This word is also the source of other English words like *population* and even *people* itself, by way of Old French *pueple*. As the spoken Latin of Spain developed into the Spanish language, Latin *populus* also became Spanish *pueblo*,

meaning "town, village," as well as "nation, people." The 16th-century Spanish explorers who visited the area naturally used this word to refer to the distinctive adobe or stone villages of the Pueblo peoples, with some buildings rising as high as five stories—a sight that must have impressed the Spaniards considerably. *Pueblo* first appears in English in 1808 in a text describing these villages of the Pueblo. The word was consequently used to refer to the peoples living in the villages as well and is first recorded with this sense in 1834.

pundit A pundit was originally an Indian scholar versed in the traditional Sanskrit texts known as the Vedas. These texts were central to Hindu religion, jurisprudence, and philosophy, and indeed the word *Veda* is derived from a Sanskrit word *vedaḥ*, which literally means "knowledge." During the early part of the 19th century, *pundit* was used by the British in India as a title for the court officer who advised British judges on matters of Hindu law. After the position was eliminated in 1862, *pundit* was applied to Indian explorers employed by the colonial government to survey and map hostile territories to the north of the British frontier in secret. This surprising use of the word is explained in *Hobson-Jobson*, a well-known dictionary of Anglo-Indian words (terms of Indian origin found in the English used in India during the British colonial period): *This application originated in the fact that two of the earliest men to be so employed, the explorations by one of whom acquired great celebrity, were masters of village schools in our Himalayan provinces.* (The men, Nain Singh and his cousin Mani Singh, are renowned for a series of skillful and daring explorations of Tibet.)

More generally, English speakers in India and abroad used *pundit* as a title of respect for revered scholars, artists, and musicians, especially those associated with ancient Indian culture. In the 20th century, the meaning of the word weakened, particularly in American English, and, like *guru*—once a Hindu teacher, now often merely someone with a following—*pundit* today sometimes signifies little more than a source of opinion.

Punjab The name of the *Punjab*, the region of the northwest Indian subcontinent bounded by the Indus River in the west and the Yamuna in the east, comes to English by way of Hindi *Pañjāb* from Persian *panj-āb*. In Persian, *panj-āb* literally means "five rivers," and refers to the tributaries of the Indus.

Persian *panj* is closely related to the Hindi word *pañc*, "five," pronounced (pŭnch). *Pañc* is thought to be the source of our word *punch*—the drink may have originally contained five ingredients. An Indian origin for the word is likely because *punch* first appears in English in contexts that make reference to India. The Persian and Hindi words for "five" are descended from the Proto-Indo-European word **penkʷe*. The same word appears in Greek as *pente*, as in *pentagon*, and in English as *five*.

The Persian word *āb* in *panj-āb* also comes from Proto-Indo-European and is derived from the root **ap–*, "water, river." Although found in other many members of the Indo-European family, this root is not continued in any English words of Old English origin. However, it is found in another English word of Persian origin discussed in this book, *julep*.

purty *Purty*, a variant of *pretty*, illustrates the linguistic process called *metathesis*, in which two sounds are reversed in order. Metathesis in English often involves the consonant *r* and an adjacent vowel, since the phonetic properties of *r* are so vowellike. For example, our word *third* was in Middle English *thrid*, and our *bird* was Middle English *brid*. By the same process, English *pretty* came to be pronounced as *purty* in some Irish and American vernacular speech. Among the words in which metathesis had produced pairs of variants, one variant has usually won out over the other because of the influence of printing and the resultant standardized spelling, but *purty* for *pretty* has survived in regional American dialects. Interestingly, *purty* is often shortened to *purt'* before *n* in fixed expressions like *purt' near*, "quite near," and *purt' nigh*.

quintessence In contemporary English, the noun *quintessence* is most often used to mean "the purest or most typical instance." The story of the word begins in the 5th and 4th centuries BC, when Greek philosophers were engaged in a lively debate about the ultimate composition of the universe. The early philosopher Empedocles (ca. 490–ca. 430 BC) held the view that the universe was made up of four elements—earth, air, fire, and water—and that these were acted upon by two principles, which he called Love and Strife. Plato (427?–347? BC) and Aristotle (384–322 BC) later discussed the existence of a fifth element, of which the heavens were thought to be composed. This fifth element was usually called *aithēr*, a word that originally referred to the heavens as the brilliant dwelling place of the gods and the realm of the stars and planets. The root of this term, *aith–*, can be found in many other Greek words referring to the notion of bright light, such as *aithops*, "flashing, fiery" and *aithra*, "cloudless sky." Besides being the element of the sky, *aithēr* was also thought to be distributed throughout earthly objects and to contribute to their cohesion. Later, followers of Aristotle began using the term *pemptē ousiā*, "fifth element," for *aithēr*. Medieval European alchemists and scientists translated the Greek phrase into Latin as *quīnta essentia*, and the Latin expression entered English as *quintessence*. As part of their investigations into the nature of matter, alchemists sought to isolate the heavenly quintessence from the other four base elements by elaborate procedures of refinement and distillation, and from their attempts, the word *quintessence* came to mean "the pure, highly concentrated essence of a thing."

quixotic The adjective *quixotic*, meaning "idealistic without regard to practicality" and also "capricious and impulsive," is an allusion to the hero of *Don Quixote*, a novel by Miguel de Cervantes (1547–1616). *Don Quixote* is a satire of the medieval romance, a literary genre typified by tales, such as the Arthurian legends, that celebrate the chivalric exploits of a wandering hero. With great irony, *Don Quixote* tells the story of Alonso Quixano, a senile old man, who, having read too many idealistic romances, can no longer perceive the world as it actually is. Under the assumed name *Don Quixote*, Quixano travels across 16th-century Spain playing the part of a chivalric hero in an elaborate delusion in which ordinary people, things, and circumstances are cast as archetypes of the medieval romance. All of Don Quixote's imagined brave and chivalrous deeds, such as rescuing a princess and confronting an evil enchanter, are rendered absurd by Cervantes' objective narration. One such episode, in which Quixano mistakes a windmill for a villainous giant, gives us the saying *to tilt at windmills*, meaning "to confront and engage in conflict with an imagined opponent or threat."

The name *Quixote*, which Quixano chooses with great care, is actually a play on words. On the surface, it evokes *Lanzarote*, the Spanish name for the Arthurian hero, Lancelot, one of Quixano's role models. However, where *lanza* means "lance," *quixote*—from Latin *coxa*, "hip"—refers to the cuisse, a plate of armor worn to protect the front of the thigh. Furthermore, *–ote*, the ending that Quixano appends to his name, is an augmentative and pejorative suffix—which, for example, in modern Spanish transforms *libro*, "book," into *librote*, "big old book," and *discurso*, "speech," into *discursote*, "long, boring speech."

The English pronunciation of *quixotic* as (kwĭk-sŏt′ĭk) is based on the older spelling of the character's name, *Quixote*. In this pronunciation, the letter *x* is simply given its usual pronunciation as (ks). In the time of Cervantes, however, the *x* in *Quixote* was pronounced like (sh). In Modern Spanish, this (sh) spelled *x* has become (KH) or simply (h) according to dialect. Nowadays

English speakers usually pronounce the character's name as (kē-hō′tē), a pronunciation modeled on the Modern Spanish version of the name. The sound change is also reflected in Modern Spanish by the current spelling of the character's name as *Quijote*, in which the *j* represents (KH) or (h).

quoit The game of *quoits*, pronounced either (koits) or (kwoits), is played by throwing flat rings of iron, rubber, or rope at an upright pin or stake, with points awarded for encircling it. The game takes its name from the object thrown, called a *quoit*, which traditionally consisted of a ring of iron slightly convex on the outside and concave on the inside, configured so as to give it an edge for cutting into the ground. In the United States, both the game and the term are associated almost exclusively with the Upper North (the northernmost tier of states from New York State westward to North Dakota). In fact, *quoits* is one of a dozen terms that are most reliable for delineating the Upper North dialect boundary.

quoit

The word *quoit* in English originally referred to a flat disc of metal or stone, such as those thrown by the ancient Greeks and Romans. The term comes from Old French *coite*, meaning "flat stone" or "quoit."

ramada One of the words Spanish contributed to the English of the American Southwest is *ramada,* a term for an open shelter roofed with brush or branches, and by extension, an open porch or breezeway. *Ramada* can also mean an arbor of twined branches; this sense illustrates the derivation of the word from Spanish *rama,*

ramada
Tumacacori National Historical Park, Arizona

meaning "branch," hence *ramada,* "arbor, mass of branches." The suffix *–ada* in Spanish denotes "a place characterized by (something)." *Ramada* might have remained a relatively obscure regional word were it not for its adoption in the name of a national chain of motels.

The Spanish word descends from the Latin word *rāmus,* "branch." In Medieval Latin, *rāmus* served as the source of the verb *rāmificāre,* "to branch out," and from this Medieval Latin word come such English words as *ramify* and *ramification.*

ramshackle A thoroughly *ransacked* house may look a little *ramshackle,* and the similarity in sound between the two words *ransack* and *ramshackle* is no coincidence. They both ultimately descend from the Old Norse legal term *rannsaka,* "to search a house thoroughly (usually for stolen property)." This word is a

compound of *rann*, "house," with an element *–saka* related to the Old Norse verb *sækja*, "to seek," and indeed to Old English *sēcan* and Modern English *seek* as well. *Ransack* first appears in Middle English in the 13th century, when it is found in legal contexts involving the search of a person for stolen goods.

In Early Modern English, a new verb *ransackle* was made from *ransack* by the addition of the frequentative suffix *–le*. (A frequentative verb is a verb that expresses a repeated action.) During the Middle and Early Modern English periods, the use of the suffix *–le* to coin new frequentative verbs was especially exuberant, and words formed in this way are often very charming to the ear— other examples of the formation include *crackle* from *crack* and *sparkle* from *spark*. *Ransackle* first appears in the 17th century, and its past participle *ransackled* seems to have been used quite often in the sense "wrecked and broken, as if by plunderers." *Ramshackled*, a form that better resembles the modern word *ramshackle*, begins to appear in the 19th century. The *Oxford English Dictionary* suggests that the alteration of *ransackled* to *ramshackled* may be due to the influence of the Scots verb *camshackle*, "to twist awry." The current form of the adjective, *ramshackle* without *–ed*, also begins to appear in the 19th century.

red herring A red herring was originally a herring cured by smoking, a process that imparts a reddish color to its flesh. Because of its strong fishy taste, the herring was sometimes considered poor quality food and associated with poverty and deprivation. Nevertheless, smoked red herrings were a dietary staple throughout northern Europe well into early modern times.

It is not known exactly how the term *red herring* came to denote something that diverts the attention of observers or investigators, but the modern meaning may have arisen in connection with the sport of hunting. A clue to its origin is found in *The Gentleman's Recreation*, a guide to hounds, hawks, horses, and other hunting matters first published in 1674 by the Englishman Nicholas Cox. Cox's work was enormously popular in its day and went through many editions, and the *Oxford English Dictionary*

calls attention to a practice described in Cox's book that may have helped give rise to the modern expression *red herring*. If the day's hunt has been uneventful and the huntsman's horse has been unable to work up a good sweat, Cox recommends having a dead cat or fox, or lacking these, a red herring, dragged over the countryside for about four miles, and then setting the hounds on the scent trail thus created. As a substitute for an animal carcass, a red herring would have been readily available in any English kitchen, and its pungent, fishy-smelling flesh would doubtless have left a scent that the hounds could track easily. By riding after the hounds as they follow the scent, the huntsman can ensure that his horse has received sufficient exercise. The modern meaning of the expression *red herring* was perhaps inspired by practices similar to those described by Cox and developed from the notion of deliberately laying an artificial trail in order to distract one's pursuers. However, the first known use of the term *red herring* in its modern sense, "something that distracts attention from an important issue," occurs in the 19th century, well after the publication of Cox's book.

reeling In the granite quarries of Maine, stones for paving were once shaped by men using small hammers called *reels*. Crews of thirty men at a time would use these hammers. As explained by John Gould in the *Christian Science Monitor* of September 13, 1985, the resulting "shattering noise as the pieces of the granite were shaped... gave Mainers a word for any sustained hubbub— *reelin*.'" *Reeling* can be used, for example, of noise made by children at play, and Gould notes that a mother in Maine might tell her children to be quiet by saying, *Hark that reelin', now, you'll wake the baby.*

rent When young people talk about their *rents*, that is, their parents, they are using a slang term that is of interest to language historians, if not necessarily thrilling for parents themselves. The term is a prime example of one of the fundamental characteristics of slang, which continually creates novel ways of referring to

things or expressing concepts that are often mentioned in daily life. While there are many slang terms, such as *bod* for *body* or *rad* for *radical* that result from the clipping of unstressed syllables from a word, *rents* is a clipping that drops a stressed syllable, much like the similar term *za* for *pizza*. The relatively rarity of this way of making slang shows the great variety of linguistic processes through which catchy slang is invented—anything goes so long as the product is perceived as irreverent, funny, or just plain cool. The clipping of stressed syllables to make new slang words, however, is not as recent an innovation as one might at first think. According to Jonathan Lighter's *Random House Historical Dictionary of American Slang*, people in 1964 had already clipped the first syllable from the biological and medical term *gonads* to form the vulgar slang term *nads*, "the testicles."

right Speakers of Standard English mainly restrict the use of adverbial *right* to modify adverbs of space or time, as in *She's right over there* or *Do it right now!* No such restriction applies in Southern vernacular speech, where *right* can be used to intensify the meaning of many adjectives and adverbs, as in *He's right nice* or *You talk right fast*. This broader use of *right* is attested as far back as the 15th century and is found in the works of Shakespeare and other great writers. Thus, what appears to be neglect of Standard English rules is actually the retention of a once-proper historical usage.

The use of *right* as an adverb indicating directness, completeness, or general intensity seems to be related to the use of *right* in a more concrete sense to refer to something that is perfectly straight or perpendicular to something else, as in *right angle*. A similar connection between concrete and metaphorical meaning lies behind the Southern adverbial usage of *plumb*, as in *He fell plumb asleep* as an indicator of completeness or totality.

rigmarole Nowadays the word *rigmarole*, frequently spelled and pronounced *rigamarole*, is used to describe a rambling series of incoherent statements or a needlessly complicated and tiresome set of procedures. In light of the various modern senses of the

word, it is fitting that *rigamarole* has its origin in the medieval English legal jargon. The word is ultimately derived from Old Norse *rógs-maðr*, "a slanderer." The Norse word was borrowed into Middle English as *rageman*, which in the language of the early English courts was used as a technical term meaning "accuser." *Rageman* was also the title given to two important early English legal documents. In 1291, the nobility of Scotland officially recognized Edward I of England (1239–1307) as their sovereign in a document that came to be called *Rageman*. The same title was also given to another document of Edward's reign, a statute of 1276 that provided for the appointment of justices to hear accusations relating to various injuries. Eventually, *rageman roll* became the general term for scrolls on which accusations were officially recorded. In imitation of these, a mock legal document called the *Ragman's roll* or *Ragman roll* came to be used as part of a game in which a series of verses containing humorous personal descriptions were written on a parchment roll. Strings were attached to the parchment, and players would choose a string and draw a verse, presumably to amusing effect. The verses were supposedly written by one King Ragman, and the text on the Ragman roll apparently began with the French words *Ragemon le bon*, "Ragemon the good."

The terms *ragman* and *ragman roll* eventually came to designate a catalog or list of any sort, and in particular one whose contents were tedious or exasperating. Although *ragman* and *ragman roll* seem to have died out by the early 17th century in literary English, *ragman roll* reappears in the first part of the 18th century in the altered form *rigmarole*, originally used in the meaning "a rambling or incoherent story." It is interesting to note that even in the 16th century, *ragman's roll* already shows the attraction to the adjective *whole* that so often accompanies its modern descendant in phrases like *the whole rigamarole*—Sir Thomas More, for example, wrote the following phrase in 1533 as part of a refutation of various Protestant doctrines: *all the heresies that they haue in all theyr whole raggemans rolle.*

Another parlor game has also gone by the name *rigmarole* in

more recent times. In Louisa May Alcott's *Little Women* (1868), the character Miss Kate explains the recipe for creating what she calls *rig-marole*:

> *One person begins a story, any nonsense you like, and tells as long as he pleases, only taking care to stop short at some exciting point, when the next takes it up and does the same. It's very funny when well done, and makes a perfect jumble of tragical comical stuff to laugh over.*

Riot Act The riot act has been read to far more people than the disturbers of the peace the Riot Act was intended to control. The official Riot Act was enacted by Parliament of the United Kingdom in 1715 to discourage unlawful assembly and civic turbulence, although the first recorded use of the term *Riot Act* to refer to this legislation does not appear until 1731. The act provided that if twelve or more people gathered unlawfully or for purposes of disturbing the peace, a portion of the Riot Act would be read to them, and if the assembled did not disperse by one hour after this reading, they would be guilty of felony. The Riot Act, which was not repealed in the United Kingdom until 1973, became a part of the public consciousness and developed an extended sense in the phrase *to read the riot act*, meaning "to warn forcefully." According to the *Oxford English Dictionary* the first use of *riot act* in this way is found in a work published in 1819: *She has just run out to read the riot act in the Nursery.*

robe The noun *robe* and the verb *rob* have more than just the letters *r*, *o*, and *b* in common. In fact, they share the same Indo-European root meaning "to snatch." When the word *robe* first appears in English in the 13th century, it refers to a long, loose, flowing outer garment worn by both men and women. The word was a borrowing of Old French *robe*, which originally referred to the booty or plunder carried off by soldiers after the defeat of an enemy or the sack of a city. To the modern mind, clothing may not at first seem to be the most typical item that a looter might desire, but in

ancient and medieval times, all clothing was woven, cut, and sewn by hand. A beautiful article of apparel thus represented a considerable investment of labor. If a piece of clothing taken as booty by a warrior did not turn out to fit him, it could be altered or else given as a gift to one of his family members or friends. In this way, the original sense of Old French *robe* was narrowed from "booty" to simply "a piece of clothing (taken as booty)" to "long garment." French *robe* itself is a borrowing from a Germanic language, and ultimately continues a Proto-Germanic noun *raubō*, "booty." The Proto-Germanic word is in turn derived from the Indo-European root *reup–*, "to rip open, to snatch, to take away." The connection between the notion of breaking open to the notion of snatching away can be neatly illustrated by the development of the English expression *rip off*, originally meaning "tear away," but now also a slang expression for "steal."

English *rob*, too, is ultimately derived from *reup–*, by way of Old French. *Rob* comes from Old French *rober*, "to rob," and the Old French verb itself is a borrowing of a descendant of the Proto-Germanic verb *raubōn*, derived from the same Indo-European root *reup–*, "to break open, snatch," as the Proto-Germanic word for "booty," *raubō*.

English has many other words ultimately derived from *reup–* besides *robe* and *rob*. In Latin, the root *reup–* gave rise to the Latin verb *rumpere*, "to break," and its numerous derivates, many of which have entered English. Words like *abrupt* (from Latin *abruptus*, literally "broken off") and *erupt* (from Latin *erumpere*, "break out") are thus ultimately derived from *reup–*. Moreover, the root *reup–* is also the source of the Sanskrit word *loptram*, meaning "booty," just like Proto-Germanic *raubō*. (In Sanskrit, a Proto-Indo-European *r* sometimes becomes an *l*.) *Loptram* developed into Hindi *lūṭ*, the source of the English word *loot*.

ruminate *Ruminate* is used mostly in the meaning "to consider" nowadays, although it still keeps its technical meaning in animal husbandry, "to chew the cud." The word illustrates how terms with abstract meanings are often derived from words with very con-

crete or mundane meanings. *Ruminate* comes from Latin *rūmināre*, which meant both "to chew the cud" (when used of animals) and "to meditate" (when used of people), just like its English descendant. The Latin verb in turn is derived from the noun *rūmen*, "gullet," a word that was applied in particular to the large first stomach of ruminant animals, such as cattle, sheep, and goats, that have four stomachs. For the early speakers of Latin—most of whom were thoroughly familiar with the cow pen and the pasture in everyday life—the metaphor behind use of the verb *rūmināre* must have been just as apparent as the metaphors intrinsic to the English expressions *Chew on that for a while!* or *Put that in your pipe and smoke it!* The English verb *ruminate* may suggest just as vivid an image if we pause to connect the two meanings of the verb and picture a cow chewing meditatively in a field.

Today, technical Latin names for the four stomachs of ruminants are often used, instead of the older names by which they have traditionally been known in the English language—although many farmers and cattlemen still use the traditional terms. In order, these technical names are *rumen, reticulum, omasum,* and *abomasum. Reticulum* means "little net" in Latin, and the reticulum has an intricate lacy appearance. Although the Romans may have borrowed their word *omāsum* from Gaulish, the ultimate origin and meaning of the term are obscure. *Abomāsum,* on the other hand, simply means "after, down from the omasum."

Ruminants eat grass and other plants that are difficult for other animals to digest, and each stomach performs a special function in digesting plant material. The rumen, the largest stomach, stores large quantities of food as it is fermented by bacteria and eventually separates into solids and liquids. The heavier solids are regurgitated, chewed as a cud, and swallowed again, while the lighter solids and liquids are passed on to the reticulum for the absorption of nutrients. The function of the omasum is not well understood, but the abomasum secretes acid like the single stomach of dogs and human beings and helps digest the remaining food before passing it into the small intestine.

The traditional name for the rumen in the English language is in fact *paunch,* a word more used today in reference to human beings than to cattle. In butcher's shops, the rumen is also called *blanket tripe,* while the reticulum is called *honeycomb tripe.* The Scottish national dish *haggis* consists a sheep's rumen stuffed with its heart, liver, and lungs. Among the traditional names of the omasum are *book tripe* or *Bible bag,* as the many thin, over-lapping layers of the baglike organ fan out like the pages of a book. The traditional name for the abomasum is *reed,* also spelled *read.* Calves' reeds are the source of rennet, the substance used to coagulate milk in the process of making cheese.

run Terms for "a small, fast-flowing stream" vary throughout the eastern United States especially. Speakers in the eastern part of the Lower North (including Virginia, West Virginia, Delaware, Maryland, and southern Pennsylvania) use the word *run.* The use of *run* to denote a stream is known from at least the early 1600s in northern England and even earlier in the form *rin,* and the American use of *run* to mean "stream" continues this dialectal use of the word in the British Isles. The noun *run,* of course, is ultimately connected with the verb *run* through the notion of running water.

Speakers in the Hudson Valley and Catskills, the Dutch settle-ment areas of New York State, may call such a stream a *kill,* from the Dutch word *kil. Brook,* ultimately descending from Old English *brōc,* has come to be used throughout the Northeast of the United States. Southerners refer to a *branch,* which is proba-bly a specialization of the word *branch* used to refer to one of the tributaries or *branches* of a river. Throughout the northern United States the term is *crick,* a variant of *creek.* These last two words probably derive from Old Norse *kriki,* "bend."

\int

sacrum The word *sacrum* designates the large bone at the base of the spine that forms part of the pelvis of most mammals. In human beings, the sacrum consists of five fused vertebrae, to which the coccyx or tailbone—the vestigial remnant of a tail—is attached. In Latin, this large bone was called *os sacrum*, literally "holy bone." (*Os* means "bone" in Latin, and *sacrum* is a form of the Latin adjective *sacer*, "holy," which is also the source of a number of other English words like *sacred*, *sacrifice*, and *sacrilege*.) The Latin term for the bone is in turn a translation of its Greek name, *hieron osteon*. (*Hieron* is a form of the Greek adjective *hieros*, "holy," while *osteon* means "bone" in Greek.) In ancient Greek animal sacrifices, certain portions of the victim were reserved for the gods, and among these was the sacrum with the tail still attached. After the gods' portions were placed in the sacrificial fire, a seer or diviner would often observe how the tail curled and sputtered in the flames, and he would interpret these signs as favorable or unfavorable. Greek representations of animal sacrifices on painted ceramics often show the tail curling in the fire and thus revealing the will of the gods.

sacrum

coccyx

The Greeks and Romans were not alone in attributing sacred properties to the sacrum. According to a story told in the Midrash (a group of medieval Jewish commentaries on the Hebrew Scriptures), the learned Rabbi

Joshua ben Hananiah once explained to the Roman Emperor Hadrian that, when the Day of Resurrection comes, the body will be reassembled around a single bone, "the nut of the spinal column." The bone was thought to be indestructible, and to demonstrate this, Rabbi Joshua had one brought before the emperor. When it was put in water, it did not dissolve; when it was put in fire, it did not burn; when it was put in a mortar, it could not be ground. In medieval lore, this indestructible bone was often identified with the sacrum.

In India as well, many schools of yoga seek to awaken the *kuṇḍalinī*, the energy that lies dormant in the sacrum until it is activated by yogic practices and channeled upward through the body in the process of spiritual perfection. The *kuṇḍalinī*, whose name literally means "spiral" or "lying in coils" in Sanskrit, is usually pictured as a serpent coiled at the base of the spine.

salmon The *salmon* is capable of remarkable feats of *saltation*, and in all likelihood the fish owes its name to the magnificent leaps it makes up waterfalls and rapids when returning to its spawning grounds. First appearing in English in the 13th century, the word *salmon* is a borrowing of Old French *salmoun* (now Modern French *saumon*), which is in turn from Latin *salmō*.

The Latin word occurs only a few times in all of Roman literature. The salmon is more abundant in northern waters, and since the oily flesh of the salmon is quick to spoil in any case, it was a rare dish even among the Roman upper classes whose tables buckled and groaned under the weight of so many other foreign delicacies. The Roman naturalist Pliny the Elder mentions the salmon in passing when listing unusual fish esteemed in different parts of the Empire: *In Aquitaine* [the southwest Atlantic coastal region of France], *the river salmon is preferred to all fish from the sea.* In a poem extolling the Moselle River (which arises in France and eventually joins the Rhine in Germany), the Latin poet Ausonius singles out the salmon especially for the muscular flick of its tail. These references suggest that Latin *salmō* was borrowed from Gaulish, the Celtic language of what is now France. In

Gaulish, *salmō* probably originally meant "jumper" and was derived from the Indo-European root **sel–*, "to jump." The same root can be seen in the Latin word meaning "to jump," *salīre*, which is the ultimate source of a great variety of English words like *salient* ("jumping out at the viewer") and *exult* (from the notion of jumping for joy). **Sel–* is even at the root of *somersault*, from the Old French word *sobresault*, ultimately derived from Latin *suprā*, "above," and *saltus*, "jumped," past participle of *salīre*.

A word related in meaning to *salmon* is discussed at the entry for the word *lox* elsewhere in this book.

sanction Occasionally, a word can have contradictory meanings. Such a case is represented by *sanction*, which can mean both "to allow, encourage" and "to punish so as to deter." It is a borrowing from the Latin word *sānctiō*, meaning "a law or decree that is sacred or inviolable, under penalty of a curse." This noun is related to the verb *sancere*, which basically meant "to render sacred or inviolable." The Latin verb was also used in the extended meaning "to forbid," since something that is forbidden lies in the power of an inviolable decree. Thus from the beginning two fundamental notions of law were wrapped up in the history of the word: law as something that permits or approves and law that forbids by punishing. In English, the word *sanction* is first recorded in the mid-1500s in the meaning "law, decree," but not long after, in about 1635, it refers to "the penalty enacted to cause one to obey a law or decree."

From the noun, a verb *sanction* was created in the 18th century meaning "to allow by law," but it wasn't until the second half of the 20th century that it began to mean "to punish (for breaking a law)." English has a few other words that can refer to opposites, such as the verbs *dust* (meaning both "to remove dust from" and "to put dust on") and *trim* (meaning both "to cut something away" and "to add something as an ornament").

sarcasm A sarcastic comment can cut to the quick, and from an etymological point of view, sarcasm is quite literally "cutting wit."

The English word *sarcasm* comes from the Greek word *sarkasmos*, "mockery, sarcasm," and *sarkasmos* is derived from the verb *sarkazein*. *Sarkazein* is first recorded in the senses "to tear flesh like dogs" and "to pluck grass with closed lips as horses do." The sense "to bite the lips in rage," recorded later, is thought to have developed into the sense "to speak bitterly, sneer." *Sarkazein* is in turn derived from *sarx*, "flesh." A form of this Greek word is found as the element *sarco–* in the English word *sarcophagus*, which literally means "flesh-eating" in Greek.

sash

I have decked my couch with fine coverlets
With striped cloth of the yarn of Egypt

—Proverbs 7:16

Passages in the Bible like this one are evidence of the great value placed on Egyptian cloth in the ancient world. One ancient word referring to the textiles of Egypt has come down to us today as our word *sash*, "strip of cloth." *Sash* is another of the small group of terms that we might call "the most ancient words in English" because they can be traced back to the ancient Near Eastern languages that were among the first ever to be committed to writing.

When we study the Bible or read summaries of world history in school, we frequently receive the impression that the Egyptians and the other peoples of the ancient Near East, such as the Babylonians, Assyrians, Hittites, and Israelites, were engaged in constant strife. In fact, the different cultures of the region also engaged a lively but peaceful exchange of goods and ideas, and this commerce helped maintain friendly relations. (The Egyptian pharaoh, for instance, even sent grain as famine relief to the Hittite kingdom located in what is now Turkey—despite the fact that the Egyptians and Hittites had often fought over the control of territories at the eastern shore of the Mediterranean.) The number and quality of the items traded among the cultures of the ancient Near East often astound the modern observer.

Egypt in particular was famed for the quality of its fine linen cloth, called *šs* in the ancient Egyptian language. There was no straightforward way of writing vowels in Egyptian hieroglyphics, so we can only speculate on the exact way the ancient Egyptians pronounced the word they wrote as *šs*. In COPTIC, the later form of the Egyptian language used in medieval Christian Egypt, the word was pronounced as *šes*. By convention, modern Egyptologists will pronounce *šs* as (shĕs) if they wish to give spoken form to the ancient Egyptian word. The Egyptian word entered Hebrew as *šēš*, the word rendered as "silk" by the translators of the King James Version of the Bible but now thought to mean "fine linen." In Proverbs 31:22, for example, the word *šēš* is used as part of a description of the ideal woman of virtue: *She maketh for herself coverlets; her clothing is fine linen* (šēš) *and purple.*

The Egyptian word *šs* also entered Arabic, where it took the form *shāsh* and referred to strips of fine cloth that could be wound as a turban or otherwise used as a sash. From Arabic, the word then reached English, where it was at first variously spelled *shash* and *shass* as well as *sash*. The forms *sash* and *shass* probably result from the phenomenon called DISSIMILATION, in which two similar or identical sounds in a word or phrase, such as the two (sh) sounds in *shash*, become less similar. The *Oxford English Dictionary* quotes the following early attestation of *sash* in English from a travelogue by Fynes Moryson published in 1607: *The Greekes and other Christians... weare Shasses, that is, striped linnen (commonly white and blew) wound about the skirts of a little cap.* In English usage, the word later came to designate any strip of cloth wound around the waist or slung around the shoulder.

scallion The name of one of the rich trading cities of the ancient Mediterranean lives on in the words for two varieties of onion, *scallion* and *shallot*. The Modern English word *scallion* is applied to two different kinds of plants belonging to the genus *Allium*, the genus in which onions, garlic, leeks, chives, and other onionlike plants are classified. One of these plants called *scallion* can also go by the name *green onion* in American English or *spring onion* in

British English. The other plant to which the name *scallion* is applied is the shallot, a pink-tinged onion whose delicate flavor is essential to the classic *sauce béarnaise*.

The word *scallion* comes from Old French *scaloun,* a dialectal variant of Old French *eschaloigne. Shallot,* on the other hand, comes from obsolete French *eschalotte* (now Modern French *échalote*), which also derives from Old French *eschaloigne. Eschaloigne* in turn comes from Vulgar Latin **escalōnia,* which developed from the term for the shallot in Classical Latin, *ascalōnia caepa,* meaning literally "onion from Ashkelon." Ashkelon, located in what is now southwestern Israel, just north of the modern city of Gaza in the Gaza Strip, was one of the chief port cities of the ancient Philistine people. The city is mentioned on several occasions in the Bible, and the name of the city in Hebrew, *Ašqəlōn,* seems to be derived from the Proto-Semitic root **ṯql,* "to weigh." (The symbol *ṯ* in this root represents a sound like the (th) in English *breath.* As Proto-Semitic developed into Hebrew, this sound became *š,* pronounced (sh) as in English *brush.*) *Ašqəlōn* perhaps originally meant "weight" or "weights" in one of the Northwest Semitic dialects, the group of closely related languages spoken in the area and including Hebrew and Phoenician, and the name probably made reference to the weightstones or standard weights put in one pan of a pair of scales when weighing goods or measuring out precious metal. It should come as no surprise that Ashkelon should be named after such weights, since the city was an important center of commerce. Through its port, the goods and produce of Palestine—including the onions so relished by the Greeks and Romans—reached the entire Mediterranean world.

If the etymology of *Ashkelon* as a Semitic word meaning "weight(s)" is in fact true, the name is related to the term *shekel* familiar to English speakers from the Bible. *Shekel* comes from Hebrew *šeqel,* which is derived from the verb *šāqal,* "to weigh," and ultimately descends from the Proto-Semitic root **ṯql,* just like *Ashkelon.* In the Bible, *šeqel* usually denotes a unit of weight equal to about half an ounce, although there was a good deal of

variation in the value of the unit according to time and place. The chief unit of currency among the ancient Hebrews was also an amount of silver weighing one shekel, and the modern state of Israel has also adopted the term *sheqel* as the name for its basic unit of currency.

schlimazel It is fun to say *schlimazel,* even if it is no fun to be a schlimazel. This word, from Yiddish *shlimazl,* refers to someone who is constantly unlucky or a habitual failure. In other words, a *schlimazel* is a person to whom you really should say *Mazel tov!* ("Good luck!"), because the good luck is sorely needed. In fact, the *–mazel* in *schlimazel* and the *mazel* in *Mazel tov!* are the ultimately the same Hebrew word.

Yiddish, the language traditionally spoken by Jews of Central and Eastern European origin, developed from medieval German dialects in combination with elements from Hebrew and Aramaic as well as the Slavic languages, and Yiddish *shlimazl* illustrates this distinctive mixture admirably. It is a compound made from elements ultimately from two different languages. The first element is Middle High German *slim,* "wrong, crooked." (Modern English *slim,* "slender," is actually a borrowing of Middle High German *slim,* now Modern German *schlimm,* "bad," or its closely related Dutch equivalent: the earlier meaning of English *slim* is still perceptible in phrases like *slim chances.*) The second element in *shlimazl* is Yiddish *mazl,* "luck." This comes from Hebrew *mazzāl,* "constellation, destiny"—that is, the position of the stars and planets determining a person's character and fate at birth. Thus a *schlimazel* is someone who was "born under a bad sign," as the song goes. The Hebrew word *mazzāl* is in turn a borrowing of an AKKADIAN word variously spelled *manzaltu* or *mazzaztum* that meant "position of a star." Akkadian was one of the main languages of ancient Mesopotamia, and observation of the stars and planets played a large role in Mesopotamian civilization. Much of the astrological lore current in Western culture, including the zodiac, is an inheritance from Mesopotamia.

The salutation *Mazel tov!* comes from Hebrew *mazzāl ṭôb,*

"Good luck!" and contains the same word *mazzāl*, "constellation," with the addition of *ṭôb*, "good." The same word *ṭôb* can also be seen in names of Biblical origin like *Toby, Tobit,* and *Tobias. Tobit,* for example, is the Greek form of the Hebrew name *ṭôbīyāh,* which means literally, "God (*Yāh*) is good."

More words from Yiddish are discussed at the entry for the word *schlock* below.

schlock A good number of English words borrowed from Yiddish (a variety of German with an admixture of Hebrew and Slavic elements) are recognizably of foreign extraction because they begin with sound combinations (shl-, shm-, shn-) not found at the beginnings of native English words. *Schlock* is such a word; it is descended from a Middle High German word for a hit or blow, and thus came to refer to damaged merchandise, and then to merchandise of poor quality. Other words beginning with this and similar sound combinations are Yiddish also: *schlep, schmooze, schmuck,* and *schnoz.* These words may not be equally common in all regions of the United States; they are most frequently heard in areas with sizable Jewish populations that either speak Yiddish or are descended from Yiddish speakers, such as New York City. Of course, not all Yiddish words borrowed into English begin with the sound (sh); one need only think of *bagel, lox, blintz, nosh, meshuga,* and *kibitz* to get a feeling for the variety of words that Yiddish-speaking Jews brought with them to the United States.

The origin of another charming Yiddish word beginning with *schl–, schlimazel,* is discussed in the previous entry.

school As children, some of us may have found school so tedious that we needed an occasional break just to relieve the boredom. From the point of view of etymology, however, school is already "free time." Modern English *school* is from Middle English *scole,* which descends from Old English *scōl.* The Old English word is a borrowing of Latin *schola,* and *schola* is in turn from Greek *skholē.* In Greek, *skholē* originally meant "rest from work" or "leisure." By

extension, it came to mean the activities which were enjoyed during leisure time. Many members of the Greek upper classes liked to fill their idle hours with learned speculation and discussion of philosophical topics, and this Greek ideal of improving oneself even in leisured moments is brilliantly apparent throughout works of the philosopher Plato (427?–347? BC), for instance. Plato wrote down much of his philosophy in the form of dialogues in which his beloved teacher Socrates engages his fellow citizens in learned conversation at drinking parties or even during chance encounters on the street. Since the Greeks liked to spend their free time in such intellectual disputation, *skholē* acquired the meaning "philosophical conversation" and by extension "lecture." From there, the word came to mean just "school." The ultimate origin of the English word *school* in the Greek word for "leisure" will come as no surprise to students who have been lucky enough to learn from great teachers—those who do not teach mere facts or frozen ideas, but a love of learning that can fill a lifetime, as Socrates did Plato.

scoot It is thought that the verb *scoot* comes from a Scandinavian source akin to Old Norse *skjōta*, "to shoot." *Scoot* is thus related to the verb *shoot*, which developed from *scēotan*, the Old English COGNATE of Old Norse *skjōta*. *Scoot* is first attested in the Scots dialect, where it originally meant "to squirt with water." The verb later appears with other senses, "to slide suddenly across a surface" and "to move or cause to move quickly," as in *The mouse scooted across the floor*. In the American Midland especially, there is a phrasal verb *scoot over*, meaning "to move over to make room (as on a bench or sofa)." The *Dictionary of American Regional English* offers the following typical use of *scoot over* from Tennessee: *Scoot over so's I can set down.*

In some varieties of American regional speech, there is a *scooch*—also found in the variants *scoosh*, *scutch*, and *scooge*— meaning "to crouch or squat in order to fit into a small space." *Scooch* can be used in the phrase *scooch over* or *down* with the same meaning as *scoot over* or *down*. *Scooch* probably descends

from an English dialectal term *scouch*, "to crouch," but the usage of the verb has been influenced by the similar-sounding *scoot.*

score

> *Four score and seven years ago our fathers brought forth on this continent a new nation, conceived in liberty and dedicated to the proposition that all men are created equal.*
>
> —Abraham Lincoln, *Gettysburg Address,* 1863

The word *score* has a variety of meanings in Modern English. A *score* can be a scratch or a notch on a surface, but nowadays the word most often refers to a variable number, like the *scores* kept at football games, or to a variable amount, as when we *settle a score* by recovering a debt due to us or getting satisfaction for a grievance. *Score* also has a slightly archaic fixed sense of "twenty," as used by Abraham Lincoln in his renowned speech. The ancestor of Modern English *score*, Old English *scoru*, has the meaning "twenty" in its first known appearance, which is found in a very late Old English text dating from around 1100.

In fact, all of the many meanings of *score* are related. In nonliterate traditional cultures lacking cheap paper or parchment, a stick incised with notches—called a *tally stick*—is as good a place as any to keep track of numbers. In this way, the development of the meaning "a mark made on a stick" to "a number" is a natural one. Old English *scoru*, "twenty," comes from Old Norse *skor*, meaning "a notch, a notch on a tally stick; a tally stick; twenty." Twenty is of course a nice round number to count by, and several European languages preserve remnants of a system of counting by twenties in everyday usage. In French, for example, the usual word for "eighty," *quatre-vingts*, literally means "four twenties."

The Old Norse word *skor* is derived from the Indo-European root **sker–*, "to cut." Modern English has inherited other derivatives of this root by way of Old English as well. On the way from Proto-Indo-European to Old English, the Proto-Indo-European consonant group *sk* became English *sh*, and thus the root **sker–* is

also the source of other Modern English words referring to cutting, including *shears,* "scissors," and *share,* "a portion cut from a whole."

In the modern world, we continue to use an ancient set of symbols based on scratches like those made on sticks: the Roman numerals. The symbol I representing the number 1 was originally the simplest scratch straight across the stick. The symbols V for 5 and X for 10, also formed from straight lines relatively easy to incise on sticks, evolved from the more elaborate notches used to write these numbers.

séance The origins of *séance* are surprisingly mundane, given the mysterious atmosphere associated with the word in its most common meaning in English: "a meeting of people to receive spiritualistic messages." The first English use of the word to refer to spiritualist séances dates from 1845, but earlier in English the word had been used for meetings more generally—as the term is still sometimes used today. The English word is a borrowing of French *séance,* which means simply "seat" and "session" and can refer to a variety of activities, such as the meeting of an administrative body or the sitting of a model for an artist. One can, after all, do many things while seated. Certainly the second recorded use of the word in English in 1803 does not promise an encounter with the spirit world: *your séances... which I have a shrewd suspicion must be something dull.* Perhaps the writer was referring to the meetings of a legislature or learned society, which sometimes put attendees to sleep rather than into a trance.

French *séance* comes from Old French *seoir,* "to sit," and the Old French verb in turn comes from Latin *sedēre,* "to sit." *Sedēre* is related to the Latin word *sessiō,* "a sitting, a seat" (source of the English word *session* itself)—both are derived from the Indo-European root **sed–.* Among the many derivatives of this root in Latin is the verb *obsidēre,* meaning literally "to sit on, at, or about" and by extension "to inhabit, to haunt, to besiege," as well as the noun *obsessiō,* the source of the English *obsess.* Etymologically, an *obsession* is something that besieges the mind.

On the way from Proto-Indo-European to the Germanic lan-

guages like Old English, the *d* in the root **sed–* became a *t* by the change known as GRIMM'S LAW and in this way, **sed–* is also the source of Old English *sittan*, ancestor of Modern English *sit*. The Modern English word *seat*, from Middle English *sete*, probably has its origins in another Germanic language—the word is most likely a borrowing of Old Norse *sæti*.

senile In earlier writings one finds phrases such as *a senile maturity of judgment* and *green and vigorous senility* demonstrating that *senile* and *senility* have not always been burdened with their current negative connotations. These two words are examples of pejoration, the process by which a word's meaning changes for the worse over time. Even though *senile* (first recorded in 1661) initially had the neutral sense "pertaining to old age" just like its Latin source, the adjective *senīlis*, it is probable that the mental decline that sometimes accompanies old age eventually caused the negative sense to predominate in the modern use of the word. Although recent medical research has demonstrated that the memory and cognitive disorders once designated by *senility* are often brought about by various diseases, rather than by the mere fact of getting older, it seems unlikely that the word will regain its neutral senses.

The Latin word *senīlis* is itself derived from *senex*, "old man." Although old age may sometimes bring infirmity, the aged also have the wisdom of accumulated experience, and this is reflected in the development of other words derived from *senex*, such as Latin *senātus*, the source of English *senate*. The Roman senate was the supreme council of state that governed Rome during its rise to power—until the real government was turned over to the emperors—and it developed from a meeting of tribal elders. Thus a *senate* is etymologically a "gathering of old men." And perhaps the decisions of the American Senate sometimes even display *a senile maturity of judgment* as well.

shaman The word *shaman* denotes a member of certain traditional societies, especially of North Asia, who acts as a medium

between the visible world and an invisible spirit world and who practices magic or sorcery for purposes of healing, divination, and control over natural events. At first glance, the word may seem to be formed from *–man* with the addition of a mysterious prefix *sha–*. In fact, *shaman* has a far different and more remarkable history, beginning in India as the Sanskrit word *śramaṇaḥ*, meaning "ascetic" or "Buddhist monk." (The root of this word, *śram–*, "perform austerities," can also be seen in English *ashram*, denoting a kind of Hindu religious community.) *Śramaṇaḥ* developed into *ṣamana* in the Prakrits, the languages descended from Sanskrit that were used by various groups, including Buddhists, from around 300 BC to AD 400. The Prakrit word was carried by the spread of Buddhism to Central Asia and appears in the Central Asian language called Tocharian B as *ṣamāne*, with the meaning "Buddhist monk." From Tocharian, the word spread further to the languages of North Asia and eventually reached Evenki, a Tungusic language spoken over a wide area in Siberia by reindeer-herders. In Evenki, the word took the form *šaman* and was used to designate a healer or one who communicates with the spirit world. The word was then borrowed into Russian, and from Russian it passed into the other languages of Europe, including English, as an anthropological term.

Shaman is probably the only word in English that has come from or passed through a Tocharian language. The two Tocharian languages, which became extinct around a thousand years ago, are usually given the rather boring names Tocharian A and B. (They are sometimes also called East Tocharian and West Tocharian or Agnean and Kuchean.) The Tocharians lived along the Silk Road in eastern Turkistan (now Xinjiang Uygur Autonomous Region in western China) at the edges of the Takla Makan desert, and we know about their languages from documents written around AD 600–800. For the most part, these documents consist of Buddhist writings, as well as a few items like caravan passes for travelers. Tocharian worshippers would dedicate individual leaves from copies of Buddhist sutras at temples, and the leaves would be blown away by the wind and buried in

the desert sands, where they were preserved by the extremely dry conditions.

Tocharian A and B together constitute an independent branch of the family tree of Indo-European languages, the group to which English also belongs. Of all peoples speaking Indo-European languages, it is the Tocharians who migrated the farthest east in ancient times. Certain archaic aspects of the Tocharian languages also suggest that they separated from the other Indo-European languages very early. The Tocharians have been of interest to both linguists and archaeologists in recent years. Linguists would like to know how and when the various Indo-European languages came be spoken across such a wide area of Eurasia, and archaeologists would like to know if the spread of cultural traits or populations in the archaeological record can be associated with the spread of a specific language group. In an attempt to answer such questions and determine the place of the Tocharians in the history of Central Asia, scholars have brought together various sorts of evidence. For example, mummies up to four thousand years old have been found in the Taklan Makan desert, and the fabrics found with them resemble the plaids woven by early Celtic peoples in Europe. Frescoes from Central Asia also depict Buddhist monks with red hair, blue eyes, and features that in general resemble those of modern European populations. Many scholars have attempted to associate such archaeological finds with the speakers of Tocharian. However, there is still much that scholars do not know about the movements of populations and the spread of culture and language in ancient times.

shambles A place or situation referred to as a *shambles* is usually a mess, but it is no longer always the bloody mess it once was. The history of the word begins innocently enough with the Latin word *scamnum*, "a stool or bench serving as a seat, step, or support for the feet, for example." The diminutive *scamillum*, "low stool," was borrowed by the speakers of West Germanic, the ancestral language that gave rise to English, Dutch, German, and their close

relatives. The Latin borrowing appears in Old English as *sceamol*, "stool, bench, table." Old English *sceamol* became Middle English *shamel*, which developed the specific sense in the singular and plural of "a place where meat is butchered and sold." The Middle English compound *shamelhouse* meant "slaughterhouse," a sense that the plural *shambles* developed (first recorded in 1548) along with the figurative sense "a place or scene of bloodshed" (first recorded in 1593). Our current, more generalized meaning, "a scene or condition of disorder," is first recorded in 1926.

Shih Tzu *Shih Tzu*, the name of a dog breed from Asia, comes from Mandarin Chinese *shīzi gǒu*, literally "lion dog." By analogy with *foxhound*, one may wonder how this breed of lap dogs ever lived up to its name. The Shih Tzu was named "lion dog," not because it ever hunted lions—as did the Rhodesian ridgeback, a large breed developed in Africa—but because it was bred with the features of the traditional Chinese representation of a lion. In this, the name *Shih Tzu* is analogous to the breed names like *affenpinscher* and *griffon*. The affenpinscher, a breed with the face of an ape, derives its name from German *Affe*, "ape," and *Pinscher*, "a type of dog with pinched, or surgically clipped, ears." The griffon, a relative of the affenpinscher, bears a nocticeable resemblance to the griffin, a fabulous beast with the head and wings of an eagle and the body of a lion.

shivaree *Shivaree* is the most common American regional form of *charivari*, a word of French origin meaning "a noisy mock serenade for newlyweds." The term, most likely borrowed from French traders and settlers along the Mississippi River, was well established in the United States by 1805; an account dating from that year describes a shivaree in New Orleans: *The house is mobbed by thousands of the people of the town, vociferating and shouting with loud acclaim.... Many* [are] *in disguises and masks; and all have some kind of discordant and noisy music, such as old kettles, and shovels, and tongs.... All civil authority and rule seems laid aside* (John F. Watson). The word *shivaree* is especially com-

mon along and west of the Mississippi River. Its use thus forms a dialect boundary running north-south, dividing western usage from eastern. This is unusual in that most dialect boundaries run east-west, dividing the country into northern and southern dialect regions. Some regional equivalents are *belling*, used in Pennsylvania, West Virginia, Ohio, Indiana, and Michigan; *horning*, from upstate New York, northern Pennsylvania, and western New England; and *serenade*, a term used chiefly in the South Atlantic states.

The French word *charivari* can mean "raucous music" and "hubbub" in general as well as more specifically "mock serenade." In the past, French charivaris were given to married couples who were thought to be mismatched or to people whose conduct was considered scandalous. The French term probably derives from the Late Latin word meaning "headache," *carībaria*, which in turn is from Greek *karēbariā*, a compound of *karē*, "head," and *barus*, "heavy." The whistling and banging of pots and pans of a traditional charivari would probably be enough to give anyone a headache.

sideburns The process of FOLK ETYMOLOGY has cruelly obscured the fame of Major General Ambrose Everett Burnside (1824–1881), popularizer of side-whiskers. During the American Civil War, Burnside fought for the Union at the First and Second Battles of Bull Run and at the Battle of Antietam, and he commanded the Army of the Potomac at the time of its defeat by the Confederacy at Fredericksburg. Despite the long list of setbacks suffered by the Union army under his command, the general was a popular figure and later went on to be governor of Rhode Island and then senator from that

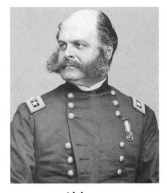

sideburns
Major General Ambrose E. Burnside

state. Burnside was also well known for his magnificent facial hair—he shaved his neck and chin but grew out his side-whiskers and mustache, which joined across his cheeks. At the time, a different sort of beard, called the *chinstrap beard*, was popular. Chinstrap beards with no mustache are familiar from portraits of Abraham Lincoln, and nowadays they are also sometimes associated with the Amish community. General Burnside's style was thus somewhat distinctive for the time, and this lead to the application of the name *burnsides* to men's side-whiskers. The earlier term for side-whiskers worn without a beard or mustache had been *muttonchops*, and this is still heard today to describe particularly full and extensive side-whiskers.

Eventually, however, the memory of General Burnside faded, and *burnsides* was reversed to *sideburns*. This reversal was presumably an attempt to make some sense out of the now obscure *burnsides*, which is obviously a compound of some sort and refers to things on the side of the head. *Sideburns*, at least, conforms to the usual pattern of English compound formation seen in other words like *eyebrow*, *earring*, *necktie*, or *sideswipe*, in which the first element modifies the second element. Nevertheless, for most of us, the presence of the *burns* in *sideburns* probably makes the compound almost as puzzling after the folk etymological reversal as before—unless we have heard of General Burnside, that is.

sierra *Sierra* is probably best known from the names of certain rugged mountain ranges, such as the Sierra Nevada ("snowy sierra") of Spain, the similarly named Sierra Nevada of Eastern California, and the Sierra Madre ("mother sierra") of Mexico. However, the word is used in both Spanish and English to refer to any range of mountains having an irregular or jagged profile. In Spanish, *sierra* literally means "saw" (compare the *Sawtooth Mountains* of central Idaho) and comes from the Latin word, *serra*, "saw," which is also the source of English *serrated*.

The mountaineering term *arête*, meaning "a sharp, narrow mountain ridge or spur," resembles *sierra* in being a metaphorical application of a word for "jagged object" to a mountain ridge.

The term is borrowed from French, and in this language *arête* has a variety of meanings besides "mountain ridge," including "awn or bristle on an ear of wheat or barley" and "fishbone." As an architectural term, it means "projecting edge formed by the intersection of two surfaces," and the meaning "mountain ridge" was perhaps originally an extension of this sense. *Arête* comes from Old French *areste*. *Areste* in turn is from Late Latin *arista*, which meant both "awn" and "fishbone."

Singapore Hong Kong, Korea, Singapore, and Taiwan, four economically vigorous regions in Asia, are often known as the *Four Little Tigers* when compared to the larger economies of China and Japan. In fact Singapore might more appropriately be called a *Little Lion*. *Singapore* comes from Malay *Singapora*, "Lion-city." This name is made up of two elements borrowed from Sanskrit, the holy language of ancient India. The pre-Islamic kingdoms of Southeast Asia and Indonesia were profoundly influenced by Hinduism, Buddhism, and Indian civilization in general, and as a result, the languages of the region, such as Malay, Javanese, and Thai, have borrowed heavily from Sanskrit in the same way that English has borrowed heavily from Latin and French.

Of the two Sanskrit elements that make up the Malay name *Singapora*, *pora* comes from Sanskrit *puram*, "city, fortress," and is related to Greek *polis*, "citadel, city." The second element, *singa–*, comes from Sanskrit *siṁhaḥ*, "lion." A form of the Sanskrit word is familiar from the name *Singh*, which all male Sikhs use as at least one of their personal names. Nowadays most English speakers probably associate the lion more with Africa than India, so they may be surprised that an ancient Indian language had a word for the lion. In ancient times, however, a variety of lion, called the Asiatic lion, was much more widespread in both Europe and Asia. The Greeks told legends about heroes like Hercules fighting the lions that used to ravage the Greek countryside. Hunting and habitat loss have gradually reduced the range of the Asiatic lion, and today only a handful of these magnificent animals survive in the wild, in a forest preserve located in the west of India.

siren The mechanical siren seems to be quite the opposite of its legendary namesake. The Sirens of Greek mythology were a group of female creatures who by their sweet singing lured mariners to destruction on the rocks surrounding their island. In ancient Greek artistic depictions, they appear either as large birds with female human heads or as large birds with the breasts, arms, and heads of women.

The mechanical siren, in contrast, broadcasts earsplitting chirps, shrieks, and wails to warn people of danger. The French physicist Charles Cagniard de la Tour (1779–1859), who invented the mechanical siren, was apparently ignorant of its future applications. Cagniard de la Tour's siren consisted of a rotating perforated disk that when driven by a stream of air or water produced musical tones. Significantly, its design allowed the frequency of the sound wave at a known pitch to be measured. The physicist explained that he named the device for its ability to produce sound even when completely submerged, in recollection of the Sirens' watery abode. A larger device used on steamships to emit fog signals was given the same name, and eventually the term was extended to devices that produce similar sounds or sounds with a similar purpose, including air raid sirens and the electronic sirens mounted on emergency vehicles.

sleigh *Sleigh* is a familiar word in American English, having entered the language from Dutch by 1700. The Dutch were among the earliest colonists in North America, and it is thus no surprise that some very common American words come from their language. *Boss, bush,* and *landscape* are all words of Dutch origin that became established in English by the end of the 17th century. In the succeeding centuries, American English also borrowed such words as *dope, knickerbocker, snoop, spook, waffle,* and *cookie* from Dutch. Even a term practically synonymous with *American,* namely *Yankee,* was in all probability originally a Dutch word, *Janke* (literally meaning "little John" or "Johnny"), for a Dutch pirate.

slivovitz Though colorless, slivovitz is a brandy or schnapps made from bluish plums. The English name for this spirit comes from German *slibowitz*, which in turn is from Serbo-Croatian *šljivovica*, a derivative of *šljiva*, "plum." The words meaning "plum" in the Slavic languages, which include such forms as Czech *slíva* and Russian *sliva*, as well as Serbo-Croatian *šljiva*, are related to Latin *līvidus*, "bluish, bruise-colored." *Lividus* is the source of the English adjective *livid*, a word synonymous with *black-and-blue* when used to describe the discoloration caused by a bruise. The Indo-European root **sleiə–*, "bluish," from which the Slavic and the Latin words are descended, has another descendant in English associated with alcohol, *sloe*, the name of a small sour plum of a dark purplish color. Many who have never seen this type of plum have tasted it in *sloe gin*, which is flavored with sloes.

smart *Smart* is a word that has diverged considerably from its original meaning of "stinging, sharp," as in *a smart blow*, one delivered with enough force to cause pain. The adjective *smart* comes from Old English *smeart*, "causing pain" and is related to the Modern High German words like *Schmerz*, "pain." The most common meaning in contemporary American usage, "clever, intelligent," probably picks up on the original notion of vigor or quick and accurate movement still present in such expressions as *a smart blow*. The meaning "clever" first begins to emerge clearly in the 1600s, but in recent times, *smart* has more often been found with this sense in American English, rather than in British English—where the word is nevertheless still often used in other meanings like "elegant, fashionable."

Smart has taken on other senses as an American regionalism. In New England and in the South *smart* can mean "accomplished, talented." The phrase *right smart* can even be used as a noun meaning "a considerable number or amount," as in the following example taken from an account by the Blues guitarist Willie Johnson of his younger days as a musician, quoted in Jas Obrecht's *Rollin' and Tumblin'* (2000): *Played over in a place called*

the Hole in the Wall. It's almost downtown in Helena. Yeah, we used to play down there right smart.

Sophocles Personal names like *Sophocles* and *Pericles* are compounds typical not only of Greek but also of other early Indo-European languages. *Sophocles* is formed from *sophos,* "wise" (as in *philosophy,* a derivative of the Greek word *philosophos* "lover of wisdom"), and *–klēs,* "glorious, famous," and thus means "having wise fame, famous for wisdom." The *peri–* in *Pericles* is a prefix that functions as an intensive adverb, so his name means "very famous, famous all around." The element *–klēs,* "glorious, famous," appearing in these and other Greek names, comes from *–kleēs,* from an earlier *klewēs.* This itself is derived from the noun *klewos* (*kleos* in Classical Greek), "fame, glory."

The Proto-Indo-European root of Greek *kleos,* "fame," is **kleu–, *klu–,* which meant "to hear, hear much of," and hence "to be famous." An adjective formed from this root with lengthening of the vowel, **klūtos,* "heard much of, renowned," became Proto-Germanic **hlūdaz.* The Proto-Indo-European *k* in **klūtos* was changed to an *h* in **hlūdaz* by the operation of the sound change known as GRIMM'S LAW. This *h* was later lost when Proto-Germanic **hlūdaz* became the English adjective *loud.* A form of the same Proto-Germanic word **hlūdaz* also appears as the first element in many old names of Germanic origin, where it has the meaning "famous"—since something famous is something one has heard much of, so to speak. The Old High German name *Hluodowīg,* for instance, can be interpreted as "famous in battle," and this name is the source of *Ludwig* in Modern High German. *Hluodowīg* was also borrowed into Latin as *Ludovīcus,* and the name appears in Italian as *Luigi,* and as *Clovis* and later *Louis* in French. The French form of the name is the direct source of the English names *Louis* and *Lewis.* In Provençal, the name took the form *Aloys,* more familiar to English speakers in its Latin form, *Aloysius,* the name of the patron saint of young men.

The Indo-European root **kleu–* is also the ancestor of the word *Slav,* literally meaning "the famous people," and of Slavic names

ending in *–slav*, like *Mstislav* in Russian, "having vengeful fame," and *Stanislaw* in Polish, "famous for withstanding (the enemy)."

spa The word *spa* derives from the resort town of Spa in Belgium, which has been famous for the therapeutic properties of its mineral springs since at least the 1500s. Already in the 1600s, the name of the town had become a common noun denoting a mineral spring, and in the 1700s it came to refer to any resort where one could go to "take the waters" for curative purposes. Less well known is the common use of the word in eastern New England to refer to a local convenience store, sometimes with sandwiches and other light fare on sale. This modern meaning of *spa* in New England grew out of an earlier meaning "soda fountain," which probably alluded to the carbonated or "mineral" water that was a staple ingredient of many soda fountain concoctions. As the American institution of the soda fountain was gradually transformed into the modern convenience store, New Englanders continued to apply the term *spa* to the kind of establishment that replaced the soda fountain as a place where one could quickly buy a refreshing drink.

spareribs When a hog is butchered, the large cuts of meat from the side and belly of the hog are almost always separated from the ribcage to be cured and made into bacon, and this leaves the ribs with only a small—but very tasty—amount of meat. These ribs, with the meat trimmed rather close to the bone, are called *spareribs.* The word *sparerib* itself is a borrowing of Low German *ribbesper*, "pickled pork ribs roasted on a spit," and the Low German word is in turn a development of Middle Low German *ribbespēr*, a compound of *ribbe*, "rib" and *spēr*, "spear, spit." The close relationship between Middle High German words *ribbe* and *spēr* and English *rib* and *spear* is of course readily perceived. The elements of the Low German compound have already been transposed in the first written attestations of the word *sparerib* in English, which date from the very late 1500s and early 1600s. Moreover, the earliest spellings of the word *sparerib*, such as *spar-*

rib and *spear-rib*, perhaps reflect some knowledge of the derivation of the word or perhaps the continuing use of spits in preparing spareribs.

Alongside the forms of the word like *spar-rib*, English also had the untransposed form *ribspare*, which persisted in English dialects even into the 1800s. Even though *ribspare*, directly reflecting Low German *ribbesper*, is attested a bit later than *sparerib*, it may perhaps have been the original form in which the word was borrowed, and the transposed forms like *sparerib* may have been created from *ribspare* as a result of FOLK ETYMOLOGY.

The meaning of the element *rib* in a form like *ribspare* would immediately have been apparent to English speakers, but the precise significance of the other element *spare* may sometimes have proved a bit puzzling. Eventually, the earlier forms like *spar-rib* and *ribspare* yield to modern *sparerib*, and this change probably reflects the influence of the adjective *spare* in its meaning "trim," and the notion that the amount of meat on spareribs is somewhat *sparing*.

For a similar transposition of the elements in a compound word in order to make the relationship between the word and its meaning more straightforward, see **sideburns.**

spartan The city of Sparta, the capital of the region called Lacedaemon in the very south of mainland Greece, vied with Athens for the domination of Greece in ancient times. Once, when someone asked why the Spartans did not have magnificent city walls like other Greek cities, the great Spartan king Agesilaos simply pointed to his fellow citizens, armed to the teeth, the most formidable soldiers in Greece: "Here are the walls of the Lacedaemonians." In order to foster and maintain a martial spirit, the Spartan upper classes endured a regimented life whose rigor was as much a source of amazement to their fellow Greeks as it is to us today, in the 21st century.

When a child was born in an upper-class Spartan family, the community elders would examine it, and if they found that it had any defects, it would be thrown over a cliff. At the age of seven,

boys left their families to live in communal barracks, where they were drilled rigorously in military exercises. They slept on reeds they plucked themselves without the aid of knives, and they had one piece of clothing, a single cloak of wool that they wore, rain or shine, throughout the year. They were deliberately underfed and encouraged to steal food, in order to learn the skill of approaching the enemy in secret. If they were caught, they were beaten for their lack of stealth, rather than for stealing. At the age of twenty, the young men were admitted to membership in the communal dining halls where all male citizens were obliged to take their meals. There they ate simple foods—barley, cheese, figs, watered wine, and pork seasoned with just salt and vinegar—that kept them fit and ready for battle. Exceptionally among the ancient Greeks, women were given a good education as well as men, so that they too could serve the city by raising the best children possible. The rough training and regimented lifestyle produced an elite corps of soldiers that enabled Sparta to dominate much of Greece from the 6th to the middle of the 4th century BC, when Spartan power entered a decline. The austere life of the Spartan people is still remembered today when English speakers use the adjective *spartan* to describe a frugal meal or an ascetic lifestyle.

The English words *spartan* and *laconic* (from *Lacedaemon*) are also used to describe language that is terse or concise. The Spartans trained the mind as well as the body, and their speech was as pointed as their spears. When an Athenian made a joke about the shortness of the standard Spartan sword, the Spartan king Agis said, "Yet we can still reach the hearts of our enemies with them."

spick-and-span The Modern English expression *spick-and-span*, which suggests satisfying cleanliness and freshness, can be traced all the way back to Old Norse *spān-nȳr*, which means literally "chip-new"—the chips here probably being those that fly when wood is hewn with an axe or smoothed with a plane. In Old Norse, *spān-nȳr* had a synonym *spān-ōsi*, that was used specifically of ships just constructed and launched. *Spān* in these words thus may have indicated the meaning "so new the chips have just flown off it." But

already in Old Norse times, *spān-nȳr* could even be used of things not constructed of wood, like new wine. The Old Norse word was adopted into English as *span-new*, "very new," which begins to appear around the beginning of the 14th century. In the 16th century, *span-new* was expanded to *spick and span new*. An element similar to *spick* is also found in Dutch expressions equivalent to *spick and span new*, such as *spiksplinternieuw*. English speakers will recognize the word *splinter* in the latter form. The element *spik* is probably a form of the word that appears in English as *spike* and in Dutch as *spijker*, "nail." The original sense of Dutch *spiksplinternieuw* may originally have meant something like "made with new timber and new nails." Many medieval ships were constructed from overlapping planks held together with many nails, and these were often pulled out to be reused elsewhere when the ship was retired. In this way, reused nails may have been quite common in cheaply constructed vessels at the time.

In the 17th century, *spick-and-span* was extracted from the expression *spick and span new* and used as an adjective or adverb on its own. Samuel Pepys, whose diaries provide a fascinating glimpse of daily life in London in the 1660s, uses the phrase in his entry for November 15, 1665:

> *It was horrible foule weather; and my Lady Batten walking*
> *through the dirty lane with new spicke and span white*
> *shoes, she dropped one of her galoshes in the dirt, where it*
> *stuck, and she forced to go home without one, at which she*
> *was horribly vexed.*

Already in Pepys's time we can perceive the association of newness with cleanliness in *spick-and-span*, and in modern times, the adjective is most often used to mean just "very clean," rather than "very new." In current usage even an old house can be tidied up *spick-and-span*.

spill Crying over spilt milk is pointless because it cannot undo the damage, which in the literal sense of this phrase is trivial; but in

the Middle Ages *spill* was used for actions that seem to demand tears. The primary meaning of Old English *spillan*, the ancestor of Modern English *spill*, was "to kill, to destroy." The extended senses of the verb, "to waste" and "to shed blood," connect the earlier meaning with the modern meaning referring to substances falling out of containers, often wastefully. But many people, castles, and fortunes were *spilled* before people started spilling milk, judging from the recorded evidence. In the Manciple's Tale from Geoffrey Chaucer's *Canterbury Tales*, a character offers the following words of wisdom: *Ful ofte, for to muche speche / Hath many a man been spilt.* ("Very often a man has been ruined by talking too much.") The verb *spill* is first recorded in the sense "to cause a substance to fall out of a container" in a work composed in the 14th century. Since then most of the senses having to do with violent destruction have become obsolete or archaic, although we still speak of spilling blood as well as milk, water, and gravy.

spinster The suffix *–ster* is nowadays most familiar in words like *pollster, jokester, huckster,* where it forms agent nouns—that is, nouns that denote the person who performs an action—that typically refer to males. However, the Old English ancestor of the suffix *–estre* was used to form feminine agent nouns. *Hoppestre*, for example, meant "female dancer." It was occasionally applied to men, but mostly to translate Latin masculine nouns denoting occupations that were usually held by women in Anglo-Saxon society. A form of the suffix can be seen in the Old English word *bæcester*, "baker," used to translate the Latin word *pistor*. It survives as the Modern English name *Baxter*.

In Middle English, the use of *–ster* (from Old English *–estre*) as a masculine suffix became more common in northern England, while in the south it remained limited to feminines. In time the masculine usage became dominant throughout the country, and old feminines in *–ster* were refashioned by adding the newer feminine suffix *–ess* (borrowed from French) to them, such as *seamstress* remade from *seamster*. In Modern English, the only noun ending in *–ster* with a feminine referent is *spinster*, which origi-

nally meant "a woman who spins thread or yarn." The development of this word reveals the oppressive social constraints that women have faced throughout history. In the 1600s, *spinster* became a technical legal term meaning "an unmarried woman," since spinning was a common occupation for unmarried women at the time. By the 1700s, *spinster* had come to denote a woman who remains single beyond the conventional age for marrying. Nowadays the word is almost always considered offensive.

stampede The word *stampede* comes from Mexican Spanish *estampida*, a word that originally meant "explosion, bang, crash, uproar," but that in American Spanish came to be used to refer to a sudden rush of animals, such as cattle or horses. The word is attested in a variety of spellings, such as *stampido* and *stampedo*, when it first begins to appear in English in the early 1800s, and these may perhaps reflect the influence of a later Spanish masculine noun *estampido*, derived from *estampida*. According to the *Oxford English Dictionary*, an American text dating from 1828 offers the first known use of a form of the word *stampede* as a more or less naturalized English term: *A little before daylight, the mules made an abortive attempt to raise a stampido.* Soon after, in the late 1840s and 1850s, the United States were to see stampedes of miners rushing westward to find gold in the California Gold Rush. The term *stampede* is also often used to describe the Klondike Gold Rush beginning in 1896.

The Spanish word *estampida*, "explosion, bang, crash," is a borrowing of Provençal *estampida*, and the Provençal word is probably of Germanic origin and is ultimately related to the English words *stamp* and *stomp*.

stark-naked Most people when they hear the expression *stark-naked* probably interpret *stark* as meaning something like "very" or "obviously," as *stark* in the phrase *stark raving mad*. Or they perhaps think that *stark* here means "bare," and that unclothed flesh has a stark appearance like a stark desert landscape. In fact, the original form of the expression in Middle English was *stert*

naked or *start naked*. In some parts of the United States, *start naked* is still in common use. But what then is the *start* in *start naked*? Does *start naked* mean "just as naked as at the start"—that is, "as on day one was born"? It is just such bewilderment that probably led to the folk-etymological replacement of *start* by *stark* in many varieties of English.

As it happens, *start* is an old word for "handle" or "the tail of an animal." The expression *start naked* thus originally meant something like "naked even to the tail (that is, the buttocks)." (*Start* is not in fact attested in English in the meaning "buttocks," but closely related words in other languages, like the ancestor of Modern German *Sterz*, used to have this meaning.) The earliest known attestations of *start naked* occur in the 1200s and describe the indignities inflicted upon saints during their martyrdom. As the word *start* began to fall out of use in the meaning "tail," speakers may have misheard the phrase and mentally replaced *start* with *stark*, perhaps more easily interpretable in this phrase. The first known attestation of *stark-naked* occurs in 1530, as a vocabulary item in a grammar of French intended for the use of English speakers. Shakespeare too uses the newer form *stark-naked* more than once in his works. In *Antony and Cleopatra* (Act 5, Scene 2), Cleopatra expresses her refusal to be led captive back to Rome in the following stark terms:

> *...Rather a ditch in Egypt*
> *Be gentle grave unto me! rather on Nilus' mud*
> *Lay me stark-nak'd...*

Start naked nevertheless lives on today and continues to compete with *stark-naked* in American English. The word *start*, "tail," also survives in *redstart*, the name for two species of birds (one in North America and one in Europe) with noticeably red tails.

stoic The Stoic school of philosophy was founded by the Greek philosopher Zeno of Citium (335?–263? BC) during the late part of the 4th century BC. Zeno taught in a building in Athens called the

Stoa Poikilē, "the Painted Stoa." (A *stoa* is a typical kind of ancient Greek building consisting of a covered walk or colonnade, usually having columns on one side and a wall on the other. The Stoa Poikilē itself was named for the painted panels of famous battle scenes that adorned its wall.) Since Zeno's followers would gather in the Stoa Poikilē to hear his teaching and discuss philosophical doctrines, the Greeks came to call them the *Stōikoi*, "the Stoics."

stoic

the Stoa of Attalus, Athens, Greece

The Stoic philosophers believed that a transcendent being had created the universe and had ordered it according to reason. Since this transcendent being had established natural principles for the best, the stoics thought that a virtuous life lived in accordance with nature and reason and embodying such qualities as wisdom, courage, justice, and temperance was sufficient for happiness. Although the Stoic philosophers developed an advanced system of logic and also speculated about the physical makeup of the universe, they are nevertheless most well known for their ideas about the proper way to lead a virtuous life. Stoicism continued to flourish in Roman times, and in its later Roman form, Stoics advocated the calm acceptance of all occurrences as the unavoidable result of divine will or of the natural order. The wise and benevolent Roman emperor Marcus Aurelius (AD 121–180) expounded his version of Stoicism in a work, usually known as the *Meditations*, that probably originated as a private notebook in which he wrote down thoughts about the nature of virtue as they occurred to him. The following passage from Aurelius's work will serve to illustrate Roman Stoicism: *If you are pained because of some external cause, what troubles you is not that thing, but your own judgment concerning it, and it is in your power to wipe this from your mind immediately* (*Meditations*, Book 8, 47). It is such attitudes as these that eventually lead to the general use of the

words *stoic* and *stoical* to describe the demeanor of persons who are seemingly indifferent to either pleasure or pain.

stoop Originally brought to the Hudson Valley of New York by settlers from the Netherlands, a few items of Dutch vocabulary have survived there from colonial times until the present. *Stoop,* "a small porch," comes from Dutch *stoep;* "front verandah," which is ultimately related to the English word *step. Stoop* is now in general use in the Northeast and is probably spreading.

Another Hudson Valley word of Dutch origin, spelled *olicook* or *olykoek* among many other variants, means "doughnut, small sweet cake fried in oil." *Olicook* comes from Dutch *oliekoek*—literally, "oil cake." The word appears to be dying out in the modern age, however. Another word of Dutch origin, *kill,* is used to refer to a small running stream throughout New York State. It comes from Dutch *kil,* meaning "channel" or "riverbed."

stove The word *stove* first referred not to a cooking or heating device but to a heated sweating-room similar to a modern steam bath or dry sauna. According to the *Oxford English Dictionary* the word is first recorded in 1456 and seems to be borrowed from Middle Low German or Middle Dutch *stove.* (Nevertheless, there are isolated occurrences in Old English of words related to the Middle Low German and Dutch words, including an Old English word *stofa* used once to explain the Latin word *balneum,* "bath." These Old English words seem to have died out, however, before the related word *stove* was imported from the continent.) Around 1545 *stove* is recorded with reference to another room, such as a bedroom, heated with a furnace. The devices used to heat these rooms came to be called *stoves* as well, a use first found sometime between 1550 and 1625. Of course, heating devices that we would call *stoves* had long been in existence, going back to Roman times. However, the stove as the chief cooking device, taking the place of the fireplace, dates only to around the mid-19th century with the widespread use of wood-burning or coal-burning cooking stoves.

The Old English word *stofa* and the Middle Low German or

Middle Dutch *stove* are both probably derived from a Vulgar Latin word **extūfa*. The Vulgar Latin word is in turn derived from **extūfāre*, "to heat with steam," from Vulgar Latin **extūfa*, "hot vapor," ultimately from Greek *tūphos*, "fever." As the Vulgar Latin spoken in the towns and countryside of Gaul developed into Old French, **extūfāre* became Old French *estuver*, meaning "to bathe in hot water" and by extension "to stew (food in a pot)," since meat and vegetables cooking in a pot can be thought of as taking a hot bath in their own juices. The Old French verb *estuver* and its related noun *estuve* are in fact the source of the English verb and noun *stew*. In this way, the same Vulgar Latin word has given us our terms for both the stove in the kitchen and the stew simmering on top of it.

strike The central role that baseball has played in American culture is known to all, but is particularly evident in the abundance of baseball expressions applied to circumstances outside the sport. When people say that they have *struck out* in an endeavor, they are using one such expression. We routinely speak of *ball-park* figures or estimates, of some unexpected quirk of fate or tricky question on an exam being a *curve ball*, of *minor-league* or *bush-league players* in a field or business, who might one day enter the *big leagues*. If we can't go to lunch with a person who invites us, we take a *rain check*. We can *go to bat* or *pinch-hit* for a friend. We can be *off base* about something or so disconnected we are *out in left field*. When we cooperate we are *playing ball*, and when we get serious or even ruthless about something, we are *playing hardball*. Some unfortunate people are said to have been born *with two strikes against them* if bad things come their way *right off the bat*. The list could go on and on, but that would only be *running up the score*.

submarine The long sandwich featuring layers of meat and cheese on a crusty Italian roll or French bread goes by a variety of names. These names are not distributed in a pattern similar to that of other regional words because their use depends on the business

and marketing enterprise of the people who create the sandwiches and sell them. *Submarine* and *sub* are widespread terms, not assignable to any particular region. Many of the localized terms are clustered in the northeast United States, where the greatest numbers of Italian Americans live. In Maine, the submarine is called an *Italian sandwich*, befitting its heritage. Elsewhere in New England and in Sacramento, California, it is often called a *grinder*. New York City knows it as a *hero*. In the Delaware Valley, including Philadelphia and southern New Jersey, the sandwich is called a *hoagie*. In Miami, the role of the submarine is filled by a similar sandwich called the *Cuban sandwich*. Along the Gulf Coast, a long sandwich made with a variety of ingredients is often called a *poor boy*. In New Orleans, a *poor boy* is likely to be offered in a version featuring fried oysters.

superman Superman, the all-American 20th-century comic-book hero, takes his name from the 19th-century German philosopher Friedrich Nietzsche's term for the ideal superior man, which is *Übermensch* in German. For Nietzsche, the *Übermensch* is a person who forgoes transient pleasures, exercises creative power, and lives at a level of experience beyond standards of good and evil. For Nietzsche, the status of *Übermensch* is the goal of human evolution. Nietzsche's word *Übermensch* (formed from German *über*, "over, above, beyond," and *Mensch*, "man, person") might have been translated *overman* or *beyondman*, but the play *Man and Superman* by George Bernard Shaw published in 1903 helped to establish *superman* as the standard English term for Nietzsche's concept. Such a term comes to us through a process called loan translation, or CALQUE formation, whereby the semantic components of a word or phrase in one language are translated literally into their equivalents in another language. In fact we do also find *overman* and *beyondman* as calques for the word *Übermensch* in early translations and discussion of Nietzsche's works in English, but they did not take root. The appearance of the comic-book character Superman in 1938, on the pages of the first issue of *Action Comics*, helped bring the

word *superman* to even greater prominence, and now it can refer to any man who seems to have more than human powers.

Svengali The novel *Trilby* by George du Maurier (1834–1896) was enormously popular after its publication, and its success has given the English language two words.

Trilby, first published in 1894, takes place in bohemian Paris of the 1850s. The sinister hypnotist Svengali uses his hypnotic powers to enslave a tone-deaf young woman named Trilby O'Ferrall and transform her into a magnificent singer. Svengali conducts her concerts and lives in luxury off the earnings from Trilby's performances. When Svengali dies from a heart attack at the beginning of a concert, Trilby awakens from her trance completely unable to sing or even remember what has happened to her. The audience hoots her from the stage, and she dies soon after, unable to survive outside the influence of the hypnotic power of her cruel master. *Svengali*, a 1931 film based on the novel *Trilby* and starring John Barrymore as the evil hypnotist, helped make Svengali even more notorious. Owing to the popularity of the novel and its various screen and stage versions, the word *Svengali* came to be used to describe persons who, with evil intent, manipulate others into carrying out their desires.

Du Maurier was also well-known as an illustrator and cartoonist, and one of his own illustrations for *Trilby* shows a character wearing a soft felt hat with a deeply creased crown. Such hats were also worn in the original London stage production based on the novel. Public enthusiasm for the novel and the play apparently helped bring the style into fashion in the late 19th and early 20th centuries, and such hats are still known as *trilbies* today.

sycophant No one likes a tattle-tale, and the term *sycophant* has had unfavorable connotations from the very beginnings in the Greek language. When the word *sycophant* first appeared in English in the 16th century, it denoted an informer or someone who comes forth voluntarily to denounce others to the authori-

ties. Very soon afterwards, *sycophant* developed the sense "servile flatterer," the most common meaning of the word in modern usage, since the obsequious followers of the powerful may denounce their rivals and tell false, manipulative stories when vying for the attention and favor of their patrons.

English *sycophant* is a borrowing of Latin *sȳcophanta*, "informer, slanderer," which is in turn a borrowing of Greek *sūkophantēs*. The Greek word literally means "one who shows a fig," and the Greeks themselves were puzzled by the expression and attempted to explain the relationship between showing figs and exposing wrongdoing in various ways. For example, the Greek historian Plutarch (AD 46?–120?) offers the following explanation of the word in his biography of the Athenian lawmaker Solon (638?–559? BC):

> *Of agricultural products, Solon permitted only olive oil to be exported, but forbade exportation of others. He gave orders that the ruler of the city should pronounce curses on those who exported them, or else the ruler himself should pay a hundred drachmas into the public treasury.... We therefore cannot consider entirely unconvincing those who say that the exportation of figs was forbidden in the past as well, and that the act of showing the thing that they pointed out* [that is, the figs being exported] *was called fig-showing.*

Nevertheless, some modern scholars have rejected the explanations of the term that were offered by ancient authors. They point out that the word for "fig" in some languages has an obscene meaning. To this day, in the Mediterranean region, there is an obscene gesture called *the fig* made by closing the fist and putting the thumb between the index and middle finger. The closed hand then resembles a fig. This gesture could also be used to ward off bad luck or the evil eye, and modern Italians and Brazilians still show the fig for such purposes today. To most Americans, the fig will look like the innocent gesture made when playing *I got your nose* with very young children—a game that

looks very strange to people in whose culture the gesture is obscene.

The fig used to be even more widely used in Europe than it is today, and the gesture was known in England as well. For example, in Shakespeare's *Henry V* (Act 3, Scene 6), the cowardly pick-pocket-turned-soldier Pistol offers the following gracious words of farewell to the loyal Welsh officer Fluellen, after the Welshman has refused to do him a favor:

PISTOL : *Die and be damn'd! and* figo *for thy friendship!*
FLUELLEN: *It is well.*
PISTOL: *The fig of Spain.*

Some scholars therefore believe that in ancient times the original *sūkophantēs* was one who gave another the fig, although to exactly what purpose—the repulsion of the wrongdoer's evil eye? a simple show of defiance or disrespect?—remains unclear.

T

tabby cat An investigation of the term *tabby* will eventually lead us to an unexpected place. Tabby cats get their name from a kind of fabric called *tabby*, since their striped or brindled coats of gray or tawny hues recall the appearance of this rich silk fabric. The term *tabby* first appears in English in the first half of the 17th century, in reference to fabric, and later in the same century it begins to be applied to cats of tabby coloration. *Tabby* comes from the French term for the same silk fabric, *tabis*, and *tabis* is in turn an alteration of Old French *atabis*. *Atabis* is ultimately derived from Arabic *al-ʿAttābī*, the name of the neighborhood in Baghdad where the fabric was manufactured in the Middle Ages. This part of Baghdad is named after *ʿAttāb*, a member of the Umayyad family, from whose generations were drawn the caliphs who ruled from Damascus in the 7th and 8th centuries. During the Umayyad caliphate, Islam spread across a vast territory stretching from Spain to regions now part of Pakistan, as the Islamic world entered a period of cultural splendor that was to continue under the Abbasid caliphate and other later rulers in the region. Europe was eager to acquire the luxurious products of the Near East at this time, and thus the word *tabby* began its journey to the English language.

tabby cat
several tabby cats

tabloid We often hear the complaint that *factoids* and *sound bytes* dominate news media in the 21st century, and simplistic and superficial reporting is often considered to be a malady of modern journalism. Readers in the 19th and early 20th centuries, however, liked their information in small doses as well, and this tendency is revealed by the history of the word *tabloid*. The term began as a trademark registered in 1884 by the British firm of Burroughs, Wellcome & Company, who applied it to the small compressed medicinal tablets they sold. Soon the word *tabloid* came to be applied to a variety of small or compressed things. Small yachts, for instance, began to be called *tabloid yachts*. In the slang of the Royal Air Force during the period around World War I, a *tabloid* was a type of small biplane. In the 1890s, in fact, the word had already become so common that Burroughs, Wellcome & Company took legal action in order to prevent its use in the product names of other firms. Nevertheless, their legal proceedings did not stop *tabloid* from becoming a general purpose adjective meaning "small" or "compressed." Critics at the beginning of the 20th century deplored *tabloid journalism* and complained that the public liked its information in overly compressed, or *tabloid*, form. The expression *tabloid newspaper* begins to appear in the early part of the 20th century in much the sense that it has today—a newspaper of small format presenting the news in condensed form and usually offering sensationalistic stories accompanied by plenty of illustrations.

tangerine The name *tangerine* comes from Tangier, Morocco, the port from which the first tangerines were shipped to Europe. The adjective *tangerine*, from *Tangier* or *Tanger*, was already an English word (first recorded in 1710), meaning "of or pertaining to Tangier." This adjective had been formed with the suffix *–ine*, as in *Florentine*. The fruit was first called a *tangerine orange*, later reduced simply to *tangerine*.

The tangerine is a particular type of mandarin orange, which is a variety of small orange with loose, easily peeled skin originat-

ing in China and Southeast Asia. It is sometimes said that the mandarin orange received its name because of its resemblance in color to the robes of a mandarin—that is, a member of one of the nine ranks of high public officials during the imperial period in recent centuries of the history of China. Alternatively, the word *mandarin* in this case may simply denote a high grade of orange—suitable for mandarins, that is.

The word *mandarin* itself has an interesting etymology. It originates as the Sanskrit word *mantrin*, literally meaning "one who has a mantra." In this particular instance, the Sanskrit term *mantra* denotes a sage piece of advice to be turned over in the mind for consideration. The designation *mantrin* was used as a title for state ministers or counselors in India, and the title spread to Malay-speaking areas to the east of India that were profoundly influenced by Indian civilization in pre-Islamic times. European adventurers and merchants picked up this official title in the form *mandarim* on their way to East Asia and eventually applied it to the state counselors in China. The word subsequently reached English in the form *mandarin*. The further etymology of the word *mantra*, the source of *mandarin*, is discussed at a separate entry in this book.

tarnation　The noun and interjection *tarnation* illustrates a phenomenon called *taboo deformation*, by which words that can be considered offensive or impolite under some circumstances are made more acceptable or softer-sounding by altering one or more sounds that make up the words. *Tarnation* appears to be a variant of *darnation*, both alterations of *damnation*, in the same way that *darn* is an alteration of *damn*. *Tarnation*, however, seems to have been influenced by *Tarnal!*, another mild oath derived from the adjective *eternal*—as used in *eternal damnation*, for instance. The *Oxford English Dictionary* cites examples of *tarnation* used in New England during the late 1700s, indicating that it has been part of American speech since colonial days.

taupe　The word *taupe* denotes a brownish-gray color. The word is a fairly recent borrowing into English, first appearing at the

beginning of the 20th century. In fact, *taupe* is simply the word for "mole" in French—not a dark-colored patch on the skin, however, but rather the burrowing mammal with grayish, silky fur and a pink snout. In French, the expressions *couleur taupe*, "mole color" or *gris taupe*, "mole gray," were used to designate cloth and other objects having the color of mole fur. *Taupe* is thus one of the wealth of French words that English has borrowed in relatively recent times in order to express the fine distinctions among different shades of colors. Some of these words, like *ecru* and *puce*, are discussed elsewhere in this book, while the origin of the word *mauve* is discussed at the word *marshmallow*.

ted The verb *ted* means "to spread newly cut hay to facilitate its drying." Strangely for such an important agricultural term, the verb first appears in Middle English and does not seem to descend from any known Old English word. Although the word may be unfamiliar to urban dwellers, *ted* is still commonly used by farmers today. In the mid-1800s, however, an American inventor produced a machine to ted the hay automatically and called it a *tedder*. Since English is inclined to make verbs out of nouns meaning implements or machines, the noun *tedder* became a verb with the same meaning as the original word *ted*. The verb *tedder*, which originated in New England, also turns up in those parts of the Midwest that received settlers from New England.

teeter-totter The outdoor toy usually called a *seesaw* has a number of regional names, New England having the greatest variety in the smallest area. In southeast New England it is called a *tilt* or a *tilting board*. Speakers in northeast Massachusetts call it a *teedle board*; in the Narragansett Bay area the term changes to *dandle* or *dandle board*. *Teeter* or *teeterboard* is used more generally in the northeast United States, while *teeter-totter*, probably the most common term after *seesaw*, is used across the inland northern states and westward to the West Coast. Both *seesaw* (from the verb *saw*) and *teeter-totter* (from *teeter*, as in *to teeter on the edge*) demonstrate the linguistic process called *reduplication*, where a

word or syllable is doubled, often with a different vowel. Reduplication is typical of words that indicate repeated activity, such as riding up and down on a seesaw.

terrier Like many types of working dogs, the terrier was named after the task for which it was originally bred. Its name was borrowed from Old French *terrier,* which is short for *chien terrier*—*chien* meaning "dog" and *terrier,* "having to do with the ground." The terrier was developed for driving game from burrows and thus was literally named the "ground dog." Other such dog classifications include the bull-dog, used for bullbaiting; the sheepdog and German shepherd, used for sheepherding; the retriever, a bird dog bred to retrieve game; the sleuthhound and the bloodhound, used for tracking or pursuing; the gazehound, which hunts prey by sight; the setter, trained to indicate the presence of game by crouching in a "set" position; and the schipperke (from Flemish *schipper,* "skipper"), used as a watchdog on a boat.

terrier
a Boston terrier

tête-à-tête The word *tête-à-tête* not only means "a private conversation between two persons" but is also used to designate a particular piece of furniture ideal for such an interview: an S-shaped sofa allowing the occupants to face each other. In French, the phrase *tête-à-tête* literally means "head to head." The phrase was originally used adverbially in French in the sense of the English phrase *face to face* or *one on one,* and in English too *tête-à-tête* was originally used as an adverb. In the 17th century, *tête-à-tête* came to be used in French as a noun meaning "a face-to-face conversation," and the noun first appears in English with this meaning in the 17th century as well. By the end of the 18th century, *tête-à-tête* also came to be the designation in French for a sofa seating two

persons, and the word first begins to appear in this sense in English in the middle of the 19th century.

tête-à-tête
a toby

The French word *tête*, "head," descends from Old French *teste*, which in turn comes from the Latin word *testa*, which meant primarily "jug, clay pot." *Testa* was also used in the meaning "potsherd" and "shell of a mollusk." In Late Latin (the Latin of the Roman Empire from around the 3rd to the 7th centuries AD), it was also occasionally used to mean "skull." While the development of the French word meaning "head" from the Latin word meaning "clay pot" may seem surprising at first, it has a parallel in English. The English word *noggin* originally referred to a small mug holding about a quarter of a pint, but it is now most often heard as a jocular way of saying *head*. The word *mug*, as in *ugly mug* and *mugshot*, is most likely a metaphorical use of the word *mug* meaning "stout ceramic drinking vessel." However, this development may not be based on the simple association of the shape of the drinking vessel with that of the head, as in the case of *noggin*. *Mug* in the sense of "ugly face" first begins to appear around 1700, and at the time, there was a fashion for ceramic vessels decorated with grotesque faces of stereotyped characters like crusty old sailors or country squires. These mugs came to be called *toby mugs* or simply *tobies*.

Thames

The modern spelling of the word *Thames* illustrates an interesting phenomenon in the history of the English language. The Romans called the river *Tamēsa* or the *Tamēsis*, in Latin, and this name doubtless has its origins in the Celtic languages originally spoken in Great Britain that were later replaced by Old English after the arrival of the Anglo-Saxons. The Thames is first mentioned in Old English around 893 in King Alfred the Great's translation of the work of the late Roman historian Paulus

Orosius. At the time, the Old English name was spelled *Temese* or *Temes.*

The spelling *Thames*, which first appears in 1649, is an example of the kind of "learned" respelling that went on in English from the late Renaissance through the Enlightenment, when the prestige of Latin and Greek prompted scholars to "correct" the form of many English words. The *a* in *Thames* is etymologically correct, since the Latin forms had that vowel, but the *h* is a "learned" error, added in the mistaken belief that *Thames* derived from a Greek word, such as the name of a Greek river called the *Thyamis.* Such errors were common, and many words that had nothing to do with Greek were respelled to make them look Greek. In many cases, the pronunciations of these words changed accordingly, yielding what linguists call a *spelling pronunciation;* for example, *author*, from Latin *auctor* and not from a Greek word, is now pronounced with a (th), even though we would strictly expect it to be pronounced with a (t) instead. The pronunciation of *Thames* remained unchanged, however, providing an etymologically explicable example of the notorious discrepancy between English spelling and pronunciation.

The phenomenon of spelling pronunciation is discussed in fuller detail at the entry for the word *author* in this book.

theater Theories about the development of the theater in the West generally begin with Greek drama; this is etymologically appropriate, since the words *theory* and *theater* are related through their Greek sources. The Greek ancestor of *theater* is *theātron*, "a place for seeing, especially for dramatic representation, theater." *Theātron* is derived from the verb *theāsthai*, "to gaze at, contemplate, view as spectators, especially in the theater," from *theā*, "a viewing." The Greek ancestor of *theory* is *theōriā*, which meant among other things "the sending of *theōroi* (state ambassadors sent to consult oracles or attend games)," "the act of being a spectator at the theater or games," "viewing," "contemplation by the mind," and "theory or speculation." The source of *theōriā* is *theōros*, "an envoy sent to consult an oracle, spectator," a compound

ultimately derived from the noun *theā*, "viewing," and the verb *horān*, "to see." It is thus fitting to elaborate theories about culture while seeing a play in a theater.

trashed Expressions for intoxication are among those that best showcase the creativity of slang. The boundless inventiveness in expressing the ordinary in not-so-ordinary ways led Walt Whitman to describe slang as *an attempt of common humanity to escape from bald literalism, and express itself illimitably.*

Colloquial and slang expressions meaning "intoxicated" can fill several pages in slang thesauruses. Most fall into a few general groups. Common are expressions that originally meant "damaged, badly affected by something," such as *trashed, smashed, crocked, blitzed, hammered, wasted, messed up,* and *blasted.* Cooking terms are also common, such as *baked, fried,* and *boiled* (said to have been coined at Princeton University in the 1920s). Terms relating to liquids or being filled are a natural source of metaphors for filling oneself up with drink or drugs: *sloshed, oiled, tanked,* and *loaded* are but a few. Some terms are not easily classified or have origins that are not fully clear, such as *tight* (first appearing in the 1830s), *plastered* (first appearing around 1912), and *blotto* (first appearing in 1917, perhaps from *blot,* since blotting paper soaks up liquid). *Stoned,* which nowadays is perhaps more often used of intoxication caused by other substances other than alcohol, is apparently taken from such expressions as *stone-drunk* and *stone-cold.* According to the *Oxford English Dictionary,* it first appears simply as *stone* in a work entitled *Hepcats Jive Talk Dictionary,* edited by Lou Shelly.

Most current terms for "intoxicated" are not very old, as one expects of slang terms generally. Of those in the lists above, *blotto, crocked, fried, loaded, plastered, tanked, tight,* and *oiled* are recorded in the first half of the 20th century, and of these only *tight* and *oiled* are known to have existed before then.

trek Though now most familiar to English-speakers and others in the title of the *Star Trek* television shows and movies, the word

trek originally referred to a journey by a much slower mode of transportation than a starship. The English word is a borrowing of Afrikaans *trek*, which is both a noun meaning "a voyage by ox wagon" and a verb meaning "to travel by ox wagon." Afrikaans, still spoken by many millions of people in the Republic of South Africa today, is descended from the Dutch dialects spoken by Protestant settlers from the Netherlands who came to South Africa in the 17th and 18th centuries. French Protestants and settlers originating in other areas of Europe also joined these Dutch settlers. In the 19th century, some of their Afrikaans-speaking descendants lived as farmers on the eastern frontiers of European settlement in South Africa and were called the Boers (from the Dutch word meaning "farmer"). A seminal event in the history of South Africa was the *Groot Trek* or "Great Trek" lasting from 1835 to 1843, when more than 10,000 Boers left the Cape Colony and traveled north and northeast because of economic problems, conflict with the Xhosa, and discontent with British colonial authorities, who had forbidden the slave trade and postulated the equality of whites and non-whites. The people who undertook the Groot Trek and occupied the grazing lands at the South African frontier were called the *Voortrekkers* or "Pioneers." The British eventually gained complete control of South Africa from the Boers at the turn of the 20th century, and the conflict between the Boers and the British helped bring the word *trek* into general use in English outside of South Africa. In English, *trek* is recorded earliest in 1822 in the compound *trektow*, "a rope joining the wagon pole and the yoke to which oxen were fastened." The earliest English recorded use of the noun by itself is found in 1849, where it means "a stage in a journey by ox wagon."

Afrikaans *trek* comes from Dutch *trekken*, which means "to march, to journey," but earlier meant "to pull, to draw." A word related to Dutch *trekken* in another Germanic language may have served as the source of the French word *trac*, which first appears in the 15th century and means "baggage following an army" and also "track." English borrowed this French word as *track*, and in this way the words *track* and *trek* are ultimately related.

tryst The underbrush of a forest furnishes ideal cover for an illicit tryst, and in this regard, it is interesting that one of the earlier meanings of the word *tryst* was "a hunting station, an appointed meeting-place for hunters." *Tryst* descends from Middle English *trist*, a word of Scandinavian origin meaning "hope" or "expectation." In Middle English, *trist* developed the extended sense "appointed meeting" and came to be used of all sorts of meetings, not just of lovers' rendez-vous or other meetings likened to romantic encounters. *Trist* also had the specialized sense "hunting station," and in this sense, the word was probably influenced by the French term *triste*, also meaning "hunting station, watch post," and borrowed from the same Scandinavian source as Middle English *trist*. Chaucer uses the word *trist* with the sense "hunting station" in his poem *Troilus and Cressida*, which tells the story of the love borne by the Trojan prince Troilus for Cressida, daughter of the Trojan priest Calchas who has gone over to the side of the Greeks during the Trojan War. Cressida's uncle Pandarus has agreed to help Troilus win Cressida's love, and in somewhat unseemly fashion Pandarus likens love to the hunt when he assures Troilus that he will speak on his behalf:

> *Lo, hold the at thi triste cloos, and I*
> *Shal wel the deer unto thi bowe dryve.*

> Keep close to your hunting station, and I
> shall drive the deer well to your bow.

The word *trist*, meaning "expectation" and "appointed meeting," seems to have died out in the south of England after the Middle English period. It survived, however, in the north of England and Scotland, and it was from Scottish that *tryst* was reintroduced into literary English in the 19th century.

Tryst is etymologically related to the word *trust*. Both words ultimately descend from the same Indo-European root **dreu–*, "to be firm," another form of which is also discussed in the entry in this book for the word *philodendron*.

tumbleset *Tumbleset* is a term for *somersault* used in the Lower South. *Tumbleset* sounds vaguely like the word *somersault*—both words have three syllables, an *m* and an *s* in the middle, and a *t* at the end—but at first glance it is not clear how exactly the two words might be related. In fact, *tumbleset* and *somersault* are both ultimately derived from Old Provençal *sobresaut*, a compound of *sobre* "over" (from Latin *suprā* "over") and *saut*, "jump" (from Latin *saltus*). The Old Provençal word entered Middle French in the variant forms *sombresaut*, "somersault," and *sombresault*. (In French, an *l* before a consonant at the end of a word tended to become a *u*, and so many French words of the period show alternations between spellings like *–aut* and *–ault* with a retained silent *l* reflecting the earlier spelling of the word. The original *l* of Latin *saltus* probably influenced the spelling of the word as well.) Both forms of the French word, with and without *l*, entered English in the 16th and 17th centuries, and the English word appeared in various spellings such as *somersault* and *somersaut*.

In Standard English, the form *somersault* has become general, but variants without the *l* continued to exist in vernacular speech. The Southern term *tumbleset* descends from one of these *l*-less forms that has been altered by FOLK ETYMOLOGY. In the case of *tumbleset*, part of the word that no longer bears any meaning for the speakers (that is, *somer*) has been replaced by the similar-sounding verb *tumble*, which makes more sense with respect to the meaning of the whole word.

U

ugly The standard sense of the adjective *ugly*, "unsightly," becomes figurative in the common expression *an ugly temper*. Regional American speech shares this figurative sense and makes it even more specific. In New England, *ugly* as applied to animals, especially large farm animals such as cows and horses, means "balky, hard to manage." In the South, on the other hand, *ugly* with the specific sense of "rude" is used of persons: *Don't be ugly, son.* Interestingly, the word *clever* follows a regional pattern somewhat similar to that of *ugly.* In New England, the adjective *clever* can be used of animals like oxen to mean "easily managed, docile." When used of people in New England, the word can also have the somewhat similar meaning "affable but not especially smart." In the South, on the other hand, *clever* can be used of persons with the simple meaning "good-natured, amiable."

From an etymological point of view, things that are ugly are simply frightful. *Ugly* comes from Middle English *ugli*, "dreadful, repulsive." The Middle English word is a borrowing of Old Norse *uggligr*, a derivative of Old Norse *uggr*, "fear."

umpire Had it not been for the linguistic process known as *false splitting* or *juncture loss*, the angry, anguished cry heard at sports events, "Kill the ump," could have been "Kill the nump." In the case of *umpire* we can almost see false splitting in action by studying the *Middle English Dictionary* entry for *noumpere*, the Middle English ancestor of our word. *Noumpere* comes from Old French *nonper*, made up of *non*, "not," and *per*, "equal." As an impartial arbiter of a dispute between two people, the umpire is

not equivalent to or a partisan of either of them. In Middle English the earliest recorded form is *noumper* (about 1350); the earliest form without an *n* is *owmpere*, recorded in a document dated 1440. How the *n* was lost can be seen if we compare the sequence *a noounpier* in a text written in 1426–1427 with the sequence *an Oumper* from a text written probably around 1475. In *an Oumper*, the *n* has become attached to the indefinite article, giving us *an* instead of *a* and, eventually, *umpire* instead of *numpire*. The same sort of false splitting has altered the forms of other words as well. *Apron*, for example, used to be *napron*, and *adder* used to be *nadder*.

The reverse process has also occurred in the history of English: words that originally began with vowels acquired an *n* from a preceding indefinite article. *Nickname* comes from an obsolete phrase *an eke name*, "an additional name." *Newt* comes from *an eute*. A variant of the Middle English word *eute* still survives as *eft*, "a newt."

urbane Can one be urbane without being urban? *Urban* and *urbane* were once synonymous. Both words come from the Latin adjective *urbānus*, which is derived from the Latin word *urbs*, "city," and originally meant just "of or relating to a city." By extension, however, *urbānus* also came to mean "elegant and polished," since city-dwellers were considered more stylish than country folk. Of the two English descendants of the Latin adjective, *urbane* appears in English first, before *urban*. *Urbane* entered English in the 16th century, either directly from Latin or by way of French *urbain*, itself a borrowing from Latin. At first, English *urbane* was used in both the sense "of a city" and the sense "elegant," but by the beginning of the 19th century the sense "of a city" had become archaic. The literal sense of the word was taken over by *urban*, a direct borrowing from Latin which first appears in the early 17th century.

Words meaning "of a city" do not always go up in the world, however. Rustics familiar with the urbanities of urbanites might note that *bourgeois* comes from a French word that originally

meant "citizen of a town," and this word is sometimes used with a pejorative nuance to describe people whose attitudes and behavior are marked by conformity to the standards and conventions of the middle class.

Utopia As the etymology of *Utopia* suggests, a true Utopia is probably not to be found anywhere. The word *Utopia* is a Latinized compound of Greek *ou*, "not, no," and *topos*, "place." Sir Thomas More (1478–1535), an English politician, humanist scholar, and writer, coined the word in his popular fictional work *Utopia*, about an island nation of the same name. More's work is framed as a conversation in which a traveler relates an account of the society built by the citizens of the island of Utopia. In Utopia, property is communally held, citizens are free to practice any religion, and every household has two slaves. Yet far from being simply More's vision of the perfect society, *Utopia* is a nuanced and humorous critique of 16th-century Europe that contrasts the orderliness of a pagan society with the chaos of the supposedly moral society of Christian Europe. More himself was a devout Catholic and opposed to Protestantism, and for his refusal to comply with the Act of Supremacy (by which English subjects were enjoined to recognize Henry VIII's authority as the head of the Church of England) he was imprisoned in the Tower of London and beheaded for treason.

It is possible that More intended the name *Utopia* to evoke a hypothetical word *eutopia* (a Latinized compound of Greek *eu–*, "good," and *topos*, "place"), which would have sounded similar when pronounced in English. Nevertheless, the extent to which he considered Utopia a good place or for that matter an ideally perfect place—as we use the word today—is still a matter of debate. In the 17th century, however, the word *Utopia* came to be used to designate any place considered ideal or perfect, especially in its social, political, and moral aspects, not just the Utopia of More's work. Later, in the 18th century, another meaning began to emerge, and the word *Utopia* was used to describe any impractical, idealistic scheme for social and political reform.

V

vaccine The word *vaccine* ultimately comes from Latin *vacca*, "cow," a word that may be familiar to readers from its descendants, French *vache* and Spanish *vaca*. But what do cows have to do with vaccines, exactly?

Before the days of vaccination, the dread disease smallpox had long been a leading cause of death all over the world. If victims survived the illness, they often had terrible disfiguring scars. In 1796, however, the English physician Edward Jenner observed that people who had caught cowpox, a mild disease contracted from dairy cows, did not get smallpox afterwards. Jenner took liquid from the cowpox sores of a milkmaid and injected a boy with it. Two months later, Jenner exposed the boy to smallpox (something that would be considered unethical by today's standards). Luckily, as Jenner expected, the boy remained healthy. Exposing people to cowpox often worked quite well, but it was risky, and the exposed person sometimes died. In its subsequent refinement and application to other diseases, however, Jenner's technique of prevention has saved millions of lives in the past two centuries.

The medical Latin name for cowpox is *variolae vaccīnae*, "smallpox of cows," and Jenner named the substance he injected *vaccine virus*. (The English word *virus* comes from Latin *vīrus* meaning "venom" or "slime," and in Jenner's time, the English medical term *virus* had the more general meaning "a substance causing a disease" rather than the more specific meaning it has today.) The liquid that Jenner injected eventually came to be known simply as *vaccine*, and his technique of preventing smallpox was also named *vaccination*.

valentine Lovers and the greeting card industry may have Geoffrey Chaucer to thank for the holiday that warms the coldest month. In the late 14th century, we begin to find the first clear references to a tradition relating February 14, St. Valentine's Day, to romantic love: St. Valentine's Day is the day on which the birds, returning in the very early spring, choose their mates. (Spring was often thought to begin in the middle of February in 14th-century Europe.) Although reference books abound with references to Roman festivals from which St. Valentine's Day may derive, there is in fact very little evidence of such a connection between ancient pagan customs and the modern holiday. Moreover, there are several saints named Valentine in the Christian tradition, but there is nothing in particular in the life stories of any of these Valentines that might have inspired the late medieval traditions surrounding St. Valentine's Day. The scholar Jack B. Oruch has therefore suggested that Chaucer was probably the first to link the saint's day with the custom of choosing sweethearts. No such link has been found before the writings of Chaucer and several of his literary contemporaries who also mention it, but after them the association becomes widespread. Oruch proposes that Chaucer, the most imaginative of his literary circle, invented it. The earliest description of the tradition may occur in Chaucer's *Parlement of Foules,* composed around 1380, which takes place *on Seynt Valentynes day, / Whan every foul* [bird] *cometh there to chese* [choose] *his make* [mate].

vandal

> *Rome raised not art, but barely kept alive,*
> *And with old Greece unequally did strive:*
> *Till Goths, and Vandals, a rude northern race,*
> *Did all the matchless monuments deface.*

> —John Dryden, *To Sir Godfrey Kneller,* 1694

Nowadays, when we hear the word *vandal,* we probably think of someone maliciously throwing a brick through a window or

holding a can of spray paint and defacing a wall. However, the English word *vandal* preserves the memory of destruction on a much larger scale. The original vandals were a Germanic tribe, called the *Vandali* in Latin, that overran Gaul, Spain, and North Africa in the 4th and 5th centuries AD and sacked Rome in 455. The Latin word from a member of this tribe, *Vandalus*, is simply the Roman pronunciation of the tribal name of the Vandals in an early Germanic language. The Germanic tribal name may go back to a Proto-Germanic word **wandljaz*, akin to the Modern English verb *wander* and literally meaning "wanderer"—an appropriate moniker for a marauding tribe.

The word *vandal* first appears in English in reference to the Germanic peoples. Because the Vandals were so strongly associated with the plundering and destruction of Roman civilization, however, the word also became a common noun used to describe those who disregard or damage things of historical or cultural significance or who are otherwise barbaric in their conduct. This is the sense of *vandal* that we find in the title of Mark Twain's 1868 speech about American tourists in Europe, "The American Vandal Abroad." In modern usage, however, the word *vandal* often simply designates a person who defaces or damages any sort of private or public property.

vegetable Andrew Marvell's poem "To His Coy Mistress" contains many striking phrases and images, but perhaps most puzzling to modern readers is this promise from the speaker to his beloved:

> *Had we but world enough, and time....*
> *My vegetable love should grow*
> *Vaster than empires, and more slow.*

One critic has playfully praised Marvell for his ability to make one "think of pumpkins and eternity in one breath," but *vegetable* in this case is only indirectly related to edible plants. Here the word is used figuratively in the sense "having the property of life and growth, as does a plant," a use based on an ancient religious

and philosophical notion of the tripartite soul. As interpreted by the Scholastics, the *vegetative* soul was common to plants, animals, and humans; the *sensitive* soul was common to animals and humans; and the *rational* soul was found only in humans. "Vegetable love" is thus a love that grows, takes nourishment, and reproduces, although slowly. Marvell's 17th-century use illustrates the original sense of *vegetable*, first recorded in the 15th century. In 1582 we find recorded for the first time the adjective use of *vegetable* familiar to us, "having to do with plants." In a work of the same date appears the first instance of *vegetable* as a noun, meaning "a plant." It is not until the 18th century that we find the noun and adjective used more restrictively to refer specifically to certain kinds of plants that are eaten.

venom Anyone who has ever been lovesick will appreciate the etymology of the word *venom*. *Venom* descends from the Latin word *venēnum*, "potion, drug," which could originally be used to designate any substance that had a strong effect on the body. Medicines were a form of *venēnum*, as were love potions. Too much of a good thing can be fatal, however, and later the word *venēnum* came to signify just "poison." *Venēnum* itself comes from the Indo-European word **wenesnom*, "love potion." The form **wenes–*, from which **wenesnom* is derived, also gives us the name for the Roman goddess of love, Venus. Both **wenesnom* and **wenes–* are derived from the same Indo-European root, **wen–*, "to desire, strive for," which is the ancestor of other words, such as *win* and *wish*, too. In English, *venom* first appeared in a medieval bestiary referring to the poisonous secretions of serpents.

vespers

> *Regularly at half-past seven, in one part of the summer, after the evening train had gone by, the whip-poor-wills chanted their vespers for half an hour, sitting on a stump by my door, or upon the ridge-pole of the house.*

> —Henry David Thoreau,
> *Walden; or, Life in the Woods*, 1854

Vespers is the name given to the service held in the late afternoon or evening in many Western Christian churches. *Vesper*, in the singular, is also a poetic English word for the evening star, which also has another poetic English name, *Hesperus*. *Vespers*, *vesper*, and *Hesperus* all go back to the same Indo-European root as the word *west*—that is, the direction of the sunset. The source of the three words is Indo-European **wes-pero–*, which means "evening, night." Modern English *west* comes unchanged from Old English *west*, which is ultimately derived from **wes-pero–*. *Hesperus*, in contrast, was borrowed from Greek, a language which regularly lost the Proto-Indo-European *w* and sometimes replaced it with *h*. English *vesper*, meaning both "evening star" and "evening-time" in English, comes from Latin *vesper*, "evening, the evening star, the west." English borrowed the name of the church service *vespers* from Old French *vespres*, another derivative of the Latin word *vesper*.

VUM New Englanders sometimes express surprise by saying, "*Well, I vum!*" This odd-sounding word is in fact an alteration of the verb *vow* that goes back to the days of the American Revolution. It is also heard simply as *Vum!* or as a sort of past participle: *I'll be vummed!* A Southern equivalent is *swan* or *swanny*, also meaning "swear": *Now, I swanny!* According to the *Oxford English Dictionary*, the word *swanny* derives from the dialect of the north of England: *I s' wan ye*, "I shall warrant ye" (that is, "I shall guarantee you").

W

Wales Although peoples speaking Celtic languages had been living in Britain long before the arrival of the Germanic invaders whose languages would eventually develop into English, it was not these invaders but rather the Celts themselves who came to be called "strangers" in English. The English words for the descendants of one of these Celtic peoples, *Welsh*, and for their homeland, *Wales*, come from the Old English word *wealh*, meaning "foreigner, stranger, Celt." Its plural *wealas* is the direct ancestor of *Wales*, literally "foreigners." An Old English adjective derived from *wealh*, *wælisc* or *welisc*, is the source of our *Welsh*.

The Germanic root from which *wealh* descended was **walh–*, "foreign," which can also be seen in a word found once in the surviving manuscripts of Old English, the compound *walhhnutu* in a document from around 1050. The word makes its next appearance in 1358 as *walnottes*. This eventually became Modern English *walnut*, which is thus literally the "foreign nut." The nut was "foreign" because it was native to Roman Gaul and Italy.

wallflower The sweet-smelling flowers of *Cheiranthus cheiri* came to be called *wallflowers* because they often grow on old walls, rocks, and quarries. The plant name is first recorded in 1578. It is not known who first made the comparison between these delicate flowers and the unpartnered women sitting along the wall at a dance, but the figurative sense is first found in an 1820 work by Mrs. Campbell Praed entitled *County Ball*. Although originally used to describe women at dances, the word is now applied to men as well and used in situations remote from a ballroom.

wanigan *Wanigan* is apparently borrowed from Ojibwa *waanikaan,* "storage pit," from the verb *waanikkee–,* "to dig a hole in the ground." Nineteenth-century citations in the *Oxford English Dictionary* indicate that the word was then associated chiefly with the speech of Maine. It denoted a storage chest containing small supplies for a lumber camp, a boat outfitted to carry such supplies, or the camp provisions in general. In Alaska, beyond the western edge of the vast territory inhabited by Algonquian-speaking peoples, the same word was borrowed into English to indicate a little temporary hut, usually built on a log raft to be towed to wherever men were working. According to Russell Tabbert of the University of Alaska, *wanigan* is still used in the northernmost regions of Alaska to designate a small house, bunkhouse, or shed that is mounted on skids so that it can be dragged along behind a tractor train and used as a place for a work crew to eat and sleep. However, Tabbert notes that in southeast Alaska, where mobile homes are a common option for housing, *wanigan* now means an addition built onto a trailer house for extra living or storage space. Classified advertisements for trailer homes frequently mention *wanigans.*

were Although many irregular verbs in English once had different singular and plural forms in the past tense, only one still does today—*be,* which uses the form *was* with singular subjects and the form *were* with plural subjects, as well as with singular *you.* The relative simplicity in the forms of most verbs reflects the long-standing tendency of English speakers to make irregular verbs more regular by reducing the number of forms used with different persons, numbers, and tenses. Since past *be* is so irregular, speakers of different vernacular dialects have regularized it in several ways. In the United States, most vernacular speakers regularize past *be* by using *was* with all subjects, whether singular or plural. This pattern is most common in Southern-based dialects, particularly African American Vernacular English. Some speakers use *were* with both singular and plural subjects; thus, one may

hear *she were* alongside *we were*. However, this usage has been much less widespread than the use of *was* with plural subjects and appears to be fading.

In some scattered regions in the South, particularly in coastal areas of North Carolina, Virginia, and Maryland, vernacular speakers may regularize past *be* as *was* in positive contexts and regularize it as *weren't* in negative contexts, as in *He was a good man, weren't he?* or *They sure was nice people, weren't they?* At first glance, the *was/weren't* pattern appears to come from England, where it is fairly commonplace. However, in-depth study of the *was/weren't* pattern in coastal North Carolina indicates that it may have developed independently in the United States, for it is found to a greater extent in the speech of younger speakers than in that of older coastal residents.

Other forms of negative past *be* include *warn't*, common in American folk speech in the 18th and 19th centuries, and *wont*, as in *It wont me* or *They wont home*. *Wont*, which often sounds just like the contraction *won't*, historically has been concentrated in New England and is also found in scattered areas of the South.

whiffletree Whiffletrees are probably no longer familiar to most urban dwellers in North America, but they were a vital element of everyone's daily life in the days before transportation and agriculture were motorized. The whiffletree is the pivoted horizontal crossbar that helps attach a draft animal to a vehicle or an implement. The form *whiffletree* is primarily used in the northeast United States, while the older term *whippletree*, of which *whiffletree* is an alteration, is still used in the Upper Northern states farther to the west. The Northeast can be considered the older dialect area of the two, since the Upper Northern dialect area was settled by English speakers moving from east to west. The use of the newer term *whiffletree* in the older dialect area of the Northeast illustrates a phenomenon commonly observed by those who study linguistic change: archaisms or older forms are often preserved at the margins of a linguistic area. Even as the older word *whippletree* was spreading westward into a new

dialect area, it was evolving into something different—*whiffle-tree*—in the area where it originated, as if the older dialect area were somehow trying to keep a step ahead.

In American English, the same object can also be called a *singletree*, which itself is an alteration of *swingletree*, still the most usual form of the word in British English. The term *swingletree* comes from *swingle*, the name for various wooden instruments, including a piece of wood used for beating flax or the part of a flail that hangs free and strikes the object being beaten. The word *tree* in the compound *swingletree*, is here being used in the meaning "wooden bar" or "pole." *Swingle* is from Middle Dutch *swinghel* and is ultimately akin to the English verb *swing*. The word *whippletree* probably derives from a blend of *swingletree* with *whippin*, another traditional term for the whiffletree.

white elephant The white elephant, a rare whitish or light-gray form of the Asian elephant, is regarded with special veneration in regions of southeast Asia and India. According to Buddhist literature and art, Queen Maya, the mother of the Buddha, conceived the Buddha while dreaming of a white elephant entering her womb.

In English, the expression *white elephant* is also applied to a possession that yields few benefits even though it requires expensive maintenance or is otherwise inconvenient, and this meaning of the term stems from a story about life at the royal court in Siam (what is now Thailand). When the king wished to honor a member of his court, he would present the courtier with a white elephant together with land and the means to feed and support the animal—it was strictly forbidden to put a white elephant to work lifting logs and performing other tasks like an ordinary elephant. If the king wished to rid himself of someone who had displeased him, however, he simply presented the courtier with a white elephant to be maintained at the courtier's own expense. The courtier could hardly refuse the king's munificence, nor could he pass the elephant along to someone else, so the royal gift usually resulted in the courtier's financial ruin. In the 19th century, it was

probably the popularity of this story that led people to use the term *white elephant* to describe any possession that is burdensome or costly to maintain. Still later, the expression came to be used of any article that is of no use to its owner.

wigwam *Wigwam* and *wickiup* are two words for traditional Native American dwellings that English has borrowed from languages in the Algonquian family. Both words are derived from the Algonquian root *wik–* (with a variant *wig–*), "to dwell," to which suffixes have been added.

wigwam
photograph by Edward S. Curtis

The word *wigwam* denotes a Native American dwelling commonly having an arched or conical framework that is overlaid with bark, hides, or mats. *Wigwam* comes from Eastern Abenaki *wìkəwαm*, which literally means "their dwelling." The Abenaki are a Native American group including various peoples speaking related Algonquian languages. The Abenaki formerly inhabited a wide area in northern New England and southeast Canada, and in the mid-18th century the Abenaki and other peoples formed an allegiance in opposition to the Iroquois and the English colonists. Today, the Abenaki population groups are centered in Maine and southern Quebec.

The word *wickiup* denotes a temporary dwelling made of a frame covered with matting, as of bark or brush, such as those used by the nomadic Native Americans of the West and Southwest United States. *Wickiup* comes from a word in one of the dialects of the Algonquian language Fox, *wiikiyaapi*, meaning "a dwelling, wigwam." The Fox formerly inhabited various parts of southern Michigan, southern Wisconsin, northern Illinois, and eastern Iowa, and today many Fox live in central Iowa and also in Oklahoma with the closely related Sauk people.

woodchuck The woodchuck (*Marmota monax*) goes by several names in the United States. Perhaps the most famous of these is *groundhog*, under which name all the legends about the animal's hibernation have accrued. The word *groundhog* probably makes reference to the

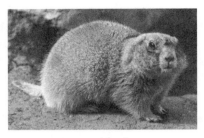

woodchuck
Marmota monax

animal's excellent burrowing abilities. In the Appalachian Mountains the woodchuck is known as a *whistle pig*, in reference to the shrill whistle it makes when disturbed. The word *woodchuck* itself is probably a FOLK ETYMOLOGY of a word in an Algonquian language of New England akin to the Narragansett word for the animal, *ockqutchaun*. The English-speaking settlers probably heard the Algonquian term and reinterpreted it to include the word *wood*, which seemed to make sense in the name of an animal that often lives on the edges of woodland and in open wooded areas.

worry Worrying may shorten one's life, but not as quickly as it once did. The ancestor of our word, Old English *wyrgan*, meant "to strangle." Its Middle English descendant, *worien*, kept this sense and developed the new sense "to grasp by the throat with the teeth and lacerate" or "to kill or injure by biting and shaking." This is the way wolves or dogs might attack sheep, for example. In the 16th century *worry* began to be used in the sense "to harass, as by rough treatment or attack," or "to assault verbally," and in the 17th century the word took on the sense "to bother, distress, or persecute." It was a small step from this sense to the main modern senses "to cause to feel anxious or distressed" and "to feel troubled or uneasy," first recorded in the 19th century.

X

xylophone Alphabet books for children frequently feature the word *xylophone* because it is one of the few words beginning with *x* that a child—or many adults, for that matter—would know. The majority of English words beginning with *x*, including many obscure scientific terms, are of Greek origin. The *x*, pronounced (z) at the start of a word, represents the Greek letter ξ, called *xi*. In the case of *xylophone*, *xylo*– is a form meaning "wood," derived from Greek *xulon*, "wood," and *–phone* represents Greek *phōnē*, "voice, sound," the same element found in words such as *telephone, microphone*, and *megaphone*. According to the *Oxford English Dictionary*, our famous *x*-word is first recorded in the edition of the *Athenaeum* from April 7, 1866: *A prodigy... who does wonderful things with little drumsticks on a machine of wooden keys, called the "xylophone."*

When not the first letter in an English word, the letter *x* is pronounced as (ks), as in *fix*, or (gz), as in *example*, in contrast to its (z) pronunciation at the beginning of words. The Greeks, however, pronounced ξ as (ks) at the beginning of words as well. Thus ancient Greek *xulon* was pronounced something like (ksülōn). The English pronunciation of (z) at the start of a word is probably the simplification of an early pronunciation (gz). Evidence for the simplification of (gz) to (z) occurs from Middle English times onwards, as for example in the word *xilobalsamum*, the name for the wood or bark of the balsam tree used as medicine, written as *zilobalsamum*.

xylophone

Y

yahoo The brilliant Irish author Jonathan Swift created the word *yahoo* in his satirical work *Gulliver's Travels* (1726). On one of his voyages, Captain Gulliver is put ashore by his mutinous crew in an unknown country where he is soon attacked by a group of foul-smelling, hairy, brutish human beings. A horse rescues him, and Gulliver soon discovers that he is in a land governed by horses endowed with the power of reason and a sophisticated language. The horses' word for themselves is *Houyhnhnm*, and their word for the brutish humanoid creatures is *Yahoo*. The Houyhnhnms keep the Yahoos as beasts of burden just as Europeans keep horses. Gulliver, who has a talent for languages, goes about learning the Houyhnhnm tongue, and the horses are puzzled by Gulliver, who by all appearances must be some sort of Yahoo but conducts himself in a civilized manner just like a Houyhnhnm. A member of the equine aristocracy, whom Gulliver lovingly refers to as *my Master*, protects and lodges this strange, civilized Yahoo. For his master, Gulliver attempts to describe the bizarre world across the water where there are many talking Yahoos just like himself, and where horses work as beasts of burden while men pretend to the power of reason. Swift uses Gulliver's descriptions as an occasion for pointed satire of society. From the beginning of his adventure, Gulliver prefers the company of the kind and rational Houyhnhnms to that of the Yahoos, who are so repulsive that when the Houyhnhnms wish to curse, they use the word *Yahoo*:

> *Thus they denote the Folly of a servant, an Omission of a Child, a Stone that cuts their Feet, a Continuance of foul or*

unseasonable Weather, and the like, by adding to each the Epithet of Yahoo. For Instance, Hhnm Yahoo, Whnaholm Yahoo, Ynlhmnawihlma Yahoo, and an ill-contrived House, Ynholmhnmrohlnw Yahoo.

Swift's inventive and astute satire gained immense popularity, and *yahoo* soon became a common word for describing a brutish or intellectually degraded person.

Gulliver's Travels has also introduced several other words to the English language. On his first voyage, Gulliver washes ashore on the island of Lilliput, whose inhibants are not even six inches tall, and this adventure has given us the adjective *Lilliputian,* "very small." On a later voyage, Gulliver visits the land of Brobdingnag, whose inhabitants are huge. The flora and fauna of this land likewise grow to immense size. This episode in Swift's work has inspired the use of the adjective *Brobdingnagian* to mean "enormous."

ye In an attempt to seem quaint or old-fashioned, many store signs or product labels use a word *ye*, as in *Ye Olde Coffee Shoppe.* The word *ye* in such signs looks identical to the archaic second-person plural pronoun *ye*, but it is in fact not the same word. *Ye* in "Ye Olde Coffee Shoppe" is just an older spelling of the definite article *the.* The *y* in this *ye* was never pronounced (y) but was rather the result of improvisation by early printers. In Old English and early Middle English, the sound (*th*) was represented by the letter thorn (þ). When printing presses were first set up in England in the 1470s, the type came from Continental Europe, where the thorn was not in use. The letter *y* was used instead because in the handwriting of the day the thorn was very similar to *y.* Thus we see such spellings as *y^e* for *the,* and *y^t* or *y^at* for *that* (which nowadays look very odd) well into the 19th century. However, the modern revival of the archaic spelling of *the* has not been accompanied by a revival of the knowledge of how it was pronounced, with the result that (yē) is the usual pronunciation today.

See also the note for *yogh* below.

yogh

*No man may telle, no þenche in þouȝt, þe riche werk þat þer
was wrouȝt.*

No man may tell, nor think in thought, the rich work that
there was wrought.

—*Sir Orfeo*, anonymous Middle English poem from the
late 1200s or early 1300s

In addition to the many grammatical differences and unfamiliar words, one of the things that modern readers find so difficult (or so charming) about Old and Middle English texts is the use of letters that have now become obsolete. These include yogh (ȝ), wynn or wen (ƿ), thorn (þ), edh (ð), and ash (æ). Yogh, originally the Old English form of the letter *g*, was used to represent several sounds in Middle English, including (y) as well as the sound (KH) in Scottish *loch* that began to disappear from most varieties of English in the 1400s. The letters *y* or *gh* have replaced yogh in modern spelling. Wynn, which represented the sound (w), was borrowed by Old English scribes from the runes, the writing system of the early Germanic peoples. It was later superseded by the letter *w*, which was developed from two *u*'s or *v*'s written together—as the name of the letter, *double u*, might suggest. Both thorn (also a rune in origin) and edh were used indiscriminately to spell the two sounds (th) and (*th*)—the sounds in *breath* and *breathe*, respectively. The combination *th* now fills their role. Ash was used in Old English to represent the vowel (ă), as in the word *stæf*, meaning both "staff, stick of wood" and "letter (of the alphabet)." In this regard, it is interesting that several of the names for these old letters also relate to wood and trees, like ash and thorn. Yogh probably comes from Old English *īw* or *ēoh*, "yew tree."

yonder

*Pickin' up pawpaws, put 'em in your pocket.
Way down yonder in the pawpaw patch.*

This traditional song about a trip through the forest picking up pawpaw fruits contains a well-known use of the American regionalism *yonder*. The adverb *yonder* is not exclusively Southern but is more frequently used in the South than in any other region of the United States. *Yonder* is not merely a Southern synonym for *there*, a word which in traditional Southern regional usage tends to mean "only a few feet from the speaker." *Yonder* carries with it an inherent sense of distance or removal greater than *there*. *Yonder* is often used of a distant person or thing that can still be seen: *the shed over yonder*. Or the person or thing *yonder* might be nearby but completely out of sight, as in the next room. Both *yonder* and the related form *yon* can be used as adjectives, as in *yonder hills* or *on yon side of the hill*. They can also be used as adverbs, as in the first verse of the well-known traditional American song "Little Maggie":

Oh yonder stands little Maggie
With a dram glass in her hands
She's drinking away her troubles
She's a-courting some other man

As an adverb, *yon* is sometimes even encountered in Standard English as part of certain idiomatic phrases such as *hither and yon*, an alternative to *hither and thither*: *They ran hither and yon looking for the ring.*

Yonder comes from Middle English and is ultimately derived from Old English *geond*, meaning "yonder." As the survival of *yonder* and *yon* in a variety of American regional dialects indicates, it is only comparatively recently that *yonder* and *yon* have slipped from conversational usage in many English dialects. Shakespeare uses *yonder* and *yon* quite frequently, and the words are still sometimes used in modern literary texts for their poetic flavor or as conscious archaisms. Most readers will be familiar with the literary use of *yonder* from the opening line of the official song of the United States Air Force, where *yonder* is used as a noun: *Off*

we go into the wild blue yonder. These words, and the music to them, were written in 1939 by Captain Robert M. Crawford, the winner of a contest held by *Liberty* magazine to find an official song for the US Army Air Corps, later to become the US Air Force.

you-all The single most famous feature of southern United States dialects is the pronoun *you-all,* often heard in its variant *y'all. You-all* functions with perfect grammatical regularity as a second person plural pronoun, taking its own possessive *you-all's* (or less frequently, *your-all's,* where both parts of the word are inflected for possession): *You-all's voices sound alike.* Southerners do not, as is sometimes believed, use *you-all* or *y'all* for both singular and plural *you.* A single person may only be addressed as *you-all* if the speaker implies in the reference other persons not present: *Did you-all* [you and others] *have dinner yet? You* and *you-all* preserve the singular/plural distinction that English used to be able to express by using forms of the pronouns *thou* and *ye. Thou* was the subject form of the second-person singular pronoun, and its corresponding object form was *thee. Ye* was the subject form of the second-person plural pronoun, and its corresponding object form was *you.*

The distinction between singular *thou/thee* and plural *ye/you* began to blur as early as the 13th century, when the plural form was often used for the singular in formal contexts or to indicate politeness, much as the French use *tu* for singular and familiar "you," and *vous* for both plural and polite singular "you." In English, the object form *you* gradually came to be used in subject position as well, so that the four forms *thou, thee, ye,* and *you* collapsed into one form, *you. Thou* and *thee* were quite rare in educated speech in the 16th century, and they disappeared completely from standard English in the 18th.

However, the distinction between singular and plural *you* is just as useful as that between other singular and plural pronoun forms, such as *I* and *we,* and different varieties of English have invented various new ways of expressing it. In addition to *y'all,*

other forms for plural *you* include *you-uns, youse,* and *you guys* or *youse guys. Youse* is common in vernacular varieties in the Northeast, particularly in large cities such as New York and Boston, and is also common in Irish English. *You-uns* is found in western Pennsylvania and in the Appalachians and probably reflects the Scotch-Irish roots of many European settlers to these regions. *You guys* and *youse guys* appear to be newer innovations than the other dialectal forms of plural *you.*

yttrium Yttrium, a silvery metallic element with the atomic number 39, plays a crucial part in the daily functioning of the modern world—compounds of yttrium provide the red color component in the cathode ray tubes of most televisions and computer monitors. Yttrium is not one of the lanthanide elements (the elements having the atomic numbers 57–71 that display similar chemical properties), but it occurs in nearly all minerals containing lanthanide elements.

A glance at the periodic table will reveal that yttrium and certain elements of the lanthanide series—*erbium, terbium,* and *ytterbium*—have names that echo each other curiously, using different permutations of just a few sounds. They are all in fact named in honor of the village of Ytterby, near Stockholm, in Sweden. In 1792, the chemist Johan Gadolin, professor of chemistry at the Academy of Åbo (located in what is now Turku, Finland, then part of the kingdom of Sweden), obtained a sample of a curiously heavy, coal-like mineral from a quarry near the Ytterby. Gadolin discovered that this mineral contained a large percentage of a new substance, a metallic oxide (or *earth* in the terminology of the time) of an unknown metal. Gadolin called his newly discovered earth *ytterbia,* which was later shortened to *yttria.* In 1843, it was discovered that yttria contained three different metallic elements, which are now designated *yttrium, terbium,* and *erbium,* all words derived from various parts of the name *Ytterby.* (According to the conventions used in the scientific language of the time, the name of the metal *yttrium* is regularly formed from the name of its earth *yttria,* just as names like

magnesium and *aluminum* are derived from the names of the earths *magnesia* and *alumina.* Since many metallic elements do not occur in nature in their free, uncompounded state but are nevertheless very common in the form of their oxides, scientists were often well acquainted with the earth of a metal before they were able to isolate the metal in its pure state.) Ytterbium, another lanthanide element discovered in 1878, was also named after the village where Gadolin's sample originated. Yet another lanthanide element, holmium, was named after nearby Stockholm, and Gadolin himself is remembered in the name of the element gadolinium.

Z

zipper Trademark laws exist to prevent the appropriation of words like *zipper*. Registered in 1925, *zipper* was originally a trademark held by the B.F. Goodrich Corporation for overshoes with fasteners. A Goodrich executive is said to have slid the fastener up and down on the boot and exclaimed, "Zip 'er up," echoing the sound made by this clever device. *Zip* already existed as both a noun and verb referring to a light sharp sound or to motion accompanied by that kind of sound—*zip* is first recorded as a noun in 1875, after having first appeared as a verb in 1852. Both words were imitations of the sound made by a rapidly moving object. As the fastener that "zipped" came to be used in other articles, its name was used as well. B.F. Goodrich sued to protect its trademark but was allowed to retain proprietary rights only over *Zipper Boots*. *Zipper* itself had already moved into the world of common nouns.

zloty The ancient association between gold and money is reflected in *złoty*, the name for the basic unit of currency in Poland. The Polish letter *ł*, an *l* with a bar through it, is pronounced just like English *w*. The Polish word *złoty* is a simple adjective meaning

zloty
obverse (left) and reverse sides of a zloty coin

"golden" that derives from the neuter noun *złoto*, "gold." The Polish word in turn comes from an earlier neuter noun **zolto*, "gold." In Common Slavic (the hypothetical language that is the

ancestor of all the Slavic languages), the *zol-* in **zolto* is a form of the Slavic root **zel–*, "to shine, be bright," which descends from the Indo-European root **ghel–*, "to shine."

Many of the derivatives of the root **ghel–* in the various Indo-European languages refer to yellow, greenish, or tawny colors. By GRIMM'S LAW the *gh* in this root became a simple *g*, and the Indo-European adjective **ghel-wo–* became Proto-Germanic **gel-wa–*. On the way from Germanic to Old English, a *g* before an *e* became the sound (y), spelled *ge* in Old English, and the root **ghel–* is thus the source of our word *yellow*. Another derivative of the root **ghel–* was **ghḷto–*. On the way from Proto-Indo-European to Proto-Germanic, **ghḷto–* became *gultham*, and the *g* in this root did not come to be pronounced as (y) as in *yellow*, since it was before a *u*. Instead, it stayed a *g*, and Proto-Germanic *gultham* eventually developed into Old English *gold*. From an etymological point of view, the English word *gold* is simply "the yellow metal."

zombie The zombies that staggered their way into American popular culture during the early part of the 20th century have their origins in the Vodou religion of Haiti. The word *zombie* was borrowed into English from Haitian Creole, the language spoken by the majority of Haitians and based on French and various African languages. *Zombie*, which ultimately derives from the Bantu language family of Africa, traveled to Haiti with the people from West Africa who were brought to the Caribbean to work as slaves on French plantations during the days before the Haitian Revolution of 1804, when Haiti was still a French colony. Although the exact source of *zombie* is not known, the word is thought to be akin to the words *zumbi*, "object with supernatural powers," and *zambi*, "ghost, departed spirit," in Kikongo, a LINGUA FRANCA of the lower Congo River, and to *nzambi*, "god," in Kimbundu, the language of the Mbundu peoples of northern Angola.

A word belonging to this group of Bantu religious terms entered Haitian Creole and came to refer to a particular concept in the Vodou religion. Vodou (also called *vodoun* or *vodun*, or popularly, *voodoo*) combines elements from Roman Catholic ritual

with animistic and magical practices derived from West African religions. Vodouisants (adherents of the Vodou religion) believe in a supreme God as well as a large pantheon of local and tutelary deities, deified ancestors, and saints, all of whom communicate with devotees through dreams, trances, and ritual possessions. In Haitian Vodou, zombies are believed to possess only the part of the soul that animates the body, for they have been deprived of the aspect of the soul that gives them their individual personality and the ability to make moral judgments. Many Vodouisants believe that maleficent sorcerers sometimes make zombies out of the recently dead by raising newly buried bodies from the grave and partially restoring their souls. According to folk belief, zombies are often discovered toiling away in fields or gardens in the service of their master.

In English, the word *zombie* first appeared in 19th-century anthropological and historical works but did not enter popular speech until the early 20th century, near the end of the United States' occupation of Haiti (1911–1934). William Seabrook introduced the American public to zombies in 1929 with his sensationalized account of his travels in Haiti called *The Magic Island*. But, as explained by Gary Rhodes in his book *White Zombie: Anatomy of a Horror Film*, the term *zombie* only became a household word after the release of the enormously successful 1932 film *White Zombie*, starring Bela Lugosi as the sinister zombie master Murder Legendre. When the company that owned the rights to *White Zombie* took legal action to prevent the makers of the film, Victor and Edward Halperin, from using the word *zombie* anywhere in their unlicensed sequel, *Revolt of the Zombies*, the company successfully argued that most Americans knew the word only from the original film, even if it had been used previously in bestselling books and had already appeared in dictionaries. In fact, during the hearing, a witness for the Halperins was forced to admit that *zombie* "had no general meaning in the English language and that not one person in a hundred knew what it meant" before *White Zombie*.

In 1939, the well-known author Zora Neale Hurston published

one of the first scholarly studies of Haitian Vodou and zombiism. Her work, however, had little effect on the popular portrayal of zombies, which continued to draw Seabrook's descriptions in *The Magic Island*. In 1942, Seabrook summed up his contribution to the popularity of zombies and surveyed the many new senses that *zombie* had acquired in American English, "I didn't invent the word *zombie*, nor the concept or the zombies. But I brought the word and concept to America from Haiti and gave it in print to the American public—for the first time. The word is now a part of the American language. It flames in neon lights for names of bars, and drinks, is applied to starved surrendering soldiers, replaces *robot*, and runs the pulps ragged for new plots."

Beginning in 1968 with George Romero's movie *Night of the Living Dead*, the American zombie lost almost all of its associations with the zombies of Haitian Vodou. Romero's film and its many sequels and imitators of the 1970s and 1980s reincarnated zombies as a horde of flesh-eating monsters who infected their victims with zombiism and could only be killed by a gory injury to the head. Opposed to this trend has been a growing scholarly interest in Vodou and zombies that continues the work of earlier ethnographers like Hurston or Maya Deren, the writer, filmmaker, and Vodou priestess who published an important study of the religion in 1953. Notably, the ethnobotanist Wade Davis has offered a scientific explanation for zombification, in which he proposes that Vodou sorcerers first induced a deathlike state in their victims and then woke them into a zombie trance by administering powerful drugs obtained from local plants and animals. Nevertheless, the popular misconceptions about zombiism continue today with the gruesome portrayal of zombies in the latest resurrection of zombie-themed entertainment, including horror films, video games, and online role-playing games—in which gamers, ironically, play the role of a zombie as they gaze bleary-eyed at a computer screen.

Glossary

affix A word element, such as a prefix or suffix, that can only occur attached to a stem or root. See more at *stem* below.

African American Vernacular English Any of the nonstandard varieties of English spoken by African Americans, especially the everyday spoken varieties used in working class communities in urban neighborhoods as well as in rural areas. African American Vernacular English is by no means spoken by all African Americans regardless of their background. In fact, the English spoken by African Americans is highly varied—as varied as the English spoken by any other racial or ethnic group. *African American Vernacular English* is often abbreviated as AAVE.

Akkadian The Semitic language of ancient Mesopotamia, the region between the Tigris and Euphrates rivers in what is now Iraq. Akkadian was written in the cuneiform writing system. Akkadian names begin to appear in documents written around 2800 BC, while full documents in Akkadian begin to appear around 2500. The language died out in the first century AD.

Algonquian Belonging to a large Native American language family spoken or formerly spoken in an area stretching from Labrador to the Carolinas between the Atlantic Coast and the Rocky Mountains. The Algonquian language family includes Abenaki, Narragansett, and Ojibwa, among other languages.

Aramaic A Semitic language originally spoken by the Arameans, an ancient people who lived in regions that are now part of modern Syria and Iraq. Aramaic was widely used as lingua franca by non-Aramean peoples throughout southwest Asia in ancient times. When the Hebrew language died out as a spoken language, Aramaic became one of the main languages of the Jewish people, and Aramaic was probably the language used by Jesus in daily life. Several languages descended from ancient Aramaic, called Neo-Aramaic languages, are still spoken today by various small communities in the Near East and in immigrant communities in the United States and elsewhere.

Arawakan Belonging to a large family of indigenous languages in South

America and the Caribbean, spoken by a widespread group of peoples living in an area that includes parts of Colombia, Venezuela, Guiana, the Amazon basin of Brazil, Paraguay, Bolivia, Peru, and formerly most of the Greater Antilles.

assimilation The process by which a sound is modified so that it becomes similar or identical to an adjacent or nearby sound. For example, the prefix *in–* becomes *im–* in *impossible* by assimilation to the labial *p* of *possible*.

augmentative Relating to or being a word that is derived from another word and indicates an increase in size, force, or intensity. For example, the Spanish word *hombrón*, "big, tough-looking man," is derived from the word *hombre*, "man," by means of the *augmentative* suffix *–ón*.

back-formation A new word created by removing an affix from an already existing word, as *baby-sit* from *babysitter*, or by removing what is mistakenly thought to be an affix, as *pea* from the earlier English plural *pease*.

Bantu Belonging to a group of over four hundred closely related languages spoken in central, east-central, and southern Africa. The Bantu languages are part of the South Central subgroup of the Niger-Congo language family and include Swahili, Kinyarwanda, Kirundi, Zulu, and Xhosa.

blend A word produced by combining parts of other words, as *smog* from *smoke* and *fog*.

calque A form of borrowing from one language to another in which the meaningful elements of a given term are literally translated into their equivalents in the borrowing language. For example, the English term *world view* is a calque of German *Weltanschauung*, made up of *Welt*, "world," and *Anschauung*, "view." Also called *loan translation*.

Celtic A subfamily of the Indo-European language family comprising the Insular and the Continental branches. The Insular branch includes Irish, Scottish Gaelic, Welsh, and Breton, while the Continental branch includes Gaulish, once spoken in the area that is now France, and Celtiberian, once spoken in Spain. Celtic languages used to be spoken across a much larger area of Europe.

cognate Related in origin, as certain words in genetically related languages descended from the same ancestral root. For example, English *name* and Latin *nōmen* from Indo-European **nō-men-*.

compound A word that consists either of two or more elements that are independent words, such as *loudspeaker, baby-sit,* or *high school,* or of specially modified combining forms of words, such as Greek *poluglōttos,*

"speaking many languages, polyglot," from *polus,* "many," and *glōtta,* "tongue."

Coptic The language of the Copts—that is, the Christian Egyptians of pre-Islamic Egypt as well as their modern descendants. Coptic descends from the Ancient Egyptian language that was written in hieroglyphs. Arabic has replaced Coptic as the everyday spoken language of modern Copts, but Coptic is still used as the liturgical language of the Coptic Church. Coptic and its ancestor Ancient Egyptian belong to the Afro-Asiatic language family, a large language family in which the Semitic language family is also included.

diminutive Relating to or being a word that is derived from another word and that indicates smallness or, by semantic extension, qualities such as youth, familiarity, affection, or contempt. The *-let* in *booklet* and the *-kin* in *lambkin* are *diminutive* suffixes.

diphthong A complex speech sound or glide that begins with one vowel and gradually changes to another vowel within the same syllable, as (oi) in *boil.*

dissimilation The process by which one of two similar or identical sounds in a word becomes less like the other, such as the *l* in English *marble* which developed from the second *r* in French *marbre.*

ejective Relating to or being a consonant made with a stream of air produced by closing the vocal cords and raising the larynx to increase pressure inside the mouth. The more usual method of producing a stream of air is by slowly contracting the lungs—this is the method used to produce most English consonants. For the most part, English has no ejective consonants, but they are nevertheless extremely common throughout the languages of the world. Ejectives are found in Georgian, Amharic, Quechua, the Mayan languages, and Lakota, for example. English ejectives may occasionally be heard in some persons' emphatic pronunciations of final voiceless stops, as in the pronunciation of *t* in the command *Sit!* when said angrily to dog.

finite Of or relating to any of the forms of a verb that can occur on their own in a main clause and that can formally express distinctions in person, number, tense, mood, and voice, often by means of conjugation, as the verb *sees* in *She sees the sign.*

folk etymology A change in the form of a word or phrase resulting from a mistaken assumption about its composition or meaning, as in *shame-faced* for earlier *shamfast,* "bound by shame," or *cutlet* from French *côtelette,* "little rib."

genitive Relating to or being a grammatical form of a noun, pronoun, or

adjective that expresses possession, measurement, or source.

Germanic Belonging to the branch of the Indo-European language family that includes English and its closest relatives. The word *Germanic* is also used as a synonym of *Proto-Germanic* as a name for the proto-language ancestral to all the Germanic languages. The Germanic languages are divided into three subgroups. The West Germanic languages include English, High German, Low German, Yiddish, Dutch, Afrikaans, Flemish, and Frisian (the closest relative of English, spoken in the Netherlands and Germany). The modern North Germanic languages include Norwegian, Icelandic, Swedish, Danish, and Faroese, all descended from various dialects of Old Norse. During the medieval period English borrowed a large number of words from Old Norse. The East Germanic group is now extinct but included the language of the Goths.

Grimm's Law A formula describing the regular changes undergone by Proto-Indo-European stop consonants in the Germanic branch of the Indo-European language family, essentially stating that Indo-European *p, t,* and *k* became Germanic *f, th,* and *h;* Indo-European *b, d,* and *g* became Germanic *p, t,* and *k;* and Indo-European *bh, dh,* and *gh* became Germanic *b, d,* and *g.*

Hebrew The Semitic language of the ancient Israelites or any of the various later forms of this language, such as the modern form that is now one of the national languages of state of Israel.

High German German as indigenously spoken and written in Austria, Switzerland, and central and southern Germany, and including the standard variety of German used as the official language in Germany and Austria and as one of the official languages in Switzerland.

Indo-European A family of languages consisting of most of the languages of Europe as well as those of Iran, the Indian subcontinent, and other parts of Asia. The Indo-European family is divided into many branches, including the Celtic, Germanic, Italic (consisting of Latin and its modern descendants and extinct relatives), Slavic, Hellenic (consisting of Greek), Anatolian (consisting of the extinct ancient language Hittite and its relatives), Armenian, Indo-Iranian, and Tocharian branches, among others.

intransitive Of or relating to a verb or verb construction that does not require or cannot take a direct object, as *snow* or *sleep.* Compare *transitive* below.

Irish The Celtic language of Ireland. After Greek and Latin, Irish has the longest literary history of any European language. Irish, rather than English, was the most widely spoken language in Ireland up to the 19th century. Although the numbers of speakers of Irish has undergone a

steep decline since then, Irish is still used as the everyday language of daily life in some communities in Ireland. Many other Irish people cultivate the language as an important aspect of their cultural heritage. Irish is also sometimes called *Irish Gaelic.*

Iroquoian Belonging to a family of Native American languages of the eastern part of Canada and the United States that includes Cayuga, Mohawk, Oneida, Onondaga, Seneca, Tuscarora, Cherokee, Erie, Huron, and Wyandot.

Iroquois Any of the Iroquoian languages spoken by the peoples forming part of the Iroquois League, a Native American confederacy inhabiting New York State and originally composed of the Mohawk, Oneida, Onondaga, Cayuga, and Seneca peoples, known as the Five Nations. After 1722 the confederacy was joined by the Tuscarora to form the Six Nations.

Late Latin The Latin language as used from the 3rd to the 7th century AD.

lingua franca A language used as a common means of communication among peoples speaking different languages.

Low German The German dialects of northern Germany. The term is a translation of German *Niederdeutsch,* from *nieder,* "low," and *Deutsch,* "German," and refers to the lowland terrain of northern Germany, not to any supposed inferior status or value of the dialects. It is sometimes difficult to tell whether an English word is ultimately from Dutch or Low German.

Lower South A major dialect region of the United States. In general, the Lower South dialect region includes South Carolina, Georgia, Florida, Alabama, Mississippi, Louisiana, southern Arkansas, and the eastern portion of Texas.

Mandarin Any of a group of Chinese dialects spoken across a wide area of China. The official national standard spoken language of China is based on the Mandarin dialect spoken in and around Beijing.

Medieval Latin The Latin language as used from about 700 to about 1500.

metathesis Transposition within a word of letters, sounds, or syllables, as in the change from Old English *brid* to modern English *bird* or in the confusion of *modren* for *modern.*

Middle English The English language from about 1100 to about 1500, a period during which a large number of words entered the language from Old French.

Middle French The French language from around the middle of the 14th century to around the end of the 16th century.

Middle High German High German from the 11th through the 15th century.

Middle Low German Low German from the middle of the 13th century through the 15th century.

Midland One of the major dialect regions of the United States. The Midland dialect region has its historical origins in the speech of Pennsylvania in colonial times and reflects the influence of settlers from Scotland, Ireland, the Netherlands, Germany, and other countries. Although the boundaries of dialect regions are often fluid and not clear-cut, the core area of Midland speech is found in West Virginia, southern Ohio, Kentucky, and southern Indiana and Illinois. This core area was settled primarily by people from Pennsylvania, Maryland, and Virginia beginning in the first half of the 18th century. Features of the Midland dialects can be found spreading out from this core area across Tennessee, the very northern parts of Georgia and Alabama, and into Arkansas, Missouri, Kansas, Oklahoma, and Nebraska. In discussions of the Midland dialects, the region is often divided into two subregions, the North Midland and South Midland. The North Midland region is sometimes referred to as the *Lower North,* and the South Midland region is often referred to as the *Upper South.* Midland words and features are discussed in this book at the entries for **andiron, anymore, dope, dragonfly, frying pan, greasy, gutter, johnnycake, need,** and **scoot.**

Narragansett The Algonquin language of the Narragansett people, a Native American people formerly inhabiting Rhode Island west of Narragansett Bay, with present-day descendants in the same area. The Narragansett were nearly exterminated in 1675 and 1676 during King Philip's War.

New Latin Latin as used since about 1500, especially as an international language of science, medicine, and scholarship.

nominative Relating to or being the form that a noun or pronoun takes when it functions as the subject of a finite verb (as *I* in *I wrote the letter*) and of words identified with the subjects of the verb *to be,* such as a predicate nominative (as *children* in *These are his children*). In languages besides English in which adjectives agree with the nouns that they modify, adjectives may also have a special *nominative* form.

nonstandard Associated with a language variety used by uneducated speakers or socially disfavored groups. The term *nonstandard* was introduced to describe usages and language varieties that had previously been labeled with terms such as *vulgar* and *illiterate.* Nonstandard is not simply a euphemism but reflects the scientific discovery that the varieties used by low-prestige groups have rich and systematic grammatical structures and that their stigmatization reflects prejudice against their

speakers rather than any inherent deficiencies in logic or expressive power.

Ojibwa The Algonquian language of the Ojibwa people, a Native American people originally located north of Lake Huron before moving westward in the 17th and 18th centuries into Michigan, Wisconsin, Minnesota, western Ontario, and Manitoba, with later migrations onto the northern Great Plains in North Dakota, Montana, and Saskatchewan. The Ojibwa are also sometimes called *Chippewa.*

Old English The English language from around the middle of the 5th century to the beginning of the 12th century. The first surviving written documents in Old English date from around the middle of the 8th century.

Old French The French language from the 9th to about the middle of the 14th century.

Old Norse The group of languages belonging to the North Germanic subbranch of the Germanic languages from their earliest attestation until the middle of the 14th century. Although the divergence between the dialects that were to become the separate languages Danish, Faroese, Icelandic, Norwegian, and Swedish had already begun long before the 14th century, the Germanic languages of Scandinavia and Iceland were still quite similar to each other until this time, and it is therefore often convenient to consider them as a whole under the term *Old Norse.* When tracing the history of English, dictionaries often cite Old Norse words in their Old Icelandic forms, but the Old Norse words in English are actually from the varieties of Old Norse spoken by settlers from Scandinavia, rather than Iceland. See more at the word *Germanic* above.

Old Provençal The Provençal language before the middle of the 16th century. Provençal is the Romance language traditionally spoken in Provence, a historical region and former province of southeast France bordering on the Mediterranean Sea. Provençal is quite distinct from French, although the two languages are closely related. The term Old Provençal is used in an extended sense as a convenient way of referring to the earlier forms of the various languages and dialects spoken in the south of France. The modern forms of these languages are generally called *Occitan.*

pejoration The process by which the meaning of a word becomes negative or less elevated over a period of time, as *silly,* which formerly meant "deserving sympathy, helpless or simple," but has come to mean "showing a lack of good sense, frivolous."

Prakrit Any of a group of Indo-European languages of India used as spoken and literary languages and recorded from the 3rd century BC to the

4th century AD. The Prakrits are either the direct descendants of early varieties of Sanskrit or of dialects quite closely related to early Sanskrit. The various Prakrit languages are representative of the stage of development between Sanskrit and its modern-day descendants, Indo-European languages of India like Hindi and Bengali.

prefix A word element that can only occur attached to the front of a word and is used to form a new word or indicate the grammatical role of the word in the sentence, such as *dis–* in *disbelieve.*

pronunciation spelling A spelling that is supposed to represent a pronunciation more closely than a traditional spelling, as *lite* for *light,* or *wanna* for *want to.*

Proto-Germanic The reconstructed prehistoric language that was the ancestor of the Germanic languages.

Proto-Indo-European The reconstructed prehistoric language that was the ancestor of the Indo-European languages.

Provençal See **Old Provençal** above.

Quechua The language of the Inca empire, now widely spoken throughout the Andes highlands from southern Colombia to Chile.

reconstruct To propose and describe a hypothetical word, ending, sound, or system of grammar in order to account for the history of a language. For example, based on the evidence of words meaning "god" in many Indo-European languages, such as Sanskrit *devaḥ* and Latin *deus,* as well as the name of the Germanic god known as *Tiw* (preserved in English *Tuesday,* "Tiw's day"), linguists reconstruct a word for "god," **deiwos,* in Proto-Indo-European. Since this form is not attested in any written document from the time when Indo-European was spoken, it is marked with an asterisk. Linguists also propose regular rules describing how reconstructed forms like **deiwos* develop into attested forms like Latin *deus.*

Romance Belonging to the group of languages that developed from the spoken Latin of the late Roman Empire, including Italian, French, Portuguese, Provençal, Romanian, and Spanish.

root The element that carries the main component of meaning in a word and provides the basis from which a word is derived by the addition of other elements such as suffixes or by the changing of the sounds in the word. Most of the words in Proto-Indo-European were derived from a simple root that often has the shape *consonant-vowel-consonant.*

Slavic The branch of the Indo-European language family including Belarusian, Bulgarian, Czech, Macedonian, Old Church Slavonic, Polish, Russian, Serbo-Croatian, Slovak, Slovene, Sorbian, and Ukrainian.

South Atlantic states The American states on the Atlantic seaboard south

of the Potomac River, considered as a dialect region. See **kindling** and **loblolly** for a discussion of words used in the South Atlantic states.

spelling pronunciation A pronunciation of a word that differs from the historically established one, arising on the basis of the word's spelling. See the entry in this book for the word **author** for an example of a spelling pronunciation.

standard Of or relating to the variety of a language that is generally acknowledged as the model for the speech and writing of educated speakers. Sometimes the term *Standard English* is used in this book to distinguish the speech and writing of middle-class educated speakers from the speech of other groups and classes, which are termed *nonstandard*. The term *standard* is highly elastic and variable, since what counts as Standard English will depend on both the locality and the particular varieties to which Standard English is being contrasted. A variety that is standard in one region may be nonstandard in another region, and within a region, a variety that is standard among the members of one social group may be nonstandard for the members of another. Thus while the term *standard* can serve a useful descriptive purpose providing the context makes its meaning clear, it should not be interpreted as conferring any positive evaluation of the language variety being termed *standard*.

stem The main part of a word, to which affixes changing the meaning of the word, or endings indicating grammatical information, may be added. In the English word *dictionaries,* for example, we can see four different separable elements: a root, two suffixes, and an ending: *dic-tion-arie-s*. The Latin root *dīc–*, meaning "to say" (from the Indo-European root **deik–*, "point"), is also seen in the English words *dictate* and *edict*. In Latin, a noun *dictiō* (meaning "the act of saying") was made from this root with the suffix *–tiō*, and English has borrowed the Latin word as *diction*. In medieval times, an additional suffix, *–ārium*, was added to *dictiōn-*, the stem of *dictiō*, to make a new word *dictiōnārium*, "book of words." English has borrowed *dictiōnārium* as *dictionary*. When we want to make a plural of this noun in English, we add an additional ending, *-s*. In Proto-Indo-European, most stems were formed in the same way as in the Latin word, by adding suffixes to a root, and then grammatical endings were added. Linguists usually write stems with an en dash or a hyphen after them. This means that the stem is not a word in itself, but requires the addition of an ending if it is to be used in a sentence.

stop A consonant produced by forming a complete closure within the oral tract (the space between the vocal cords and the lip, excluding the nasal cavity) and subsequently releasing this closure with a burst of air, as in

the sounds (p) in *pit* and (d) in *dog*. The stop (p) is produced by making a closure with the lips, and the stop (d) is produced by making a closure with the front part of the tongue against the gums behind the back of the teeth. See also *voiced* and *voiceless.*

suffix An affix added to the end of a word, root, or stem, serving to form a new word or functioning as an inflectional ending, such as *-ness* in *gentleness, -ing* in *walking,* or *-s* in *sits.*

taboo deformation The alteration of the sounds in a word that is considered sacred, offensive, or vulgar to make the word more acceptable in situations where its use is required. For example, *Jeezum Crow* is a taboo deformation of *Jesus Christ,* while *goldurnit* is a taboo deformation of *God damn it.*

transitive Of or relating to a verb or verbal construction expressing an action carried from the subject to the direct object or requiring a direct object to complete its meaning. Compare *intransitive* above.

Upper South See *Midland* above.

Upper North A major dialect region of the United States. In general, the Upper Northern dialect region runs east to west from Connecticut, western Massachusetts, and Vermont through most of New York, the very northernmost part of Pennsylvania and Ohio, and into Michigan, Wisconsin, and Minnesota as well as the northern part of Illinois and Iowa. See **whiffletree** for a discussion of a word typical of the Upper North.

velar Related to or being a sound articulated with the back of the tongue touching or near the soft palate, as (g) in *good,* (k) in *king,* or the (кн) in Scottish *loch.*

voiced Uttered with vibrating vocal cords, as in the production of vowels and voiced consonants like (d) and (b).

voiceless Uttered without vibration of the vocal cords, as the sounds (t) and (p).

Vulgar Latin The common speech of the ancient Romans, which differed from the standard language of Latin literature and is the ancestor of the Romance languages.

Index

Main entries are in **boldface** type.

XYZ

Picture Credits

agnostic Corbis-Bettmann **andiron** © Houghton Mifflin Company School Division **baroque** Art Resource, New York/Victoria & Albert Museum, London **brogue** Courtesy of Dr. Martens AirWair **cannibal** Library of Congress LC-USZ62-1784 **cynosure** Tech-Graphics **dachshund** © Houghton Mifflin Company/Photograph by Evelyn Shafer **earwig** Cecile Duray-Bito **gerrymander** Library of Congress **gingko** Chris Costello **gung ho** Corbis **krewe** Corbis/A.J. Sisco **loblolly** Chris Costello **macabre** Art Resource, New York/Foto Marburg **Melba toast** Corbis/Hulton-Deutsch Collection **muumuu** Corbis/Lake County Museum **Old Scratch** Art Resource, New York/Snark **petard** "Military Antiquities Respecting a History of the English Army from Conquest to the Present Time" by Francis Grose Esquire, 1812 **philodendron** Chris Costello **puce** *Micrographia* by Robert Hooke, 1665 **quoit** Getty Images/Hulton Archive **ramada** Corbis/Greg Probst **sacrum** Laurel Cook Lhowe **sideburns** Library of Congress LC-DIG-cwpb-05368 **stoic** Corbis/Ruggero Vanni **tabby** Corbis Royalty-free **terrier** © Houghton Mifflin Company/Photograph by Evelyn Shafer **tête-à-tête** © Houghton Mifflin Company School Division **wigwam** Library of Congress LC-USZ62-101173 **woodchuck** Corbis Royalty-free **xylophone** Getty Images/Photodisc **zloty** © Houghton Mifflin Company School Division